The City Lost & Found

With contributions by
Ken D. Allan
Eric Avila
Beatriz Colomina
Dana Cuff
Josh Glick
Brynn Hatton
Craig Lee
Paula J. Massood
Timothy Mennel
Mariana Mogilevich
Max Page
Erin Reitz
David Sadighian
Joshua Shannon
Jacqueline Stewart
Lawrence J. Vale
Leslie Wilson
Rebecca Zorach

The City Lost & Found

Capturing New York, Chicago, and Los Angeles, 1960–1980

Katherine A. Bussard
Alison Fisher
Greg Foster-Rice

Princeton University Art Museum

Distributed by Yale University Press
New Haven and London

Lenders to the Exhibition

The Alvin Baltrop Trust, New York
Ann and Steven Ames, New York
The Art Institute of Chicago
Avery Architectural & Fine Arts Library, Columbia University, New York
Bruce Silverstein Gallery, New York
Oscar Castillo, Los Angeles
Chicago Film Archives
Chicago History Museum
City Archives and Records Center, Los Angeles
Stuart Cohen, Evanston, Illinois
Craig Krull Gallery, Santa Monica
Department of Rare Books and Special Collections, Princeton University
Archive of Carlos Diniz
Walter O. and Linda J. Evans, Savannah, Georgia
Gallery Luisotti, Santa Monica
Harry Gamboa Jr., Los Angeles
The Getty Research Institute, Los Angeles
Goldberg Family Archive, Chicago
Howard Greenberg Gallery, New York
The Huntington Library, San Marino, California
Indiana University Art Museum, Bloomington
Joan Flasch Artists' Book Collection, School of the Art Institute of Chicago
Kenneth Josephson, Chicago
The J. Paul Getty Museum, Los Angeles
Kohn Gallery, Los Angeles
Estate of Helen Levitt
LeWitt Collection, Chester, Connecticut
The Library of Congress
Marian Goodman Gallery, New York
Marquand Library of Art and Archaeology, Princeton University
Matthew Marks Gallery, New York
Mitchell-Innes & Nash, New York
M. Paul Friedberg and Partners, New York
Museum of Contemporary Art, Chicago
Museum of the City of New York
Northwestern University Library, Evanston, Illinois
Pace/MacGill Gallery, New York
Paula Cooper Gallery, New York
Paul Kasmin Gallery, New York
Princeton University Art Museum
Rhona Hoffman Gallery, Chicago
Robert Mann Gallery, New York
Ronald Feldman Fine Arts, New York
Rosamund Felsen Gallery, Santa Monica
Rose Gallery, Santa Monica
Ryerson and Burnham Libraries, The Art Institute of Chicago
School of Architecture Library, Princeton University
The Tamiment Library, New York University
Wisconsin Historical Society, Madison
Rebecca Zorach, Chicago

Directors' Foreword

It is in the very nature of cities both to be changed by and to change those who use and animate them. The historical nature of this exhibition and its accompanying publication—temporally distant in some ways yet immediate in others—demonstrates this while also reminding us that the changes that took place in our cities in the 1960s and 1970s underpin many of the economic, political, social, and cultural realities of urban life in the United States today. Certainly the city has never been more important, with a great majority of Americans now living in cities and their suburbs. Indeed, measured in terms of recent population shifts and particularly of population outflow, two of the cities under consideration in *The City Lost and Found*—Los Angeles and New York—rank among the fastest changing in the nation.

It thus seems timelier than ever to consider the very nature of our cities and the ways in which we encounter them visually. It is our hope that *The City Lost and Found* will prompt an important discussion about the places in which the majority of us live, work, and play, raising questions such as: Who has shaped our vision of cities, both today and in the past? What role do images have in engaging citizens in critical discourse about our cities? How do artists respond to contemporary considerations of public space; changing urban neighborhoods, including the phenomenon of gentrification; and urban diversity? How do images reflect our urban reality, tell us fictions, and shape change?

The very origins of *The City Lost and Found* reflect a desire to transcend traditional divisions in artistic mediums, curatorial specializations, and scholarly fields. While the project initially grew out of Katherine Bussard's research on Martha Rosler's street photographs of New York City and Greg Foster-Rice's writing on Romare Bearden's photomontage murals of a block in Harlem,

it was further contextualized by Alison Fisher's work on architecture and urban planning in the 1960s and 1970s. Their close collaboration made it possible for the team to address a diverse selection of artworks and other materials in relation to the broader social, economic, and political narratives of the era.

The City Lost and Found is a natural reflection of our two institutions' historical interest in architecture, photography, and related fields of study, and it provides a profound and fruitful opportunity for us to join forces to greater effect in developing this landmark project. Both the Art Institute of Chicago and the Princeton University Art Museum have long-standing histories of organizing critically acclaimed exhibitions and accompanying publications that have contributed vital new scholarship to these fields. At the Art Institute, important precedents for the curatorial aims of *The City Lost and Found* include the scholarly approach to photographic practice across mediums in *Light Years: Conceptual Art and the Photograph, 1964–1977* (2011) and the exploration of American urbanism in *Bertrand Goldberg: Architecture of Invention* (2011–12). The Princeton University Art Museum was not only one of the first American institutions to take up the history of photography as a subject of serious academic inquiry, but it has also sustained that commitment in recent years with projects such as *The Itinerant Languages of Photography* (2013), which considered photography's capacity to circulate across time and space, and *New Jersey as Non-Site* (2013) and its revelation of historic breakthroughs in site-based conceptual and performance art in the Garden State. We believe that *The City Lost and Found* stands to have a similar impact by focusing on the groundbreaking intersections of art, popular media, and spatial practices in New York, Chicago,

and Los Angeles during a crucial period in American history.

No project of this kind would be possible without the contributions of many. Our first thanks go to the exhibition's inspired and inspiring curators, Katherine Bussard, Alison Fisher, and Greg Foster-Rice, who have deliberated—initially in Chicago and then across the distance between Chicago and Princeton—for a period of five years. Together, they defined the fundamental focus of *The City Lost and Found* and determined how best to deliver that focus through an exceptional selection of objects in diverse mediums. To the many lenders who have parted with fragile objects—and allowed them to be seen in a wholly new context—we extend our most heartfelt gratitude.

A host of funders have likewise fostered a boundary-crossing project that defies many traditional expectations; in their willingness to embrace a boldly new way of looking at the American city, these funders too are pioneers. A generous grant from the Barr Ferree Foundation Fund for Publications in the Department of Art and Archaeology at Princeton University has fundamentally underwritten this publication. Major donors for the project's development and presentation at the Art Institute of Chicago include the Graham Foundation for Advanced Studies in the Fine Arts and the Richard H. Driehaus Foundation. Major support for the project at the Princeton University Art Museum has come from Susan and John Diekman, Class of 1965; Christopher E. Olofson, Class of 1992; M. Robin Krasny, Class of 1973; David H. McAlpin Jr., Class of 1950; James E. and Valerie A. McKinney; the Allen R. Adler, Class of 1967, Exhibitions Fund; Elchin Safarov and Dilyara Allakhverdova; and the Partners and Friends of the Princeton University Art Museum.

As Jane Jacobs wrote in *The Death and Life of Great American Cities*, "Cities have the capability of providing something for everybody, only because, and only when, they are created by everybody." Through the compelling body of material that it brings together, *The City Lost and Found* invites us to consider the ways in which artists, urban planners, city dwellers, visitors, and observers alike participated in the unmaking and remaking of our greatest cities—and we now invite you to join in that process.

James Christen Steward
Director
Princeton University Art Museum

Douglas Druick
President and Eloise W. Martin Director
The Art Institute of Chicago

Foreword

The City Lost and Found: Capturing New York, Chicago, and Los Angeles, 1960–1980 represents brilliantly what I consider to be the most exciting developments in urban studies in the past decade or so: the emergence of new problematics relying on controlled comparisons—whether regional, national, or international—and the move away from statistical positivism toward a more inductive method, identifying patterns, configurations, and structural systems of process. Using photographs and films of the three cities during an especially contentious period, *The City Lost and Found* brings fresh perspective to historical topics that have great significance for our present-day relationship with cities.

In the books that occupied me from about 1990 to 2007—*New York, Chicago, Los Angeles: America's Global Cities* (1999) and its sequel, *Race, Space, and Riots in Chicago, New York, and Los Angeles* (2007)—I developed theoretically informed explanations of the histories and dynamics, especially racial, of these three great American global cities. I investigated the demographic diversity, the organization of space, the role of minorities in the economic base, and the political structures and cultures of each city over time. I found that these dimensions could not be treated as independent variables. Cities are interactional systems of local actors whose behavior is shaped by the past, by opportunity structures afforded within larger national and even global conditions, and by legal and economic forces. By introducing the visual to this approach and connecting it to these social, political, and economic dimensions, *The City Lost and Found* further deepens our understanding of the complexity of urban systems.

Comparative approaches to cities are expanding our ability to identify key dynamics in the context of time, space, and culture. The three cities in *The City Lost and Found* have typically been studied separately. Different schools of urban studies emerged for New York, Chicago, and Los Angeles, establishing distinctive methods and key problematics for each city. As a result, urbanists—including art historians dedicated to the urban—who try to understand more than one city are forced to test, and possibly question or integrate, what they see against the assumptions and discourses established by the school in which they were trained. The breadth and depth afforded by moving beyond preconceived assumptions and disciplinary habits is the main payoff for itinerants like myself, and I recommend it as a method for transcending place-specific tunnel vision. *The City Lost and Found* does just that and jolts us into seeing American cities and their history in new ways.

When approached about this project by the curators, I was encouraged by the forward momentum of urban studies and excited about the opportunities that visual analysis of urban imagery provides for a deeper and more interdisciplinary understanding of cities. I was reminded too of the greatness of cities and the value of assessing these global American cities from a multitude of perspectives.

Janet L. Abu-Lughod with
Lila Abu-Lughod

After a series of conversations with Janet Abu-Lughod that led to this foreword, we were deeply saddened to learn of her death in December 2013. This project owes a considerable debt to her scholarship, and we are very grateful for her enthusiasm and generosity as well as that of her daughter Lila Abu-Lughod. —KB, AF, GFR

Introduction

Katherine A. Bussard, Alison Fisher, and Greg Foster-Rice

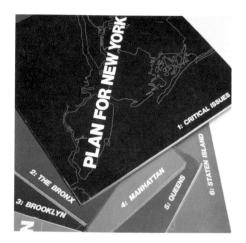

1 *Plan for New York City*, published by the New York City Planning Commission, 1969

The city of the 1960s and 1970s was in crisis. Buildings were on fire. Massive highways threatened vibrant neighborhoods. Citizens were taking to the streets in protest. In short, the future of the city was anything but assured. From the pages of *Life* magazine to municipal reports, these decades witnessed a widespread recognition of forces that threatened to destroy the social and physical fabric of American cities.[1] Nowhere was this more evident than in the country's three largest cities: New York, Chicago, and Los Angeles. As early as 1961, however, Jane Jacobs imagined one form of urban revival in her famous book *The Death and Life of Great American Cities*.[2] Jacobs's ideas galvanized a generation of artists, planners, and activists, ultimately leading—for better or for worse—to the reaffirmation of these cities by the 1980s as the cultural and financial capitals of the country, complete with soaring real estate prices and art markets. *The City Lost and Found: Capturing New York, Chicago, and Los Angeles, 1960–1980* explores a pivotal period through a variety of art, media, and urban-planning practices. In these projects, photography and film were used not only to represent and expose conditions of crisis but also to articulate new constellations of images, goals, and futures for American cities.

This exhibition and publication examine the work of a host of actors in the city—including artists, filmmakers, urban planners, architects, activists, and the mass media—who transformed conditions of crisis into provocative and visually compelling statements about the culture, landscape, and politics of the three largest cities in the United States. This period saw the emergence of a new kind of photographic and cinematic practice in the art world, on the covers of magazines, and in the pages of planning documents, a practice that shifted away from aerial views and sweeping panoramas and instead turned to in-depth studies of streets, pedestrian life, neighborhoods, and seminal urban events. Not only did these close examinations offer the public a complex image of life in American cities and create forms of artistic engagement with the texture and experience of urban culture, but they also served as important models for architects and planners. *The City Lost and Found* breaks with the traditional disciplinary boundaries that have structured scholarship on this period, arguing for the collective impact of the circulation and exchange of new photographic and filmic practices in an extraordinary era for American cities.

New York, Chicago, and Los Angeles were the most populous and influential cities in the United States during the second half of the twentieth century.[3] Despite the distinct histories of social and economic development in each of these cities, by 1970 all three had been faced with profound demographic shifts, changing economic bases, and civil unrest. This confluence of social, physical, and political problems led each city's mayor and planning department to undertake a comprehensive city plan that would for the first time focus on quality of life and the environment as well as on the "hard" remedies of housing, transportation, and jobs (fig. 1).

Although the urban sociologist Janet Abu-Lughod was among the first to argue for the shared trajectories of New York, Chicago, and Los Angeles, she has also pointed out that these cities developed generationally, with New York's economic expansion and population growth

dating to the nineteenth and early twentieth centuries, Chicago's rapid expansion occurring in the early to mid-twentieth century, and Los Angeles developing last but emerging as one of the nation's strongest economies by the 1960s.[4] The influence of these three cities extends to the development of a school of urban sociology strongly identified with the physical form of each city. The "Chicago school" is associated with urban ethnography and evolving rather than fixed social structures in the early twentieth century. The loosely affiliated "Jane Jacobs school" of New York place-based and community-focused urbanism played an important role in the second half of the twentieth century, followed by the "Los Angeles school," which identified that city's fragmented, sprawling character with postwar American urbanism.[5] The existence of these schools of thought points to the paradigmatic role of these three cities in critical discussions of American society and to the distinctive ways in which New York, Chicago, and Los Angeles responded to the period's challenges and opportunities. Our project has benefited from groundbreaking comparative studies of cities by Abu-Lughod and other scholars of sociology and geography, and we have drawn on aspects of this methodology to enrich our examination of visual culture and the important shared histories, struggles, and creative practices of these three cities.[6]

The project spans two decades—from the election of John F. Kennedy to the election of Ronald Reagan—and frames a tumultuous period in American cities. Much of the work in the exhibition and publication responds to the urban challenges identified by President Lyndon B. Johnson—including poverty, segregation, scarce employment opportunities, and a lack of community involvement in the crucial decisions affecting the future of urban neighborhoods—which would be targeted by a series of federal programs known as the Great Society.[7] In a 1964 speech announcing his vision for the nation, Johnson called not only for investment but also for the development of new ideas and experimentation to solve urban problems: "Our society will never be great until our cities are great. Today the frontier of imagination and innovation is inside those cities and not beyond their borders."[8]

This sense of urgency and optimism built on the successes achieved by the civil rights movement in the preceding decade while grappling with the many changes in American cities stemming from massive demographic shifts, including the exodus of the white middle class from center cities to the suburbs and the movement of African Americans from the rural South to the urban North and West during the height of the Great Migration, as well as many other smaller migrations and immigrations in the second half of the twentieth century.[9] The civil rights movement also responded to these developments with a set of urban strategies in the 1960s. These included local nonviolent protests by the likes of the Congress of Racial Equality's chapter in New York (fig. **2**) as well as more ambitious and sweeping demands for urban change. For example, in 1965 Martin Luther King Jr. chose Chicago as the site for his Open Housing Movement to draw attention to housing discrimination and segregation in that city as well as to its history of white-on-black violence as black families moved into white neighborhoods.[10]

As the 1960s progressed, these urban political movements expanded, diversified their tactics, and became more local and specific to the neighborhoods they served, encompassing branches of the national Students for a Democratic Society and the Black Panthers;

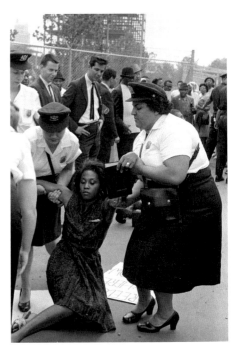

2 Leonard Freed, *Civil rights demonstration, Brooklyn, New York*, 1963

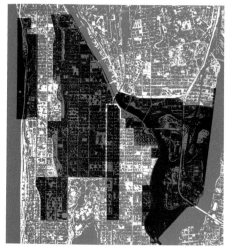

3 Cover of *The New City:
Architecture and Urban
Renewal*, published by the
Museum of Modern Art, New
York, 1967

groups organized around place, such as Chicago's Rising Up Angry; and those targeting specific political and social issues in cities, like the Los Angeles Chicano Moratorium, which mobilized against the Vietnam War.[11] *The City Lost and Found* builds on recent studies acknowledging the importance and specificity of the civil rights struggle in northern cities, complementing them and identifying the need for further examination of the ways in which these movements impacted the representation of cities and ultimately actual urban spaces.[12]

Another important factor in this history is the long legacy of urban renewal, which frequently resulted in the demolition and erasure of entire neighborhoods and became part of public debates about cities, whether in newspaper articles or in a 1967 exhibition at the Museum of Modern Art in New York (fig. **3**).[13] Much of the violent displacement of communities in New York and Chicago, and to a lesser extent in Los Angeles, was done in the name of eradicating "blight." This powerful yet imprecise term was targeted in the 1960s by critics, activists, and researchers such as Jane Jacobs and the sociologist Herbert Gans, who sought to expose the prejudice and ignorance that made many planners and decision makers blind to the value of community in vibrant lower-income neighborhoods.[14] Urban renewal was also used by local governments to further entrench historical racial divisions in cities as a means of "protecting" real estate values in white neighborhoods and encouraging private investment in the increasingly disenfranchised inner city, luring developers back from the suburbs. In New York and Chicago, public housing was a complicated aspect of this era of redevelopment, on the one hand further concentrating low-income residents, often by race or ethnicity, and on the other offering places where many families developed strong social and political networks.[15] Another critical reaction to urban renewal—as well as to the more gradual loss of buildings through arson and neglect—was the emergence in these three cities of historic preservation movements, the most publicized manifestation of which was the 1965 New York City Landmarks Law, fueled by a passionate and failed attempt to save the famous Penn Station from demolition.[16]

Citizen action in the city developed during this period as an antidote to years of top-down, closed-door decision making, taking the form of community interest groups such as Jacobs's Committee to Save the West Village and the Conservative Vice Lords on the West Side of Chicago, as well as an array of temporary mobilizations and occupations of city spaces for public use, including political protests, riots, and art performances.[17] Urban demonstrations were essential to making visible and highly public the demands for equal rights by a variety of groups, including the Latino high school students who staged walkouts in East Los Angeles and the gay rights and women's rights groups that organized marches in New York.[18]

Federal and municipal governments also recognized the need for more direct and localized forms of civic engagement, although the results were often mixed. Johnson's Model Cities program of 1966, for example, identified troubled urban neighborhoods and invited local people to choose and implement the programs and services most needed for their own communities.[19] Programs like the Environmental Protection Agency's innovative photography survey Documerica (1971–77) focused on framing the concerns of the agency through complex portraits of urban places and landscapes around the country (figs. **4–9**).[20] The mayors of each of these three cities responded differently to these challenges,

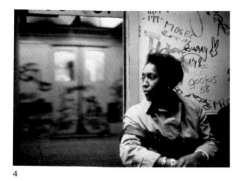

4

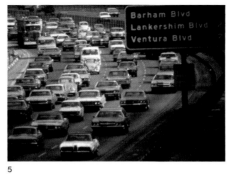

5

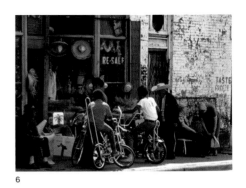

6

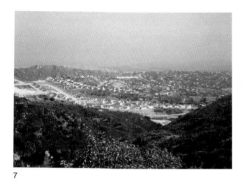

7

8

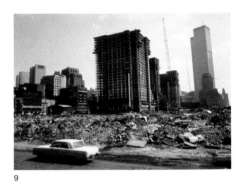

9

with Chicago's Richard J. Daley (1955–76) and Los Angeles's Sam Yorty (1961–73) maintaining very centralized forms of administration, while John V. Lindsay (1966–73) is known for his novel attempts to decentralize decisions about public schooling in New York.[21] Nevertheless, all three administrations incorporated this new spirit of participation and focus on the needs of individual neighborhoods into comprehensive plans that were for the first time designed to represent and be accessible to the public.

The idea of the city as a series of encounters guided by the sense of sight has long been a trope of the literature on urban experience.[22] Yet it achieved renewed significance in the 1960s and 1970s through a set of complex interrelationships among photography, film, and urbanism that helped situate photographic and cinematic images of the city at the intersection of public debate, artistic practice, and popular culture. The period saw expanded possibilities for direct engagement with city streets, with image makers privileging immersion and a sense of lived experience in the city, as evidenced by Gordon Matta-Clark's use of the newly developed and highly portable Arriflex SR 16 mm camera for *City Slivers* (1976; fig. **34**) and the heightened visibility of street photography in influential exhibitions such as *Toward a Social Landscape* and *New Documents*.[23] More experimental uses of photography—including collage, installation, photographic murals, and projected images of the city—were often predicated on the idea that these images could function as interventions into the urban fabric. At the same time, journalistic imagery of demonstrations in the streets shaped the public's understanding of the city, with activists and city public-relations departments scrambling to use photography and film to make competing claims about crisis or renewal. The work of many artists and planners reveals not only a concern with images circulating in the mass media but also a critical appropriation of the very tools—including street photographs, serialized images, and in

4-9 Photographs from the Environmental Protection Agency's Documerica project, 1971-77

4 Erik Calonius, *Interior of a graffiti-marked subway car*, May 1973

5 Gene Daniels, *Hollywood Freeway near Ventura Beach*, May 1972

6 John H. White, *Sidewalk merchandise on Chicago's South Side*, June 1973

7 Charles O'Rear, *New housing encroaches on the Santa Monica Mountains off Mulholland Drive*, May 1975

8 Danny Lyon, *Two youths in Uptown, Chicago, Illinois*, August 1974

9 Wil Blanche, *Construction on Lower Manhattan's West Side*, May 1973

10 Robert Abbott Sengstacke,
Wall of Respect, 1968
(printed later). Inkjet
print. Getty Images

some cases cinematic depictions—that attracted such a high degree of popular attention to the struggles and identities of American cities.

In broad terms, then, *The City Lost and Found* emphasizes efforts by urban communities, organizations, and social movements in New York, Chicago, and Los Angeles to embrace city streets as places to preserve authenticity, demand equality in the public realm, and present new visions for the future of the American city. The first of these ideas—the public call to preserve authenticity and community in city neighborhoods—includes the foundations of the preservation movement, which sought to protect buildings and historic neighborhoods, as well as efforts to preserve the existing populations and social composition of cities. Artists' engagements with this theme include the use of the image-text relationship in the book *Harlem Stirs* (1966; fig. **53**), which treats the entire neighborhood of Harlem as the protagonist in a struggle for self-determination,[24] as well as James Nares's experimental film *Pendulum* (1976; fig. **64**), which recalls the languid motion of a wrecking ball.

Another major theme underlying this project is demonstration, construed in the broadest sense as encompassing a variety of practices that helped shape and communicate public perceptions about social struggles and changes in American cities in the 1960s and into the 1970s. Materials relating to this theme include documentary or mass-media photographs of the protests, riots, and marches that swelled city streets as well as temporary appropriations of urban space by artists and filmmakers. Murals like the *Wall of Respect* (1967–71; figs. **10**, **144**), on Chicago's South Side, or the performance pieces of the Los Angeles Chicano art collective Asco (figs. **37**, **236**) reveal the street as a vital space for public events as well as a place for making strong and often critical claims about crime and police violence, social and political exclusions, and misrepresentations in the mass media. This expansive notion of demonstration reflects the devastating history of protests that received front-page newspaper and magazine coverage in the 1960s, making the entire nation, if not the world, sit up and take notice of the problems facing America's largest cities (and soon enough its smaller ones). It also shows how these cities served as sites where different groups, including artists and underrepresented communities, could stage their identities, develop site-specific creative practices, and demand recognition of their right to live equally in the city.

A third key idea, renewal, addresses those projects and proposals that sought to remedy existing problems in the cities as well as to imagine new futures. It includes the emergence of new planning models developed by municipal agencies and grassroots activists that recognized the importance of diversity and shifted the goals and visual language of city plans to preserve and support distinctive qualities of urban neighborhoods, areas, and streets. Arthur Tress's photographic portfolio *Open Space in the Inner City* (1971; fig. **92**), for example, was intended as a kind of interactive exhibition of images reflecting the many possibilities for abandoned lots, old industrial piers, and other neglected spaces in New York, while DeWitt Beall's film *Lord Thing* (1970; fig. **166**) documents the efforts of the Conservative Vice Lords, a street gang turned community organization that renounced violence and transformed its neighborhood on the West Side of Chicago through job training, youth services, and other social programs.

Taken together, this exhibition and book chart a seminal and previously underexamined context for photography in American cities

of the 1960s and 1970s. Although this period of art practice has been the subject of important scholarship and exhibitions in recent years, we focus on the ways in which photography and film catalyzed disparate makers—including the architect Paul Rudolph, the photojournalist Barton Silverman, and the performance artist Mierle Laderman Ukeles—and their creative approaches to the city as a goal, site, and stage.[25] Our project sheds light on the role of images in setting new directions for urban planning in the 1960s and 1970s and argues that the crucial issues in the politics and landscapes of New York, Chicago, and Los Angeles would not have been as legible and knowable to image makers or the American public without photography as the ambassador.

In some cases this project has led to the critical reframing of the work of well-known artists, such as the rediscovered photographs of Allan Kaprow's Happening *Moving* (1967; fig. **11**), which show the artist and his collaborators roaming the streets of Chicago and staging the occupation of an abandoned apartment on Skid Row. We also bring new attention to less familiar figures, like the architect Shadrach Woods, whose career in Europe and work with photography gave him a unique perspective on preserving mixed-use spaces in New York's SoHo, one that emphasized the neighborhood's historic connection to the industrial economy. In other instances, we place the work of those who have long been identified with their close visual attention to cities—such as Garry Winogrand, Art Sinsabaugh, and Julius Shulman (fig. **12**)—into a different, more interdisciplinary context. Finally, *The City Lost and Found* identifies the common threads in art practices in three cities that are usually analyzed in isolation or even positioned in opposition. Blurring traditional boundaries separating practices, professions, scholarly fields, and geography, this project offers an opportunity to experience the deep interconnections in the political, social, and visual realities of American cities in the 1960s and 1970s.

This publication therefore recognizes the historic and fertile cross-pollination of photography and diverse practices—architectural research, performance art, documentary film, and popular media—that allowed for an unprecedented level of critical engagement with the problems and potentials of American cities. Just as these practices and objects speak to topics as wide-ranging as race riots, housing abandonment, community politics, and revitalization efforts, this book features essays from scholars in many fields—urban studies, planning, architecture, art history, and film studies—in order to address questions of the urban and its representation in art and media from multiple disciplines and points of view. These essays—whether thematic overviews, topic treatments, or focused interpretations of a single object or project—are organized by city to illustrate the interwoven nature of ideas and practices within each city. Conversely, in-depth essays by the three principal authors extend this analysis across all three cities to create a comparative dialogue around specific topics. These include Greg Foster-Rice's exploration of the experiential and participatory qualities of art practices, planning, and film; Katherine Bussard's consideration of pivotal urban demonstrations as presented by the print media and television; and Alison Fisher's examination of architects' proposals for large-scale projects that engaged with the scale and fabric of the existing historical city. Taken as a whole, this book offers an immersive experience of each city, one made richer by the layered conversations in city-specific essays, complemented by the comparative consideration of the three cities in the principal essays.

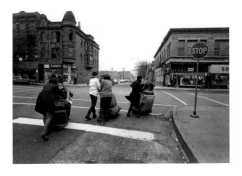

11 Peter Moore, photograph of Allan Kaprow's *Moving*, 1967. Gelatin silver print. Courtesy of Paula Cooper Gallery. © Barbara Moore / licensed by VAGA, New York

12 Julius Shulman, *Bunker Hill Redevelopment, Los Angeles*, 1980. Gelatin silver print. Julius Shulman Photography Archive, Getty Research Institute, Los Angeles

Focusing on a key moment in the 1960s and 1970s when the image of the city was contested, negotiated, and debated in new and important ways, this project proposes an alternative understanding of urbanism in that era. Further, we hope that readers of this publication and visitors to the exhibition come to understand how this period laid the foundations for social, economic, political, and cultural aspects of contemporary life in American cities. These connections continue to inspire artists, scholars, policy makers, designers, and the public to question the role of art in engaging citizens in critical discourse, drawing new attention to pressing urban issues such as gentrification, public space, and urban diversity. *The City Lost and Found* signals an expanded dialogue about social agency and urban representation, whether in the 1960s and 1970s, today, or tomorrow.

1 Dozens of publications from the 1960s described the crisis in American cities from different perspectives, including articles in popular magazines, work by sociologists on race and poverty, and studies of urban policy and planning. For a sampling of such writing, see the special issue "The U.S. City: Its Greatness at Stake," *Life*, December 24, 1965; Ralph Ellison, Whitney M. Young Jr., and Herbert Gans, *The City in Crisis* (New York: A. Philip Randolph Educational Fund, ca. 1966–70); *The Threatened City* (New York: City of New York, 1967); and Robert Goodman, *After the Planners* (New York: Simon & Schuster, 1971).

2 Jane Jacobs, *The Death and Life of Great American Cities* (New York: Random House, 1961).

3 For census data, see http://www.census.gov /population/www/documentation/twps0027/tab19.txt.

4 Janet L. Abu-Lughod, *New York, Chicago, and Los Angeles: America's Global Cities* (Minneapolis: University of Minnesota Press, 1999), 1–16.

5 Key texts associated with each school include, for Chicago, New York, and Los Angeles, respectively, Robert Ezra Park, Ernest Burgess, and Roderick McKenzie, *The City* (Chicago: University of Chicago Press, 1925); David Halle and Andrew A. Beveridge, eds., *New York and Los Angeles: The Uncertain Future* (New York: Oxford University Press, 2013); and Robert M. Fogelson, *The Fragmented Metropolis: Los Angeles, 1850–1930* (Berkeley: University of California Press, 1993).

6 See Abu-Lughod, *New York, Chicago, and Los Angeles*; Janet Abu-Lughod, *Race, Space, and Riots in Chicago, New York, and Los Angeles* (New York: Oxford University Press, 2007); and Dennis R. Judd and Dick W. Simpson, eds., *The City, Revisited: Urban Theory from Chicago, Los Angeles, and New York* (Minneapolis: University of Minnesota Press, 2011).

7 It is worth noting that some aspects of Johnson's Great Society initiative were carryovers from the Kennedy administration. Civil rights, for example, was a key policy area for both administrations, but the Great Society saw many demands codified into law, with the Civil Rights Act of 1964 and the Voting Rights Act of 1965. Among the many other accomplishments of the Great Society, those with a strong impact on America's

cities included the War on Poverty (via the Economic Opportunity Act of 1964), which generated dozens of federally funded programs such as the Neighborhood Youth Corps, designed to provide work experience to poor youth in cities; education legislation that made funds available for bilingual schooling; various improvements to the Social Security program; numerous new laws aimed at environmental protection; and housing reform via the Housing and Urban Development Act of 1965 and the Demonstration Cities Act of 1966. For a recent contextualization of many of these domestic efforts by the Johnson administration as well as its simultaneous escalation of the war in Vietnam, see James T. Patterson, *The Eve of Destruction: How 1965 Transformed America* (New York: Basic Books, 2012).

8 Lyndon B. Johnson, "Remarks at the University of Michigan" (1964), in *Public Papers of the Presidents of the United States: Lyndon B. Johnson* (Washington, DC: U.S. Government Printing Office, 1963–64), vol. 1, 704–7.

9 During the 1950s, for example, suburbs grew at ten times the rate of central cities, and the nation's suburban population more than doubled from 1950 to 1970. See Eric Avila, *Popular Culture in the Age of White Flight: Fear and Fantasy in Suburban Los Angeles* (Berkeley: University of California Press, 2004), 4. For a recent consideration of the Great Migration, see Isabel Wilkerson, *The Warmth of Other Suns: The Epic Story of America's Great Migration* (New York: Random House, 2010).

10 The Chicago Freedom Movement of 1965–67 was also led by James Bevel and Al Raby, and it is largely credited with inspiring the 1968 Fair Housing Act. Previously the Federal Housing Administration encouraged segregated housing, favored the purchase of single-family homes, and inhibited loans for properties in densely settled neighborhoods, and the National Association of Real Estate Boards regarded intentional integration as a violation of its code of ethics. Martha Biondi, *To Stand and Fight: The Struggle for Civil Rights in Postwar New York City* (Cambridge, MA: Harvard University Press, 2003), 112–14. See also the seminal text by Arnold R. Hirsch, *Making the Second Ghetto: Race and Housing in Chicago, 1940–1960* (Chicago: University of Chicago Press, 1998), and Douglas S. Massey and Nancy A. Denton, *American Apartheid: Segregation and the Making of the Underclass* (Cambridge, MA: Harvard University Press, 1993).

11 See, among others, Robert Fisher, *Let the People Decide: Neighborhood Organizing in America* (New York: Twayne, 1994); Maurice Isserman and Michael Kazin, *American Divided: The Civil War of the 1960s* (New York: Oxford University Press, 2000); and Dan Berger, ed., *The Hidden 1970s: Histories of Radicalism* (New Brunswick, NJ: Rutgers University Press, 2010).

12 See, for example, Biondi, *To Stand and Fight*.

13 The practice of urban renewal evolved over the first half of the twentieth century but is most associated with an extreme form of redevelopment that removed whole sections of the historical urban fabric (or even whole neighborhoods) in favor of modern developments, often for use by a higher-income population. Although early debates about the phenomenon were largely restricted to specialists, work by Jane Jacobs and others brought the issue to the public realm. See Alexander von Hoffman, "The Lost History of Urban Renewal," *Journal of Urbanism* 1, no. 3 (2008): 281–301, as well as sources cited in Alison Fisher's essay in this volume, pages 174–205.

14 Herbert Gans was one of the first sociologists to study low-income urban neighborhoods in the United States, with work on the so-called slum of Boston's West End, which was cleared by urban renewal during the course of his research. His observations about the strong social networks of this Italian American community influenced Jane Jacobs, and this neighborhood is mentioned frequently in *The Death and Life of Great American Cities*. See Herbert Gans, *The Urban Villagers: Group and Class in the Life of Italian-Americans* (New York: Free Press, 1968).

15 Public housing was effectively quashed by anticommunist politicians in Los Angeles in the 1950s. See Don Parson, *Making a Better World: Public Housing, the Red Scare, and the Direction of Modern Los Angeles* (Minneapolis: University of Minnesota Press, 2005), and Dana Cuff, *The Provisional City: Los Angeles Stories of Architecture and Urbanism* (Cambridge, MA: MIT Press, 2000). Important books on public housing in New York and Chicago include Samuel Zipp, *Manhattan Projects: The Rise and Fall of Urban Renewal in Cold War New York* (Oxford: Oxford University Press, 2010), and D. Bradford Hunt, *Blueprint for Disaster: The Unraveling of Chicago Public Housing* (Chicago: University of Chicago Press, 2009).

16 The demolition of seminal buildings in Chicago and New York—the architect Louis Sullivan's Garrick Theater in 1960 and Penn Station in 1963—came to be recognized as important moments in the struggle for historic preservation in the United States, with public awareness of preservation arriving later in Los Angeles. In Chicago, the photographer Richard Nickel led the campaign to save and preserve Sullivan's buildings and left an important photographic archive of lost buildings (fig. **134**). See Richard Cahan, *They All Fall Down: Richard Nickel's Struggle to Save America's Architecture* (New York: John Wiley & Sons, 1994). Recent scholarship has challenged the centrality of Penn Station to the enactment of 1965 legislation in New York, but this building quickly became an icon of the movement. See Anthony C. Wood, *Preserving New York: Winning the Right to Protect a City's Landmarks* (London: Routledge/Taylor & Francis, 2008). For more on the preservation of buildings and communities in Los Angeles, see Dolores Hayden, *The Power of Place: Urban Landscapes as Public History* (Cambridge, MA: MIT Press, 1995).

17 Throughout this publication the reader will encounter the use of varied terms—*protest, riot, uprising,* and *rebellion* among them—which are intended to reflect the names commonly used for such events as well as the evolving discourse surrounding them.

18 These demonstrations, like those of nearly every political and social protest movement in the 1960s, derived their strategies and tactics from earlier civil rights efforts. This included an understanding of the pivotal role of photographic—and later televised—representation of the struggle.

19 Model Cities was a direct response to the perceived failure of urban renewal to improve living conditions and race relations in the inner city. Part of Johnson's Great Society, the 1966 program focused on a more holistic approach to federal aid in 150 low-income neighborhoods around the country. The goal was to assist low-income communities with job training, health care, and housing through programs developed in partnership with neighborhood leaders. Although this program did raise community awareness and participation in municipal politics, it was plagued by funding and implementation problems and ultimately considered unsuccessful. See John A. Andrew III, *Lyndon Johnson and the Great Society* (Chicago: I. R. Dee, 1998).

20 Documerica, a project created in 1971 by the Environmental Protection Agency to document environmental conditions in the United States, commissioned more than one hundred photographers working around the country. During the course of the project, a secondary focus on the urban landscape and communities of the inner city developed, particularly in Chicago and New York, with work by renowned photographers such as Danny Lyon and Arthur Tress. While there has been relatively little scholarship on Documerica, Barbara Lynn Shubinski's recent dissertation affirms the significant role played by photographers who documented these cities. See Barbara Lynn Shubinski, "From FSA to EPA: Project Documerica, the Dustbowl Legacy, and the Quest to Photograph 1970s America" (Ph.D. diss., University of Iowa, 2009).

21 Yorty has escaped book-length critical analysis, but numerous publications on Daley and Lindsay are relevant to this project, among them Adam Cohen and Elizabeth Taylor, *American Pharaoh: Mayor Richard J. Daley; His Battle for Chicago and the Nation* (Boston: Little, Brown, 1990); Sam Roberts, ed., *America's Mayor: John V. Lindsay and the Reinvention of New York* (New York: Museum of the City of New York and Columbia University Press, 2010); Vincent Cannato, *The Ungovernable City: John Lindsay and His Struggle to Save New York* (New York: Basic Books, 2001); and Joseph P. Viteritti, ed., *Summer in the City: John Lindsay, New York, and the American Dream* (Baltimore: Johns Hopkins University Press, 2014).

22 Some key examples include Edgar Allan Poe, "The Man of the Crowd" (1840), in *The Selected Writings of Edgar Allan Poe: Authoritative Texts, Backgrounds and Contexts, Criticism*, ed. G. R. Thompson (New York: Norton, 2004); Charles Baudelaire, "The Painter of Modern Life" (1863), in *The Painter of Modern Life and Other Essays*, trans. and ed. Jonathan Mayne (New York: Da Capo, 1986), 1–40; and Walter Benjamin "The Flâneur," in *Charles Baudelaire: A Lyric Poet in the Era of High Capitalism*, trans. Harry Zohn (London: Verso, 1997), 35–66.

23 The 1975 Arriflex SR 16 mm camera was notable for its small size and silent operation, allowing users to wander the streets with relative anonymity. *Toward a Social Landscape,* curated by Nathan Lyons, was presented at the George Eastman House in 1966, and *New Documents*, curated by John Szarkowski, was on view at the Museum of Modern Art in 1967.

24 John O. Killens, prologue to *Harlem Stirs*, text by Fred Halstead and photography by Anthony Aviles and Don Charles (New York: Marzani & Munsell, 1966), 7.

25 Recent exhibitions and books on this period include Lynne Cooke and Douglas Crimp, eds., *Mixed Use, Manhattan: Photography and Related Practices, 1970s to the Present* (Madrid: Museo Nacional Centro de Arte Reina Sofía; Cambridge, MA: MIT Press, 2010); Patricia Kelly, *1968: Art and Politics in Chicago* (Chicago: DePaul University Art Museum, 2008); and Rebecca Peabody, ed., *Pacific Standard Time: Los Angeles Art, 1945–1980* (Los Angeles: Getty Research Institute and the J. Paul Getty Museum, 2011).

The Dynamism of the City: Urban Planning and Artistic Responses to the 1960s and 1970s

Greg Foster-Rice

The scenes that illustrate this book are all about us. For illustrations, please look closely at real cities. While you are looking, you might as well also listen, linger and think about what you see.
—Jane Jacobs

The epigraph to Jane Jacobs's famous book *The Death and Life of Great American Cities* (1961) establishes a subtle but significant distinction between conventional illustration, which depicts a static and frequently presumptive set of urban conditions, and the importance of direct observation, which involves attentive and extended analysis of the city as a dynamic stage for social action. The intellectual context for this emphasis on close looking was part of a broader shift in thinking about cities as complex, dynamic social systems. In the field of municipal planning, this shift coalesced around the emergence of planning that incorporated greater citizen participation and advocacy for the rights of impoverished residents of blighted areas that nonetheless provided a sense of community.[1] For example, the influential architecture critic Ada Louise Huxtable identified the master plans for New York (1965–69), Chicago (1963–66), and Los Angeles (1965–70) with this new emphasis on "quality of life" rather than the issues of physical decay and infrastructure that were typically the focus of earlier city plans. She described this movement's "break with tradition" as a kind of metacriticism regarding "what a plan should be" because the plans emphasized the renewal of the populace (through education, job opportunities, and participation in government) over the renewal of the built environment.[2]

The visual context for this interest in direct observation was a rejection of the conventional illustrative way of looking *at the city* in favor of methods that could both represent and, in many cases, simulate or instigate social encounters *in the city* via complex formal vocabularies, unconventional methods of presentation, and direct engagement with the social fabric. As a means of creating analogues of urban experience, photography and film came to dominate the imaging of the city because, on the one hand, they appeared to have a continuous, indexical relationship to reality and, on the other hand, their technological development paralleled and helped shape the urbanization of modern society. What distinguishes the urban imagery of the 1960s and 1970s is the correlation between this decisive period in the reconsideration of American urbanism and the profusion of experimentation within American photography and film. These experiments can be attributed at least in part to broader changes within both mediums. In the case of photography, the medium was increasingly accepted as a fine art practice, which rejuvenated it from within. This period also saw the increasing adoption of photographic imagery by artists with little or no professional training in photography, which invigorated the medium from without.[3] In the case of film, the decline of the Hollywood studio system allowed for an explosion of independent cinema in the 1960s and 1970s, and the influence of Jean-Luc Godard, who encouraged filmmakers to take to the streets rather than the studio, helped establish what has been called observational or direct cinema. At the same time, artists with no prior experience in filmmaking appropriated the medium, often in the pursuit of expressive and frequently nonnarrative moving imagery that looked closely at and lingered on the city streets.

Both the intellectual and the visual context of direct observation collided in the master plans for New York, Chicago, and Los Angeles,

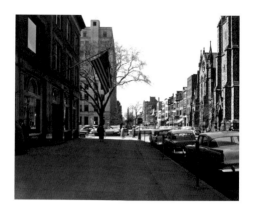

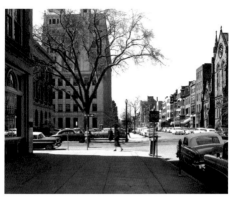

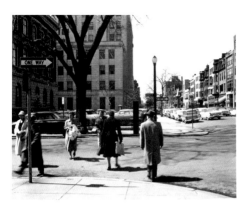

13 *50 ft. intervals, Newbury Street*, 1954-59. Nishan Bichajian, photographer, György Kepes and Kevin Lynch, researchers. Gelatin silver prints. Massachusetts Institute of Technology, Kepes/Lynch Collection

which were the first city plans to make extensive use of photography and film not just as documents of existing conditions but also as conceptual inspirations and as persuasive tools for the communication of the goals of the completed plans. The incorporation of experimental photographic and cinematic techniques fundamentally shaped the way that urban planners considered the city during the 1960s and 1970s, reinforcing a general movement toward observational analysis and social planning. Key to these experiments were the influence of direct cinema, the reconsideration of the photo-essay, the use of unusual image formats, and the influence of theories about the centrality of "images" to lived social experience. Just as important is the way that, conversely, photographic and cinematic artists—including the film director Haskell Wexler, the documentary photographer Bruce Davidson, and the photo-conceptualist art collective Asco—incorporated the city into their work. The commingling of the photographic and the urban is therefore absolutely central to the experience and function of American cities in the 1960s and 1970s. Nevertheless, the practices of planners and artists had different goals and reached different audiences via different platforms, which resulted in different outcomes for the plans examined in the first part of this essay and the artworks examined in the second part.

Part 1: Planning the Image of the City / Imaging the Plan of the City
The new urban planning of the 1960s and 1970s was inspired by the period's general questioning of existing modes of authority and systems of order.[4] This attitude was even reflected in the guidelines for the federal Model Cities program (1966–74), which prioritized social services and citizen participation, thus further encouraging the governments of New York, Chicago, and Los Angeles to develop socially themed comprehensive plans for their cities in order to receive federal funding.[5] Under the additional influence of Kevin Lynch—an MIT professor of urban planning, the author of the widely read *The Image of the City* (1960), and an official adviser to the Chicago and Los Angeles plans—each of the comprehensive plans also emphasized and analyzed the "appearance" of its city.[6] In *The Image of the City*, Lynch argued that the task of urban planners was not just demolishing and rebuilding but also understanding and improving the visual legibility of urban space. Although his book was not illustrated with photographs, his unpublished preliminary study "The Perceptual Form of the City" (1954–59, authored with György Kepes) included almost two thousand photographs that formed "a study of the sequence of impressions in a city: in particular how the thread of continuity and order is maintained during such a constantly shifting

sensuous experience."[7] "Perceptual Form" was thus arguably the stylistic forebear or precedent of the plans of the 1960s. A typical sequence from it depicts various landmarks that played a role in the pedestrian navigation of the streetscape, such as a prominent flag and an intersection (fig. **13**). Lynch's early use of photography was highly factual—it documented the objects of the urban experience and described certain physical elements of that experience with clarity and precision—yet the photographs did not convey much of a sense of rootedness within actual urban experience.[8] Given their cold, quiet, and clinical detachment in comparison with the vitality of an actual city, it is not surprising that Lynch supplemented them with oral interviews on the streets to provide a more dynamic sense of "looking, listening and lingering."[9] The comprehensive plans similarly attempted to supplement the photographic observation of their respective cities with innovative techniques and formats that could provide a sense of being in the city, a task that would be achieved to even greater effect by the artists and activists discussed in part 2 of this essay.

Plan for New York City
The *Plan for New York City* was the most ambitious of the period's comprehensive city plans in terms of the scale of its subject, the scale of the plan itself, and its incorporation of cinematic and photographic ideas, imagery, and techniques. New York's population of 7.8 million in 1960 dwarfed Chicago's 3.6 million inhabitants and Los Angeles's 2.5 million, and the physical manifestation of the plan matched this outsize scale, resulting in a fifty-minute cinematic synopsis of the plan and a six-volume, twenty-eight-pound, seventeen-by-seventeen-inch-square planning document with more than 450,000 words, approximately eight hundred photographs, and more than two hundred maps (fig. **14**).[10] The six-volume print edition included an introductory volume titled *Critical Issues*, followed by one volume for each of the boroughs, such that the weighty tomes almost became an analogue for the city itself. The goals of the plan can best be summarized as an emphasis on downtown density (and strengthening of the "national center," or central business district) with special attention paid to social problems throughout the city and the introduction of social and economic remedies. That said, it was notable for its lack of specific remedies in favor of broad statements of support for social services, job retraining, and housing reform. The plan also supported the establishment of sixty-two Community Planning Districts, which was an attempt to decentralize authority and give priority to local initiatives but which in retrospect made it difficult to pass significant initiatives, at least according to critics.[11] Somewhat controversially, as it engendered further criticism that the plan had been created in secret, this enormous undertaking was engineered by a small group of associates handpicked by Mayor John V. Lindsay. They included Donald H. Elliott, the chairman of the New York City Planning Commission; William H. Whyte, a noted sociologist and lead author of the final draft of the plan; and members of the Department of City Planning's Urban Design Group, which was composed of a small group of Ivy League–educated architects sympathetic to the work of Lynch.[12]

The plan's emphasis on design and cinematic and photographic spectacle and the folksy, vernacular tone of both the film and the books attest to its intended mass appeal and the mayor's well-known affinity for mass media.[13] As the architectural historian McLain Clutter argues, the Department of City Planning's attempts to make the plan accessible to

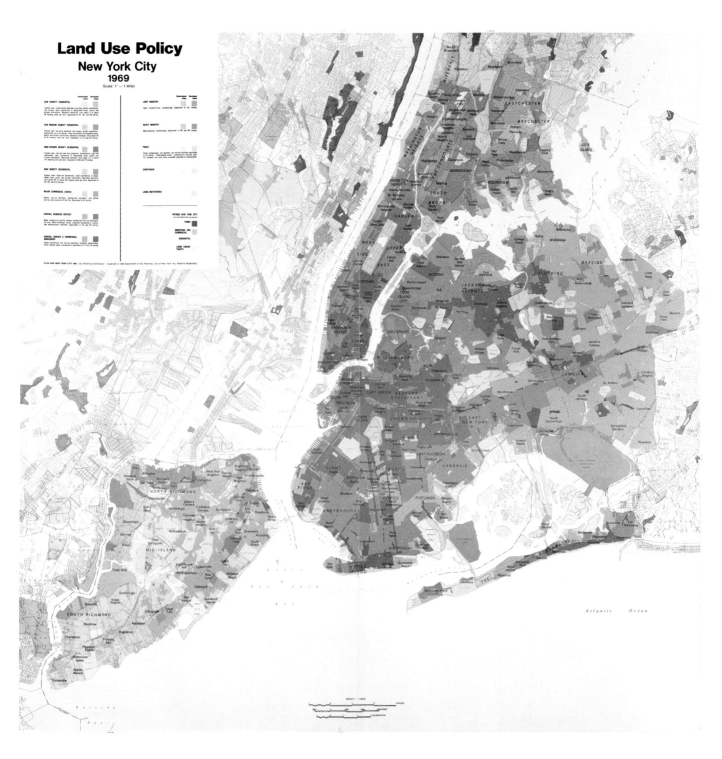

14 Pull-out map from
Plan for New York City,
published by the New York
City Planning Commission,
1969

the average New Yorker relied heavily on Lynch's ideas, and "the manipulation of the image of the city was believed to be a critical bridge in situating the urban subject within actual urbanism."[14] In other words, the plan's almost overdetermined use of film and photography implied the Department of Planning's belief in the necessity of interpreting genuine urban experience through its cinematic and photographic representation. Clutter's argument is especially evident in the plan's cinematic preamble, *What Is the City but the People?*, which was broadcast on New York's

public television channel 13 in a prime-time slot on Tuesday, November 18, 1969, at 7 p.m., the same week that the *Plan for New York City* was publicly unveiled. Introducing the film to the news media, Elliott declared: "The film frankly explores the sometimes hostile environment in the city's role as the place of opportunity.... It captures the city as it is." As if to dramatize this point, the film's opening title sequence presents a startling and disturbing mix of aerial footage shot from a helicopter (whose presence is emphasized by the inclusion of loud rotor sounds) and street footage of fearsome, brutal interactions: a man and a woman punching each other, protestors screaming at the camera, two apparently homeless men beating each other with bottles in the street (fig. **15**). This sequence's emphasis on the physical and psychological risks of urbanism recalls the sociologist Georg Simmel's famous description of the challenges of urban life, in which the city dweller is pummeled by "the rapid telescoping of changing images, pronounced differences within what is grasped at a single glance, and the unexpectedness of violent stimuli."[15]

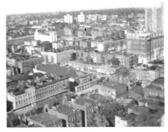

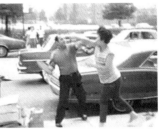

In its melodramatic juxtaposition of aerial views with street perspectives, the opening sequence also implicates earlier urban planning's conventional emphasis on buildings and infrastructure as insufficient to address the social problems that exist at street level. Formally and argumentatively, it thus allegorizes not only the opening text of the *Plan for New York City*, which candidly declares that "there is a great deal wrong" that needs to be addressed at the street level, but also the tropes of 1960s independent cinema, which returned moviemaking to the streets through the use of more portable cameras and more sensitive film stock.[16] For example, the near-contemporaneous *Midnight Cowboy* (1969), which was directed by the famed documentarian John Schlesinger, was filmed in the streets, frequently without permits, and with a mix of actors and bystanders, as in the scene in which Jon Voight's naive cowboy-in-the-big-city character is startled by the blasé attitude of New Yorkers who ignore a man lying unconscious on a Fifth Avenue sidewalk (fig. **16**).[17] Likewise, the end credits for *What Is the City but the People?* nod to the "direct cinema" quality of films like *Midnight Cowboy* by acknowledging: "Whatever its foibles, this film is true and believable because real people ... are so deeply involved.... Even to those who didn't know we were looking.... Thanks." Such correlations between direct cinema and urban planning help make the case for the interrelatedness of traditionally segregated categories of representation such as fine art, mass media, and urban planning during this crucial period in the development of American cities. Conversely, they also imply that the urban experience itself was a reflection of the commingling of real incidents and projected imagery.[18]

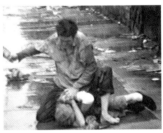

15 Stills from *What Is the City but the People?*, directed by John Peer Nugent and Gordon Hyatt (Fund for the City of New York, 1968)

To drive home this point, one of the more inventive scenes in *What Is the City but the People?* draws attention to the Planning Department's awareness of the role that photographic imagery played in the idea of the city during the 1960s and 1970s. It shows a meeting between the Planning Department and residents, one of whom holds up a snapshot of her Brooklyn neighborhood as evidence of the need to preserve the area's low-density zoning, thus starting with a conventional idea of the photograph as document (fig. **17**). Following a brief close-up of the photograph, the film cuts to a scene of that resident walking in her neighborhood with Donald Elliott and arguing for the denial of zoning variances that could put an apartment building on a lot currently occupied by a single-family home. The snapshot displayed at the meeting

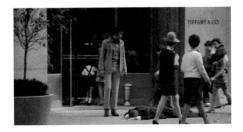

16 Still from *Midnight Cowboy*, directed by John Schlesinger (United Artists, 1969)

therefore becomes a literal and figurative point of contact between the citizenry and the plan. It is representative of the iconic role that images of the city played at all levels of urban reimagining in the 1960s and 1970s and also of the hope that urban images might transcend their purely representational function and provoke, as happens in this scenario, a material engagement with the city.[19]

The six-volume printed edition of the *Plan for New York City* similarly asserted the importance of photographic mediation through its extensive use of the photo-essay, a form that was undergoing significant revision at the hands of practitioners like Bruce Davidson, Robert Frank, and Danny Lyon, all of whose work was reproduced inside. The task of editing the almost eight hundred photographs, about three quarters of which were made expressly for the *Plan for New York City*, fell to Charles Harbutt, an acclaimed Magnum photographer who also shot a majority of the new images. The density of imagery was so uncharacteristic of earlier city plans that it was frequently noted by reviewers and seemed to mirror the density of urban experience itself, visually reinforcing the plan's promotion of density.[20] The first volume, *Critical Issues*, for example, begins with a ten-page sequence of photographs that oscillated between the vast scale of the city and the intimacy of human social inter-action through a variety of scenes (including beaches, picket lines, and restaurant kitchens), captured by a variety of photographers (including Andreas Feininger and Helen Levitt as well as Harbutt) and shot from a variety of proximities to the subjects (fig. **18**). In addition to arranging similar "city symphonies" scattered throughout the six volumes, Harbutt created multipage photo-essays around each of the four main themes in *Critical Issues*: the national center, opportunity, environment, and government. These photo-essays recall his novel approach to what he called the multilevel picture story, which he described in a 1962 issue of *Contemporary Photographer* as a rebuttal to the conventional narrative sequence of *Life* magazine photo-essays in favor of a more symbolic approach.[21] For example, the eight-page photo-essay "Opportunity" balances what Harbutt described as the journalistic level (pictorial facts through legible photographic records of people, places, and things) with the allegorical level (a broad theme of, in this case, the limited opportunities available to certain communities, exemplified by images of a cramped residence) and the editorial level (the photo-essay ends with images of children at school and men working in a factory, implying the need for education and job training, which were important themes in the plan) (fig. **19**).

The five borough volumes of the plan are less densely illustrated, but the photographs are no less radical for reasons having to do primarily with their procedure. First, almost all the photographs were made for the project, whereas the first volume included many existing photographs. Second, the photography was undertaken systematically, district by district, with guidance from the staff of each of the sixty-two Community Planning Districts. These districts provided local knowledge and helped steer Harbutt and a small staff of photographers to both the most dis-tressing and the most impressive features of their communities. A spread on Bronx Community Planning District 2, for example, included depic-tions of derelict buildings but also community-organized vest-pocket parks that a nonresident might overlook (fig. **20**). The *Plan for New York City* thus included a novel and relatively high degree of community input as part of its embrace of the new social planning.

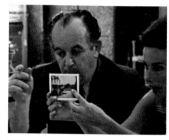

17 Stills from *What Is the City but the People?*, directed by John Peer Nugent and Gordon Hyatt (Fund for the City of New York, 1968)

18,19 Spreads from *Plan for New York City*, published by the New York City Planning Commission, 1969

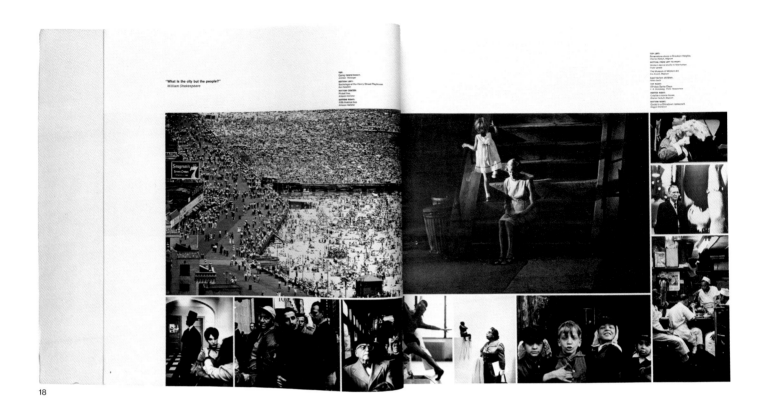

"What is the city but the people?"
William Shakespeare

18

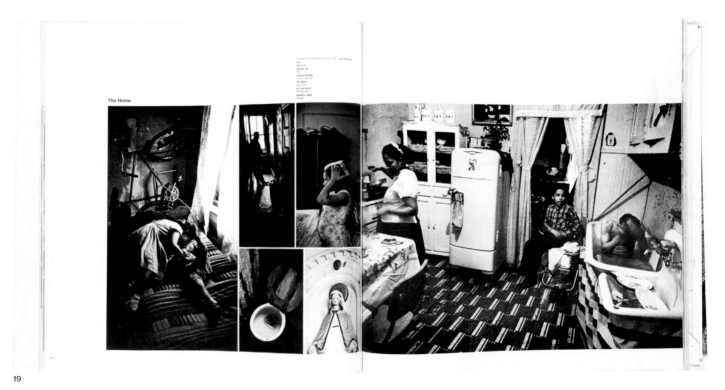

The Home

19

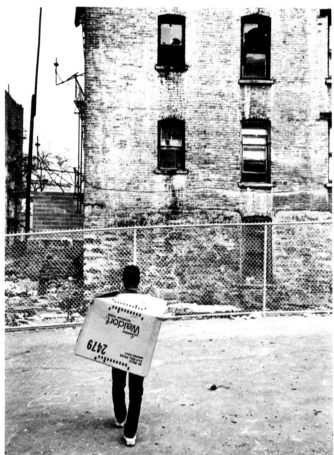

Hunts Point

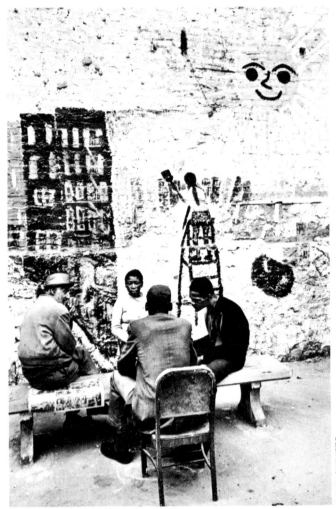

Hunts Point: vest pocket park

PHOTOS: BURK UZZLE

20 Detail of a page
from *Plan for New York
City*, published by the
New York City Planning
Commission, 1969

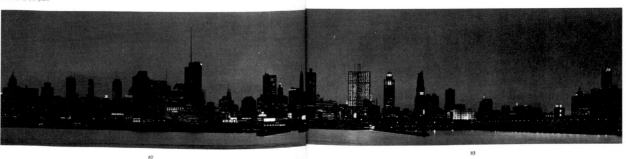

XI QUALITY OF LIFE IN CHICAGO

The city is most of all a place to live, as well as a place to make a living. Chicago is both a great, cosmopolitan city and a collection of local community areas. The Comprehensive Plan seeks to improve the quality of life on both these levels. Its aim is to maintain and improve Chicago as a center of excitement, color, and a diversity of people, ideas, and culture, while still encouraging a comfortable environment conducive to personal and social relationships.

Person-to-person contacts through social, civic, recreational, and cultural activities within the local community are essential to the good life. Locating and developing schools, parks, field houses, and libraries can encourage and facilitate participation in these activities. There are also unique advantages of living in a large city that transcend the social and cultural opportunities of the neighborhood. Policies for the city's physical development can help to make these advantages available to all Chicagoans.

Good urban design is vitally important to enhancing life in the city. Appearance is a primary consideration in the detailed development of projects involved in the various elements of the plan.

America's future will depend largely upon the ability of its people to live interesting and productive lives in cities. In only a few generations, the United States has changed from a rural to an urban society. Today, 60 out of every 100 Americans live in metropolitan areas. The movement of people to cities, coupled with rapid changes in technology and transportation, has thrust heavy demands on city governments and city residents. And the trend toward further concentration of the population in metropolitan areas will continue.

As stated in the Introduction of this report, the basic goal of the Comprehensive Policies Plan is "to improve the quality of living for every resident." The aims and aspirations of a great city must extend beyond merely assuring the basic necessities of life. The city is the source of new ideas, social progress, and artistic achievement, as well as industrial production. It contains art museums, orchestras, and public monuments and open spaces, as well as factories and offices. It is a place to live, as well as to make a living.

A city with millions of people, because of its very size, offers many unusual opportunities for civic, cultural, and social activities. Chicago, unlike most smaller cities, can support several professional theater presentations, large museums, highly specialized medical and business services, a wide range of retail stores, professional sports, and special events such as trade shows and expositions. As a result, all of the people of Chicago have a wide choice of activities, and individuals with highly specialized skills have a market for their services.

In addition to these opportunities which are unique simply because Chicago is a large city, the city must provide for the day-to-day personal and social relationships that are common to all human societies—raising a family, making friends, and pursuing individual interests and hobbies. And there must be opportunities for privacy and solitude.

Throughout the Comprehensive Policies Plan, proposals have been directed toward the goal of improving the quality of life, through recommendations which enhance the advantages of life in the city as a whole and those which create a satisfying community life. There are two subjects which have a particularly close relationship to the basic goal of improving the quality of life: community appearance and cultural and recreational activities.

The Comprehensive Plan of Chicago

Like the plan for New York, Chicago's comprehensive plan not only offered broad statements of policy but also emphasized the appearance of the city and gestured to citizen participation. Unlike that of New York, Chicago's plan was less concerned with social services and unfolded in stages, beginning in 1964 with the publication of *Basic Policies for the Comprehensive Plan of Chicago*, which outlined the proposed policies, followed by more than fifty presentations and community forums in coordination with neighborhood groups over the next year, and concluding with *The Comprehensive Plan of Chicago*, published in 1966.[22] One of the great but underexamined innovations of Chicago's plan was the planning commissioner Ira J. Bach's hiring of the acclaimed photographer and University of Illinois professor Art Sinsabaugh in 1963 as a "photographic consultant" who would not merely illustrate the plan but also help guide its development.

Sinsabaugh's photographs are among the most distinctive visual records of the city of Chicago precisely because their exaggerated visual qualities amplify the experience of the built landscape, contributing what the photographer called "special photographic seeing" (see fig. **21**).[23] As he explained in a proposal to the Department of City Planning, his use of a special long-focus lens, coupled with the high quality of his specially manufactured twelve-by-twenty-inch negatives, allowed him to make panoramas without the lenticular distortion around the edges that

21 Spread from *Basic Policies for the Comprehensive Plan of Chicago*, published by the City of Chicago, Department of City Planning, 1964. Photograph by Art Sinsabaugh

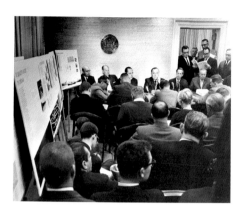

22 Mayor Richard J. Daley
at a meeting of the Chicago
Plan Commission, *Chicago
Sun-Times*, 1964

was common to those made from rotating cameras or images stitched together in the darkroom. This meant that his photographs not only captured a singular moment but also offered an unparalleled sense of crystal-clear peripheral vision that he likened to the human eye, thus presenting the city from a naturalistic vantage point.[24] Perhaps most impressively, Sinsabaugh's camera and lens allowed him to photograph across a wide field of vision while maintaining a perfectly perpendicular relationship between the horizon and any human alterations to the landscape, which regular cameras would render at increasingly extreme angles toward the edges of the picture frame. This, in turn, paralleled the plan's section titled "Quality of Life," which, borrowing from Lynch, emphasized the importance of the "appearance of the city," declaring, "The city's structures have an accentuated visual importance because they are vertical forms contrasting with these two great horizontal expanses [the flat prairie and the lakefront edge]."[25] Without discrediting this general observation, it is important to note that this level of "appearance" is observable only with the distance and abstraction afforded by something like Sinsabaugh's photographs and that their dominance within the 1964 *Basic Policies* existed at the expense of alternative, coexisting views that could be obtained with greater proximity to and engagement with the fabric of the city, such as street photography and direct cinema. (See, for example, the nearly contemporaneous experiences provided by *Medium Cool* and the *West Wall*, discussed below.) Sinsabaugh's combination of abstraction with visual themes specific to Chicago, such as the tendrils of the Circle Interchange (fig. **123**), was therefore in perfect harmony with the comprehensive plan's emphasis on, in Bach's words, broadly "abstract policies" intended "to improve the residential environment,… to strengthen and diversify the economy,… and to enlarge human opportunities," thus making them ideal for Bach's public presentations of the *Basic Policies* (fig. **22**).[26]

Yet if Sinsabaugh's photographs were not specific to any particular solution, they depended heavily on one of the more problematic legacies of a prior generation of development: the extension of freeways through many neighborhoods. Sinsabaugh famously recalled his frustration with not being able to step far back enough to capture whole areas of development—to mimic, in essence, the act of scanning the horizon with one's eyes or the stroll across or through an area. The solution arrived when he realized that the freeways provided "an access, an opening, a swath cut right through the heart of the City in all directions." By photographing from across the freeway, he could capture a cross section of development (fig. **23**).[27] He gradually became aware that these cuts that gave him access to the city had mortally wounded entire neighborhoods. Later statements reveal his recognition that his photographs were being made in a race against time, as entire "neighborhoods were laid bare and their very bowels exposed."[28]

In the end, both Sinsabaugh and the Department of City Planning were coming to the same realization: the old policies of urban renewal often backfired, as when the demolition of the Halsted/Harrison neighborhood to build a downtown University of Illinois campus resulted in such a public outcry that it would be the last of the wholesale neighborhood demolitions and led to Bach's departure from the Department of City Planning. Bach acknowledged that the *Basic Policies* had failed to connect with constituents. Much to his disappointment, the policies were so abstract that after more than fifty public meetings in 1964–65,

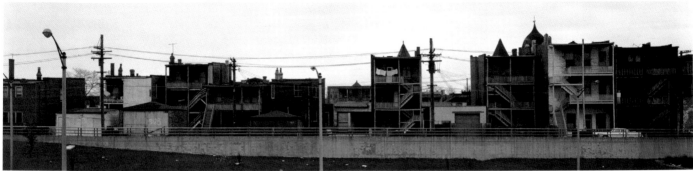

23

24

he exasperatedly proclaimed that participants seemed incapable of seeing beyond their immediate context. Most questions revolved around whether public housing would come into the participant's neighborhood, where it might depress property values, itself a telling statement about the long-term pitfalls of that failed urban-renewal scheme.[29]

Without Bach at the helm, *The Comprehensive Plan of Chicago* of 1966 adopted a more conservative visual approach, utilizing only a series of ten color photographs to illustrate the "Quality of Life" section of the final document (fig. **24**). Taken by Sinsabaugh using a 35 mm camera, they include cheery, almost saccharine illustrations of picnicking families that seem more fitting for a tourist brochure.

23 Art Sinsabaugh, *Chicago Landscape #26*, 1964. Gelatin silver print. The Art Institute of Chicago, Restricted gift of Mr. and Mrs. Myron Goldsmith, Photography Department Fund

24 Spread from *The Comprehensive Plan of Chicago*, published by the City of Chicago, Department of Development and Planning, 1966. Photographs by Art Sinsabaugh

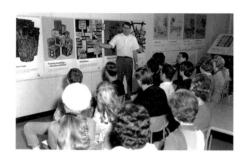

25 *Centers for Choice,*
ca. 1968. City of
Los Angeles Archives

Concepts for Los Angeles

Of the three cities discussed here, Los Angeles went the furthest in attempting to engage citizens in the process of urban planning. Under the guidance of the city's director of planning, Calvin S. Hamilton, the Department of Planning published *Concepts for Los Angeles* (1967), a photographically illustrated book with four different "concepts" or proposals: "Centers," "Corridors," "Dispersion," and "Low Density." That document was followed by two years of listening forums that were guided by two hundred trained docents at dozens of "Centers for Choice," where posters showing the different concepts guided public lectures and discussions mirroring the period's optimism about shared governance and its hyperawareness of "urban imagery" (fig. **25**). Central to the democratic nature of this process was a massive publicity and outreach campaign that involved sending out more than six hundred thousand questionnaires, of which fifty thousand were returned, validating the "Centers" concept, which promoted a series of mixed-use nodes of a highly urban character that would be connected by transit corridors. These ideas were detailed in the *Concept Los Angeles* brochure of 1970.[30]

If the Los Angeles Department of City Planning didn't have an established documentary photographer like Harbutt or Sinsabaugh to serve as a consultant, it did involve Kevin Lynch to an even greater extent than the other cities. For example, a typical photographically illustrated spread for the *Concepts* plan of 1967 included a mix of stock photographs purchased from well-known sources of architectural photography, such as Julius Shulman's photographs of the aerospace industry and modernist houses, along with direct cinematic studies of people crossing intersections that recall Lynch's studies for *Perceptual Form* (fig. **26**). Like the majority of the images in *Concepts*, these street photographs were taken by John Pastier, a young planner in the department who argued that the direct observation of "what people do in their environment … is a much bigger determinant of what happens in spaces than studying the ideas of the designer."[31]

This belief was central to a specialized study commissioned by the Department of Planning, the lavishly illustrated *Visual Environment of Los Angeles* (1970), which begins with an inventory of the visual form of Los Angeles drawn directly from Lynch's categories of visual experience in *The Image of the City*: paths (routes of travel), edges (boundaries between areas of contrasting character), nodes (strategic spots that form focal points), districts (areas with recognizable character traits), and landmarks (individual objects that stand out) (see fig. **27**). Stylistically *Visual Environment* drew heavily on Lynch's book *The View from the Road* (1964; fig. **28**), which explored the sensory perception of the built environment from the window of a car and used innovative "film strips" to convey "the essentials of the major visual effects" of this new kind of perception: "The experience of a city is basically a moving view, and this is the view we must understand if we wish to reform the look of our cities."[32] The style of *The View from the Road*'s film strips, which were meant to be read from bottom to top as an approximation of how the human eye scans the field of vision, helped the vertically arranged photographs in *The Visual Environment of Los Angeles* convey a sense of motion, even if the former images were extracted from genuine twenty-four-frame-per-second cinematic film while the latter were more like conventional film stills: photographs taken on the set with a still camera to document the production.[33] It is a subtle distinction but

 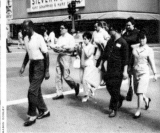

The people of Los Angeles encompass a great range of ages and origins.

Tourism and entertainment, although still important, account for a smaller share of the local economy than formerly, while the defense, aerospace, and electronics industries have become major employers.

LIFE STYLE

Residents of Los Angeles enjoy a variety of life styles and activities. Different types of housing and environment are available. There is always "something happening"—a ball game, the theater, an Iowa picnic, an outdoor concert, a beach party. The Angeleno has a sense of individuality which he can and does express in his choice of a place of residence and his leisure time activities. Unfortunately, like many cities today, Los Angeles also has citizens who are unable to avail themselves of these opportunities because of social and economic barriers, both seen and unseen.

Los Angeles is most often characterized by a relaxed, casual style of living, as exemplified by the single-family house with its backyard patio and perhaps a swimming pool. The stress on year-round outdoor living is also reflected in leisure activities. Residents of Los Angeles have their choice of mountains, desert or seashore within an hour's drive. There is an abundance of sports activities for spectator or participant.

Cultural and entertainment opportunities abound in Los Angeles. The Hollywood Bowl, Greek Theatre, museums of art, science and industry, and the Greater Los Angeles Zoo are but a few of the more popular attractions. The Music Center complex provides the city with top-flight musical and dramatic productions. "Little Theater" groups are popular.

The spirit of individualism, coupled with a superb educational system, gives Los Angeles an aura of progressiveness. This is one of the main centers of space age activities. The science-based industries have flourished because of the abundance of scientific and engineering personnel who, in turn, are attracted by the city's fine educational facilities—University of Southern California, University of California at Los Angeles, California Institute of Technology, and many other private and public universities and colleges. There is a hunger for education, among adults as well as youth. It has been estimated that by the end of this decade more than a million Californians will be studying at colleges and universities.

There is an atmosphere of acceptance in Los Angeles that has been conducive to experimentation. Los Angeles is a proving ground for new products and new ideas—in education, in architecture, in government, in religion, in business and finance.

Mobility is another outstanding characteristic of life in Los Angeles. The changing of residence on an average of once every four years is unique in itself, but it pales beside the daily movement of people in their automobiles. In no other city does life center so much on the automobile as it does in Los Angeles, the home of the first drive-in restaurants, theaters, banks, and churches. At least seventy percent of all Angelenos drive to work. They travel ten miles to try out a new restaurant, twenty miles to see a movie, thirty miles to visit friends, and do not consider it unusual. The more than 500 miles of freeways that criss-cross the metropolis make such mobility possible.

This freedom of movement gives life a special flavor; it offers the individual the chance to enjoy and participate in an environment that is uniquely Los Angeles.

Petroleum discovery and harbor development were major economic stimuli in the past. Today Los Angeles is a major oil processing center, and its port ranks first in cargo handling and commercial fishing on the west coast.

The climate, proximity to natural amenities, and prevalence of residential open space all permit an outdoor way of life every day of the week, and throughout the year.

 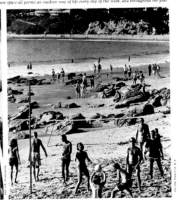

10

11

26

Paths

Paths are routes of travel from which people observe the City. They
3A are the freeways and highways such
3B as Wilshire Boulevard, Sunset
3C Boulevard and Ventura Boulevard.

Edges

Edges are boundaries between areas of contrasting character. At the citywide scale these are mainly created by large landscape features such as the Santa Monica and San Gabriel Mountains, the Baldwin Hills and Pacific Ocean. Others are created by man made constructions such as the Sepulveda Flood Control Basin, the Los Angeles River
4 channel and Marina Del Rey.

Nodes

Nodes are strategic spots which form focal points. They may be small parks and plazas or concentrations of activity at key street intersections such as Olvera Street, Pershing
5A Square, and Hollywood and Vine.

Districts

Districts are areas, or regions, which are recognizable as having some common identifying character. Many contain special uses. Some examples are Sunset Strip, Westwood Village, the Airport, and visually distinctive residential areas like Baldwin Hills
5B Village, Hancock Park Estates
5C and Park La Brea.

Landmarks

Landmarks are individual objects or sometimes groups of objects, that stand out in the City appearance due to their size, color, or unique silhouette. Examples of individual landmarks are City Hall, the Equitable Tower in Wilshire Center, the County Art Museum in the Miracle Mile; the Planetarium in Griffith Park; the Capitol Records Building in Hollywood; the Vincent
6A Thomas Bridge at the Harbor; and
6B the Coliseum in Exposition Park.

3A

3B

3C

4

5A

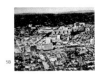
5B

5C

6A

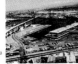
6B

7

27

26 Spread from *Concepts for Los Angeles*, published by the Department of City Planning, Los Angeles, 1967

27 Page from *The Visual Environment of Los Angeles*, published by the Department of City Planning, Los Angeles, 1971

Read Up

42

28 Photographs from *The View from the Road*, by Donald Appleyard, Kevin Lynch, and John R. Myer. Published by MIT Press, Cambridge, Massachusetts, 1964

one with significant implications because, in contrast to *The View from the Road*'s direct observation that is analyzed after the fact, the film stills in *The Visual Environment of Los Angeles* imply that Los Angeles is a film set that comports itself to be photographed or, at the very least, to be seen photographically.

Rather than an object of visual inquiry, the city in this scenario becomes an image to be seen. This important distinction reverberated throughout the Los Angeles architecture and planning community, as evidenced by the emergence of companies like Environmental Communications (EC), which produced photographic slides of Los Angeles for architects, planners, and university classrooms.[34] In a telling moment at a 1975 symposium on alternative architecture practices, EC's founder, David Greenberg, acknowledged the influence of Ed Ruscha's photographically inspired artwork on the perception of Los Angeles—and especially of its freeways—as "a giant sculpture" or work of art that could best be apprehended through photographic representation.[35] The implication was that photography was not only a practical intermediary but also a necessary step toward the comprehension of the city of Los Angeles *as an image*, in an ontological sense, with practical consequences for both planning and the lived social experience of the city. Perhaps the most dramatic example of this "city as image" sensibility lies in one of the most unusual passages in *The Visual Environment of Los Angeles*, which called for the use of spectacular lighting effects at night to essentially make over the city into a cinematic mirage in order to provide for more legible nodes and landmarks after dark (fig. **227**).[36]

• • •

The comprehensive plans for New York, Chicago, and Los Angeles deserve full credit for their progressive qualities—from the integration of advanced ideas about photographic and cinematic seeing to their attempts to encourage citizen participation. Nonetheless, as *comprehensive* plans they had specific aims to fulfill, including offering a broad array of social solutions, and the imperative to reach a general audience. Critics frequently pounced on these qualities as weaknesses of the three plans, each of which suffered some immediate setbacks. For example, Beverly M. Spatt, New York's assistant commissioner of planning, offered a dissenting opinion that the *Plan for New York City* was short on specific plans but long on a "Santa Claus list" of platitudes for the improvement of social services, health care, and job training at a time of fiscal instability.[37] The subsequent economic crisis of the 1970s further set back the *Plan for New York City*, as the dominant image of the city came to be reflected by the infamous October 30, 1975, edition of the *New York Daily News*, whose front page read: "Ford to City: Drop Dead." While that sensational headline was not entirely accurate and Ford agreed to a $2.3 billion aid package for the near-bankrupt city just two months later, that aid was tied to specific reductions in social service spending and tightening of the fiscal belt, making much of the *Plan for New York City* untenable.[38]

Following criticism that Chicago's comprehensive plan was also too vague and contained too few actionable proposals, it was appended by a series of sixteen community plans, the last and most ambitious of which was guided not by the city but by private business interests organized under the auspices of the Central Area Committee (CAC). Foreshadowing a legacy of privatization and the diminishing role of civic leadership in

planning, Mayor Daley hoped that conceptual "ownership" of the plan might also mean that developers would pay for its implementation. The CAC outsourced the development of the plan—titled *Chicago 21*, thus signaling its twenty-first-century ambitions—to Skidmore, Owings & Merrill (SOM), which produced a lavish document sheathed in a silver cover that scholars have noted mimicked the glamour and confidence of SOM buildings like Bruce Graham's Hancock and Sears Towers.[39]

The enduring legacy of the *Concept Los Angeles* plan has primarily been its ability to raise awareness of planning and to involve citizens in the planning process. But as Reyner Banham concluded in 1971, the project "had quietly withered away, leaving behind little more than the proposal that the city shall develop much as it has in the recent past—clusters of towers in a sea of single family dwellings."[40] As with most of the comprehensive plans, its scale and the added emphasis on image made it hard to implement concrete changes in the urban fabric of Los Angeles.

Part 2: Making Images in/as the City

Operating outside the constraints of comprehensiveness, broad goals, and the institutional structure of planning departments, independent artists and urban activists were able to achieve a different perspective, one that perceived the order and dynamism amid the apparent disorder of urban life. As Jacobs wrote in *The Death and Life of Great American Cities*: "To see complex systems of functional order as order, and not as chaos, takes understanding.... Once they are understood as systems of order, they actually look different."[41] The more localized perspective of artists and activists allowed them both to understand complex systems of functional order within specific parts of the city and to utilize these systems in their photographic and cinematic explorations of urbanism. The resulting images operated in a metonymic or synecdochic way *in/as the city* rather than merely offering depictions *of the city*. This distinction is key since metonymy and synecdoche function differently than metaphor, operating by contiguity rather than mere similarity.[42] The significance for many artists and activists in the 1960s and 1970s is the insistence that their practice was not just a commentary about the city but also an extension into and of the city.

The commingling of the lived social experience of the city and its representation is neatly summarized by an anecdote from the making of Haskell Wexler's feature-length film *Medium Cool* (1969), which was shot on location in Chicago during the 1968 Democratic National Convention protests. The film's story revolves around a television news cameraman who is no longer able to maintain his coolly distant demeanor toward the various urban crises unfolding before his camera when he learns that his footage is being turned over to the FBI as part of its investigations into leftist political groups. *Medium Cool* featured a mix of professionals alongside nonprofessionals and a variety of direct cinema techniques that raised questions about the distinctions between artifice and reality. According to assistant cameraman Andrew Davis, the film's cast and crew "spent a lot of time just trying to be a part of the fabric of what the kids in the streets were doing," thus allowing the actors to experience real events "in character."[43] In one of the most famous scenes, members of the film crew were masquerading as newsmen so that they could wade deep into the crowds of protesters when they were misperceived as a threat by some National Guardsmen, who turned a tear-gas hose on them (fig. **29**). Amid a loud "whoosh," the soundman coughs, gags, and chokes

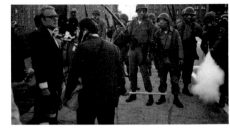
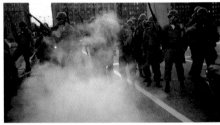
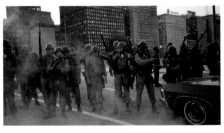

29 Stills from *Medium Cool*, directed by Haskell Wexler (Paramount, 1969)

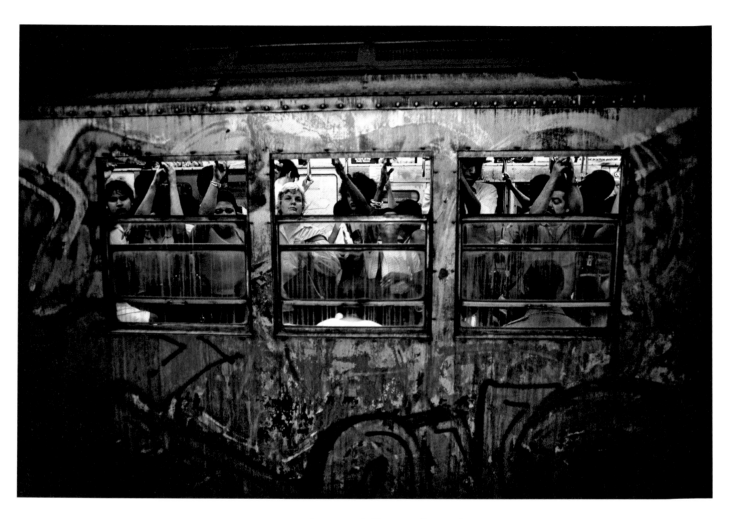

30 Bruce Davidson, *Subway*,
1980. Chromogenic print.
Courtesy of Howard
Greenberg Gallery, New York

out, "Look out Haskell, it's *real*." Wexler has stated that this disruption of the fourth wall was not just a theatrical gesture but a real embodied experience: "When you're looking through the camera, in a sense you're not there. You are looking at the movie you're trying to make. But when the tear gas came at me it was a strong enough jab from the so-called real world to remind me that the ground glass is no barrier to your lungs, your eyes, your face."[44] The anecdote emblematizes the claim that the city was not just the subject matter of the work of art but that it was a constituent element of the social experience of living in the city and the process of making art there.

Bruce Davidson's photographic project *Subway* (1979–80) similarly blurs the distinctions between the process of art making and the finished artwork. Davidson's photographs enshrine the subway of the late 1970s, which was infamous for its lack of air-conditioning, inadequate lighting, and walls covered in a dense patchwork of graffiti.[45] The viscerality of the actual subway is matched by the visual expression of tactile experience in Davidson's photograph of passengers crammed inside a subway car covered in layers of graffiti, grimy water trails, oxidized metal, and greasy streaks that confront the viewer's gaze as if these surfaces were the surface of the photograph itself (fig. **30**).

Indeed, the surface density of Davidson's photographs invites an embodied gaze on the part of viewers, causing them to linger over the surface of the image. This recalls scholar Laura Marks's discussion of

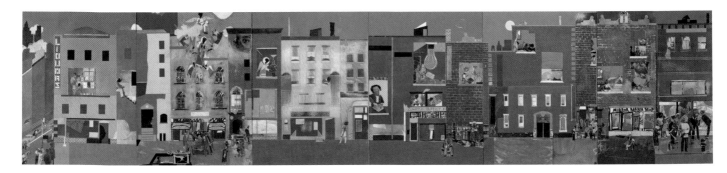

the "superficiality" of certain types of images, which privilege looking at the surface and discerning an impression of texture, which she describes as a "labile, plastic sort of look, more inclined to move than to focus."[46] Marks argues that this encourages interaction with the surface as if it were an object or another human body via the implied sensation of contact with the surface of the image.[47] Davidson's own comments about his experience in the subway mirror this simultaneity of experience and the toggling back and forth between the surface of the subway car and its passengers: "The subway interior was defaced everywhere with a secret handwriting that covered the walls, windows, and maps.… Sometimes, when I was looking at one of these cryptic messages someone would come and sit in front of it, and I would feel as if the message had been decoded." If the faces of subway riders and the graffiti seemed interchangeable, or at least relatable as indexes of urban human subjectivity, then the broader message of Davidson's photographs was their ability to convey the city through the synecdoche of the subway.[48]

A similar expression can be found in Romare Bearden's *The Block* (1971), a monumental, eighteen-foot-long mural on six wood panels that depicts a particular block of Lenox Avenue between 132nd and 133rd Streets in Harlem (fig. **31**).[49] On the one hand, *The Block* is an experimental document of a particular block. This is especially noticeable in the bottom register of the mural, which shows typical neighborhood institutions such as a liquor store, funeral parlor, church, barbershop, and corner grocery as well as people walking the street, conversing on corners, sitting on front stoops, and playing on the sidewalk. On the other hand, *The Block* is not just a representation of this section of Lenox Avenue and not just a series of symbols or metaphors but is also a metonym for "the city," of which the block is a part, and a synecdochic reference to urbanism, with which city blocks are associated.

Importantly, *The Block* is composed of cut, pasted, and visibly manipulated photostats, newspaper and magazine images, fabric scraps, and bits of paper combined with paint, pencil, and even ballpoint-pen marks. Therefore, in addition to *representing* city dwellers' innumerable acts of "making do," from the conversion of an apartment's front steps into a temporary living room to the children's appropriation of the sidewalk as a playground, the artistic technique for creating *The Block* also functions as a kind of making do that is literally *representative of* the everyday practices of urban residents. For example, the scraps of fabric that Bearden used to depict tablecloths and bed linens not only metonymically represent the whole cloths from which they were cut but also mirror the adaptive reuse of such scraps by urban seamstresses who couldn't afford to let them go to waste. Perhaps most literally, Bearden actually "built" *The Block* by using techniques similar to those employed

31 Romare Bearden, *The Block*, 1971 (full view and detail). Cut and pasted printed, colored, and metallic papers, photostats, pencil, ink marker, gouache, watercolor, and pen and ink on Masonite. The Metropolitan Museum of Art, Gift of Mr. and Mrs. Samuel Shore, 1978

by the rehabbers and renters who continually tinkered with their buildings. For example, he fabricated doors by joining pieces of paper in the same approximate positions as the columns, beams, and archways of an actual doorway. In order to represent stone elements such as the columns on building facades, he used cut-up photographs of what appears to be stonework. A year later, in 1972, Bearden took this process of building even further with *The Block II*, which literally extended itself into three dimensions through the use of subtle but noticeable layers of Masonite paneling to establish a low bas-relief surface that mirrored the slightly uneven setbacks of the buildings along a street like Lenox Avenue (fig. **45**). As such, *The Block* and *The Block II* alternate between seeming like representations of buildings and being seen as "built things" themselves. The latter testifies to their metonymic status as constituent parts of the built environment of the city.

The presentation of *The Block* in Bearden's 1971 retrospective at the Museum of Modern Art in New York included an audio component featuring muted jazz and church music alongside street sounds such as the noise of moving vehicles, footsteps, laughter, children playing, news broadcasts, and the general cacophony of an urban setting.[50] All these gestures implicitly argue that the city cannot be experienced as a mere image but must also be heard and touched. Even further, it must be allowed to touch us—to possess us—in order to be truly experienced.[51] That sense of possession and embodied viewing is only reinforced by the fact that to experience *The Block* one must, quite literally, stroll along its surface just as one might stroll up and down an actual city block, further establishing the piece's metonymic relationship to the idea of the city.

What does it mean for a photographic or cinematic image to move? How can images move, either physically or optically, and how can they move us, both physically and emotionally, to experience the sensation of the city and to understand the inherent dynamism of its functional order?[52] A starting point for addressing these questions can be found in the *Sequential Views* of Robbert Flick, which were made in 1979–80 as part of the Los Angeles Documentary Project, a commission for the city's bicentennial celebration.[53] Each of the *Sequential Views* is composed of one hundred still frames taken with a 35 mm camera while moving through a specific part of the city (fig. **32**). Flick's initial proposal was to "document the ways in which the influx of islands of high-rise municipal buildings has altered the topography of the community of Inglewood, resulting in major sociological and ethnological changes."[54] Yet shortly after beginning the project, he altered course, quite literally, while exploring the neighborhood from his car. "I started in Inglewood, starting out from the parking structure, circling out, established the boundaries of Inglewood, and I followed all of the edges, started to see things, see how the neighborhoods are really not defined by imposed boundaries, but are really defined by traffic patterns that emerge. Century Boulevard on the North Side and on the South Side are really worlds apart because of the traffic density."[55]

Flick's experience revealed that motion and temporality were distinct tropes of the Los Angeles urban landscape—that the city was defined less by fixed landmarks than by trajectories that "emerged." This discovery necessitated the rejection of conventional single-frame landscape photography and the use of multiple photographic frames that could replicate an experience of Los Angeles. As he elaborated in his Guggenheim Fellowship application of 1982: "Most of my impressions

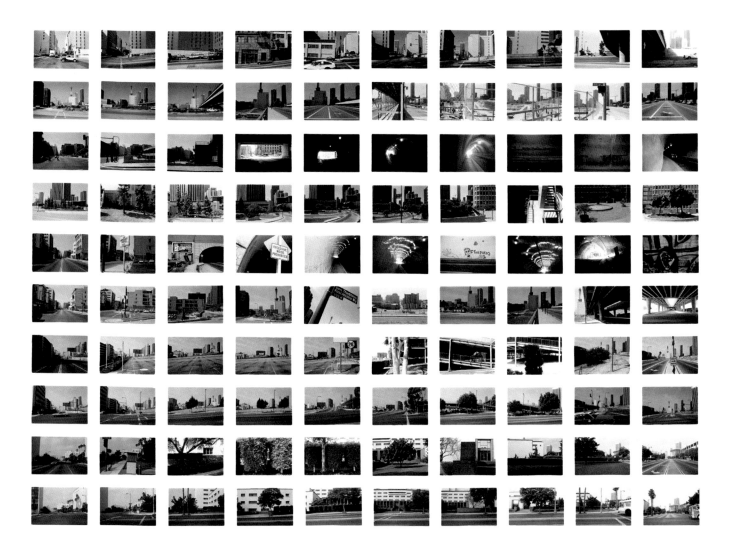

of Los Angeles were gleaned in quick succession as retinal imprints from a fixed distance while traveling through the urban landscape by car. Repetition itself appeared to me one of the dominant characteristics of the area."[56] As with Davidson's *Subway* photographs, there is an element of Marks's roving eye that was "more inclined to move than to focus," but in Flick's work that impression is conveyed by the tile-like surface of the one hundred individual prints that make up the grid as a whole, which allows the entire sequence to be experienced at a glance before one looks closely at sequences of individual photographs.

Zooming in on a work like Flick's *SV012B/80 Downtown LA between Temple and 4th* (1980; fig. **32**) allows important details to become apparent, such as the obvious trajectory from left to right and the beginning of new trajectories with each row. The fourth row, for example, moves off the streets and onto the elevated pedestrian walkways that were one of the few infrastructural components of the *Concepts* plan to be built and whose failure as a social experiment is evident in their utter abandonment by pedestrians. More generally, as we traverse the entirety of *SV012B/80*, there is both a sense of continuity within Flick's trajectories and a sense of contiguity with our experience of the actual city as constant, unending, and not easily rendered by a single view.

32 Robbert Flick, *SV012B/80 Downtown LA between Temple and 4th*, 1980. Gelatin silver print. Courtesy of Robert Mann Gallery, New York

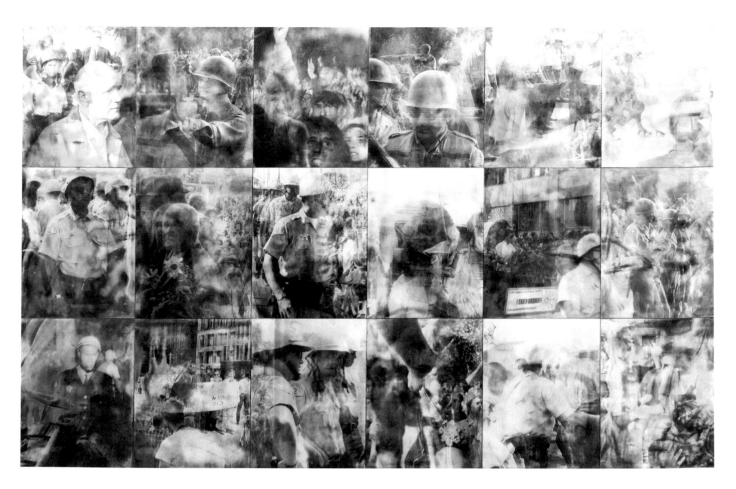

33 Alfons Schilling,
Chicago, August, 1968,
1968. Assembled lenticular
photographs. Princeton
University Art Museum, Gift
of Mr. and Mrs. Geoffrey
Gates, Class of 1954

Like Flick, the Swiss-born, New York–based artist Alfons Schilling explored how movement in front of the photographic image could alter the work, taking the surface density and intersubjective encounter that were implied in Davidson's subway photographs to an even more visceral level. Schilling's *Chicago, August, 1968* (fig. **33**) uses a grid of eighteen lenticular prints, with each print containing three distinct images, to convey the chaotic atmosphere of the protests at the Democratic National Convention. As viewers walk across the dense patchwork of images, the surface seems to jump off the picture plane. Even subtle tilts of the head reveal changes in perspective, from the view of a policeman to the view of the back of a protestor's head, dramatically situating us within the crowd of this massive urban spectacle that took place in Chicago's Grant Park. The lack of clear focus mimics the blurriness of rapid motion, causing a dizzying, vertiginous sensation that proprioceptively engages our internal sensors and triggers a sense of disequilibrium not unlike being caught in an actual mob scene. Certain patterns of images—the back of a head, followed by an image of a billy club–toting policeman—may even cause us to wince, as if we feel the pain of the implied blow. Although not quite powerful enough to trigger the fight-or-flight response of the sympathetic nervous system, Schilling's piece comes closest, perhaps, of all the ostensibly still photographic objects in this exhibition to capturing the experience of being a "man *of* the crowd," that is, part of a crowd rather than merely a spectator.[57]

Gordon Matta-Clark's *City Slivers* (1976; fig. **34**) provides an entirely different sense of motion or voyage through the urban landscape. The film

is composed of several dozen short, thirty-to-sixty-second glimpses through narrow slits cut into mats that remain largely static but occasionally open or close, like shutters, or follow the camera as it tracks up the canyons of streets or pans across aerial perspectives on the city.[58] In many sections the mats allowed for multiple exposures on the same strip of film stock, a process over which Matta-Clark had some control but that also embraced a high degree of chance since he could never know precisely where images would overlap or meet one another, not unlike strangers passing on a street. The use of a new Arriflex SR 16 mm camera, whose near-silent mechanism and optics were specifically developed for on-location shooting, allowed him to capture subjects with relative anonymity and provides a sense of being immersed in the vitality of the city.[59]

Originally projected without authorization onto the Municipal Building in Lower Manhattan, which housed the Department of City Planning and other city offices, *City Slivers* had overtones of a temporary tactical assault on the agencies and institutions that many would identify with the decline of the city through failed programs of urban renewal. Although *City Slivers*' temporary projection was not as aggressive as *Window Blow-Out* (1976), in which Matta-Clark literally shot out all the windows of the New York Institute for Architecture and Urban Studies with a BB gun, it is clearly indicative of the artist's antagonistic relationship to institutional architecture and planning and his concern with the occupation of urban space.[60] Just as *Window Blow-Out* recalled the broken windows of recent urban riots and insurrections, the temporary annexation of the facade of the Municipal Building recalls the occupation of five Columbia University buildings by student activists in 1968, among other temporary takeovers of institutional space.

As with most of Matta-Clark's work, however, the meaning of *City Slivers* and even its political import are as dependent on structures of form and being as they are on metaphoric or symbolic action. These structures are most readily apparent in the way it is required to be projected into a corner at the full height of the interior space whenever it is not shown projected onto a building.[61] If one expects the film to bring the immersive and frequently disorienting scale of the city indoors, the corner projection elaborates on this concept in subtle but surprising ways by literally folding the screen along the "crease" of the corner. Because the corner is farther from the projector than the left and right margins of the projected image, the resulting frame is no longer rectangular but hexagonal, with a distinct central axis in the corner. This has the disorienting effect of depicting all movement across the picture plane as either sloping down toward the center (if one registers it as a flat hexagonal image) or receding into space (if one registers it as a "bent" and, quite literally, three-dimensional image).

In a sequence depicting revolving doors, for example, viewers may choose to "enter" the space established by the corner, where they can become immersed between images of revolving doors—an experience that instills no small amount of wonder and anxiety. The film culminates in a nearly panoramic view of the spire of the Empire State Building, whose simultaneous visibility and inscrutability as it is wedged into the corner implies the failed promise of the panoptic perspective typically associated with urban planning. More subtly than the projection onto the Municipal Building, the interior projection of *City Slivers* and the privileging of "slivers" of experience therefore call into question the ability of planning to capture the fluid dynamics of urbanism.

34 Gordon Matta-Clark, stills from *City Slivers*, 1976. 16 mm film, color, silent; 15 min. Courtesy of the Estate of Gordon Matta-Clark and David Zwirner, New York / London

If *City Slivers* was about the representation of space and its implied material consequences, Chicago's nascent Black Arts Movement literally built on and in the spaces of the city to activate community neighborhoods around images of black pride. In response to Mayor Daley's unveiling of the Chicago Picasso in 1967, the Visual Arts Workshop of the Organization of Black American Culture (OBAC) painted the *Wall of Respect* (1967–73), which was everything the Picasso was not—locally made, collaboratively produced, integrated within a city neighborhood (specifically that of Forty-Third and South Langley), and political in both iconography (it depicted heroes of the civil rights movement) and production (it was painted as a "guerrilla action" without consent of the building's owner).[62] Like Bearden's *Block*, the *Wall of Respect* had a definite quality of making do, in that it made use of existing windows and other structural details of the building as framing devices for the images, many of them painted from photographs and some of them actual photographs adhered to the wall (fig. **10**). Further, while the building itself was not open for occupancy and use, the screen of the mural functioned as a definite point of civic engagement, a meeting place, and a proscenium for music and poetry performances by the likes of Gwendolyn Brooks and Haki Madhubuti. The political nature of the *Wall of Respect* was reinforced by rumors that it attracted the attention of the FBI's Counter Intelligence Program, which attempted to sow seeds of discord within OBAC in hopes of disrupting the production of the mural.[63]

The *Wall of Respect* inspired the photographers Bob Crawford, Roy Lewis, and Robert Sengstacke to install a trio of photomurals on the sides of buildings in black neighborhoods on the city's South and West Sides in 1968.[64] Although Lewis's *West Wall* was literally on the west wall of the building that served as its support, symbolically the name identified it as a monument to the black population on the city's West Side (fig. **35**). It was also a memorial to Martin Luther King Jr., who had stayed in a home a few blocks away earlier that year, just prior to his assassination in Memphis, an event that triggered widespread unrest on the West Side and a notoriously brutal police response.[65] Radiating from a central image of King, the *West Wall* was composed largely of photographs of local residents acting in, occupying, and engaging with the streets of their neighborhoods—boys playing in fire hydrants, men sweeping the streets clean, women selling jewelry at an informal street market, families enjoying live music outside.

The *West Wall* was documented in a one-dollar book that featured reproductions of each photo from the mural alongside the poetry of Eugene Perkins, which made clear that the building of these community walls was a direct action in response to the unbuilding of neighborhoods at the hands of municipal neglect and urban renewal (fig. **36**):

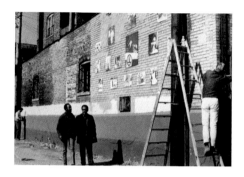

35 Ann Zelle, photograph of *West Wall: Proud of Being Black*, photographic installation by Roy Lewis, 1968 (printed later). Inkjet print. Courtesy of Ann Zelle

> THE WALL OF RESPECT
> NOW … THE WEST WALL
> Dig them
> Dig them
> Boss Creations
> beautiful monuments of Blackness for Black people to dig
> Most things in Lawndale
> are tainted by the blight of
> dilapidated buildings (Union to End Slums)
> cluttered alleys

and the cloak and dagger
exploits of Daley's missionaries who try to
steal land from Black
people with bogus urban
renewal contracts[66]

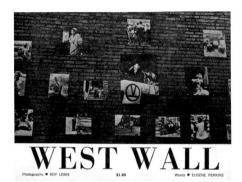

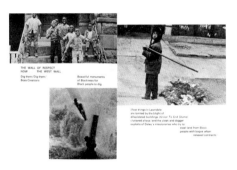

36 Cover and page from *West Wall: Proud of Being Black*, by Roy Lewis and Eugene Perkins. Published by Free Black Press, Chicago, 1968

Within this context of image circulation—and especially given the direct address of Perkins's poetry—Lewis's photographs are not mere documents of a specific time and place but a projection of neighborhood vitality and a call to action directed at a specific audience: the community on the West Side. The specificity of the *West Wall*'s audience speaks to its intentional neighborhood situatedness by comparison with the comprehensive plans, which were ostensibly intended for "the city" but found themselves effectively challenged to address an audience of that scope.[67] The sense of local community in Lewis's images was reinforced by the mural's function as an initial rallying point—a first stage of occupation—for the rehabilitation of the abandoned storefront building into the cooperative community arts center Art & Soul, itself the work of the Conservative Vice Lords, a former street gang turned community organization.[68] In their engagement of collective action as their essence and their substance, the *Wall of Respect* and Lewis's *West Wall* recalled the urbanist Lewis Mumford's famous description of the city as "a theater of social action, and an aesthetic symbol of collective unity. The city fosters art and is art. The city creates the theater and is theater."[69]

In Los Angeles, the Chicano photo-conceptual collective Asco (Harry Gamboa Jr., Gronk, Willie Herrón, and Patssi Valdez) embraced a similar practice of direct action employing photography but in a way that reflected the local environment.[70] Specifically, Los Angeles was a city whose image was determined by the centrality of the movie industry, even to the degree that planning documents like *The Visual Environment of Los Angeles* appropriated cinematic motifs (as noted above). Consequently, one of Asco's primary outlets was the No Movie, a type of intervention into the urban environment that appropriated certain stylistic qualities of the movies but was casually, even flippantly performed with an eye to fictitiousness. *Instant Mural* (1974; fig. **37**) was one of the first No Movies and exists as a series of 35 mm film stills of a performance in which Gamboa photographed Gronk taping Valdez to a wall, ostensibly creating a "living" mural whose conceptual and performative nature played on the association of Chicano artists with the mural movement, proposing the idea of the mural as an urban public event or social spectacle.[71] More significantly, it was also an underhanded memorialization of the moment that radicalized the members of Asco, especially Gamboa, who just three years earlier had witnessed the infamous Chicano Moratorium protest from a spot near the wall where *Instant Mural* was performed. As he later recalled, pointing to a photograph of the protests by Victor Aleman that shows the precise location of the wall on which Valdez would be taped three years later (fig. **38**):

On January 31, 1971, nearly a dozen uniformed Los Angeles County Deputy Sheriffs lined up across the intersection of Whittier Boulevard as several hundred young people marched peacefully along Arizona Street in protest against ongoing police intimidation and brutality in the Chicano community. The demonstration became eerily theatrical as deputies raised their fully loaded shotguns while the unarmed protesters approached the boulevard.

37 Asco, *Instant Mural*,
1974 (printed 2007).
Photograph by Harry Gamboa
Jr. Inkjet print. Courtesy
of Harry Gamboa Jr.

The deputies suddenly began free-firing their weapons many times and scores of wounded people fell to the asphalt while many others scattered for relative safety. At least one individual was killed.... I was among the lucky youths who were spared. I walked away from this extreme violation against humanity transformed and intent on finding an alternate method to confrontational street politics.[72]

Asco emerged as that alternative, using subversive tactics such as *Instant Mural*, whose instantaneity and ephemerality were also a necessity since the Los Angeles County Sheriff's Department had imposed a curfew on the neighborhood that made it illegal for two or more Chicanos to assemble.[73]

As described by Chon Noriega, the No Movie format functions as an "intermedia synaesthesia" that substitutes an affordable medium (the 35 mm still camera) for a more expensive medium to which the subjects had little access (television or motion picture cameras).[74] The No Movie also cleverly relies on the predominance of images of the city—in this case images of Chicano murals—to intervene within and disrupt that image stream and potentially to have a real impact on the lived social experience of city residents. Lastly, the No Movie's resistance to easy categorization (as exemplified by the name of the genre) calls into question the very role of images within the media, creating the conditions of its own visibility and establishing an alternative or parallel network

of critical image practice that operates in the spaces between the gallery, mass media, and the city.[75]

The establishment of alternative networks of critical image practice and circulation presents a final distinction between the artists and activist image-makers and the comprehensive plans. Exemplified by Asco's No Movies, this notion was taken to an equally grand extreme by the self-described multimedia performance artist Mierle Laderman Ukeles, who in 1978 embarked on a multiyear project known as *Touch Sanitation*, in which she shook the hand of every one of the eighty-five hundred sanitation workers, or "sanmen," employed by the city of New York (fig. **39**).[76] If the piece offered a compelling expression of gratitude to the workers after their vilification during the sanitation strikes of 1968, it also established Ukeles's social and political camaraderie with the workers.

As a working artist Ukeles identified with the workers, and her performance is ultimately about empathy and the bridging of differences through shared experience. Explaining her work as a performance artist, she wrote: "This term 'performance' is important here because of the similarity with what you do. You are out there 'on stage' in the public eye everyday, rain or shine, performing your work as 'the sanman' no matter how you are feeling inside."[77] The scale of *Touch Sanitation* demanded Ukeles's equivalent dedication—if she was to shake all eighty-five hundred hands, she had to work the same hours on the same inclement days as the workers. Further, by touching them, she established a bond of trust with the workers as fellow residents since, like most city employees, they were required to live within the city limits.[78] Ukeles's achievement is heroic and comparable to other durational performance works from the period, like Tehching Hsieh's *One Year Performance (Cage Piece)*, in which the artist locked himself inside a cage for twelve months in 1978–79.[79] *Touch Sanitation*, however, is distinguished by its social nature and the fact that it gave near-equal billing to the workers, extending the model of citizen participation within "social planning" from the mere inclusion of different voices to actually engaging them as coauthors. As Ukeles wrote in the brochure explaining her project (fig. **70**), which was published as a "calling card" for the workers: "I'm creating a huge artwork called TOUCH SANITATION *about* and *with* you, the men of the Department. All of you."[80] In videos of her daily interactions with the workers, Ukeles not only connected the sanmen to the city—every handshake is accompanied by the words "Thank you for keeping the city alive"—but she also persuaded other citizens to shake the workers' hands, thus establishing direct social engagements between disparate groups of people across the city.[81]

Photography played a key role in the project as documentation, as evidenced by the hundreds of slides of Ukeles engaging with the workers. If her pantomime mimicry of their actual labor might initially seem disingenuous, it also reflects her recognition that for all the parallels she drew between herself and the sanitation workers, there were significant differences as well, not the least of which is that they were all men and she was a woman (a fact underscored by the intentional visibility of her feminine coiffure in the photographs). But the photographic image of the city—and the desire to counter the dominant image of the city— also underlay the broader conceptualization of the project. As she wrote in her brochure: "This is an artwork about *hand-energy*. What you are expert at, what you do everyday. The touch, the hand of the artist and

38 Victor Aleman, *Just before the Gunfire*, 1971. Gelatin silver print. Courtesy of the artist

39 Mierle Laderman Ukeles, photographs from *Touch Sanitation* performance, 1977-84. Slide show. Courtesy of Ronald Feldman Fine Arts, New York

the hand of the sanman. I want to make a chain of hands: the public—the makers and users / and the sanmen—the make-roomers and the carriers away. Hand to hand. A hand-chain to hold up the whole City. Or a web, spun by hand. Circling the City, bound round and round until it's all woven together. To put together the whole thing. That's the real picture of New York City."[82]

This "real picture of New York City"—a picture of a chain of hands, a network of citizens, collaboratively engaged in the work of the city— offers a dramatic contrast to the mainstream media's images of the city in crisis but also to the image of the city in the comprehensive plans, which called for citizen participation but were ultimately the product of urban planners.

• • •

As analyzed in the first part of this essay, the various comprehensive plans of the 1960s and 1970s attempted to improve on previous top-down urban-renewal plans through their use of direct observational techniques borrowed from photography and cinema and the incorporation of varying degrees of citizen participation. New York, Chicago and Los Angeles were similarly innovative in their use of imagery and engagement of public discourse, but the contours of those innovations were specific

to the circumstances of each city. If New York acknowledged its five boroughs but focused on the "national center" of Manhattan, Chicago almost exclusively emphasized the central business district, and Los Angeles did away with centralization in favor of nodes. What they all shared was the sheer scale called for by the comprehensive nature of these plans as well as the imperative to achieve broad-based solutions, which necessarily distinguished them from the efforts of the locally situated and independently operating artists and activists described in the second part of this essay. The political scientist James C. Scott describes this latter kind of local knowledge as an important counterbalance to hegemonic, institutional authority and argues that it can come only from practical experience, which neatly encapsulates such varied social and artistic practices as Wexler's exposure to tear gas, Davidson's daily subway peregrinations, Bearden's built thing, and the handshakes between Ukeles and eighty-five hundred sanitation workers.[83] Photography and cinematography function as the connective tissue between these varied practices because of their perceived connection to real experiences in the social life of the city. In their tangibility and relatability to direct experience, these works challenge not only the image of the city put forth in the city plans but also those offered by the mass media, even as they appropriated and recontextualized those images, as in Bearden and Schilling's collages or Asco's reenactments. Emphasizing process, complexity, and open-endedness in their engagement with the city, these artists and activists argue for the necessity of practical experience as a means to urban awareness and as a state of *being in the city*.

Epigraph: Jane Jacobs, *The Death and Life of Great American Cities* (New York: Random House, 1961), epigraph.

1 Christopher Klemek, "The Rise and Fall of New Left Urbanism," *Daedalus* 138 (Spring 2009): 73–83.

2 Ada Louise Huxtable, "Plan Is Regarded as Break with Tradition," *New York Times*, November 16, 1969.

3 This dichotomy is exemplified by the varied practitioners included in the exhibition *Mirrors and Windows*, presented at the Museum of Modern Art in 1978, and the accompanying catalogue. See John Szarkowski, *Mirrors and Windows: American Photography since 1960* (New York: Museum of Modern Art, 1978).

4 See Klemek, "Rise and Fall."

5 Hilary Ballon, "The Physical City," in *America's Mayor: John V. Lindsay and the Reinvention of New York*, ed. Sam Roberts (New York: Museum of the City of New York and Columbia University Press, 2010), 136, 144–46. See also Roger Biles, *The Fate of Cities: Urban America and the Federal Government* (Lawrence: University of Kansas Press, 2011).

6 Kevin Lynch, *The Image of the City* (Cambridge, MA: MIT Press, 1960).

7 Kevin Lynch, "Description of the Different Studies within 'The Perceptual Form of the City,'"

K.L. 3-8-55, retrieved from http://dome.mit.edu /handle/1721.3/33656.

8 On the difference between factuality (the presentation of facts) and facticity (a sense of being in the world) as it pertains to photography, see Aron Vinegar, "Ed Ruscha, Heidegger, and Deadpan Photography," *Art History* 32 (December 2009): 852–73.

9 James Wedberg, "Report on Direction-Asking Interviews Conducted for the Rockefeller Project 'Perceptual Form of the City,' in Boston, Massachusetts," Winter 1957, retrieved from http://dome.mit.edu/handle/1721.3/36503.

10 For census data, see http://www.census.gov /population/www/documentation/twps0027/tab19 .txt. For *Plan for New York City* data, see Louis K. Loewenstein, "Review Comment," *Journal of the American Institute of Planners* 37 (September 1971): 354.

11 Brian J. O'Connell, "Concentration: The Genius of the City; A Critique of *The Plan for New York City*," *Journal of the American Institute of Planners* 42 (January 1976): 74.

12 For a brief overview of Lindsay and the Urban Design Group, see Ballon, "Physical City," 132–47.

13 Lindsay's role in assisting the return of filmmaking to New York, for example, has been ably covered by scholars like James Sanders and McLain Clutter,

the latter of whom has persuasively argued that a cinematic way of thinking underlay much of the work of the Department of Planning in New York City. James Sanders, *Celluloid Skyline: New York and the Movies* (New York: Knopf, 2001); Sanders, "Adventure Playground," in Roberts, *America's Mayor*, 84–101; McLain Clutter, "Imaginary Apparatus: Film Production and Urban Planning in New York City, 1966–1975," *Grey Room*, no. 35 (Spring 2009): 58–89.

14 Clutter, "Imaginary Apparatus," 71.

15 Georg Simmel, "The Metropolis and Mental Life" (1903), in *The Sociology of Georg Simmel* (New York: Free Press, 1976), 11.

16 François Penz, "The City Being Itself? The Case of Paris in *La Haine*," in *Visualizing the City*, ed. Alan R. Marcus and Dietrich Neumann (London: Routledge, 2007), 144.

17 *Midnight Cowboy* was filmed in the summer of 1968, was released in the summer of 1969, and went on to win the Academy Award for best picture in April 1970. It thus precisely overlapped the development of *What Is the City but the People?*, which was released in November 1969. Further, the cinematographer for *What Is the City?*, Arthur Ornitz, served as the cinematographer for Jon Voight's screen test for *Midnight Cowboy*, so there was even some direct overlap of staff between the two films. "Arthur J. Ornitz," *Internet Encyclopedia of Cinematographers*, http://www.cinematographers.nl /GreatDoPh/ornitz.htm.

18 It is worth noting that Schlesinger's director of photography, Adam Holender, would go on to serve as director of photography for the harrowing urban drug-addiction film *The Panic in Needle Park* (1971), and the cinematographer for *What Is the City but the People?*, Arthur Ornitz, would go on to film *Serpico* (1973) and *Death Wish* (1974), both stories about a New York City besieged by criminality. For a focused analysis of the New York film industry and its relationship to urban planning, see McLain Clutter's forthcoming book *Imaginary Apparatus: New York City and Its Mediated Representation*.

19 It would be easy to dismiss this moment as a token gesture to the idea of citizen participation or even to the power of images since the citizen in question presents herself as a relatively affluent white homeowner. But the film then goes on to cover the African American participants in the Central Brooklyn Model Cities program, who defend the rights of black and Puerto Rican working-class citizens and even praise the Watts, Detroit, and Chicago riots—known primarily through media images—for bringing the plight of working-class persons of color to the forefront of national discourse. They then call out Model Cities as an opportunity, through diverse citizen involvement, to get active in their city. See Bret A. Weber and Amanda Wallace, "Revealing the Empowerment Revolution: A Literature Review of the Model Cities Program," *Journal of Urban History* 38 (January 2012): 173–92.

20 For example, Loewenstein remarked how unusual it was that a planning document like *Critical Issues* devoted 64 of 182 pages almost exclusively to illustrations. Loewenstein, "Review Comment," 355.

21 Charles Harbutt, "The Multi-level Picture Story," *Contemporary Photographer* 5, no. 3 (1966): 10–12. Charles Harbutt, telephone conversation and correspondence with the author, February 6, 2014.

22 For a basic history of *The Comprehensive Plan of Chicago*, see D. Bradford Hunt and Jon B. DeVries, *Planning Chicago* (Chicago: American Planning Association, 2013), 41–55.

23 Art Sinsabaugh to Ira A. Bach, commissioner of city planning, April 11, 1963, Art Sinsabaugh Archive, Indiana University Art Museum, Bloomington.

24 Sinsabaugh's analogy is a bit of an exaggeration since the clarity with which the human eye sees objects across such a wide field of vision is actually the result of quick, accommodative refocusing, but he was right to argue that his photos give the *impression* of undistorted human vision and thus mimic the sensory experience of the city. Art Sinsabaugh to Jerry Jacobsen, Chicago Department of City Planning, November 4, 1963, Sinsabaugh Archive.

25 *Basic Policies for the Comprehensive Plan of Chicago* (Chicago: Department of Planning, 1964), 84.

26 For example, associate commissioner Larry Reich directly cited the importance of the long, narrow format to achieving the goals of the Planning Department. Larry Reich, Chicago Department of City Planning, to Art Sinsabaugh, September 6, 1963, Sinsabaugh

Archive. On "abstract policies," see Ira J. Bach, manuscript for *From the Eye of the Storm*, ca. 1971, Ira J. Bach Papers, box 14, Chicago History Museum.

27 Art Sinsabaugh, "Background Thoughts on Chicago Landscape Project," undated, Sinsabaugh Archive.

28 In fact, in a decidedly activist mode, Sinsabaugh even devised a photographic mock-up of the neighborhoods that would be lost if a Crosstown Expressway were to be built in Chicago, a project that was ultimately canceled in the 1970s over neighborhood objections and a lack of funding. Nanette Esseck Brewer, "When Photography Met City Planning: Art Sinsabaugh's Urban Landscapes," manuscript of presentation at National Cityscapes Conference, Case Western Reserve University, March 27–29, 2008, 12.

29 Bach, manuscript for *From the Eye of the Storm*, 17.

30 Anne V. Howell, *City Planners and Planning in Los Angeles (1781–1998)* (Los Angeles: Central Publications Unit, Los Angeles Department of City Planning, 1998), 20–25.

31 Forum on Alternative Architecture Practices hosted by the Southern California Institute of Architects on November 1, 1975, http://sma.sciarc.edu/video/alternative-architecture-design-forum-part-one-of-two.

32 Donald Appleyard, Kevin Lynch, and John R. Myer, *The View from the Road* (Cambridge, MA: MIT Press, 1964), 63.

33 Steven Jacobs, "The History and Aesthetics of the Classical Film Still," *History of Photography* 34 (November 2010): 373.

34 Ibid.

35 Greenberg's comments recall the sculptor Tony Smith's by now famous 1966 anecdote, in which he describes driving the unfinished New Jersey Turnpike at night in the early 1950s and experiencing it as if it were a new kind of art or at the very least an experience that liberated his views of art. Samuel Wagstaff Jr., "Talking with Tony Smith," *Artforum* 5 (December 1966): 19.

36 For more on this proposal, see Ken Allan's essay in this volume, especially page 228.

37 Beverly Moss Spatt, "A Report on the New York Plan," *American Institute of Planning Journal* 36 (November 1970): 438.

38 Sam Roberts, "Infamous 'Drop Dead' Was Never Said by Ford," *New York Times*, December 28, 2006.

39 Hunt and DeVries, *Planning Chicago*, 58.

40 Reyner Banham, *Los Angeles: The Architecture of Four Ecologies* (1971; Berkeley: University of California Press, 2009), 119.

41 Jacobs, *Death and Life*, 376.

42 In their most basic forms, metonymy is a figure of speech in which something generally associated

with a concept stands for it, as when "city hall" is used to refer to the mayor or city government in general, and synecdoche is when a part stands in for the whole, as when "the street" comes to stand for the city.

43 Dialogue transcript of Paul Cronin's film *Look Out Haskell, It's Real: The Making of Medium Cool* (2013), 67, www.lookouthaskell.com.

44 As it turns out, although the scene was real, the sound engineer's declaration of that reality had to be overdubbed because the crew was not recording audio at that precise moment. Nonetheless, as Wexler later claimed, this minor instance of overdubbing was representative of the blurring of fiction and documentary, acting and reality, that was at the heart of the film. Ibid., 115.

45 It was an experience equally memorialized by the 1974 song "Subway" from the children's program *Sesame Street*, which describes uncomfortable physical encounters, as when one character exclaims, "Hey, your thumb's in my eye," to which Bert supplies the refrain: "Packed inside a train / It's too crowded to complain / On the subway." *Sesame Street: Old School, Vol. 2 (1974–1979)*, directed by Jim Henson et al. (New York: Sesame Street, 2013), DVD.

46 Laura U. Marks, "Video Haptics and Erotics," *Screen* 39 (Winter 1998): 338.

47 Like other writers on haptic visuality, Marks cites the influence of early haptic studies such as Alois Riegl, *Late Roman Art Industry* (1901; Rome: Giorgio Bretschneider, 1985). Gilles Deleuze also picked up on this distinction as a way of describing the textural and embodied sensations produced by Francis Bacon's decidedly unillusionistic, frequently gruesome portraits, in which human bodies resemble meat. Gilles Deleuze, *Francis Bacon: The Logic of Sensation* (Minneapolis: University of Minnesota Press, 2003).

48 Bruce Davidson, "Subway" (1986), in *Subway* (Los Angeles: St. Ann's Press, 2003), 111.

49 My analysis of Bearden's *The Block* is based in part on my earlier publication, Greg Foster-Rice, "Romare Bearden's Tactical Collage," in *Romare Bearden in the Modernist Tradition: Essays from the Romare Bearden Foundation Symposium, Chicago, 2007*, ed. Ellie Tweedy (New York: Romare Bearden Foundation, 2008), 103–12.

50 Sound recording by Daniel Dembrosky, Shorewood Publishers, Curatorial Exhibition Files, Exh. #958, Museum of Modern Art Archives, New York. Bearden's precise role in the making of the audio collage is uncertain, and it may have been the work of the curator of the retrospective, Carroll Greene. Object Files, *The Block*, 1978.61.1–6, Metropolitan Museum of Art, New York.

51 Ironically, one may find evidence of *The Block*'s ability to impose itself, like the city, in the comments of a visitor to the 1971 Museum of Modern Art exhibition requesting that the curators turn down the volume "so as to be able to enjoy the exhibit without being shouted at." Jeanne W. Lood, comment, Curatorial Exhibition

Files, Exh. #958, Museum of Modern Art Archives, New York.

52 Proprioception, or the sense of the relative position of the parts of the body and their deployment in movement, and kinesthesia are extensively explored in relationship to cinema in Thomas Gunning, "Moving Away from the Index: Cinema and the Impression of Reality," *Differences: A Journal of Feminist Cultural Studies* 18 (Spring 2007): 29–52.

53 For more on the project as a whole, which featured the work of eight photographers and was funded by the National Endowment for the Arts, see Mark Rice, *Through the Lens of the City: NEA Photography Surveys of the 1970s* (Jackson: University Press of Mississippi, 2005), 159–65.

54 "Los Angeles Documentary Project," *Camera* 60 (February 1981): 39.

55 *Robbert Flick: Selected Works, 1971–1981* (Los Angeles: Los Angeles Municipal Art Gallery, 1982), 15.

56 Robbert Flick, Solomon R. Guggenheim Fellowship Application, 1982, quoted in Tim B. Wride, "Trajectories: The Photographic Work of Robbert Flick," in *Robbert Flick: Trajectories* (Los Angeles: Los Angeles County Museum of Art; Göttingen, Germany: Steidl, 2004), 18.

57 The phrase "man of the crowd" is drawn from the title of an influential short story by Edgar Allan Poe, first published in 1840, about a nameless narrator following another man through the crowded streets of London.

58 Chris Chang, "Vision: Vertigo; Further Excavations of Gordon Matta-Clark," *Film Comment* 49 (May–June 2013): 17.

59 Matta-Clark's wife, Jane Crawford, recalls how he made *City Slivers* using an Arriflex 16 mm camera borrowed from Robert Rauschenberg. "Using an anamorphic lens, he matted out vertical strips in front of the camera lens. With only slivers of light allowed to penetrate the negative, Gordon framed slivers of the City. Then he moved the mat strips, rewound the negative by hand in the dark and reshot, exposing different slivers of the negative. The result looked astonishingly high tech in 1976. What's still very impressive is to realize that the effects were achieved entirely in-camera; the golden rule of the day was never to touch the negative." Jane Crawford, "Twenty Adventures," in *City Slivers and Fresh Kills: The Films of Gordon Matta-Clark* (San Francisco: San Francisco Cinematheque, 2004), unpaged.

60 Pamela Lee, *Object to Be Destroyed: The Work of Gordon Matta-Clark* (Cambridge, MA: MIT Press, 2001), 116.

61 The first such projection, the one that established this requirement, was at Holly Solomon Gallery in SoHo in 1976. Ibid.

62 This latter point also ensured its ephemerality as the building was mysteriously, and suspiciously, damaged by fire in 1971 and subsequently condemned and razed by the city in 1973. Jeff Donaldson, "The Rise, Fall, and Legacy of the Wall of Respect Movement," *International Review of African American Art* 15, no. 1 (1991): 22–26; Rebecca Zorach, "Art and Soul: An Experimental Friendship between the Street and a Museum," *Art Journal* 70 (Summer 2011): 72.

63 Donaldson, "Rise, Fall, and Legacy," 23–25.

64 "New Walls for City," *Chicago Defender*, October 22, 1968, 14–15.

65 Ibid. See also Zorach, "Art and Soul," 73–75.

66 Eugene Perkins and Roy Lewis, *West Wall* (Chicago: Free Black Press, 1968), unpaged.

67 Lewis's epigraph for the book even declares "For my people (BLACK AND BEAUTIFUL) with love and respect." *West Wall*, unpaged.

68 Zorach, "Art and Soul," 74–75.

69 Lewis Mumford, "What Is a City?" (1937), in *The City Reader*, 5th ed., ed. Richard T. LeGates and Frederic Stout (London: Routledge, 2011), 91–95.

70 On Asco, see C. Ondine Chavoya and Rita González, eds., *Asco: Elite of the Obscure; A Retrospective, 1972–1987* (Ostfildern, Germany: Hatje Cantz; Williamstown, MA: Williams College Museum of Art; Los Angeles: Los Angeles County Museum of Art, 2011).

71 Harry Gamboa Jr., "In the City of Angels, Chameleons, and Phantoms: Asco, a Case Study of Chicano Art in Urban Tones (Or, Asco Was a Four-Member Word)" (1991), in *Urban Exile: Collected Writings of Harry Gamboa Jr.*, ed. Chon A. Noriega (Minnesota: University of Minnesota Press, 1998), 80. On the extension of conventional notions of the mural by Chicano artists in the 1970s, see Sandra de la Loza, "La Raza Cosmica: An Investigation into the Space of Chicana/o Muralism," especially the section "The Mural as Event," in *L.A. Xicano*, ed. Chon Noriega, Terezita Romo, and Pilar Tompkins Rivas (Los Angeles: UCLA Chicano Studies Research Center Press, 2011), 53–61.

72 Harry Gamboa Jr., "Against the Wall: Remembering the Chicano Moratorium," *East of Borneo*, http://www.eastofborneo.org/articles/against-the-wall-remembering-the-chicano-moratorium.

73 Harry Gamboa, in "No Movie for Asco: Harry Gamboa Jr. & Rita Gonzalez," YouTube video, 2:06:02, presentation at Nottingham Contemporary, October 15, 2013, http://www.youtube.com/watch?v=2u7x4t_rVZg.

74 Chon A. Noriega, "Road to Aztlan: Chicanos and Narrative Cinema" (Ph.D. diss., Stanford University, 1991), 192, quoted in C. Ondine Chavoya, "No-Movies: The Art of False Documents," in *Only Skin Deep: Changing Visions of the American Self*, ed. Coco Fusco and Brian Wallis (New York: Abrams, 2003), 200.

75 Jesi Khadivi, "Artmoreorless: The Early Performances of Asco," http://arcpost.ca/articles/artmoreorless-the-early-performances-of-asco.

76 For an overview of Ukeles and *Touch Sanitation*, see Shannon Jackson, *Social Works: Performing Art, Supporting Publics* (New York: Routledge, 2011).

77 Mierle Laderman Ukeles, *Touch Sanitation*, brochure (1979).

78 On the history of the sanitation workers and city residency requirements, see Winnie Hu, "Law Eases Residency Rule for City Sanitation Workers," *New York Times*, December 23, 2005. For general histories, see Martin Melosi, *The Sanitary City: Urban Infrastructure in America from Colonial Times to the Present* (Baltimore: Johns Hopkins University Press, 2000), and Stephen Corey, *Garbage! The History and Politics of Trash in New York City* (New York: New York Public Library, 1994).

79 See Adrian Heathfield and Tehching Hsieh, *Out of Now: The Lifeworks of Tehching Hsieh* (London: Live Art Development Agency; Cambridge, MA: MIT Press, 2009).

80 Ukeles, *Touch Sanitation*.

81 Mierle Laderman Ukeles, *Waste Flow Video*, 1979–80, courtesy of the artist and Ronald Feldman Fine Arts.

82 Ibid.

83 James C. Scott, *Seeing Like a State: How Certain Schemes to Improve the Human Condition Have Failed* (New Haven, CT: Yale University Press, 1998), 309–41.

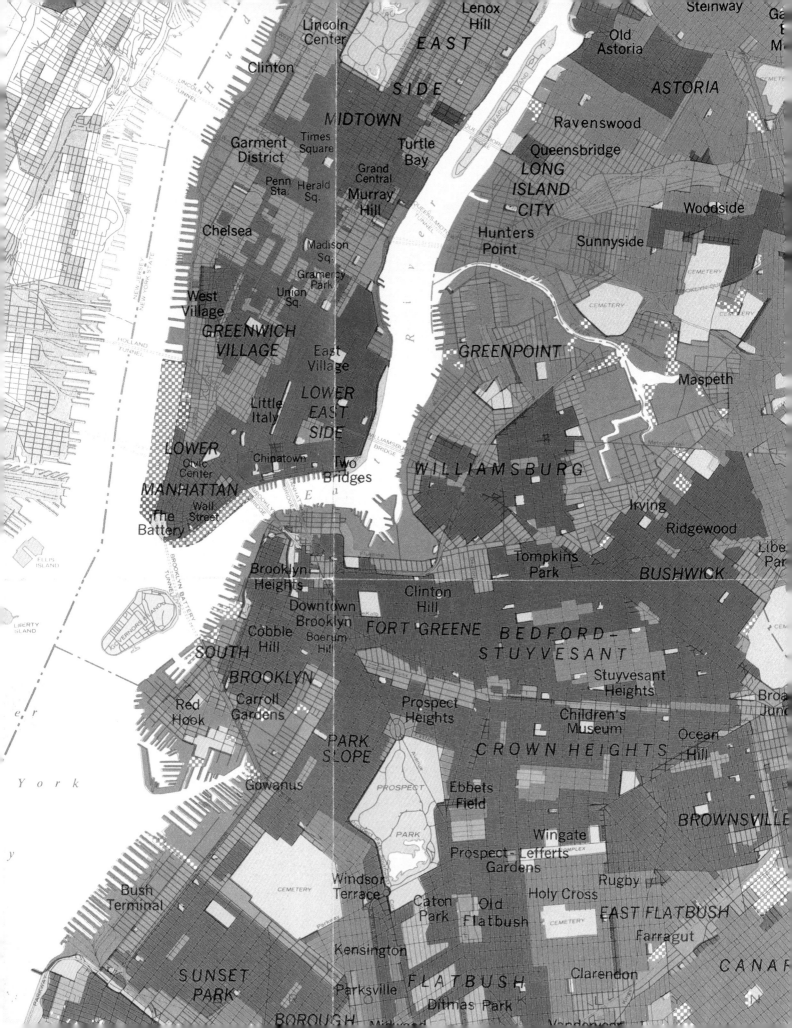

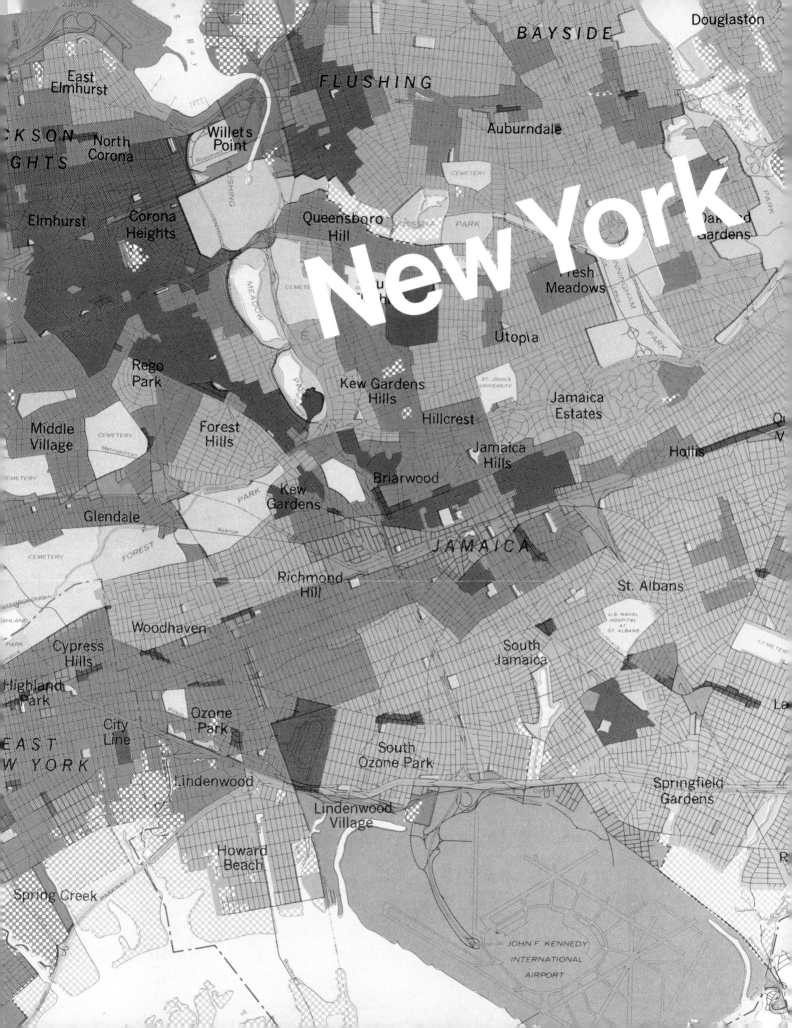

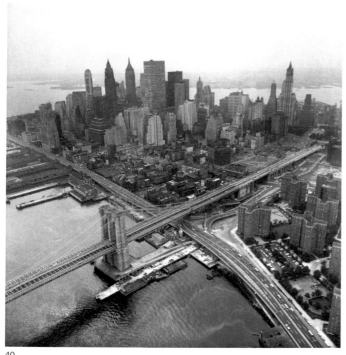

40

41

42

40 Danny Lyon, *Lower Manhattan*, from *The Destruction of Lower Manhattan*, 1967 (printed 2007). Gelatin silver print. Princeton University Art Museum, Gift of M. Robin Krasny, Class of 1973

41 Danny Lyon, *West Street and the West Side Highway, just north of the Trade Center site*, from *The Destruction of Lower Manhattan*, 1967 (printed 2007). Gelatin silver print. Princeton University Art Museum, Gift of M. Robin Krasny, Class of 1973

42 Danny Lyon, *West Street between Jay and Duane Streets*, from *The Destruction of Lower Manhattan*, 1967 (printed 2007). Gelatin silver print. Princeton University Art Museum, Gift of M. Robin Krasny, Class of 1973

43 Danny Lyon, *Facade of 82 Beekman*, from *The Destruction of Lower Manhattan*, ca. 1967. Gelatin silver print. The Art Institute of Chicago, Restricted gift of Mr. and Mrs. Gaylord Donnelley

44 Cover of *The Destruction of Lower Manhattan*, by Danny Lyon. Published by Macmillan, New York, 1967

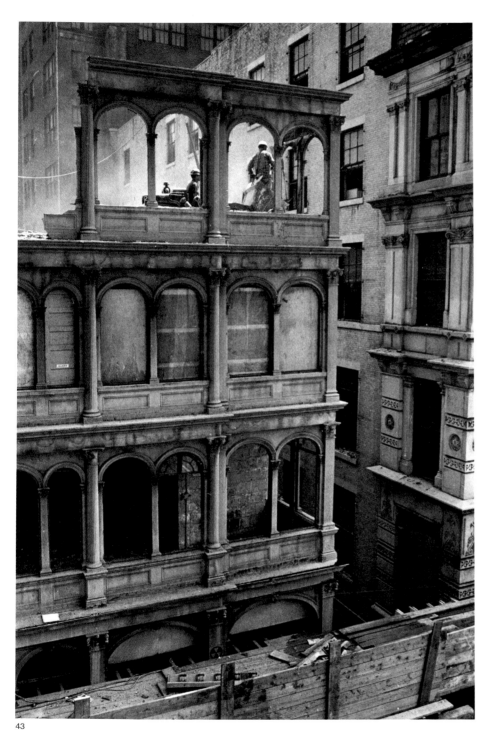

43

44

45

45 Romare Bearden, *The Block II*, 1972. Paper collage with foil, paint, ink, graphite, and surface abrasion on 17 fiberboard and plywood panels. Collection of Walter O. and Linda J. Evans

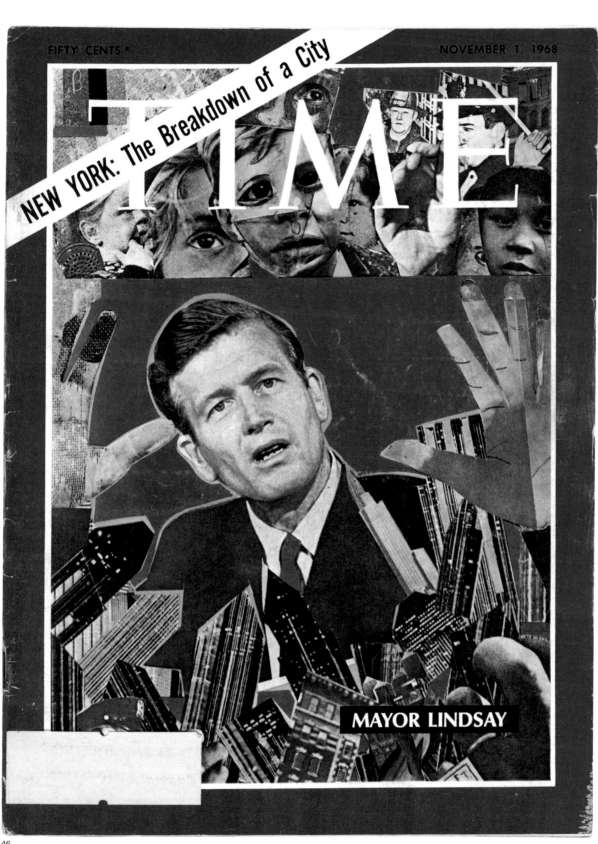

47

48

46 Cover of *Time* magazine,
November 1, 1968. Design
by Romare Bearden

47 Thomas Struth, *Crosby
Street, Soho, New York*,
1978. Gelatin silver print.
Courtesy of Marian Goodman
Gallery, New York

48 Thomas Struth, *West
25th Street, Chelsea, New
York*, 1978 (printed 2012).
Gelatin silver print.
Courtesy of Marian Goodman
Gallery, New York

49 Thomas Struth, *115th
Street at 2nd Avenue,
Harlem, New York*, 1978.
Gelatin silver print.
Courtesy of Marian Goodman
Gallery, New York

49

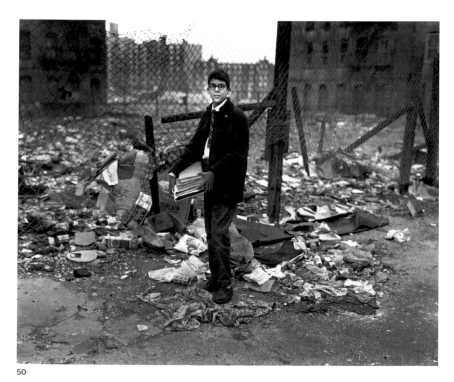

50

51

52

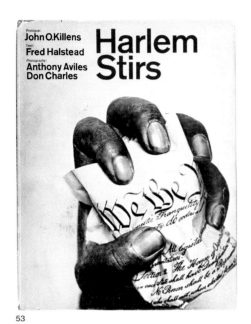

53

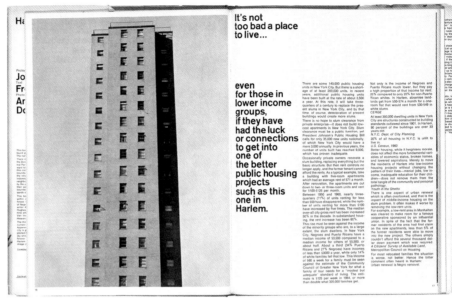

50 Bruce Davidson,
Untitled, from *East 100th
Street*, 1966-68. Gelatin
silver print. Courtesy of
Howard Greenberg Gallery,
New York

51 Bruce Davidson,
Untitled, from *East 100th
Street*, 1966-68

52 Cover of *Harlem on
My Mind: Cultural Capital
of Black America, 1900-
1968*, by Allon Schoener,
Thomas P. F. Hoving,
and Candice Van Ellison.
Published by Random House,
New York, 1969

53 Cover and spread from
Harlem Stirs, by Fred
Halstead with photography
by Anthony Aviles and
Don Charles. Published
by Marzani & Munsell,
New York, 1966

54 Spread from "A Harlem
Family," *Life*, March 8,
1968. Photographs and text
by Gordon Parks

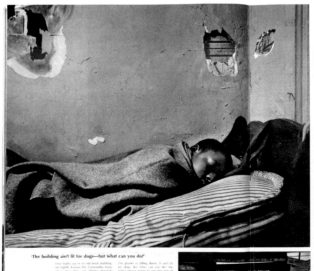

54

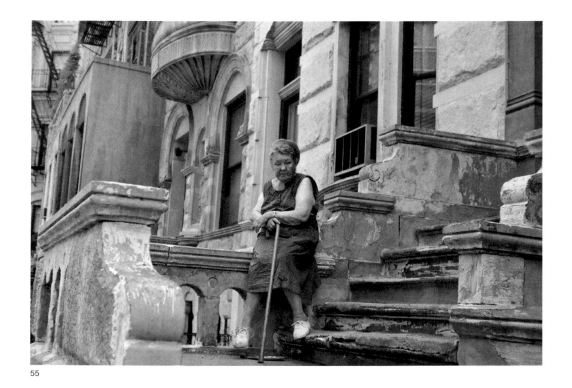

55

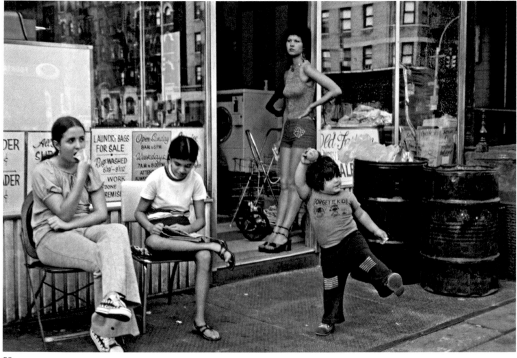

56

55-58 Helen Levitt,
New York, ca. 1972,
photographs from
the slide show *Projects:
Helen Levitt in Color,
Museum of Modern Art,*
1974. Courtesy of the
Estate of Helen Levitt

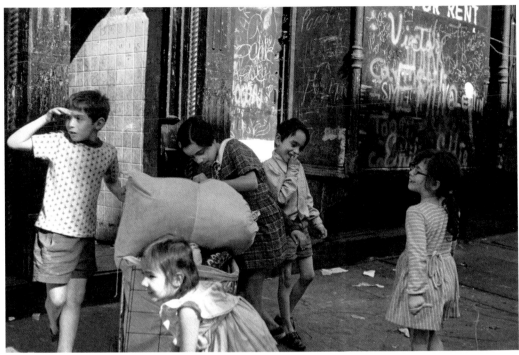

57

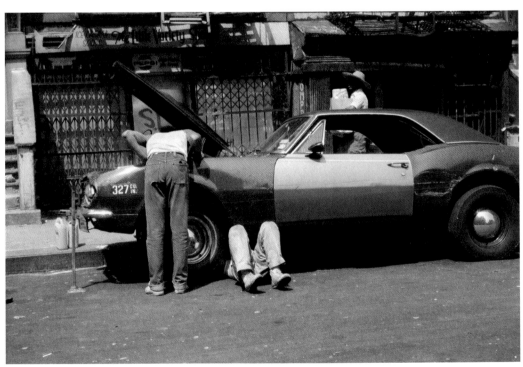

58

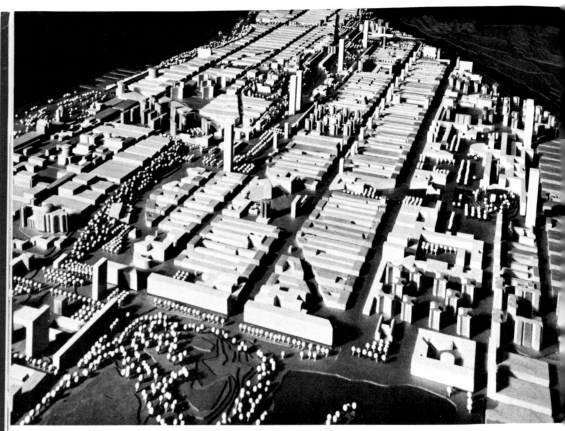

Model. Central Park in foreground.

Left: Plan shows sixteen typical blocks lying between Lenox and Eighth Avenues in the area that the general scheme proposes to preserve and improve without destroying the clarity of the street grid. Possible strategy for local development converts backyards into playgrounds; potentially adequate existing housing is rehabilitated; public buildings acquire the appropriate settings that their social importance might suggest.

Facing page: Perspective shows four such block renovations in the context of the existing city.

Pedestrian circulation
■ Roads

59 Spread from *The New City: Architecture and Urban Renewal*, published by the Museum of Modern Art, New York, 1967

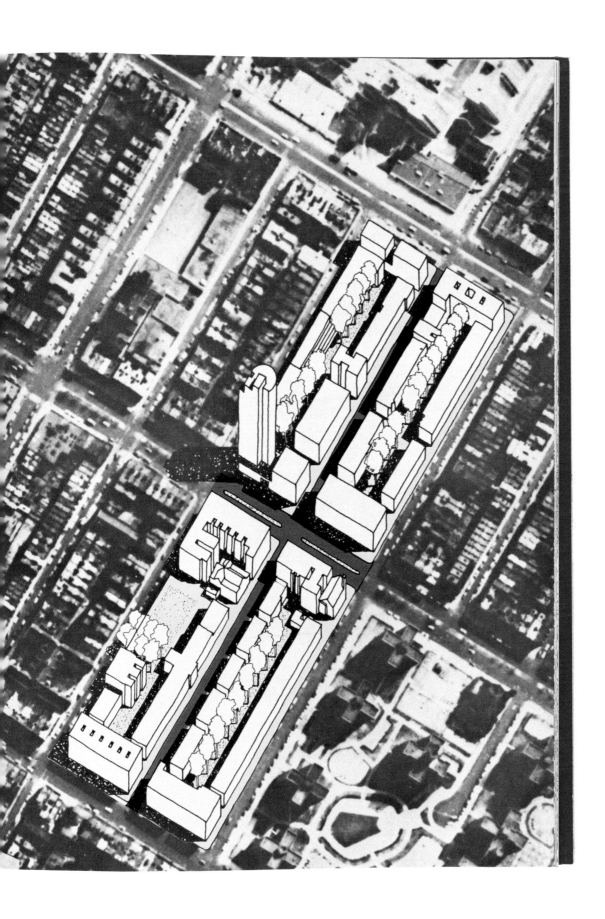

60 Cover of *The Man in the Street: A Polemic on Urbanism*, by Shadrach Woods. Published by Penguin Books, Baltimore, 1975

61 Garry Winogrand, *Hard Hat Rally, New York City*, 1969 (printed 1978). Gelatin silver print. Princeton University Art Museum, Gift of Victor S. Gettner, Class of 1927, and Mrs. Gettner

62 Leonard Freed, *Protesters in the street during a civil rights demonstration, Brooklyn, New York*, 1963. Gelatin silver print. Courtesy of Bruce Silverstein Gallery, New York

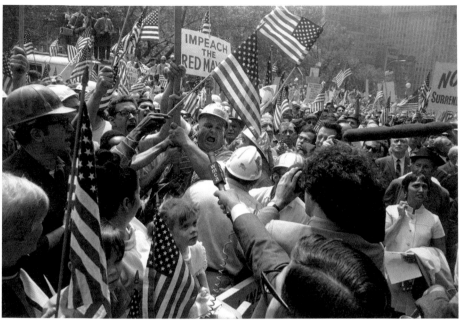

61

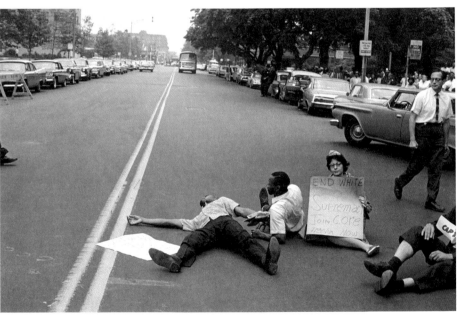

62

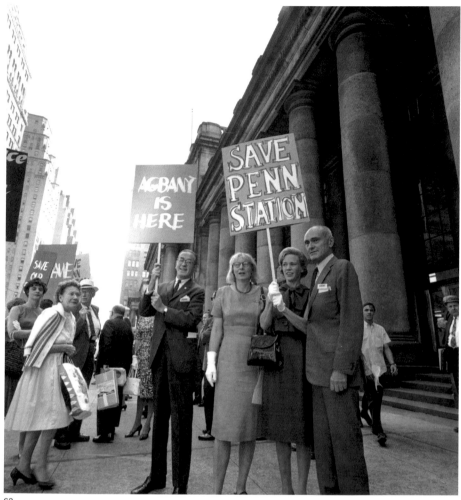

63

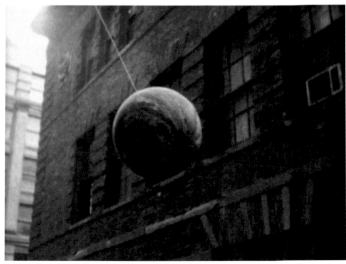

64

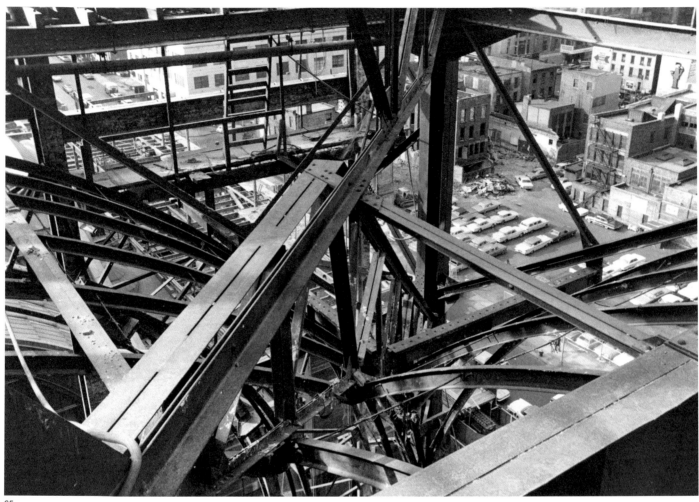

65

63 Walter Daran, *Save Penn Station*, 1963 (printed later). Inkjet print. Estate of Walter Daran / Getty Images

64 James Nares, *Pendulum*, 1976. Super 8 film transferred to DVD, black and white, sound; 17:15 min. Courtesy of the artist and Paul Kasmin Gallery, New York

65 Aaron Rose, *Untitled (The demolition of Pennsylvania Station, 1964-1965)*, 1964-65. Gelatin silver print. Museum of the City of New York, Gift of Aaron Rose, 2001

66

67

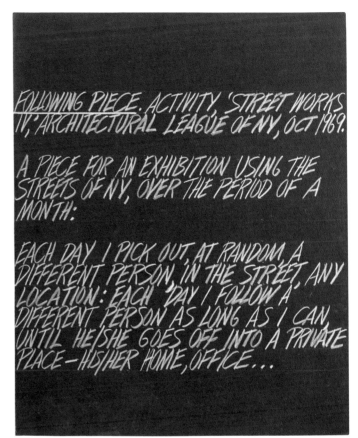

68

66 Alvin Baltrop, *The Piers*, 1975-86. Gelatin silver print. The Alvin Baltrop Trust

67 Andy Blair, *Abandoned West Side Highway*, 1975 (printed later). Inkjet print. Courtesy of the artist

68 Vito Acconci, *Following (Two Works)*, 1969. Gelatin silver print and chalk on paper. Princeton University Art Museum, Museum purchase, Fowler McCormick, Class of 1921, Fund

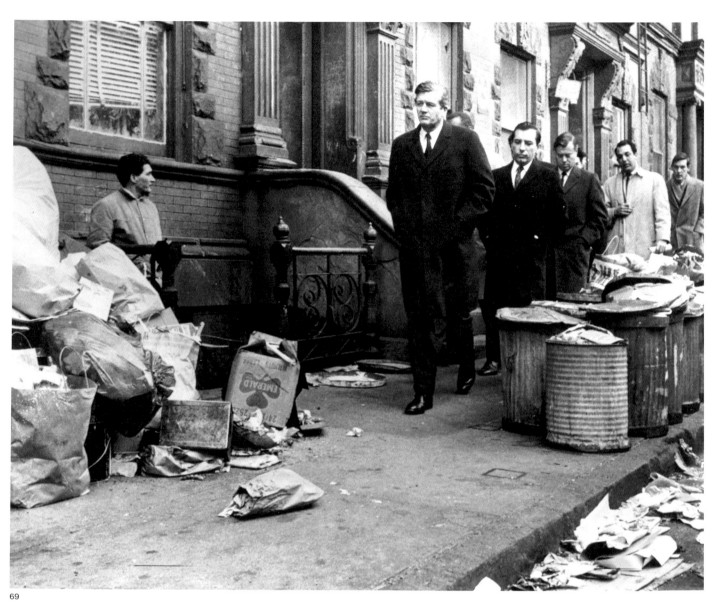

69

69 *Untitled (Mayor Lindsay Walking the Streets during the Sanitation Workers' Strike)*, 1968. AP Wirephoto

70 Mierle Laderman Ukeles, brochure for *Touch Sanitation* performance, 1977-84. Courtesy of Ronald Feldman Fine Arts, New York

"TOUCH sanitation" ©1979

A Maintenance Art Work:
Mierle Laderman Ukeles

City of New York
Department of Sanitation

City-Performance / Video / Exhibition

Public Art with Public Workers in Public Spaces for the Whole Public. It's True.

for information call : 566 5527

DEAR SANMAN,

Nobody understands enough about what you do, how tough it is to work day after day on a job like this, about how hard it can be in lousy weather.

I've been talking to sanmen for over a year: about "blood money"–involuntary overtime; "material"–what everybody calls garbage; "conditions"–when the people out there don't pack it right and you're stuck with it; and "air-mailing"–when they just toss it out the window. Blizzards; garbage cans frozen to sidewalks; "sausage bags" splitting on you; broken trucks; terrible, exciting streets; how all people make waste, and how some are wasted themselves. It's all there, and more. Being disappointed, fiscal crisis, back pains, families, neighbors, fathers, injuries, surprises, hidden needles, things exploding, rats jumping on your chest, sleet down your neck and back. It's about holding up your end of your truck team; about people swearing at you, not looking you in the eye; about doing a good job anyway. Commitments and how they lock you into things for years beyond what you ever imagined; about this City.

I'm creating a huge artwork called TOUCH SANITATION about and with you, the men of the Department. All of you. Not just a few sanmen or officers, or one district, or one incinerator, or one landfill. That's not the story here. New York City Sanitation is the major leagues, and I want to try to "picture" the entire mind bending operation. To try to face each one of you, to shake your hand. In every corner of our City, the act of facing sanmen as public "performance" art.

I am an independent "maintenance" artist. I don't work for the city, the unions, the newspapers or networks.

This is how I'm planning the TOUCH SANITATION "performance". I'll travel to where you work. It will take 10 "sweeps" around and around to "hand over" the whole city. "Sweep 1" will include the first Sanitation district in each borough of the city; "sweep 2" will be the second district in each city-borough, and so on, as plotted on the map. I'll try. Even at 6 a.m. roll call sometimes. I won't disturb your work. The first part will start mid-summer, then a break, with the final part in the fall. I hope to invite the public to join me sometimes, to wave and shake hands with you also.

The Department will track me on the telex everyday I'm out with you, so you'll always know where and when I'm going to show up.

I'm also going to take photographs and make a videotape of the "performance" so that others can view it. To give you a chance, if you'd like, to tell the public individually about you, your needs, where you're at. You can participate in directing the shooting. Whatever I shoot, I'll show you a playback immediately, so you'll know what's on tape. There are no secret things I'll be doing; I respect your work rules and your privacy.

At the end, after many months, there will be a public exhibition for you, your family, your friends, and all New York. I'll let you know where. The exhibition will show the video and photos of the whole "performance".

Another thing, TOUCH SANITATION is for my kids and all the children in the City. I want to take kids along with me. I figure if they can understand the kind of unending work it takes to keep our City going, and if they can focus on what your everyday presence in their own world means, then they will have learned something basic and stabilizing; and this can be a more civilized, even friendlier place for them to grow up in.

What kind of artist am I, you might wonder? I handle regular art "material" and also all kinds of far-out "material", as you do. As necessary. If I am asked to classify myself, I say I am a "multi-media performance artist". The term "performance art" for me means creating voluntary actions with real people on-the-spot in public: a living artwork.

This term, "performance", is important here because of the similarity with what you do. You are out there "on stage" in the public eye everyday, rain or shine, performing your work as "the sanman", no matter how you are feeling inside. Very demanding.

The Talmud, in speaking about how precious human life is, says: "Each human being is a whole world."

You do the most necessary work in the City. You keep coming back. You are probably the biggest experts on what's going on around here. I'm amazed when I talk to sanmen. They can tell me what a street will look like even before we come there. Magicians. Of all the people who symbolize the City as "public workers", you know the City. You feel it in your hands, in your backs, in your bones.

More than the policeman and more than the fireman. They're there to handle things gone wrong and out of commission. You're there to handle the "normal", what's going-going-gone, what keeps coming continually.

Without you, the City is a joke. Impossible. Pffftt! You know that, of course. Making waste–keeping the santruck hopper grinding away–is the surest sign that we're alive. Dead people don't make anything anymore. But what's forgotten is that it's not your waste or your fault. Many people want you to be their "grown-up" for them. They don't want to think about the other half of their lives, about their mess, their waste, their decay. They don't want to "face" it because they think they're supposed to be "stars" nowadays: always fresh, always "up". You handle the "down", the "throw out", the "throw away and forget it". Only, here in New York City especially, there's really no "out" and no "away". Not anymore.

Mister Sanman! Actually, you are a model of the man of the 21st century. You already work in the NEW way we all will have to act on planet Earth since cities' natural and fiscal resources are becoming increasingly limited, where there's no more "out" space. We're all "in" it together, and we must all take part in caring for our living places and, ultimately, for the whole earth. Or we will destroy it.

YOU ARE THE BALANCING AGENTS. You do hard, heavy, physical work, traditional "men's" work. (No woman has passed the sanman's or officer's entrance exam. Yet.) At the same time, you nurture, you "husband" the City. So we don't drown in yesterday, today. You keep the delicate balance between what's fresh and what's decayed. You carry Everyday out in your hands and bring it, refreshed, back here again. You feel pain and loneliness because of a gulf that has regrettably opened up that separates you from the public, for the reason that none of us understands these things well enough. Or how to celebrate the necessity of it. It's time for us all to learn to honor this balancing kind of work you do.

I've talked a lot about "hands", to "handle" waste, "handling" the pressures and difficulties of the job, and finally – about "shaking, shaking, shaking hands". This is an artwork about hand energy. What you are expert at, what you do everyday. The touch, the hand of the artist and the hand of the sanman. I want to make a chain of hands: the public–the makers and users / and the sanmen–the make-roomers and carriers-away. Hand to hand. A hand chain to hold up the whole City. Or a web, spun hand to hand. Circling the City, bound round and round until it's all woven together. To put together the whole thing. That's a real picture of New York City.

I invite you to join me in making TOUCH SANITATION. I invite the public to participate by waving at you wherever they see you. Everyday. To make a citywide everyday wave. If I, a "maintenance" artist, can do it, everybody can.

Thank you sanman. Thank you for keeping New York City alive!

SEE YOU,

Mierle Laderman Ukeles

Mierle Laderman Ukeles
1979

With gratitude for support from:

BEARD'S FUND, INC.

NATIONAL ENDOWMENT FOR THE ARTS
a federal agency

NEW YORK CITY
DEPARTMENT OF SANITATION

URBAN ACADEMY

Under the auspices of the
NEW YORK FOUNDATION FOR THE ARTS

Printing courtesy of
AVON PRODUCTS

The City of New York Department of Sanitation

Your project #1 "Touch Sanitation" illuminates the services of a working community whose contribution to the City is traditionally passed over and culturally neglected.

Sincerely,

Norman Steisel
COMMISSIONER

Uniformed Sanitationmen's Association

Congratulations!

This Union has no objection to your work; in fact we welcome such a project which promotes the sanitation man and gives the public a true insight into their lives and working conditions.

Sincerely yours,

Edward Ostrowski
President

Sanitation Officers Association

I enjoyed our conversation pertaining to your project "Touch Sanitation." I think that what you are doing will be a wonderful morale builder for Sanitation Officers and Sanitation Men. Your sensitivity to the everyday problems in our work force is commendable. Hopefully, your project will enlighten the public, making them as sensitive and understanding to our everyday problems as it has done for you.

Sincerely yours,

Louis F. Pastoriza
President

photos by Anthony Pepitone

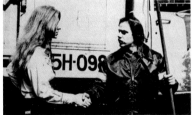

ABOUT THE ARTIST:
Mierle Laderman Ukeles, director of Maintenance Art Works, wrote the "Manifesto for Maintenance Art" in 1969. Goal: creating forms for public celebration of necessity. Last large performance with 300 maintenance workers in a N.Y.C. skyscraper, "I Make Maintenance Art One Hour Every Day", was exhibited at the Whitney Museum Downtown, Fall, 1976. TOUCH SANITATION is the first in a series called "Maintenance Art Works Meets the Dept. of Sanitation".

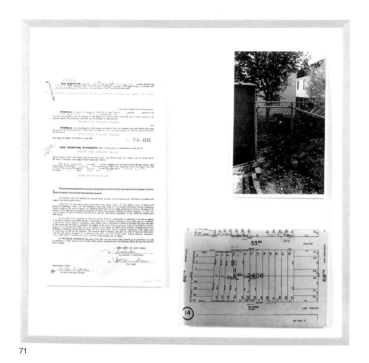

71

71 Gordon Matta-Clark,
*Reality Properties: Fake
Estates "Maspeth Onion"
(Block 2406, Lot 148)*,
1973. Gelatin silver print
and documents. Courtesy
of the Estate of Gordon
Matta-Clark and David
Zwirner, New York / London

72 Gordon Matta-Clark,
cover of *Walls Paper*, 1973.
Artist's book. Printed
by Buffalo Press, New York.
Joan Flasch Artists' Book
Collection, School of the
Art Institute of Chicago,
Special Collections

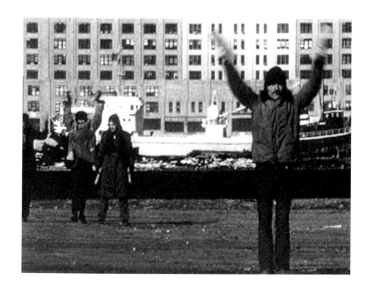

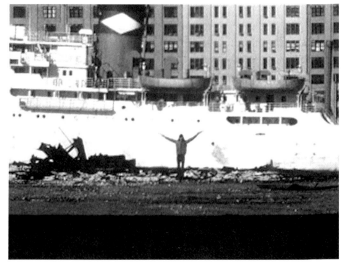

73

73 Joan Jonas, stills from
Songdelay, 1973. 16 mm film
on video, black and white,
sound; 18:35 min. Courtesy
of Electronic Arts Intermix
(EAI), New York

74 Camilo José Vergara,
Harlem, 1978 (printed later).
Chromogenic print. Courtesy
of the artist and Rose
Gallery, Santa Monica

74

Jane Jacobs, *The Death and Life of Great American Cities* (1961)

Timothy Mennel

Probably the best-known picture of the urbanist Jane Jacobs appears on the cover of the 1992 Modern Library reissue of her 1961 book *The Death and Life of Great American Cities*. It shows a smiling woman in clunky glasses perched on a stool at the White Horse Tavern in what today we call the West Village (fig. **76**). It's nothing fancy, and neither is she.

At the time Jacobs was writing her transformational book, planners, politicians, and developers tended to espouse and act on the view that cities were imperiled by their own history, that old neighborhoods were bad neighborhoods, and that wholesale reconstruction was the way to save the cities from themselves.[1] Who was killing New York? The question reverberates through images of the time like the start of a whodunit. How did the city of V-E Day and the Great White Way and a mayor known as the Little Flower become an unrelenting panorama of decay and despair?

Jacobs, using fine-grained descriptions of the street life of her neighborhood and its economic and social complexity, challenged and eventually upended this view. She wrote with convincing passion about what she saw on actual streets, and that—along with the gradual realization that the new neighborhoods had as many problems as what they had supplanted, if not more—changed the conversation over what makes a city worth living in. Jacobs showed that the world seen from an old barstool had more value than those in power recognized. She showed that neighborhoods were not constructs on a map but actual places inhabited by actual people, whose daily lives were not imperiled by the city—those people *were* the city.

That photo of Jacobs is in black and white, but of course Jane Jacobs's neighborhood—and her city, her world—was in color. And in that color—the saturated color, say, of Helen Levitt's slide show of New York street life (figs. **55–58**)—there is something more than there is in Jacobs's depiction of city neighborhoods. Jacobs could be both hard- and softheaded about city life, delineating economic truths and subtle social networks but also painting gauzy pictures that did not always fully engage with the diversity and unhappiness out there. She could articulate the power of the street as well as the economic significance of import substitution, yet she also fetishized nonnormative city dwellers and tended to oversimplify ethnographic issues.[2] In Levitt's photographs, there is life, yes, and strength and the power of mere survival. But there is poverty, there is bare-bones existence, there is an aura of desperation, and there is the half-buried truth that not everything that is ought also to be celebrated. We can savor the slice of watermelon while recognizing that the crabapple face that eats it might have a life that actually does need to be fixed.

We can romanticize even the ruins now: those places that evoked fear at the time ooze something we call authenticity today. But the city of lively neighborhoods and dense sociability is also the city of touts and hoods, of chickens and frowns. The city is not just an aesthetic experience. People live there too.

1 Perhaps the best recent description and analysis of this era is Samuel Zipp, *Manhattan Projects: The Rise and Fall of Urban Renewal in New York* (New York: Oxford University Press, 2010). See also Christopher Klemek, *The Transatlantic Collapse of Urban Renewal: Postwar Urbanism from New York to Berlin* (Chicago: University of Chicago Press, 2011).

2 Jacobs's *The Economy of Cities* (New York: Random House, 1969) and *Cities and the Wealth of Nations* (New York: Random House, 1984) dealt thoughtfully with economic abstractions and their relevance to urban prosperity, but her last book, *Dark Age Ahead* (New York: Random House, 2004), is embarrassing amateur ethnography. For an array of perspectives on Jacobs's continuing relevance—or lack thereof—see Max Page and Timothy Mennel, eds., *Reconsidering Jane Jacobs* (Chicago: American Planning Association, 2011), particularly Thomas Campanella's notorious essay "Jane Jacobs and the Death and Life of American Planning" (141–60).

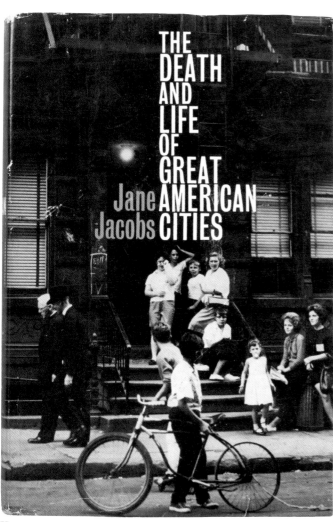

75

76

75 Cover of *The Death and Life of Great American Cities*, by Jane Jacobs. UK edition, published by Jonathan Cape, London, 1962. Cover design by Jan Pienkowski

76 Cervin Robinson, *Jane Jacobs at the White Horse Tavern*, 1962. Courtesy of the artist

Shirley Clarke, *The Cool World* (1963)

Paula J. Massood

A scene near the beginning of Shirley Clarke's *The Cool World* (1963) introduces the film's major themes. In it, Duke Custis, the film's teenage protagonist, takes an end-of-the-year school trip to the New York Stock Exchange, riding a bus through Manhattan. The scene is shot from inside the vehicle as it makes its way through Harlem and down Fifth Avenue, eventually reaching its destination on Wall Street. As a teacher explains passing sites, like the Plaza Hotel, to his students, the young men can only look out the windows at the white wealth that exists beyond their neighborhood's borders. This irony, of living in but not belonging to New York City, is further underscored at the end of the scene, when the students are encouraged to take a brochure with the title "Own a Piece of America" before entering the stock exchange. For these young African American and Hispanic men, such dreams are distant possibilities.

The Cool World is based on a novel by Warren Miller.[1] The rights to the novel were purchased by Frederick Wiseman, who produced the project and asked Clarke to direct. Clarke then worked with Miller and the actor Carl Lee to adapt the story for the screen. Like the novel, the film is told from the point of view of fourteen-year-old Duke, whose two goals are to become leader of the local street gang and to purchase a Colt pistol from a neighborhood gangster. The film was shot almost entirely in Harlem, with exteriors filmed on neighborhood streets and interiors set in an abandoned tenement loaned to the shoot by the New York Housing Authority. Its style is at once narrative and experimental, with aesthetics drawn from both fiction and nonfiction film. Clarke, a former dancer who began her film career making documentaries, was also an original member of the New American Cinema movement, which was founded by a group of New York

filmmakers looking to make films outside the industrial, stylistic, and narrative constraints of Hollywood.[2]

Working independently allowed Clarke the freedom to draw from a variety of fiction and nonfiction film movements, including Italian Neorealism, the French New Wave, the city symphony, cinema verité, and American direct cinema.[3] The result is a film that explores Duke's limited world in varied and nuanced ways. More conventional narrative scenes of the young man's interactions with friends and family, for example, are juxtaposed with experimental montage sequences that combine street shots with a jazz sound track and Duke's voice-over to create what one reviewer described as a "tone poem of the slums."[4]

The overall aim of the film's visual and aural components is to explore Harlem's people and places and to illustrate the area's limitations. Duke's mother, for example, can barely make ends meet on wages earned washing clothes, his absent father abandoned the family he couldn't support, and Duke's only legitimate employment opportunity is in a liquor store, a choice the young man rejects. In such a limited world, then, owning a gun is like owning a piece of America, and being a gang leader is the best Duke, a young black man, can hope for in an urban America limited by politics, economics, and place.

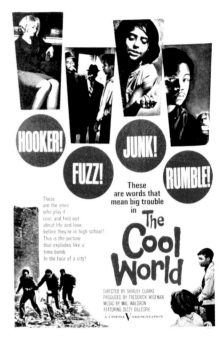

77

1 Warren Miller, *The Cool World* (New York: Little, Brown, 1959).

2 See David E. James, ed., *To Free the Cinema: Jonas Mekas and the New York Underground* (Princeton, NJ: Princeton University Press, 1992).

3 See Dave Saunders, *Direct Cinema: Observational Documentary and the Politics of the Sixties* (New York: Wallflower, 2007).

4 Albert Johnson, "The Negro in American Films: Some Recent Works," *Film Quarterly* 18 (Summer 1965): 26.

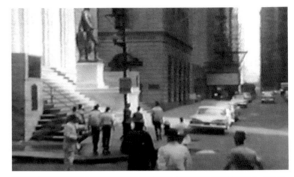

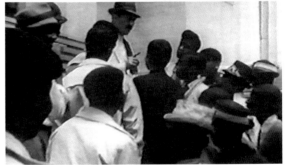

78

77 Poster for *The Cool
World*, directed by Shirley
Clarke (Zipporah Films,
1963)

78 Stills from *The Cool
World*, directed by Shirley
Clarke (Zipporah Films,
1963)

Martha Rosler's *Downtown* photographs (ca. 1964)

Katherine A. Bussard

For Martha Rosler—an artist who is committed to a thoroughgoing critique of the function of truth, myth, and artistic practice in everyday experience—the notion that photography can serve a documentary function has long offered both great problems and great potential. Although she would eventually write a poignant critique of the history of documentary photography, that critique as well as her overarching interest in urban issues stemmed from her own picture taking, which began in the 1960s.[1] Initially she photographed nature during escapes from the city, searching for transcendence through nature. As early as 1964, however, she began photographing her walks on New York City's sidewalks and her drives down its streets. As Rosler stated in an interview with the art historian Molly Nesbit and the curator Hans Ulrich Obrist: "Street photography was the ocean in which I swam."[2]

Unlike a tradition of street photography that relied on the fortuitous, the accidental, and happenstance—as exemplified by Helen Levitt's pictures, in which the fleeting gestures of child's play animate the scene or a woman's outfit causes her to blend visually into the stoop on which she is perched (figs. 55–58)—Rosler's street photographs present the sidewalks and stoops from the vantage point of a passerby. Her more distant position, whether the result of taking the photograph from inside a car or from the opposite side of the street, allowed for an emphasis on those aspects of the city that interested her most. In the interview with Nesbit and Obrist, Rosler explains:

In my urban photographs there was the class romanticism of ruins—always looking for the signs of activity just past: junkyards, ancient tar wagons, and accumulations of discarded objects.

Obrist: They are street scenes without people?

Rosler: Yes, street scenes without people, as far as I could manage. I was interested in the marginal: things at the edge of the East River, decrepit industrial buildings, giant waterfront gravel heaps. But there are also street scenes with people, in "anonymous" neighborhoods in Brooklyn and the Lower East Side—as long as I am riding past in the car. The mediation of the vehicle represents my presence, the walker in the city, in this case, the rider. The passages are actual, not primarily metaphoric . . . passages through and out of the urban landscape.[3]

Rosler's attention to specific neighborhoods within New York was not accidental but built on street photography's long tradition of engagement with working-class or economically depressed enclaves, in which there was a more vibrant street life. To this tradition, she brought a heightened sense of responsibility and a keen awareness that urban exclusions based on class structures often aligned with racial and ethnic segregation as well. By the time she began photographing in earnest, the picture magazines and newsweeklies regularly featured the silent urban poor. In the same year that Rosler began making these images, President Lyndon B. Johnson declared a nationwide "War on Poverty," a response to revelatory studies like Michael Harrington's book *The Other America* (1962). At the same time, a surge of art world interest in photography also affected the conceptualization of street photographs, allowing Rosler to explore and challenge the restrictions of the genre. Employing a medium with a burgeoning presence in art galleries and an increasing dominance in news coverage, she began to use photographs of streets to show people, conditions, things, and spaces. As she has acknowledged: "A city embodies and enacts a history. In representing the city, in producing counter-representations, the specificity of a locale and its histories becomes critical. Documentary, rethought and redeployed, provides an essential tool, though certainly not the only one."[4] Rosler's early documentary street photographs trained her eye on the visual aspects of the city that reflected her most urgent critical arguments about urban history.

1 Martha Rosler, "In, Around, and Afterthoughts: On Documentary Photography," in *Decoys and Disruptions: Selected Writings, 1975–2001* (Cambridge, MA: MIT Press; New York: International Center of Photography, 2004), 151–206.

2 "Martha Rosler in Conversation with Molly Nesbit and Hans Ulrich Obrist," in *Martha Rosler: Passionate Signals*, ed. Inka Schube (Ostfildern-Ruit, Germany: Hatje Cantz; Hannover, Germany: Sprengel Museum Hannover, 2005), 14.

3 Ibid., 14.

4 Martha Rosler, "Fragments of a Metropolitan Viewpoint: A Project by Martha Rosler," in *If You Lived Here: The City in Art, Theory, and Social Activism*, ed. Brian Wallis (Seattle: Bay Press, 1991), 32.

79-82 Martha Rosler, *Untitled*, from the series *Downtown*, ca. 1964. Gelatin silver prints. Courtesy of the artist and Mitchell-Innes & Nash, New York

79

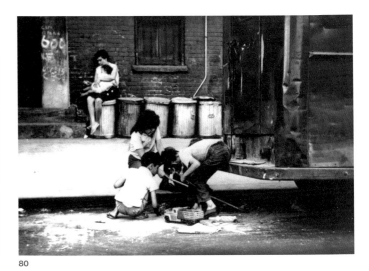

80

81

82

Hoving's Happenings (1966)

David Sadighian

In September 1966 *Time* magazine reported on the popular fervor surrounding "the brightest star on [New York City mayor] John Lindsay's new team": his thirty-five-year-old parks commissioner, Thomas P. F. Hoving.[1] The article describes an incident at Central Park's recently built Fountain Café, where two starstruck New Yorkers spot Hoving and proceed to pitch ideas to the charismatic young commissioner. One suggests constructing a miniature golf course near Manhattan's Riverside Drive, which sends Hoving's hands flying as he sketches designs on a scrap of paper. For the *Time* reporter, the encounter illustrated why, just one week earlier, Hoving had generated stories in both the *New York Times* and the *Daily News*, each on a different news item. Judging from his café performance, it was as though Hoving could think and act at the brisk pace demanded by mass media. As he later recounted: "My Parks team had created a joyful revolution. They made me a folk hero, the Clown Prince of Fun City. . . . Hardly a day passed when I wasn't in the press."[2]

Mass media proved instrumental for Hoving's "joyful revolution," not only drawing larger audiences to the city's parks but also redefining the public's perception of park space as an aesthetic medium for mass reception. "A park is like a stage," he commented to *Newsweek* earlier that summer, adding that parks "should teach and enrich and relax and inspire and be like works of art for the entire city to enjoy."[3] The latter aspect was crucial for Hoving, who held a Ph.D. in art history and joined the Lindsay administration after working as a curator at the Cloisters, the Metropolitan Museum of Art's outpost for medieval art and architecture. Viewing New York's parks as works of art in their own right, he appointed the first-ever curators for Central Park and Prospect Park to oversee their conservation and publish guidebooks on their respective histories. Yet even as Hoving conceptualized the urban park as an artistic medium, he saw parks less as precious museum objects than as spaces for play. In this vein, new policies enacted after his January 6, 1966, inauguration included removing an antiquated ban on kite flying (outlawed in 1906 because it spooked horses) and closing Central Park's roadways to vehicular traffic on Sunday mornings to make them available for pedestrian use. If such policies envisioned urban parks as dynamic social environments, other programs realized this concept in a manner not unlike participatory performance art.

So much became clear when Hoving appointed Phyllis Yampolsky as the city's first artist-in-residence. Yampolsky was best known at the time for *Hall of Issues* (1961–62), her interactive public forum at Greenwich Village's Judson Memorial Church. From her bureaucratic platform, Yampolsky disseminated experimental art practices to an expanded, eager public—one that coalesced in both the physical space of the city's parks and the network space of popular media. Announced by savvy press releases ("N.B.—Good Press Photos"[4]), Yampolsky's projects included festivals, games, and activities in which groups of pedestrians collectively produced ephemeral environments. Adults and children gathered en masse to participate in events such as a Build-Your-Own-Castle workshop in the shadow of Central Park's Belvedere Castle and a widely attended Chalk-Carpet Contest on the mall in Central Park (figs. **83–85**). The popularity of these events led to the coining of the alliterative slogan "Hoving happening," which was subsequently applied to nearly all future park events presided over by New York City's happening impresario-cum-commissioner. (Indeed, the promiscuous use of *happening* attests to the term's currency in the avant-garde and pop-cultural spheres alike.) Although Hoving would soon return to the Met as its celebrated and controversial director (1967–77), his brief stint as parks commissioner had already dismantled modes of art reception normally contained within the institutional frames of the museum and gallery. If, for Hoving, a public park could be a work of art, it was one framed by publicity.

This research was supported by a generous grant from the Graham Foundation for Advanced Studies in the Fine Arts.

1 "Peopling the Parks," *Time*, September 2, 1966, 48.

2 Thomas P. F. Hoving, *Making the Mummies Dance* (New York: Simon & Schuster, 1993), 26.

3 "Summer Romance," *Newsweek*, July 18, 1966, 26.

4 Department of Parks press release, August 1, 1966, New York City Municipal Archives, Parks and Recreation Administration Files, 1966, box 904, location 103285.

83,84 Build-Your-Own-Castle-and-_____-In-It-Day, 1966. New York Parks Photo Archive

85 Chalk-Carpet Contest, 1966. New York Parks Photo Archive

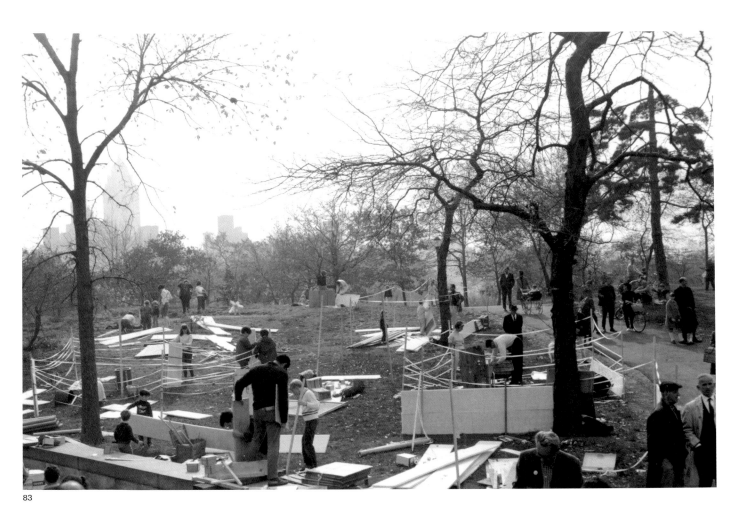

83

84

85

Vacant Lots as Building Blocks
Reclaiming New York's Wastelands

Mariana Mogilevich

86

In the early 1960s one journalist after another reported that East 100th Street was New York City's "worst block." A landscape of decay, it was the harbinger of a bleak urban future of rubble and rats, poverty, hopelessness, and violence. The street was also rife with spatial contradictions. Extraordinarily dense, with poor families overflowing from its decaying tenements onto the busy street and sidewalks, the block was simultaneously barren, pockmarked by empty space. Some buildings stood empty—abandoned save the addicts taking refuge in the basement—while vacant lots where tenements once stood served as "combination dumping ground for tenants' garbage and a playground for the children who spill over from the overcrowded street," according to one 1963 account.[1]

When Bruce Davidson came to photograph the East Harlem block, he was drawn to those interstitial spaces, posing neighborhood residents in front of and within the debris (figs. **50**, **51**).

86 Bruce Davidson, *Untitled*, from *East 100th Street*, 1966-68. Gelatin silver print. Courtesy of Howard Greenberg Gallery, New York

87 *A Citizens' Survey of Available Land*, published by the Metropolitan Council on Housing, New York, 1964. New York University, Tamiment Library

But if children played and adults gathered in the muck, they found valuable open space in other margins. Davidson found a young boy flying a kite from a tenement rooftop, the open sky above and a bridge of the East River barely visible in the distance (fig. **86**). A family picnicked at the river's ragged edge, their hammock hanging from two trees between litter and a smokestack. Oppressed by a lack of open space, Davidson's photographs, like their subjects, searched longingly from the confines of a harsh urban environment for the spatial reprieve of air and water. As the photographs recognized, waste and space—waste in space, wasted space—defined life in the city.

In the early 1960s this paradoxical lack of open space and environmental amenities, alongside an abundance of empty spaces, usually filled with trash, played out in poor neighborhoods across the city, from East Harlem and the Lower East Side to Bedford-Stuyvesant in Brooklyn. Amid optimistic attempts to rebuild the city without bulldozer renewal, the vacant lots that symbolized decline and disinvestment were increasingly seen as sites of opportunity. Civic groups cataloged them and agitated for their reappropriation for new housing or small parks. The Metropolitan Council on Housing compiled a listing of vacant lots in neighborhoods across the city that could be redeveloped into low-cost, small-scale "vest-pocket" housing, thereby avoiding massive tenant relocation. In the photograph on the report's cover (fig. **87**), the camera appears to have cut through a chain-link fence to reclaim a lot that is barren except for some bricks and cans.

In early 1965 a Bedford-Stuyvesant group conducted a comprehensive survey of vacant land in the Brooklyn neighborhood, finding 378 vacant lots and almost as many abandoned or burned-out buildings. Securing private funds and leasing the lots from the city,

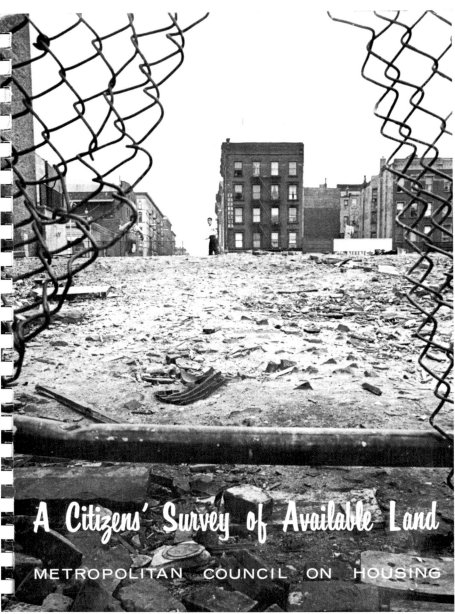

87

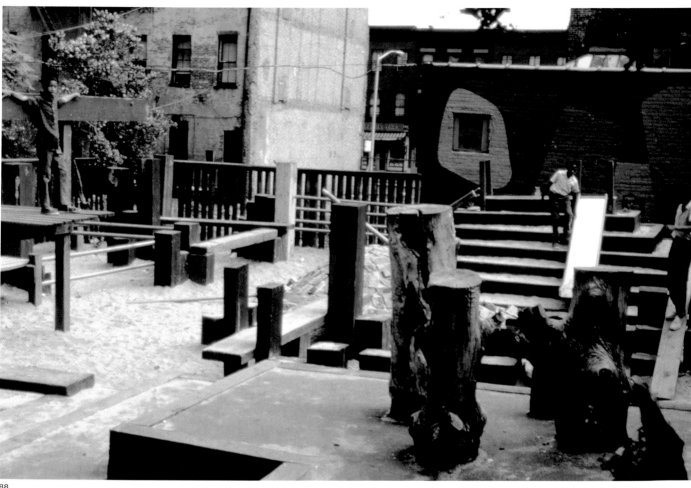

88

they designated two sites for development into small vest-pocket parks. Paul Friedberg, a young landscape architect, designed the parks at Quincy Street and Lefferts Place (fig. **88**). His design, resourceful and collaborative, was without precedent in the city.[2] Friedberg reclaimed materials—trees on the site and secondhand timbers from a nearby lumberyard—to keep construction costs low. He designed simple wooden assemblages that local residents could build from models, rather than having to read plans. Neighborhood children contributed to the design as well, as the architect adjusted his plans in accordance with their suggestions and his observations of their activity while the parks

were under construction. The result was an urban environment unlike the city's existing playgrounds of asphalt and steel. Here children could scamper, climb, and jump, determining their experience of the space rather than following the dictates of standardized equipment.

By the time Bruce Davidson arrived on East 100th Street in 1966, the Metro North Citizen's Committee was overseeing housing rehabilitation in the neighborhood. Residents also teamed up with the architect Ulrich Franzen to propose a vest-pocket park at 313–315 East 100th Street, a lot that had been vacant since 1937 (figs. **89**, **90**). The modest park inaugurated in 1966 lacked many of the flourishes of

Franzen's design; it consisted principally of asphalt, a chain-link fence, a mural, and a cluster of concrete pillars for sitting and climbing. It is another early example of the many concrete utopias that would crop up as vest-pocket park mania swept across the city. These wastelands provided an opportunity for reclamation and urban reinvention as community groups and philanthropists initiated projects that emphasized, to varying degrees, neighborhood beautification, community organization, and youth recreation. The last of these was particularly associated with the most pressing problems in the inner city. In 1967 the report of the National Advisory Commission on Civil Disorders (or Kerner Commission) put "poor

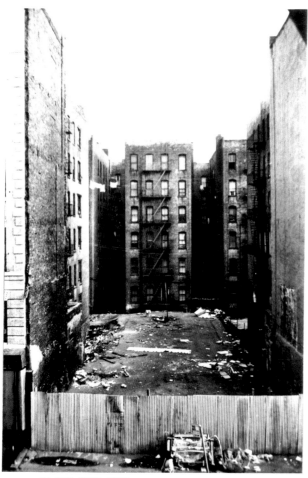

311 EAST 100TH STREET
TODAY

89

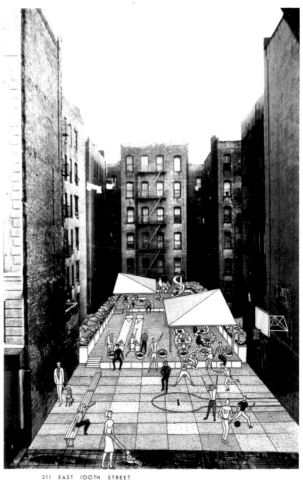

311 EAST 100TH STREET
PROPOSED PARK

90

88 M. Paul Friedberg, *Vest Pocket Park, Lefferts Place, Brooklyn, 1967*. New York Parks Photo Archive

89 Ulrich Franzen, *Vest Pocket Park, 313-315 East 100th Street (Before)*, 1965. Drawing. Parks Council Records, Avery Architectural & Fine Arts Library, Columbia University, New York

90 Ulrich Franzen, *Vest Pocket Park, 313-315 East 100th Street, Proposal*, 1965. Drawing. Parks Council Records, Avery Architectural & Fine Arts Library, Columbia University, New York

recreation facilities and programs" high on a list of causes of the "civil disturbances" that had troubled American cities since rioting began in Harlem in the summer of 1964.[3] Improving open space in the inner city was as much a matter of pacification as a question of civil rights.

Vest-pocket parks, pools, and housing found strong advocates in city government in the era of "small is beautiful." Small-scale projects promised a more democratic—that is, decentralized and participatory—spatial politics. Thomas P. F. Hoving, the New York City parks commissioner, attempted to institutionalize a municipal system of

provisional parks, declaring that "utopia would mean a park or playground … every four or five blocks."[4] Friedberg gave form to these aspirations, turning ten vacant lots into experimental city parks between 1967 and 1969. These vest-pocket parks were unabashedly urban in their form, with play components made from precast concrete, wood timbers, steel bars, pipes, and cables. The parks continued the dense pattern of their surrounding neighborhoods, packing a number of experiences into a tiny lot. Conceived as coproductions between city and citizens, the parks were planned and designed in consultation with

neighborhood groups. Recuperated from so much waste, vacant lots became models for urban democracy.

Despite these cleanup efforts, trash was recalcitrant. With few resources for maintenance in the Parks Department budget and disagreement between residents and parks administrators as to who was responsible for keeping parks clean, many of Friedberg's vest-pocket parks quickly returned to their original state. Litter mixed with sand, and children laid waste to some playgrounds, burning down wooden equipment. By 1973 two of the experimental parks were "surrendered," in the Parks Department's terminology. Four more would follow by 1985.

New York's waste problems did not stop at its vacant lots. Garbage, piling up and burning in the streets, was a potent symbol of disorder and inequality in the city. A nine-day sanitation strike in 1968 was an embarrassment of national proportions. The following year, a "garbage riot" unfolded in East Harlem as residents protested the city's inability or unwillingness to keep certain parts of town trash-free. By the first Earth Day, in 1970, a broader environmental movement mobilized around concerns with the quality of the city's air and water. New environmental concerns generated their own landscape interventions on the city's margins in the early 1970s. Large state parks on the Hudson and Harlem Rivers, and Gateway, the first urban national park, were designed to rehabilitate the waterfront and increase access to open space in the inner city. Yet most of the new large-scale reclamation projects on the waterfront sought economic development and not an expanded public realm. Public and private investment poured into riverside enclaves at the South Street Seaport, Javits Convention Center, World Trade Center, and Battery Park City, as the city repositioned itself and the urban environment, hoping these shiny new

objects would draw attention away from a landscape laid to waste, away from the burned-down buildings and graffiti in the subways.[5]

In areas of the city that did not see infusions of capital for large-scale transformation, vacant lots multiplied to become semivacant blocks. Vest-pocket parks, deemed failed experiments in decentralization, were supplanted by a new approach to environmental remediation: do-it-yourself. Like Voltaire's Candide at the end of his grueling journey through a landscape of cruelty and misfortune, New Yorkers cultivated their gardens. Short on cash and optimism, city government and private groups began to offer instructions rather than new construction. Many vest-pocket park sponsors moved into lower-cost interventions, with "rubble to roses" programs for city gardens. Some three blocks from East 100th Street, residents planted trees, shrubs, and flowers in a new "community garden"; others grew vegetables nearby (fig. **91**). Residents of the Lower East Side, East Harlem, and the Bronx built casitas in abandoned lots, replicating Puerto Rican working-class landscapes down to the roosters. (The art of gardening was not the only form of aesthetic reclamation of vacant lots. The lot as work of art found another expression in Gordon Matta-Clark's *Fake Estates* project [1973–74; fig. **71**].)[6]

Unlike the vest-pocket parks, these community gardens sought not to reconstruct the city but to evade it. The gardens reclaimed wasted space but not urban life. While many vest-pocket parks opened out as an extension of the city street, inner-directed gardens used chain-link fencing to protect their pastoral enclosures from the city beyond. Without investment from the city, residents of East Harlem, Bedford-Stuyvesant, and the Lower East Side took to heart E. F. Schumacher's argument in his influential book *Small Is Beautiful* that "we can, each of us,

work to put our inner house in order."[7] In less than a decade, the city's vacant lots had gone from overlooked blight to shared urban terrain and, by the late 1970s, private agrarian claims. Yet waste had become an integral part of the public realm.

1 Woody Klein, *Let in the Sun* (New York: Macmillan, 1964), 42. The book was based on excerpts from Klein's reporting for *New York World-Telegram and Sun* in June 1963. New York mayor Robert Wagner and U.S. attorney general Robert F. Kennedy's tours of the blocks were widely publicized in the media, alongside reports like Richard Eder's front-page article "Night Cloaks Crime in City's Toughest Block," *New York Times*, July 25, 1960.

2 See, for example, Mariana Mogilevich, "Landscape and Participation in 1960s New York," in *Use Matters: An Alternative History of Architecture*, ed. Kenny Cupers (New York: Routledge, 2013), 209–22.

3 *Report of the National Advisory Commission on Civil Disorders* (New York: E. P. Dutton, 1968), 144.

4 Thomas P. F. Hoving, "Think Big about Small Parks," *New York Times*, April 10, 1966.

5 On the reclamation of the waterfront and connections to art and development, see Rosalyn Deutsche, *Evictions: Art and Spatial Politics* (Cambridge, MA: MIT Press, 1996), and more recently, Douglas Crimp, "Action around the Edges," in *Mixed Use, Manhattan: Photography and Related Practices, 1970s to the Present*, ed. Lynne Cooke and Douglas Crimp (Madrid: Museo Nacional Centro de Arte Reina Sofía; Cambridge, MA: MIT Press, 2010).

6 See Jeffrey Kastner, Sina Najafi, and Frances Richard, eds., *Odd Lots: Revisiting Gordon Matta-Clark's "Fake Estates"* (New York: Cabinet, 2005).

7 E. F. Schumacher, *Small Is Beautiful: Economics As If People Mattered* (New York: Harper & Row, 1973), 281. According to Schumacher, people "organized in small units will take better care of their bit of land or other natural resources" than would larger governments (33).

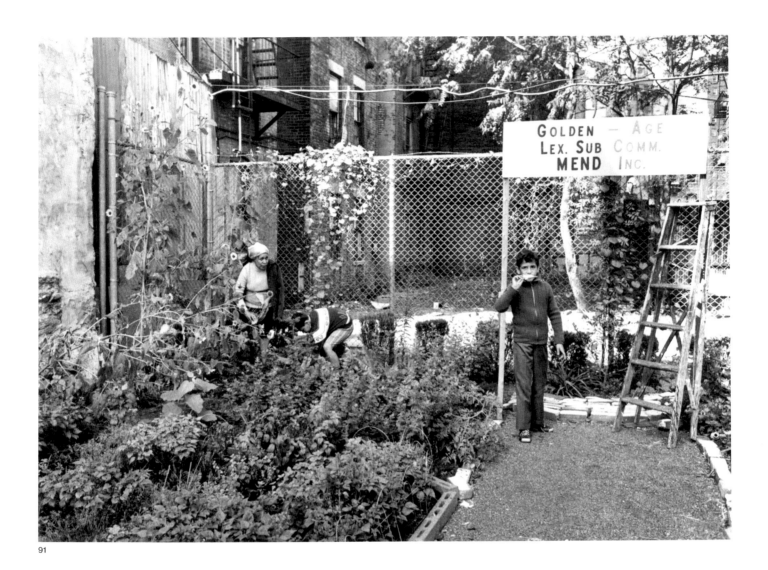

91

91 MEND Garden, 1968-69.
Parks Council Records,
Avery Architectural & Fine
Arts Library, Columbia
University, New York

Arthur Tress, *Open Space in the Inner City* (1971)

Katherine A. Bussard

Shortly after his return to New York in 1968 after several years overseas, Arthur Tress began working on the series of photographs that would become *Open Space in the Inner City*. His goal was to locate and document those urban spaces that reflected condensed human impact on the environment as well as those that offered transitional and potentially transformational points of respite and recreation. Small city parks appeared in the project, but so did sunbathers on abandoned industrial waterfront piers, vacant lots that could become gardens, a picnic under a bridge, as well as rooftops, cemeteries, and other overlooked or neglected locations. Each of these open spaces was either already being used unofficially in the way a city park would be or suggested how many such spaces were available to be utilized in this way. In addition to images of these spaces, Tress expanded the photographic scope to include images that spoke to themes of urban deterioration, such as overcrowding, automobile congestion, and pollution in New York City, which exemplified a broader and more national set of well-known urban concerns. Indeed, in his introductory text, Tress references a finding from the National Advisory Commission on Civil Disorders report (also known as the Kerner Commission report), which indicated that the widespread urban riots of the 1960s were fueled not only by unemployment, police brutality, and slum housing but also by the absence of urban recreational facilities.[1]

In 1970 the Sierra Club Gallery in New York presented an exhibition of the project, which featured Tress's photographic prints alongside other materials, including architectural drawings, models of successful local vest-pocket parks,[2] magazine articles, and newspaper headlines.[3] The exhibition announcement—which pairs a rendering of a vest-pocket park by the landscape architect M. Paul Friedberg with Tress's photograph of an isolated boy riding his bike in the shadow of roadway infrastructure overhead—signals Tress's ambition to spur viewers to think about practical spatial solutions hand in glove with the problems depicted in his photographs.

The exhibition of *Open Space in the Inner City* was featured prominently in the *New York Times*, including in a review by A.D. Coleman, who notably began with a discussion of the gathering momentum of the environmental movement. (The first Earth Day would occur one month later, with Tress creating an impromptu sidewalk display of his *Open Space* images along the railings of Union Square Park in New York.) Contextualizing the project in this way, Coleman applauds Tress's timeliness as a "perceptive spokesman for this vital cause."[4] Indeed, the very mode of display in the Sierra Club exhibition and the circulation of these images in the 1971 portfolio also reflected a timely urban critique meant to spur conversation about the city's future.

A New York State Council on the Arts (NYSCA) grant in 1971 allowed for the publication of the *Open Space* portfolio.[5] The NYSCA made the portfolio available at little cost to any interested school, community center, library, or other organization that could use the photographs to stimulate discussion. A text suggested uses for the portfolio's images, including arranging one's own exhibition, either following the categories explained—or not—and expanding it to include other materials relating to the question of open spaces in the inner city. It is this participatory element that makes the portfolio and the exhibition so remarkable and forward-thinking, representing Tress's best efforts at addressing an issue outlined at the beginning of his introductory statement: "We have put a man on the moon before we have solved the problem of collecting our cities' garbage. Our metropolitan centers grow more impossible to live in as millions of Americans congregate about our large urban areas. We have come up with few intelligent solutions to the crisis."[6]

1 Arthur Tress, "Introductory Statement," in *Open Space in the Inner City: Ecology and the Urban Environment* (New York: New York State Council on the Arts, 1971), unpaged.

2 On vest-pocket parks, see Mariana Mogilevich's essay in this publication, pages 82–87.

3 An earlier exhibition of the project at the Focus Coffee House–Photographic Gallery had relied on the photographs alone, clustering twenty or so small prints on panels for a presentation that evoked the congested urban spaces depicted.

4 A.D. Coleman, "Finding a Place to Breathe, to Live," *New York Times*, March 15, 1970.

5 Tress's portfolio grew out of a visit to the 1970 exhibition by Allon Schoener, director of the NYSCA's Visual Arts Program from 1967 to 1972 and the organizer of the infamous 1969 exhibition *Harlem on My Mind* (see fig. **52**).

6 Tress, "Introductory Statement," unpaged. Tress's reference to garbage collection reflects the impact of New York's sanitation strike of 1968; for more on that crisis, see pages 110–11 in this volume.

92 Arthur Tress, Cover and photographs from *Open Space in the Inner City*, 1971. Portfolio of photographic prints. Private collection

Clason's Point, East River, Bronx

Jamaica Bay, Brooklyn

Mosel Degan Expressway, Bronx

92

THIS IS NOT
A
PUBLIC
PLAYGROUND

Open
Space in
the Inner
City

Ecology and the Urban Environment/Photographs by Arthur Tress
An exhibit portfolio by the New York State Council on the Arts for the New York Museums Collaborative

Hudson Street Pier, Hudson River, Manhattan

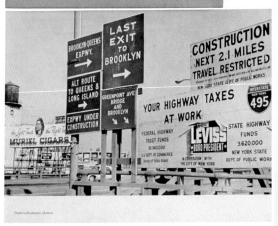

Queens Boulevard, Queens

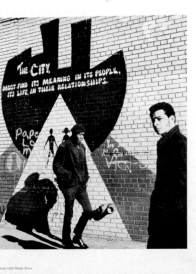

East 100th Street, Bronx

Hans Haacke, *Real-Time Social Systems* (1971)

Greg Foster-Rice

In the spring of 1971, after making a decade's worth of art about natural systems like the weather, the artist Hans Haacke prepared two photo, map, and text installation pieces about social systems: *Shapolsky et al. Manhattan Real Estate Holdings, a Real-Time Social System, as of May 1, 1971* (1971) and *Sol Goldman and Alex DiLorenzo Manhattan Real Estate Holdings, a Real-Time Social System, as of May 1, 1971* (1971). These pieces identified various strategies by which a few real estate cartels controlled massive amounts of property that they neglected to maintain but through which they profited greatly via a series of internal real estate transactions.

That year, Haacke's planned solo exhibition at the Guggenheim Museum in New York was canceled on the grounds that these two pieces identified the activities of specific individuals, therefore presenting possible legal problems for the museum, and also because they exceeded the museum's definition of art practice by exploring concrete structures of property relations, at least according to the Guggenheim's director, Thomas Messer.[1] Consequently, these pieces are frequently cited as marking the emergence of a new, more political phase of institutional critique in Haacke's work.[2] While the cancellation of the Guggenheim exhibition certainly solidified the museum critique of Haacke's real estate pieces, *The City Lost and Found* refocuses attention on their photographic content and recontextualizes them within period debates about the city, adding further complexity to their acknowledged political nature and redefinition of the object of art.[3]

For the real estate pieces, Haacke utilized a straightforward photographic method, making a single image of each building held by the Shapolsky and Goldman-DiLorenzo cartels after conducting extensive research in the files of the office of the County Clerk of New York County. Since the original records were entirely textual, Haacke's juxtaposition of facts with maps and photographs helps to locate these abstract social systems within the fabric of the city and within an experience of the city that is explicitly temporal. In *Sol Goldman*, for example, each property is indexed by a single frame on the roll of film (sometimes horizontally, sometimes vertically), which literalizes Haacke's action of walking by each property in sequence, an act that itself literalizes a social system—a real estate cartel—that was previously hidden among the records of the county clerk's office.

The visual manifestation of this system takes on added urgency in the context of the tenants' rights movement of the late 1960s and early 1970s, which reacted to a sharp increase in severely decayed and abandoned buildings, new rent regulations that were unfavorable to tenants, and an increase in tenant displacement due to a rise in arson and building neglect as well as the beginning waves of gentrification. Tenants responded to these challenges by forming tenant organizations, by occupying abandoned buildings and establishing cooperatives, and by drafting legislation that legalized the rent strike as a protected tactical response to landlord mismanagement of properties.[4]

All this was front-page news in the early 1970s, but it has received surprisingly little attention in the subsequent art historical discourse on Haacke's work. Conversely, these issues were preeminent for commentators at the time, like the architecture and urban-planning critic Ada Louise Huxtable, who in 1972 singled out an updated version of *Shapolsky et al.* for its trenchant critique of tenements while giving less regard to how it shifted debates about art as institutional critique: "Presented as a succinct visual phenomenon, it may or may not be art, but it is superb social analysis and it is boffo."[5] Haacke himself rejects the reductive nature of labels like "institutional critique" to describe a specifically artistic movement, suggesting his greater affinity with social movements like the tenant rights revolution, which shed light on problems that go beyond artistic discourse and impact a broader segment of the populace, such as the 75 percent of New Yorkers who were tenants in the 1970s.[6]

1 Rosalyn Deutsche, "Property Values: Hans Haacke, Real Estate, and the Museum," in *Hans Haacke: Unfinished Business* (New York: New Museum of Contemporary Art, 1987), 32–33.

2 See, for example, Deutsche, "Property Values," and Benjamin Buchloh, "Hans Haacke: The Entwinement of Myth and Enlightenment," in *Hans Haacke: Obra Social* (Barcelona: Fundació Antoni Tapies, 1995), 49.

3 Haacke's interest in the city was first apparent in his unrealized piece *Environment Transplant* (1969), which proposed to bring the real-time social system of the city directly into the Los Angeles County Museum of Art by projecting sound and image from a video camera–enabled truck that would drive through Los Angeles and provide real-time footage of whatever transpired on the city streets. Although never finished because of its technological complexity, the piece does not merely assert a generalized institutional critique of the museum as an ivory tower but specifically highlights its status as a place within the city that frequently ignored the concerns and conditions of urban residents since the projections could have included images of homelessness and impoverished neighborhoods and evidence of absentee landlordism. Luke Skrebowski, "All Systems Go: Recovering Hans Haacke's Systems Art," *Grey Room*, no. 30 (Winter 2008): 70–71.

4 On the tenants' rights revolution, see Ronald Lawson with the assistance of Reuben B. Johnson III, "Tenant Responses to the Urban Housing Crisis, 1970–1984," in *The Tenant Movement in New York City, 1904–1984*, ed. Ronald Lawson (New Brunswick, NJ: Rutgers University Press, 1986).

5 Ada Louise Huxtable, "Megalopolis Show: Artists and the Urban Scene," *New York Times*, October 31, 1972.

6 Kristen Hileman, "Romantic Realist: A Conversation with Hans Haacke," *American Art* 24 (Summer 2010): 81; Lawson and Johnson, "Tenant Responses," 210.

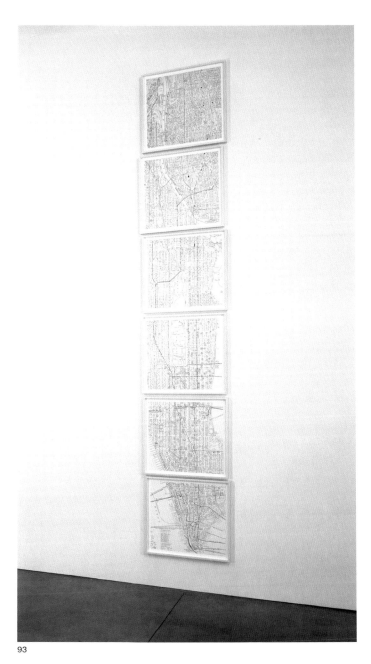

93

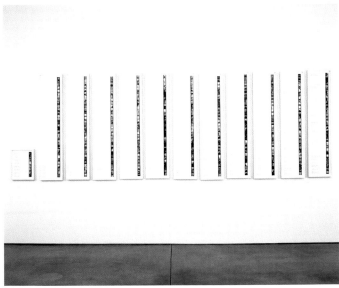

94

93-95 Hans Haacke, *Sol
Goldman and Alex DiLorenzo
Manhattan Real Estate
Holdings, a Real-Time
Social System, as of May 1,
1971*, 1971 (installation
details). Mixed media.
LeWitt Collection, Chester,
Connecticut. Courtesy
of Hans Haacke and Paula
Cooper Gallery, New York

336-40 E 63 St.
Block 1437 , Lot 32 , 75 x 100'
6 story semi-fireproof elevator apt. bldg. built after 1920
Owner Southern Associates, Inc.
Transfer rec. 9-15-1964
Land value $145 000 , total $385 000 (1971)

225 E 63 St.
Block 1418 , Lot 11 , 125 x 100'
12 story elevator apt. bldg.
Owner Greenpoint Terminal Warehouse, Inc.
Transfer 5-8-1964 rec.
Land value $420 000 , total $1 700 000 (1971)

40-46 E 62 St.
Block 1376 , Lot 45 , 66 x 100'
9 story fireproof elevator apt. bldg.
Owner Southern Associates, Inc.
Transfer rec. 12-7-1962
Land value $235 000 , total $420 000 (1971)

21 E 62 St.
Block 1377 , Lot 14 , 18 x 100'
5 story converted dwelling
Owner Avon Associates, Inc.
Transfer 12-15-1971 , rec. 5-25-1972 , from Chatham Associates, Inc.
Land value $98 000 , total $145 000 (1971)

241 E 60 St.
Block 1415 , Lot 19 , 20 x 100'
4 story converted dwelling
Owner Avon Associates, Inc.
Transfer from Chatham Associates, Inc. 12-15-1971, rec. 5-25-1972
Land value $80 000 , total $125 000 (1971)

217 E 60 St.
Block 1415, Lot 9 , 20 x 100 '
5 story walk-up apt. bldg.
Owner Avon Associates, Inc.
Transfer from Chatham Associates, Inc. 12-15-1971, rec. 5-18-1972
Land value $90 000 , total $135 000 (1971)

215 E 60 St.
Block 1415 , Lot 108 , 20 x 100'
4 story walk-up converted dwelling
Owner Avon Associates, Inc.
Transfer from Chatham Associates, Inc. 12-15-1971, rec. 5-18-1972
Land value $90 000 , total $125 000 (1971)

41-45 E 60 St.
Block 1375 , Lot 28,29,30 , 60 x 100'
6 story walk-up converted dwelling
Owner Sutton Associates, Inc. & Avon Associates, Inc.
Transfer rec. 3-2-1970 & 7-7-1972
Land value $276 000 , total $402 000 (1971)

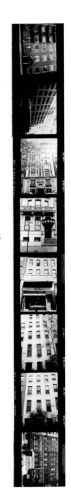

95

Richard Haas, *Proposal: To Paint the Shadow of Madison Square Garden* (1976)

Alison Fisher

Richard Haas's *Proposal: To Paint the Shadow of Madison Square Garden Tower on the Corner of Park Avenue South and 23rd Street* is one of his earliest designs for a large-scale wall painting, leading to the trompe l'oeil murals that would define his career. Haas was trained as a painter and began working in New York in 1968, first creating remarkably detailed dioramas of streetscapes and interiors on the Lower East Side and then producing detailed etchings and lithographs of buildings that mimic photographic views and cropping. His first executed mural, *112 Prince Street*, created just before his shadow series, was a trompe l'oeil composition designed for the side of a loft building on the corner of Prince and Greene Streets in SoHo. This mural was one of a series of proposals that exactly mimicked the volumetric details of buildings with cast-iron facades, thus "completing" the design and activating walls of rough brick that had been exposed by the removal of the adjacent buildings (figs. **96**, **97**). It was the recognition of just this sort of everyday scar or rupture in the urban landscape—resulting from urban renewal, demolition, or arson—that led in 1967 to the creation of City Walls, a public art organization that commissioned Haas's mural on Prince Street.[1]

Many of the large wall murals created in New York during this period tended toward Op Art abstraction, but Haas's representational work continued his practice of reflection and subtle interventions into New York's built environment. Moving up in scale from his murals depicting lost traditional storefronts on the side streets of Little Italy, his shadow projects proposed painting monumental silhouettes of distinguished buildings in Lower Manhattan that had been demolished over time.[2] Like his earlier work with photo collage for his dioramas, his proposals for the shadow series employed the photographic image

of the city as the ground and context for his interventions. *Proposal: To Paint the Shadow of Madison Square Garden* shows a dramatic view of Park Avenue and Twenty-Third Street featuring a tall, ornate building with an exposed-brick side. Haas painted over the photograph with white and gray gouache to project a shadow of the 1890 Madison Square Garden building, with its recognizable domed cupolas and tower topped by a sculpture of Diana by Augustus Saint-Gaudens, constructed less than two blocks away from the intersection featured in the photograph (fig. **98**).[3] This building, which was torn down in 1925, was the second of four buildings that would bear this name, the last of which is constructed on the site of the former Pennsylvania Station (1910), whose demolition in 1963 is often cited as an impetus for the historic preservation movement of the 1960s. Although Haas's later murals moved in the direction of pastiche and post-modern-inspired architectural fantasies, this collage is an important example of the ways in which photography was used not only to represent the conditions of contemporary American cities but also to evoke and make claims on their layered histories.

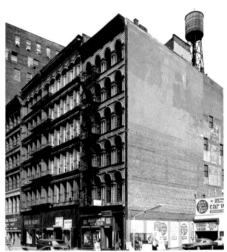

96

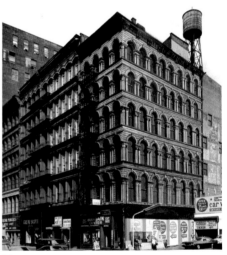

97

1 "What Is City Walls Inc.: A Brief History," Public Art Fund Archive 1996–2009 (MSS 270), box 6, folder 5, Fales Library and Special Collections, New York University. I am very grateful to Craig Lee for his valuable research in this archive in December 2013. City Walls was led by Doris C. Freedman, a public art pioneer who served from 1967 to 1970 as New York City's first director of cultural affairs, and in 1977 the organization became part of Public Art Fund.

2 Haas often chose blank walls as the canvas for this series of proposals but also prepared two studies showing silhouettes of historic skyscrapers projected on the towers of the World Trade Center, an interesting but unrealizable idea. See Richard Haas, *Richard Haas: An Architecture of Illusion* (New York: Rizzoli, 1981), 145.

3 This building had a certain amount of notoriety in its short life as its architect, Stanford White, was murdered there by his ex-lover's husband in 1906.

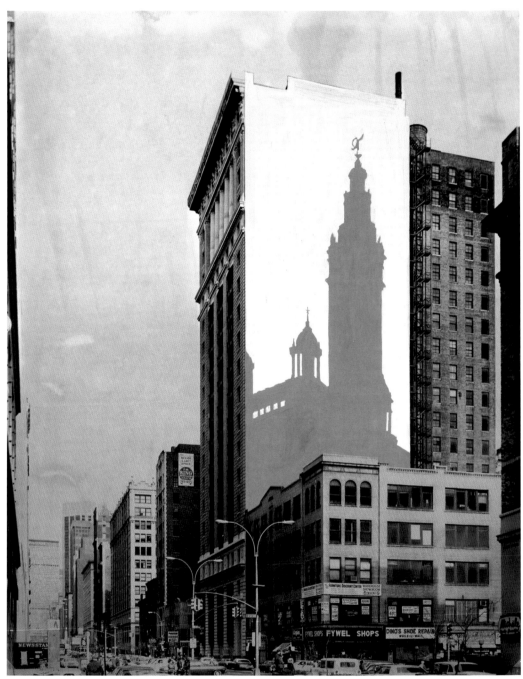

96,97 Richard Haas,
*Proposal: To Paint Cast
Iron Facade on the Side
of the Building at the
Corner of Houston and
Broadway, New York*, 1974.
Gouache on gelatin silver
prints, hand colored.
The Art Institute of
Chicago, Gift of Meta S.
and Ronald Berger

98 Richard Haas, *Proposal:
To Paint the Shadow of
Madison Square Garden
Tower on the Corner of
Park Avenue South and 23rd
Street*, 1976. Gouache on
gelatin silver print, hand
colored. The Art Institute
of Chicago, Gift of Meta S.
and Ronald Berger

98

Making a Mess

The Real and Imagined Destruction of New York

<div style="text-align: right;">

Max Page

</div>

In the 1959 film *The World, the Flesh and the Devil*, Harry Belafonte makes his way from Scranton, Pennsylvania (oddly enough, the hometown of the urbanist Jane Jacobs), to a New York City destroyed by some version of a neutron bomb, in which all the people are dead and swept away but the buildings are intact. The city is a cool, elegant sculpture garden of skyscrapers. It is haunting and beautiful in its emptiness (fig. **99**). It was the most eloquent of a series of portrayals of post–nuclear apocalypse Manhattan that offered one harrowing vision of New York's end: the city devoid of people. The scenarios of nuclear disaster imagined by civil defense planners and popular culture makers alike never came true, but New York's economic and physical decline in the 1960s and 1970s offered fertile ground for a new species of New York disaster fantasies. Residents no longer lived in fear of an atomic bomb but instead inhabited a New York threatened by destruction from within: budget cuts that were rendering the city unsafe, abandoned and demolished buildings, drugs, and crime. Indeed New York gained a new name in the 1960s and 1970s: "Fear City," as it was called in a pamphlet produced by unions representing police, firemen, and other public-safety employees in 1975 (fig. **100**).[1]

The fantasies of New York's end were aptly summarized by Susan Sontag in 1966. These science fiction films are, she wrote, "concerned with the aesthetics of destruction, with the peculiar beauties to be found in wreaking havoc, making a mess."[2] The mess, however, is not caused by a split-second event, a twenty-megaton bomb dropped a thousand feet above the city, or by an invader from Mars. The mess is rather a human mess, caused by the city and its urban-renewal perpetrators, such as Robert Moses, as shown by Danny Lyon in his heartbreaking portrait of

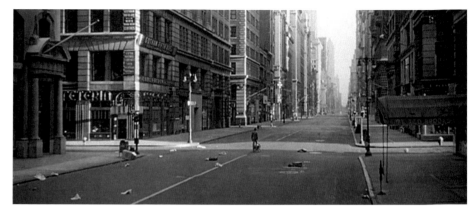

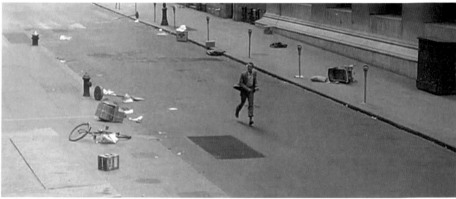

99

the eighteenth- and nineteenth-century fabric of Lower Manhattan being ripped down (figs. **40–44**) or by Peter Hujar in his images of parking lots along the West Side of Manhattan (fig. **101**). It was the flight of the white middle class to the suburbs, leaving empty buildings and lots in the Bronx and Brooklyn. It was what those on the right and, increasingly, those in the middle of the political spectrum viewed as the self-destructive tendencies of new migrants, especially people of color.

Films of the 1970s exploited these sentiments and helped transform them into a dominant narrative of New York's suicide, leading to its near bankruptcy in 1975 and an infamous newspaper headline declaring that the federal government would not help the city: "Ford to City: Drop Dead."[3] In that year and the following two, artists made

100

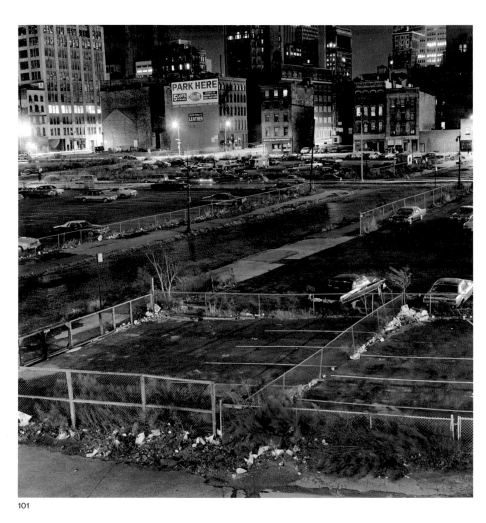

101

99 Stills from *The World, the Flesh and the Devil*, directed by Ranald MacDougall (Metro-Goldwyn-Meyer, 1959)

100 Cover of *Welcome to Fear City: A Survival Guide for Visitors to the City of New York*, published by the Council for Public Safety, New York, 1975. Wisconsin Historical Society

101 Peter Hujar, *West Side Parking Lots*, 1976. Gelatin silver print. © 1987 The Peter Hujar Archive LLC; courtesy of Pace/MacGill Gallery, New York, and Fraenkel Gallery, San Francisco

compelling works that encapsulated the popular image of New York destroying itself. Andy Blair's haunting photograph of a ravaged car (fig. 67)—picked clean of anything of value—on the closed West Side Highway conveys both a feeling of complete abandonment and emptiness and a feeling that hidden in the shadows are people ready to ravage anything left alone too long. Blair was just a teenager when he took this photograph, getting to the vantage point by hiking along four miles of the closed highway. The artist and film-maker James Nares's seventeen-minute 8 mm film *Pendulum* (1976; fig. 64) is equally haunting. The film shows a vacant city as well, with a wrecking ball swinging back and forth in a Tribeca

street, coming perilously close to hitting the buildings. In part of the film, we see the city from the perspective of the wrecking ball. This is what the city had come to by the mid-1970s, Nares seemed to be saying: a city left to the wrecking ball, dedicated to its own demise.

Two Hollywood films bookend the 1970s fascination with the city of ruin. *Soylent Green* (1973; fig. 102) is set in a New York of 2022, a city of forty million that looks like an updated vision of Jacob Riis's pioneering work of photojournalism *How the Other Half Lives* (1890): the city is packed into ancient buildings, people sleep on top of one another on staircases, and everyone squabbles over every

102

102 Stills from *Soylent Green*, directed by Richard Fleischer (Metro-Goldwyn-Mayer, 1973)

103 Still from *Escape from New York*, directed by John Carpenter (Metro-Goldwyn-Mayer, 1981)

scrap. Meet the newfangled food: Soylent Green. All are trapped in a decaying city that offers nothing more than mere survival at best.

Eight years later, in the film *Escape from New York* (1981; fig. **103**), Manhattan's separation from the rest of the nation is complete. Along with *Wolfen* (1981), *1990: The Bronx Warriors* (1982), and *2019: After the*

Fall of New York (1983), *Escape from New York* was one of several important New York disaster films that came out in the early 1980s, when the city was supposed to be already on its way out of urban despair. It begins where the classic nuclear-war thriller from 1964, *Fail-Safe*, ends: with a radar view of Manhattan Island. Now it is 1997, and the radar is not tracking a nuclear attack but surveying a federal prison. The entire island has been turned into a maximum-security prison but one with no guards inside. In search of the president of the United States, whose plane has crash-landed in the prison-city, Snake Plissken (Kurt Russell) traverses the horrific streets of Manhattan, where complete anarchy, physical and social, reigns.

In between these two films, the bicentennial year brought with it a song by Long Island's own Billy Joel, titled "Miami 2017 (Seen the Lights Go Out on Broadway)," which described a destroyed New York: "I've seen the lights go out on Broadway / I saw the ruins at my feet." This was for many the popular sense of New York in the late 1960s and 1970s and into the early 1980s: a dying place filled with ruins and with people who had nowhere else to go. Nuclear war would be disastrous. But it wasn't so different from what New York was doing to itself.[4]

Decline and fall—history is rarely so neat. Even as artists and filmmakers began to circle around the theme of the city destroyed, a newly invigorated preservation movement was busy creating the institutions, laws, and "facts on the ground" to begin to stem the tide of destruction that had overtaken much of the city.[5] Jane Jacobs's book *The Death and Life of Great American Cities* (1961) had said little about historic preservation, but it did propose what at the time may have seemed counterintuitive or simply ridiculous: older buildings were essential to the diverse social

103

and economic life of neighborhoods. Jacobs's own advocacy efforts included a very public defense of Pennsylvania Station, which was torn down starting in 1963. While New York had a long history of historic preservation efforts, the demolition of Penn Station galvanized activists into renewed fervor, leading to the creation in 1965 of the New York City Landmarks Preservation Commission (LPC). The LPC rapidly deployed its police powers, beginning with the legal protection of the Astor Theater (now the Public Theater), on Astor Place. By its twenty-fifth anniversary, it had designated as historic 856 buildings while delimiting fifty-two neighborhoods as historic districts. The city that had manufactured rubble now started to play the tape in reverse: collapsing buildings stood straight, peeling paint miraculously became smooth again, stoops were repaired, and boarded windows gave way to new panes of glass.

The gentrification of New York's neighborhoods was on.

1 See Miriam Greenberg, *Branding New York: How a City in Crisis Was Sold to the World* (New York: Routledge, 2008), chap. 5.

2 Susan Sontag, "The Imagination of Disaster," in *Against Interpretation* (New York: Farrar, Straus & Giroux, 1966), 213.

3 The headline appeared on the front page of the *Daily News* on October 30, 1975.

4 In 1978, in "Shattered," the Rolling Stones added: "Rats on the West Side, bedbugs uptown / What a mess! This town's in tatters / I've been shattered." See David Brooks, "The Bursting Point," *New York Times*, September 4, 2005.

5 The literature on preservation in New York City is extensive. The best overview of the rise of the Landmarks Preservation Commission in the 1960s is Anthony C. Wood's *Preserving New York: Winning the Right to Protect a City's Landmarks* (New York: Routledge, 2007). On the debate over gentrification, see Suleiman Osman, *The Invention of Brownstone Brooklyn: Gentrification and the Search for Authenticity in Postwar New York* (Oxford: Oxford University Press, 2011). For historical background on the rise of preservation in New York in the early part of the twentieth century, see Max Page, *The Creative Destruction of Manhattan, 1900–1940* (Chicago: University of Chicago Press, 1999), and Randall Mason, *The Once and Future New York: Historic Preservation and the Modern City* (Minneapolis: University of Minnesota Press, 2009).

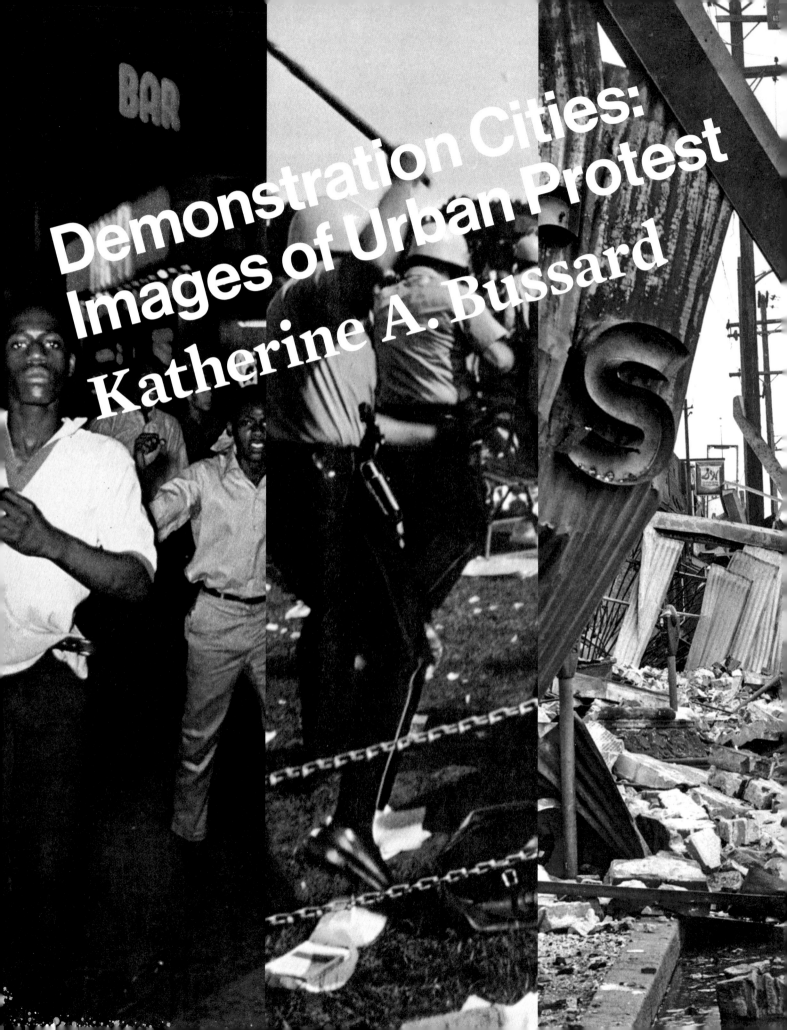

Demonstration Cities:
Images of Urban Protest

Katherine A. Bussard

Streets are the dwelling place of the collective. The collective is an eternally unquiet, eternally agitated being that—in the space between the building fronts—experiences, learns, understands, and invents.
 —Walter Benjamin

The 1960s saw a major upsurge in public demonstrations and protests.[1] These mass gatherings were prompted by various causes but were primarily clustered around racial injustice, opposition to the war in Vietnam, and the demand for greater opportunity and access for those ill served by the American political, economic, and social system. An assortment of "eternally unquiet, eternally agitated" groups organized or enacted these demonstrations. They ranged from loosely connected individuals to tightly disciplined cadres, and from small, often local groups to major national organizations. Demonstrations offered a means of performing collectivity in the service of a shared goal, whether long-term and carefully articulated or immediate and spontaneous. They could be violent or nonviolent, legal or illegal. The term *demonstration*, as used in this essay, is purposefully encompassing, and I intend it to act as a legitimizing umbrella term to describe events that can also be termed protests, marches, riots, rebellions, uprisings, sit-ins, or strikes, depending on the degree of violence, scale, or organization of the actions involved.[2] These are not static terms, moreover, and the term *demonstration*, as broadly construed here, allows for this fluidity: a protest against police brutality can and did transition into a riot.

According to the historian Matthias Reiss, "All protest marches share certain basic features, most notably the involvement of crowds, the occupation of space, navigation of—usually urban—landscapes, and, as events in the public sphere, interaction with society."[3] Reiss touches on two characteristics shared by most demonstrations of the 1960s, despite differences in goals, ideologies, and strategies. First, apart from protests on college campuses, the vast majority took place in cities, especially major cities. Some of this can be attributed to population density: only cities make it possible to assemble crowds of the kind necessary to transform the streets into politically occupied sites. Indeed, demonstrations were one of the ways in which cities were tested in the 1960s. Second, the immediate aim of most demonstrations was publicity, and the "interaction with society" that demonstrators sought often took place through the media, which relied increasingly on photographic and televisual images. The demonstrations of the 1960s were not the first time Americans had used city streets to seek political and social change, but they were the first sustained nationwide demonstrations to capitalize on well-established, widely circulating illustrated newspapers and picture magazines, as well as on burgeoning mainstream television nightly news programs.[4] *Life* magazine, for example, gave prominent photographic coverage to civil rights protests in the 1960s, at a time when its weekly issue was one of the most important media organs in the country, reaching even more people than a single television program.[5] Attracting media attention was a crucial goal of even the most spontaneous demonstrations: as one participant in the Watts rebellion succinctly declared, "We won, because we made the whole world listen to us."[6] A contemporaneous analysis of urban disorders of the 1960s supported this claim, concluding, "There is no protest unless protest is perceived and projected."[7]

This essay considers specific photographic and televised coverage associated with eight demonstrations that took place in New York,

Chicago, and Los Angeles between 1964 and 1970. These images of demonstrations contributed to Americans' understanding of city streets as well as to their ideas about the physical and social conditions of the cities in which the demonstrations took place. Images of early civil rights demonstrations, for example, influenced, informed, and even inspired subsequent demonstrations throughout the 1960s. The strategies depicted in demonstration photos became so codified that by 1970 many of the protest marches actually began to look alike in photographic terms: a banner leading the procession, marchers holding placards, and so on. Beyond this swirl of general social and cultural awareness of demonstration images during the decade, there is the very clear indication that these images informed certain artists' practices and resulted in direct responses to the events pictured.

In addition, these images are part of a consistent and far-reaching shift in the collective image of the American city during this era, a shift in photographic, cinematic, and planning practices that privileged the close observation of streets, neighborhoods, and seminal urban events. In this respect, demonstration images align with street photographs, and it can be beneficial to consider the former as examples of the latter; both often rely on the photographer to be in the midst of the crowd in order to convey the greatest sense of involvement in a dynamic urban scene for eventual viewers.[8] One of the most telling examples of this shift to close observation of streets is the prominence granted to street photographs of New York City in the comprehensive city plan that municipal leaders published in 1969, hiring photographers from the renowned Magnum photo agency to produce the images that would illustrate the oversize volumes of the plan.[9] The *Plan for New York City* (figs. **18**, **19**) of course involved only one city and was circulated chiefly through distribution to local public libraries. The images discussed in this essay offer an even broader sense of the implications of street-centric visual practices because they appeared in nationally distributed magazines, on the front pages of major newspapers, and on television screens across the United States. These images reached a large audience, altering public perceptions of the events transforming the nation's three largest cities and shaping a broad consensus vision of urban problems.

The discussion that follows focuses on images from major media outlets that serve as reasonable indicators of the content of mass media more broadly during this era: the dominant weekly picture magazine (*Life*); the two most popular newsweeklies (*Time* and *Newsweek*); the three major newspapers in the cities under discussion (the *New York Times*, *Chicago Tribune*, and *Los Angeles Times*); and the "big three" television networks (ABC, CBS, and NBC).[10] *Life*, the most prominent picture magazine of the day, was founded in the 1930s precisely to invert the formula of text-driven newsweeklies with supplemental illustrations, like *Time* and *Newsweek*.[11] *Life* emphasized photojournalism, putting pictures first and working captions around them to create photo-essays on specific news topics. By the 1960s *Time* and *Newsweek* had absorbed some of these visual strategies. Moreover, the three magazines often chose the same lead or cover story. Newspapers were altogether slower to embrace photographs, rarely publishing photo-essays, and none featured any color photographs during the 1960s. Television, the newest form of media in the era, was rapidly changing in response to network and viewer demands, and national nightly-news programs were becoming increasingly prominent. For more than a decade, nightly newscasts

lasted fifteen minutes, but in 1963 these programs doubled in length, allowing for greater and more detailed reporting.[12]

These media outlets targeted a broad swath of working- and middle-class readers and viewers, many of whom had taken or would take refuge in the suburbs by the 1960s.[13] For this audience, the ways in which mass media presented urban life mediated their understanding of urban change during this period. Urban change, as framed by these media outlets, tended to be represented by images of strife and protests because they made for a visually engaging, if sometimes sensational-ized, story. One could argue that this emphasis served as confirmation for white, middle-class Americans that the city had become a place of decline, conflict, and crisis (thereby encouraging further isolation from these problems), but it seems more interesting to posit that it also served to alert this broader public to the aims of mass protests, which gained increasing front-page and lead-story prominence throughout the 1960s. For example, the civil rights movement—like other social, political, and economic movements of the 1960s that would follow it—understood the power of the media. If photographs of the movement's actions could not help white moderates see the reality of racism, the urgency of the struggles would go unrecognized, allowing for the complacent view that the problem might go away. In this respect, there may be no better example than photographs from 1963 of peaceful demonstrators in Birmingham, Alabama, being brutally attacked by police dogs and knocked down by firemen's hoses. The most famous of these, by Bill Hudson and Charles Moore, appeared in countless newspapers and in *Life*, respectively, and elicited moral outrage on a national and interna-tional level.[14] Whether in Birmingham or elsewhere, it remained critical for all demonstrators throughout the decade to find modes of activism that could be made visible—specifically photographically visible through the media—in order to transform public opinion. Pictures of demon-strations provided evidence of urban fears, struggles, defeats, goals, and victories at the same time that they shaped, reinforced, and challenged the image of the city. This is particularly profound at a moment in history when the majority of Americans were residing in cities and therefore squaring their own local experiences—whether of Newark, Cleveland, or San Francisco—with the images circulating nationally of New York, Chicago, and Los Angeles.

· · ·

By the 1960s America's center cities were home to large concentrations of black and other minority residents as a result of large-scale migration from the South to northern cities as well as sustained and systemic segre-gation.[15] In her landmark book *The Death and Life of Great American Cities*, published at the dawn of the 1960s, Jane Jacobs identified racial inequality as a key urban issue: "Sidewalk public contact and sidewalk public safety, taken together, bear directly on our country's most serious social problem—segregation and racial discrimination."[16] Although Jacobs goes on to indicate that other efforts are required—housing, jobs, and education remained pivotal touchstones for civil rights—with hindsight her pronouncement reads as forewarning, since the 1960s would be marked by urban demonstrations, disturbances, and riots protesting discrimination. By the early years of the decade the civil rights movement had established national goals of legal equality, integration,

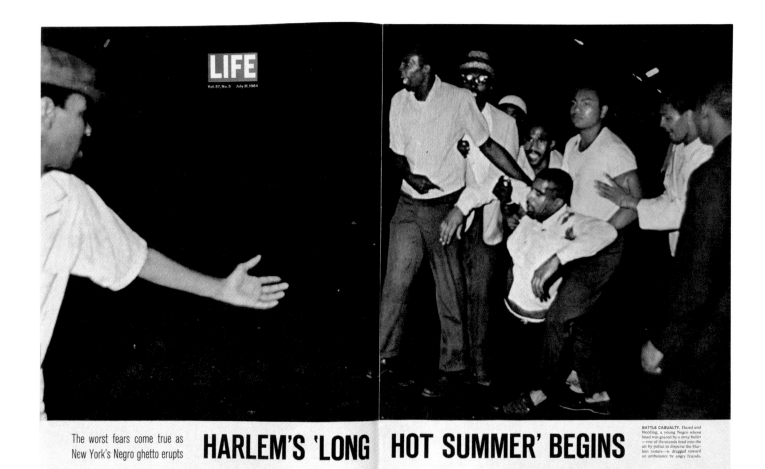

The worst fears come true as New York's Negro ghetto erupts

HARLEM'S 'LONG HOT SUMMER' BEGINS

BATTLE CASUALTY. Dazed and bleeding, a young Negro whose head was grazed by a stray bullet —one of thousands fired into the air by police to disperse the Harlem rioters—is dragged toward an ambulance by angry friends.

104 Spread from "Harlem's 'Long Hot Summer' Begins," *Life*, July 31, 1964. Photograph by Frank Dandridge

and the transformation of mainstream institutions and practices in order to increase opportunities for African Americans, and it was beginning to address more specifically urban issues as well. In New York, for example, residential racial segregation and housing shortages were compounded by de facto job discrimination, police brutality, inferior schools, and an economic recession felt first in black areas. The movement's shift in strategy paralleled one from efforts to accomplish its objectives through nonviolent means in the early 1960s to more violent reactions beginning in 1964.[17]

The Harlem–Bedford-Stuyvesant Riots

On July 31, 1964, the editorial content of *Life* magazine opened with a striking photograph (fig. **104**). Spanning two pages, the full-bleed image captures a dramatic gesture of assistance amid chaos, as one man reaches out across the darkness of night toward another man, bleeding and supported by his compatriots. Below this image, which opens a ten-page photo-essay, the editors ran a banner of text including the article's title, tagline or subtitle, and a caption for the photograph.[18] This text is as telling as the photograph. The photo-essay's title, "Harlem's 'Long Hot Summer' Begins," suggests a sense of inevitability in a nation becoming ever more accustomed to demonstrations, protests, and urban disturbances related to racial inequality. The previous summer President John F. Kennedy had alluded to this general condition in his televised

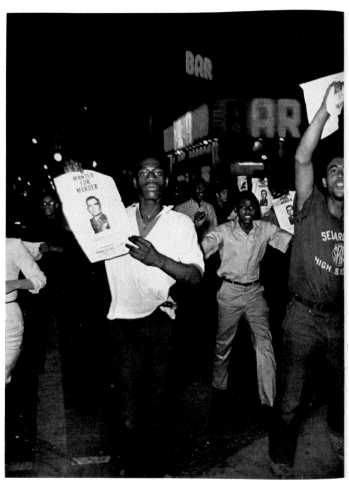

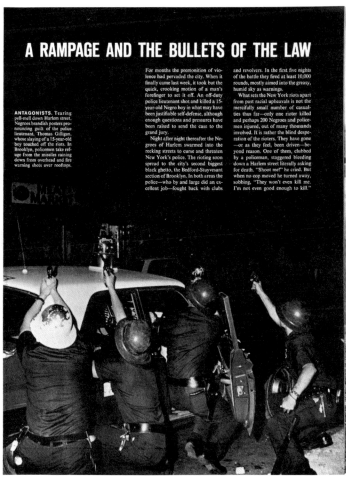

A RAMPAGE AND THE BULLETS OF THE LAW

ANTAGONISTS. Tearing pell-mell down Harlem street, Negroes brandish posters pronouncing guilt of the police lieutenant, Thomas Gilligan, whose slaying of a 15-year-old boy touched off the riots. In Brooklyn, policemen take refuge from the missiles raining down from overhead and fire warning shots over rooftops.

For months the premonition of violence had pervaded the city. When it finally came last week, it took but the quick, crooking motion of a man's forefinger to set it off. An off-duty police lieutenant shot and killed a 15-year-old Negro boy in what may have been justifiable self-defense, although enough questions and pressures have been raised to send the case to the grand jury.

Night after night thereafter the Negroes of Harlem swarmed into the reeking streets to curse and threaten New York's police. The rioting soon spread to the city's second-biggest black ghetto, the Bedford-Stuyvesant section of Brooklyn. In both areas the police—who by and large did an excellent job—fought back with clubs

and revolvers. In the first five nights of the battle they fired at least 10,000 rounds, mostly aimed into the greasy, humid sky as warnings.

What sets the New York riots apart from past racial upheavals is not the mercifully small number of casualties thus far—only one rioter killed and perhaps 200 Negroes and policemen injured, out of many thousands involved. It is rather the blind desperation of the rioters. They have gone —or as they feel, been driven—beyond reason. One of them, clubbed by a policeman, staggered bleeding down a Harlem street literally asking for death. "Shoot me!" he cried. But when no cop moved he turned away, sobbing, "They won't even kill me. I'm not even good enough to kill."

address to the nation: "We face, therefore, a moral crisis, as a country and a people. It cannot be met by repressive police action. It cannot be left to increased demonstrations in the streets.... It is time to act in the Congress, in your state and local legislative bodies, in all our daily lives."[19]

The tagline or subtitle to the *Life* photo-essay—"The worst fears come true as New York's Negro ghetto erupts"—reinforces language like Kennedy's and relies, as did the president, on assumptions about audience. *Life*'s readership was predominantly white and middle-class. More specifically, the magazine's anticipated reader was thirty to thirty-four years old, from the professional or skilled labor class, college-educated, married, and likely living in a city.[20] At the outset of the 1960s, *Life* enjoyed a healthy circulation of six million.[21] Though it did not reach a majority of the U.S. population at any point in its history,[22] its photographically driven content undoubtedly influenced the political, social, and cultural values of many Americans.[23] The magazine had been founded with the conviction that a better way of life, and therefore a better America, could result simply from the magazine's embodiment of optimism and confidence. *Life* set out to disseminate news and ideas to what the art and cultural historian Erika Doss has called "an ever increasing body of consumers fluent in the language of pictorial communication."[24] In light of this, its editors' choice to lead off the photo-essay with a photograph imbued with notions of assistance, camaraderie, and empathy is a telling one, as is the caption penned for this image.[25] It made clear

105 Spread from "Harlem's 'Long Hot Summer' Begins," *Life*, July 31, 1964. Photographs by Don Charles (right) and Frank Dandridge (left)

the role of the police in escalating the anger among protestors: "Battle Casualty. Dazed and bleeding, a young Negro whose head was grazed by a stray bullet—one of thousands fired into the air by police to disperse the Harlem rioters—is dragged toward an ambulance by angry friends."

The caption makes reference to the police, and indeed the unrest was initially triggered by police action, a fact noted in the image that follows it (fig. **105**). In this "establishing shot" of sorts for the riots, demonstrators surge toward the photographer (and therefore the magazine reader) against a decidedly urban backdrop of neon marquee signs and streetlights. The posters they hold pronounce the guilt of the white police officer whose deadly shooting of a black youth, James Powell, on July 15 prompted widespread community anger, which escalated to encompass looting and arson until the arrival of special police units on July 20.[26] In the *Life* photo-essay, the first image of the police appears opposite that of the demonstrators. While the caption explains that the policemen "take refuge from the missiles raining down from overhead and fire shots over rooftops," the visual effect of yet another full-bleed photograph, albeit in black and white, is one of active aggression against an enemy that is not visible anywhere in this shot but is suggested by the image of protestors on the left-hand page.

The next spread of the photo-essay does little either to alleviate the visual perception of police aggression or to represent the acts of arson, looting, and violence carried out by many protestors. The text on this spread instead does that work, but even the header "Bludgeonings and Molotov Cocktails" cannot compete with the visual impact of six additional photographs of city streets as sites of racial conflict, violent mayhem, and abandoned victims. Subsequent pages present a historical report titled "How Neuw Haarlem Sank into Squalor" and a discussion under the header "Collapse of Decent Leadership," which is critical of civil rights leaders. But the photo-essay ends with an imploring and humanizing appeal accompanying a full-bleed close-up of Powell's grieving classmate: "Somewhere there must be many who look at the girl on the opposite page—one betrayed by her leaders, hurt by Whitey—and yearn to wipe the tears from her eyes." Through images and texts, *Life*'s editors were asking their readers—white, comfortably middle class, and likely urban dwellers—to become invested in the problems and the pain that gave rise to the unrest.

The events unfolded over six days in two separate neighborhoods—unrest spread from Harlem to the Brooklyn neighborhood of Bedford-Stuyvesant—marking the first significant race riots of the 1960s.[27] The generalities of this event would be repeated throughout the decade in cities across the Untied States. Likewise, photographic images like those in the *Life* photo-essay would disseminate these demonstrations' ongoing political utilization of city streets to a broader American public. As the sociologist Janet Abu-Lughod observed, "Just as canaries are the first to perceive and suffer from gases in mining shafts, so the black ghettos in the US may have been the first to experience signs of more pervasive distress."[28] *Life*'s photo-essay on the Harlem–Bedford-Stuyvesant riots was one of the first sustained representations of the rising expectations and stakes of the civil rights movement, which were going woefully unmet by the deteriorating cities and neighborhoods in which large numbers of black citizens lived.[29] Writing of this period, the American studies scholar Wendy Kozol notes, "*Life* magazine was instrumental in showing white Americans these struggles and defining the terms of debate."[30]

The Watts Rebellion

Photographs of the Harlem–Bedford-Stuyvesant uprisings reached American audiences through *Life*'s photo-essay, coverage in both *Time* and *Newsweek*, and articles in some major newspapers. (Notably, there was little photographic coverage in the local *New York Times*.)[31] It was the next major race riot of the 1960s, the Watts rebellion, that would truly dominate print media. Featured on the front page of not only the local *Los Angeles Times* but also the *New York Times*, photographs of the events in Watts also circulated nationally as lead stories in *Life*, *Time*, and *Newsweek*. Moreover, as will be discussed, certain photographic tropes emerged from the expansive coverage and gained prominence through their repetition across media outlets in the United States.

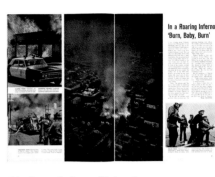

106 Spread from "Out of a Cauldron of Hate—Arson and Death," *Life*, August 27, 1965. Photographs by J. R. Eyerman (center), Jo Flowers (bottom left), and Co Rentmeester (top left and bottom right)

The particular motivations behind the Watts uprising included a pattern of police brutality toward minorities and a dire shortage of affordable housing. Public housing was a near anomaly in Los Angeles, despite racially restrictive covenants that made it impossible for blacks to live in many areas of the city. Even though President Johnson's War on Poverty was in full swing, poverty and unemployment were high, and the Vietnam War was hijacking federal funds away from domestic social programs, not to mention sending a disproportionate number of black men to the front lines. The city's mayor, Sam Yorty, was widely criticized for ignoring the signs of growing unrest.[32] As the psychologist Kenneth B. Clark wrote in a *New York Times Magazine* article just weeks after the riots: "It is one measure of the depth and insidiousness of American racism that the nation ignores the rage of the rejected—until it explodes in Watts or Harlem. The wonder is that there have been so few riots, that Negroes generally are law-abiding in a world where the law itself seemed the enemy."[33]

As with the disorder that broke out in New York's Harlem and Bedford-Stuyvesant neighborhoods, the particular characteristics of Watts shaped a race riot unique to that setting.[34] The inseparability of space and politics is embodied in one of the many aerial photographs from the riots: it captures Los Angeles's sprawling low-density blocks in order to better delineate the single block engulfed by arsonists' flames (fig. **106**). This is one of four distinct subject categories to which published photographs of Watts would generally adhere in the coverage of six days of rioting in August 1965: aerial surveillance, uncontrolled looting, property destruction, and armed policing.[35] Aerial photographs of city blocks burning by day and night were among the most common images not only because of their ability to convey scope within an urban setting but also for the simple reason that they could be obtained without personal risk to the photojournalist. Some photographs of looting attempted to show the act as it happened, meaning that sequential frames of film were often published side by side to establish a sense of the crime's unfolding. Or, as was the case with one of the most widely reproduced looting images, those doing the looting were shown in motion, running through the streets with the looted goods in their arms. Images of destroyed storefronts or burned-out, overturned cars conveyed an appropriate sense of the force and ferocity of the rioters' actions.

The photographs on the front page of the August 14, 1965, edition of the *New York Times* made plain these categories, with each caption beginning with a single word: "Looting," "Destruction," "Fire." In addition to featuring what would become three of the four pictorial tropes of

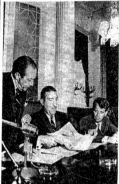
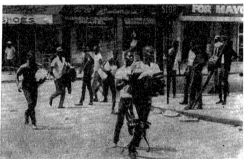

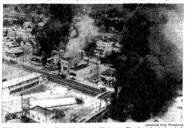

107 Front page, *New York Times*, August 14, 1965

108 Cover of *Time*, August 20, 1965. Cover photographs from the Associated Press and United Press International

the Watts riots, the paper's sequencing of the images from top to bottom gave its readers a sense of the impact from pedestrian to street to neighborhood views (fig. **107**). All three of these categories were again represented in the photographic collage that graced the cover of *Time* magazine on August 20, 1965 (fig. **108**). (One of the photographs in the collage, that of the looting, also appeared in the *Los Angeles Times* on August 14.) *Time*'s use of photojournalism on the cover was remarkable in and of itself—since almost all the magazine's covers at this time were portraits of famous figures—but the use of *three* such photographs is extraordinary and suggests that one image was not enough to convey the scope of the urban protest. In addition, even though many color photographs were taken during the riots, *Time* opted for black-and-white images. (That chromatic anomaly may well have caught the attention of Vija Celmins, the Los Angeles–based painter known for her mono-chromatic and nearly photographic canvases; she painted the *Time* cover that year, graying out even the magazine's signature red image border; see fig. **230**.)

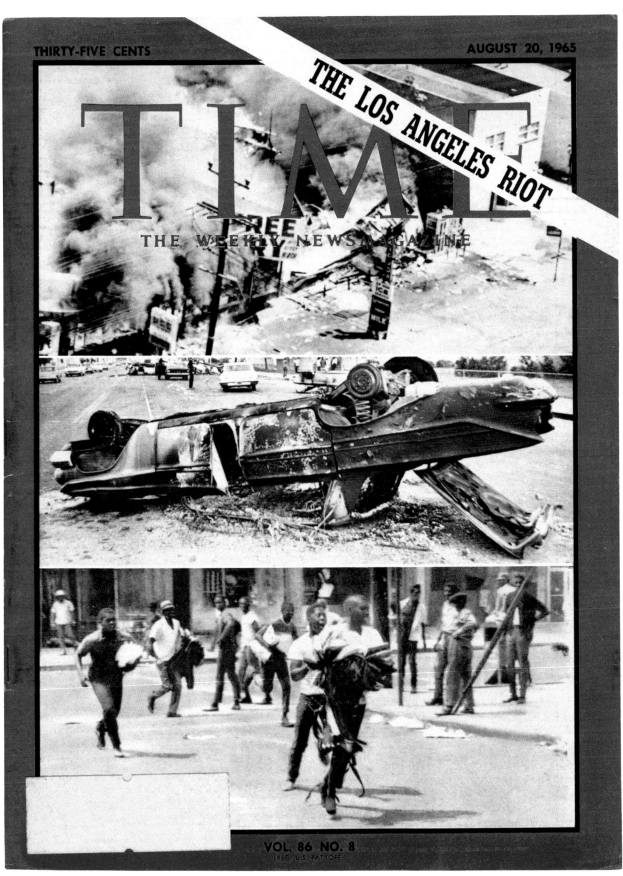

THIRTY-FIVE CENTS

AUGUST 20, 1965

THE LOS ANGELES RIOT

TIME

THE WEEKLY NEWSMAGAZINE

VOL. 86 NO. 8
(REG. U.S. PAT. OFF.)

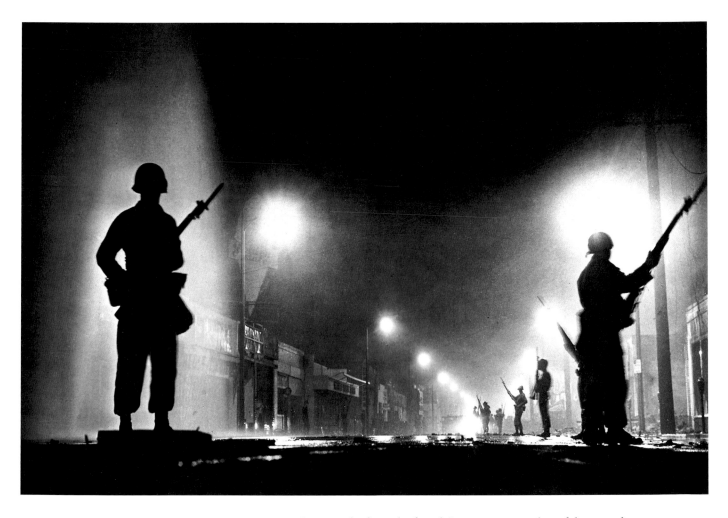

109 John Malmin, photograph published on the front page of the *Los Angeles Times*, August 14, 1965

110 Cover of *Newsweek*, August 30, 1965. Photograph by Larry Schiller

Photographs from the fourth image category, that of the armed policing of Watts by LAPD officers or National Guard troops, consistently represent these forces in number and very often in ways that suggest the militarized zone that Watts became. On the first morning after the National Guard troops arrived, the front page of the *Los Angeles Times* offered its readers a nighttime view of soldiers occupying the street, accompanied by the caption "Warlike Scene" (fig. **109**). Images such as this made it increasingly clear that the riot, if it had ever been a conflict between black residents and the white business owners whose stores were targeted, had become a battle between African Americans and military and municipal forces, both almost exclusively white.[36] By the time the August 30, 1965, issue of *Newsweek* (fig. **110**) appeared on newsstands and in homes across America, one could posit that this impression of Los Angeles as a militarized zone was deep and familiar enough that it had pushed out any need for images of the protestors. Alternatively, when considered alongside *Life*'s cover image for its August 27 issue (fig. **208**), the *Newsweek* cover photograph becomes a call for reflection. Whereas *Life*'s cover, with the headline "Arson and Street War—Most Destructive Riot in U.S. History," gave a human face to the event by showing a man somberly salvaging belongings from his burning home, the *Newsweek* cover presents a view of urban destruction, abandonment, and militarized policing as the backdrop to a single question: "Los Angeles: Why?" If the one can be understood as an

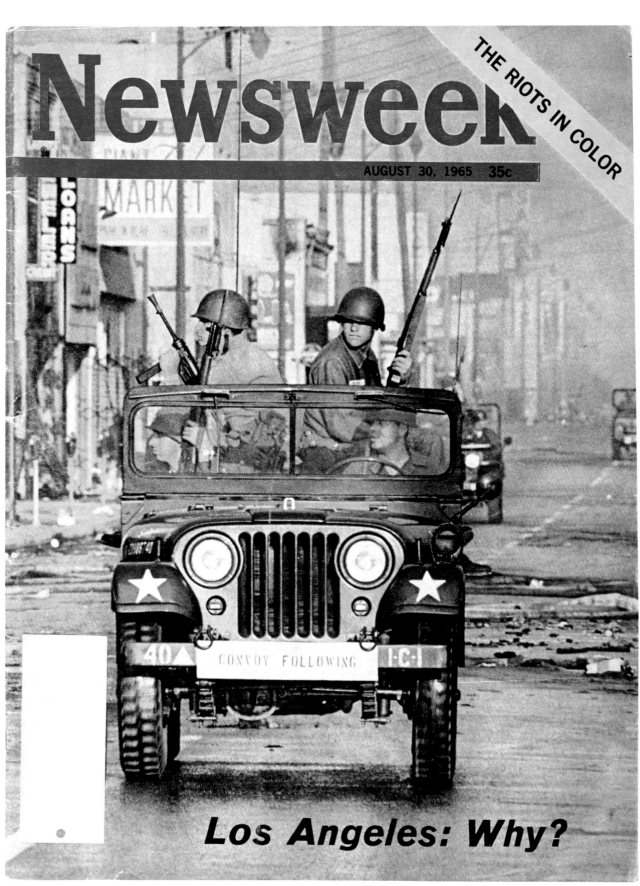

Newswee*k*

THE RIOTS IN COLOR

AUGUST 30, 1965 35c

Los Angeles: Why?

111 "Garbage Piles Up,"
New York Times, February 5,
1968. Photographs by
Patrick A. Burns

attempt to personalize the "most destructive riot" in the country's history, the other is a more generalized and sweeping effort to question the causes. Both approaches are indicative of how photographic images acquired new urgencies and intensities in an era of urban demonstrations.

When Roy Wilkins, the executive secretary of the NAACP, told the *Los Angeles Times* that he "would demonstrate every day [since the] only thing some people understand is public disturbances,"[37] his declaration had a powerful resonance. The Watts riots had, after all, garnered prominent above-the-fold photographic coverage on the front pages of two of the nation's largest metropolitan newspapers, the *New York Times* and the *Los Angeles Times* (figs. **107**, **109**). Additionally, photographs of Watts dominated the covers of *Life*, *Newsweek*, and *Time*. Street demonstrations were frequently evoked by those in the political arena, including Wilkins, in part because of how productively photographic coverage of demonstrations made visible the problems of urban populations. Such evocations allowed any informed member of the public, particularly one who read newspapers or one of the popular magazines of the era but might be geographically distant from the events, to envision recent demonstration photographs as they tried to comprehend the question of "Los Angeles: Why?"

The coverage of the Watts riots in 1965 and of the no fewer than two hundred race riots in U.S. cities in its aftermath[38]—indeed, the statistical peak of coverage of urban riots in newsmagazines occurred in 1967[39]—was such that by 1967 nearly every American would have been able to conjure a photographic image of a city in racial crisis. The demonstrations related to the civil rights movement's quest for racial equality informed subsequent urban actions as well as their photographic depiction. In short order, many Americans would have the ability to conjure images of other kinds of demonstration cities: those marked by labor strikes, student walkouts, antiwar protests, and mass gatherings in support of gay rights, environmental issues, and women's rights.

New York Sanitation Workers' Strike

During the decade that would become synonymous with demonstrations, labor strikes were not uncommon, but one strike that had an extraordinary impact on a city and its infrastructure was the February 1968 strike by New York's sanitation workers, which led the mayor to conclude, "In a word, New York is a mess."[40] While the strike held some interest for the national media, it is most instructive as an example of sustained photographic coverage by a single local newspaper. The *New York Times* had good reason to stay abreast of this demonstration protesting low wages and demanding an equitable contract: garbage piled up on the city's streets at a rate of about ten thousand tons per day.[41] For its initial photographic coverage of the strike, the newspaper presented a cluster of images demonstrating the effects of the first three days of garbage accumulation (fig. **111**). Not only does the sequencing of the five images attempt to articulate the story visually, but traditional photo captions have also been replaced by a continuous narrative making heavy use of ellipses. "No garbage has been collected here since Thursday … because of sanitation workers strike. Trash is piling … up on streets throughout the city." On the fifth evening of the strike a group of East Village residents, having collected trash from their neighborhood and then spent the day fruitlessly seeking a place to dispose of it, dumped the garbage in the middle of the street in protest. The *Times* sent the photographer Larry Morris to the scene and ran his dramatic photograph of trash piled two feet deep the following day (fig. **112**).[42]

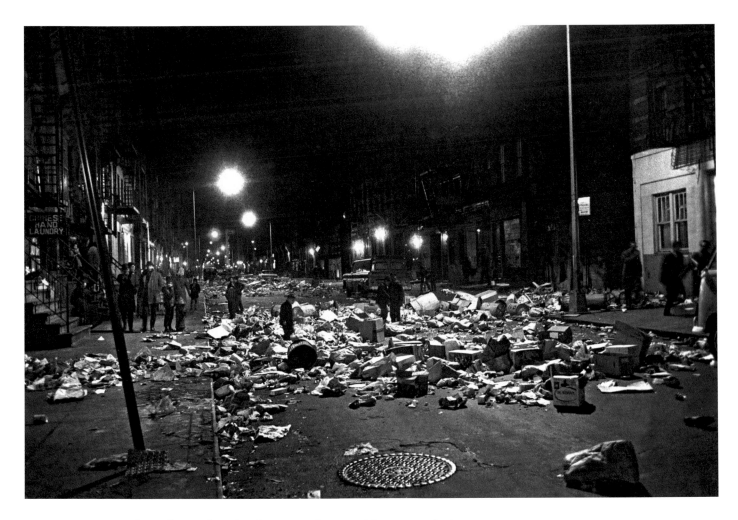

As the strike continued, subsequent photographic coverage in the *Times* documented efforts to reclaim the streets: volunteers cleaning up trash, firefighters supervising trash fires on the sidewalks, and Mayor Lindsay walking in neighborhoods to stay in touch with his constituents (fig. **69**).[43] After nine days, the strike was broken, and the first collections were slated in so-called slum areas with dense apartment or tenement housing and the most uncollected garbage, including Harlem, which had been featured prominently in the *New York Times*' photographs. Such class divisions among the affected neighborhoods became the subject of a *Los Angeles Times* article, which made plain the link between the sanitation strike and other urban demonstrations: "The lesson is not that either side [of the issue] is right or wrong. It is that social tensions of the most explosive kind are at work in the battle to reform cities."[44] Indeed, two days after New York's strike ended, the sanitation workers of Memphis, Tennessee, a majority of whom were black, also went on strike to demand an end to discrimination and poor working conditions, which had recently led to job-related deaths. (The iconic placards carried by the demonstrators declared, "I *am* a man," and this strike would eventually involve Martin Luther King Jr., just prior to his assassination.) Thus, as the 1960s progressed, it became increasingly apparent that direct confrontation through demonstrations was not only an effective political tactic for issues of all kinds but also one that had reverberations throughout the nation.

112 Larry Morris, photograph published in "Garbage Protest Closes 5 Blocks," *New York Times*, February 7, 1968

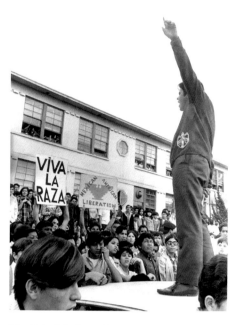

113 Hal Schulz, photograph published in "Student Disorders Erupt at 4 High Schools; Policeman Hurt," *Los Angeles Times*, March 7, 1968

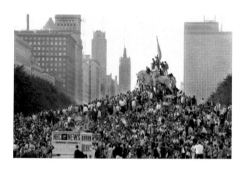

114 Barton Silverman, photograph published in "Outlook after Chicago Violence," *New York Times*, August 31, 1968

115 Still from *The Huntley-Brinkley Report* (NBC Nightly News), August 27, 1968

East L.A. Student Walkouts

In March 1968 high school students in Los Angeles began staging boycotts of their classes to protest inferior educational conditions in schools with de facto segregation. Although these protests began at one predominantly Mexican American and another nearly all-black high school, they spread to encompass thousands of additional students as well as some teachers at a total of seven high schools, the majority of them serving Mexican American students on Los Angeles's Eastside.[45] Many news photos from the walkouts show rows of uniformed officers blocking streets or barricading sidewalks—by then a fairly generic visual representation of demonstrations—but the lead photo on the second day of coverage by the *Los Angeles Times* chose to emphasize the demonstrating youths (fig. 113). Slogans appear on posters held high in the crowd: "Mexican American Liberation" and "Viva la Raza."[46] Such news photos gave voice to the students' demands, including more bilingual instruction, more focus on Mexican heritage in the curriculum, smaller class sizes, the termination of insensitive teachers, and student rights.[47] More broadly, the photographic depictions of the walkouts represented a show of power and unity in one of the first mass actions by urban Mexican Americans.

1968 Democratic National Convention Protests

As the historian David Farber notes in his landmark book *Chicago '68*, the events surrounding the 1968 Democratic National Convention in Chicago were unlike other urban protests of the era: "Chicago '68 was different because it occurred at a time when and a place where the nation watched and knew that what they were watching was themselves.... It offered Americans an irrefusable opportunity to consider what they thought of themselves and their country."[48] Farber's references to "watching" intentionally signal representations beyond those in the print media. Televised news, especially national evening news programs, had experienced a meteoric rise and by 1968 could claim as much if not more influence on public opinion—and, by extension, public policy—than magazines like *Life*. The three major networks (ABC, CBS, and NBC) had all greatly expanded their nightly news coverage such that, by the week of the August 1968 convention, not only were their signature anchors on-site in Chicago, but they were also offering up to ten hours of additional live coverage and commentary after the regular broadcast depending on the evening.[49]

All three networks began making reference to the convention, their coverage, and the anticipated demonstrations on their nightly news programs the Friday before the convention started. Devoting between two and four minutes to the topic, each program cited statistics about the preparations being made by demonstrators and authorities alike for a confrontation.[50] In spite of discussions of peaceful protests and language from the administration of Mayor Richard J. Daley about maintaining order, a showdown was fully anticipated, in no small part because the convention was preceded by the assassinations of Martin Luther King Jr. in April and Robert F. Kennedy in June, widespread social and political upheaval, a flourishing youth counterculture, continued urban unrest, and increasing attrition in Vietnam.[51] The immediate goal of the ten thousand demonstrators—most of them young, almost all of them white and middle class[52]—was to challenge convening Democrats over their policy in Vietnam, but the resulting conflict was also, more broadly, about

how politics and democracy in America worked.[53] In a parallel function, the resulting images—both televised and printed—offered viewers not only an antiwar demonstration but also a city in which democracy was being tested. One of the clearest examples of such an image may be Barton Silverman's photograph of protestors overtaking a commemorative statue in the heart of downtown Chicago's Grant Park, a public space that became the most frequent battleground between the demonstrators and the authorities (fig. **114**).

On Tuesday, August 27, NBC nightly news reported on police clubbing demonstrators "with zeal"; quoted a *Newsweek* reporter as having heard the cops yell, "kill, kill, kill"; and featured an interview with one victim, the bloodied NBC reporter John Evans (fig. **115**). Evans told of being hit with a billy club *after* a policeman noticed he was filming, giving force to the claims reported in the same segment by Jack Perkins:

> Some Chicago policemen believe that if newsmen weren't there, the demonstrators wouldn't be, and in that sense they blame the newsmen for the demonstrations. So last night some Chicago police officers sought out and beat newsmen, not in spite of the fact they were newsmen but because of it. They beat cameramen to keep them from filming policemen beating other people. This attempt to suppress the news and these beatings are, of course, in violation of Chicago Police Department orders, but they happened. And none of the newsmen we talked to had ever seen anything like it in any other city in this country.[54]

Those viewers watching NBC's special convention coverage after the regular news program the next night were in for the visual shock of footage from a moment slightly earlier in the evening when police surged toward the demonstrators gathered on Michigan Avenue by the convention's headquarters, the Conrad Hilton Hotel (fig. **116**). Seconds after these dramatic scenes, the audio of the footage shifts as the chant by demonstrators becomes louder and more discernible: "The whole world is watching!" Even if this claim was exaggerated, it demonstrates how the protesters anticipated and capitalized on an important national moment for politics and media. Many Americans undoubtedly saw footage of these scenes during the networks' regular nightly-news programs the following evening, August 29 (fig. **117**). Indeed, in the twenty hours between these airings, the footage had attracted enough attention that Daley's administration was claiming that the press and television had mounted a propaganda campaign against the police. Frank Sullivan of the Chicago Police Department declared at a press conference that demonstrators were "bent on the destruction of the United States of America," adding, "By golly, they get the cooperation of the news media."[55] As if to refute this claim, or simply to allow viewers to form their own impressions, NBC aired more than one minute of footage from the previous evening's clashes without any live reporting from the field or voice-over commentary from the anchors, as was typical of their previous use of recorded footage during the convention.

In this light, Norman Mailer's catchphrase "the siege of Chicago" suggests the extent to which the authorities saw the demonstrations (if not the protestors as well) as a threat coming from outside the city and warranting paramilitary response to the tune of twenty-six thousand troops.[56] Indeed those watching the last hour of NBC's live special coverage of the convention on August 29 could see the militarizing of

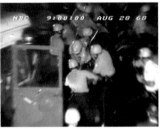
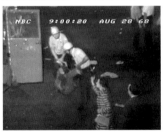
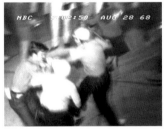

116 Stills from "NBC Special Coverage of Democratic National Convention," August 28, 1968

Chicago's streets with the National Guard's use of barbed-wire barricades affixed to jeeps.[57] Televised images such as these—as much as the overwhelming number published in tandem with front-page coverage on August 29 by the *Chicago Tribune*, *New York Times*, and *Los Angeles Times* and accompanying cover stories in *Life*, *Newsweek*, and *Time*—conveyed to a broad sweep of Americans the vision of a city under siege and perhaps even a democracy being challenged.

Perhaps no single printed image captures this better than Barton Silverman's intimate and terrifying photograph of a Chicago policeman raising his club to bring it down on the photographer (fig. **157**). When the *New York Times* ran this photo alongside a report on the police assaults on newsmen in Chicago, the newspaper was not offering information that was altogether different from what aired on television. However, the highly personal nature of Silverman's photograph—in which any viewer of the picture must take his place and imagine the billy club about to strike—made for not only a chilling still image (as opposed to a televised event) but also an reminder of the power of press photographs.[58]

This power did not diminish after the convention. The condemnation and judgment of what one official report would term a "police riot" was so pervasive—and so linked to the media coverage of the events—that the Daley administration felt compelled in the weeks after the convention to undertake a propagandistic editing of the documentary film *What Trees Do They Plant?* (fig. **158**) before it aired on local television as well as to publish a magazine imitative of *Time* or other newsweeklies titled *Crisis in Chicago, 1968* (fig. **118**).[59] In an attempt to tell the "untold story of the convention riots," Daley repurposed news photos that had been published elsewhere and added others that better suggested the aggression of demonstrators. The publication made the difficult claim that the press and television news—indeed, all mass media—had gotten it wrong with their visual representations of the events. The perception of unchecked police aggression lingered, and the profusion of media images succeeded in searing into popular culture visions of pale blue helmets and raised billy clubs.

Stonewall Riots

Quite distinct from representations of the DNC protests or the other demonstrations addressed in this essay, photographs of the Stonewall riots were few, and news coverage involving such images was slim to nonexistent. An unexpected but routine raid on the Stonewall Inn, a popular gay bar in New York's Greenwich Village, in the early hours of June 28, 1969, led to violent protests. The spontaneous nature of the riots, coupled with the relatively short duration of the clash between police and hundreds of the bar's patrons as well as onlookers, may largely explain the lack of photographs from the first evening. Among the local press, it seems that only the *New York Daily News* was able to feature a photograph taken during the unrest. The *Village Voice* ran a related photograph of bar patrons posed on the streets of the Village but not until July 3. Most intriguingly, the city's paper of record, the *New York Times*, assigned Larry Morris to take photographs four nights after the initial raid but never published any of them. Morris captured the increased police presence due to a "partial riot mobilization" on subsequent nights (which saw similar violent clashes between Stonewall patrons and police), and he also recorded an important commemorative gesture—

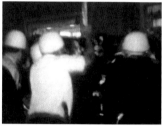

117 Stills from *CBS Evening News with Walter Cronkite*, August 29, 1968

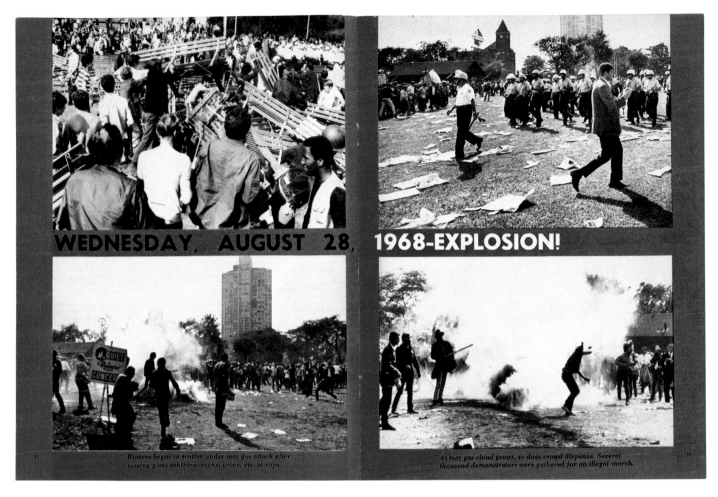

118 Spread from *Crisis
in Chicago, 1968: Mayor
Richard J. Daley's Official
Report; The Untold Story
of the Convention Riots*,
by Richard J. Daley.
Published by Bee-Line
Books, New York, 1968

a strand of lights hung across the inn's facade—that literally highlights the location and defies its invisibility (fig. **119**).[60]

The substantial absence of timely photographic coverage is not only out of sync with the galvanizing role that the Stonewall riots would come to play in the gay rights movement but also suggestive of the way in which a paper like the *New York Times* could choose *not* to make visual the emergence of a persuasively photographic demand for gay rights. There are many possible explanations for this, including potential concerns about "outing" those photographed (or those taking the photographs) as well as the discretion that the *Times* prided itself on, in contrast to the sensationalism of other papers. (The *Daily News*, for example, felt no compunction about running the headline "Homo Nest Raided, Queen Bees Are Stinging Mad.") Regardless, within the gay rights movement, the sense that gay liberation began on city streets and would continue to assert its visibility there in years to come via marches and protests is signaled by the slogan "Out of the closets and into the streets."

Outside the movement, however, it was a different story. If the presence of photographs of the era's demonstrations served to influence attitudes toward urban life, the *absence* of such photographs relating to a particular cause had the potential for an equally influential impact—the suppression of a topic within public discourse.[61] This would remain the case until at least the first anniversary of the Stonewall riots, in 1970,[62] by which time the planned march on the streets of New York yielded images of a movement embracing a set of strategies—placards and banners,

119 Larry Morris,
unpublished photograph
of the Stonewall Inn
for the *New York Times*,
July 2, 1969

linked arms, and a procession along a preordained route—that were becoming normalized and even anticipated, as two other demonstrations in 1970 make clear.

Earth Day and the Women's Strike for Equality

By the time the environmental demonstration known as Earth Day and the Women's Strike for Equality occurred on April 22 and August 26, 1970, respectively, photographic and televised coverage of demonstrations had certainly become codified, if not rote. Although plans for both dates were nationwide and varied, the central focus was the thousands marching down New York's Fifth Avenue because of that city's status as the nation's media center.[63] Strategically, both the environmental movement and the women's movement—like others before and after—understood that New York remained a critical hub for news coverage, with ABC, CBS, NBC, *Life*, *Newsweek*, and *Time* all headquartered there. (Indeed, all three of the major television networks altered their broadcast schedules.)[64] In a landmark move, Mayor Lindsay authorized closing Fifth Avenue to traffic and making it a "pedestrian mall" in celebration of Earth Day. For the Women's Strike, the city's more modest concession of one lane of traffic was quickly overrun, and demonstrators took over the entire avenue during rush hour.[65]

Thus, when *Life* covered the two events, it could reduce each to a single image, both of which embodied what had become a standard

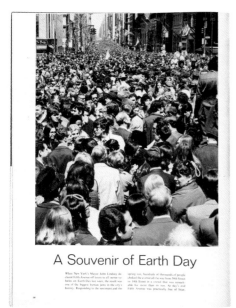

120

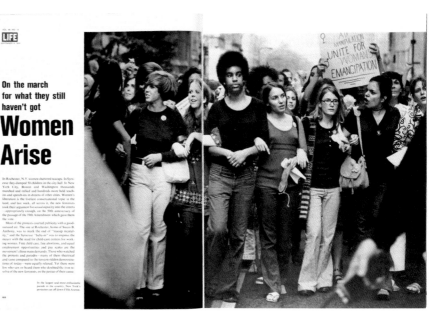

121

visual trope of demonstration photographs: a sea of marchers (figs. **120**, **121**). In the Earth Day image, the raised vantage point slightly above the crowd conveys its density down the length of Fifth Avenue; in the representation of the Women's Strike, the more pedestrian viewpoint allows the crowd to surge toward the viewer, placards in hand. In the May 1, 1970, issue, *Life* gave Earth Day just this one page of coverage. And although the Women's Strike was the impetus for the magazine's lead story in the September 4, 1970, issue, subsequent pages after the image of the march move quickly away from the events of the demonstration to the personal profiles of eight women who have "made it" in a man's world. Such a shift in coverage away from photographs of newsworthy actions—perhaps now better served by televised news in any case—seems indicative of *Life*'s late-hour attempts to save its dying enterprise through the emotional, humanist connection that it had always sought with readers.[66] *Life*'s emphasis on the personal belies the women's rights movement's understanding—as with the civil rights and antiwar movements before it—that public demonstrations in major cities were central to its cause.

· · ·

The demonstrations of the 1960s treated city streets as spaces in which, to borrow the words of Walter Benjamin, quoted at the beginning of this essay, the "eternally unquiet" and "eternally agitated" could express their dissatisfactions and aspirations. Photographs and televised scenes were a pivotal aspect of demonstrations in this era, and the demonstration images discussed here and others like them transformed New York, Chicago, and Los Angeles into demonstration cities: national, collective visions of contestation and the need for urban change. The impact of such images can be seen in the way that some demonstrations arose in the wake of others, even mirroring them in terms of visual strategies. It is also manifest in artists' responses to the city, such as Arthur Tress's photographic portfolio exploring concepts of public space (fig. **92**) or

120 *"A Souvenir of Earth Day," Life*, May 1, 1970. Photograph by John Zimmerman

121 Spread from *"Women Arise," Life*, September 4, 1970. Photograph by John Olson

Noah Purifoy's tactile engagement with the remains of city space undone (fig. **231**). The demonstration images of the 1960s, as much as any others in this book, visualized what Benjamin astutely termed the experiences, learning, understanding, and invention of the collective. These pictures helped form a shift in perceptions of the American city during this era, one that was decidedly oriented to the spaces between the building fronts. While some members of the public took to the streets themselves, many others did not, and for this group—a majority of Americans—photographic and televisual images of demonstrations helped transform their understanding of the political, economic, and social struggles of the decade.

Epigraph: Walter Benjamin, *The Arcades Project*, trans. Howard Eiland and Kevin McLaughlin (Cambridge, MA: Belknap Press of Harvard University Press, 2002), 423–24.

1 While the 1960s are distinct, there is a long history of urban demonstrations in the United States. For two general histories of American protest, see Paul A. Gilje, *Rioting in America* (Bloomington: Indiana University Press, 1996), and Neil A. Hamilton, *Rebels and Renegades: A Chronology of Social and Political Dissent in the United States* (New York: Routledge, 2002).

2 Janet Abu-Lughod has defined the urban riot as a form of struggle and resistance to cultural, political, economic, and/or social grievances located in a particular site of contestation. Urban riots can materialize spontaneously or result from organized aggression, but the actions must reach a certain scale and intensity in order to be a riot and not, for example, a protest. When such demonstrations are termed race riots, it means that one group takes these actions against another on the basis of racial identity. Abu-Lughod cites intensity, duration, number of people dead or injured, number of arrests, amount of property damage, and geographic scope of damage as factors that characterize a riot. Janet Abu-Lughod, *Race, Space, and Riots in Chicago, New York, and Los Angeles* (Oxford: Oxford University Press, 2007), 3, 12. See also Peter K. Eisinger, "The Conditions of Protest Behavior in American Cities," *American Political Science Review* 76 (March 1973): 13, and Rodney F. Allen and Charles H. Adair, eds., *Violence and Riots in Urban America* (Worthington, OH: Charles A. Jones, 1969), 4.

3 Matthias Reiss, introduction to *The Street as Stage: Protest Marches and Public Rallies since the Nineteenth Century* (London: German Historical Institute; Oxford: Oxford University Press, 2007), 4.

4 By the early 1960s demonstrations benefited from television's radically expanded capability to broadcast events live around the globe. "In 1953 45% of American households had televisions; just three years later the number had jumped to over 83%. The Telstar I communications satellite began to enable worldwide television linkups in 1962; the March on Washington for Jobs and Freedom of 1963, the largest political demonstration in the United States to date, was one of the first events to be broadcast live around the world." Steven Kasher, *The Civil Rights Movement: A Photographic History,*

1954–68 (New York: Abbeville, 1996), 12. For more on television's role in disseminating news about the issues of the 1960s, see Lynn Spigel and Michael Curtain, eds., *The Revolution Wasn't Televised: Sixties Television and Social Conflict* (New York: Routledge, 1997). In their introduction to the book, the editors write: "The authors in this volume also share the conviction that prime-time television affords us a distinctive opportunity to explore significant social issues at a time when representation was being increasingly defined as a key political issue that helped constitute group identities (such as hippies, new women, or Black Power) forged in opposition to 'mainstream' culture" (11). See also Herman Gray's essay in that volume: "Remembering Civil Rights: Television, Memory, and the 1960s," 348–58. For a season-by-season account of televised nightly-news issues, see Harry Castleman and Walter J. Podrazik, *Watching TV: Six Decades of American Television*, 2nd ed. (Syracuse, NY: Syracuse University Press, 2010), 136–214.

5 Ibid., 13.

6 Quoted in James T. Patterson, *The Eve of Destruction: How 1965 Transformed America* (New York: Basic Books, 2012), 184. See also Patterson, *Freedom Is Not Enough: The Moynihan Report and America's Struggle over Black Family Life from LBJ to Obama* (New York: Basic Books, 2010), 70.

7 Eisinger, "Conditions of Protest Behavior," 15. Notably, this assessment dates to 1971, since the published paper is a revision of one prepared for a panel on the political legacy of urban protests in the 1960s for the Annual Meeting of the American Political Science Association in September 1971. A contemporaneous communications study of the major issues from 1960 to 1970 found that people "had to rely on the mass media for the bulk of their information" about these issues and that the amount of media attention an issue received closely aligned with a popular sense of what constituted the major issues of the moment. G. Ray Funkhouser, "Trends in Media Coverage of the Issues of the '60s," *Journalism and Mass Communication Quarterly* 50 (September 1973): 533, 538. The study conducted content analysis by counting the number of articles dealing with specific issues appearing in *Time*, *Newsweek*, and *U.S. News and World Report* for each year from 1960 to 1970 (the study omitted newspapers).

8 Despite these similarities, histories of photography have rarely reckoned with demonstration images,

let alone considered them a form of street photography. For recent (and perhaps the only) examples, see Katherine A. Bussard, *Unfamiliar Streets: The Photographs of Richard Avedon, Charles Moore, Martha Rosler, and Philip-Lorca diCorcia* (New Haven, CT: Yale University Press, 2014); Bussard, "Canon and Context: Notes on American Street Photography," in *Street Art, Street Life*, ed. Lydia Yee and Whitney Rugg (New York: Aperture, 2008), 90–98; and Frazer Ward, "Shifting Ground: Street Art of the 1960s and '70s," ibid., 99–104.

9 See Greg Foster-Rice's essay in this volume, pages 18–47.

10 Other notable media categories that will remain outside the scope of this essay but that nevertheless held a certain sway include: local television networks, national weekly newsreels, and alternative presses. Local television networks often provided greater, more detailed coverage of news events in their respective cities, but the audience remained local as well. While still shown in movie theaters across the country, national weekly newsreels were in their death throes. Alternative presses maintained more niche audiences; nevertheless their rise coincided with the most tumultuous years of crisis in 1960s America. Widespread political activism, current events, and the affordability and accessibility of telex and mimeograph technologies combined to create the conditions for "one of the most spontaneous and aggressive growths in publishing history." Louis Menand, "It Took a Village: How the *Voice* Changed Journalism," *New Yorker*, January 5, 2008, 44. For an example of an alternative press publication from this era, see Brynn Hatton's contribution to this book, pages 162–63.

11 Although *Time* published mostly photographic portraits in its first decade (1923–33), Michael Carlebach has noted that the prominence and bold use of photographic illustrations in early and successful issues of *Newsweek* (founded 1933) undoubtedly prompted *Time*, the nation's premier newsmagazine, to reexamine its use of pictures. Michael L. Carlebach, *American Photojournalism Comes of Age* (Washington, DC: Smithsonian Institution Press, 1997), 184.

12 Castleman and Podrazik, *Watching TV*, 170.

13 As America's black population became increasingly concentrated in its center cities, the outward expansion of suburbia sanctioned a new white identity. During the 1950s, for example, suburbs grew at ten times the rate

of cities, and the nation's suburban population more than doubled from 1950 to 1970. This "white flight" was basically a structural process by which white suburbs isolated themselves from urban racialized poverty. At a time when black urban populations were increasing and in need of more housing, white property owners and many businesses—the sources of the tax base for public services and jobs, respectively—evacuated cities in which much working- and lower-class housing was deteriorating or at risk of demolition through urban renewal. Indeed, so many African Americans were displaced that a common slogan of protest was "urban renewal is Negro removal." This phrase has been credited to James Baldwin, who said in an interview, "Most cities are engaged in . . . something called urban renewal, which means moving Negroes out: it means Negro removal, that is what it means." Quoted in Kenneth B. Clark, "A Conversation with James Baldwin" (1963), in *Conversations with James Baldwin*, ed. Fred L. Standley and Louis H. Pratt (Jackson: University Press of Mississippi, 1989), 42. See also Eric Avila, *Popular Culture in the Age of White Flight: Fear and Fantasy in Suburban Los Angeles* (Berkeley: University of California Press, 2004); Kevin Kruse, *White Flight: Atlanta and the Making of Modern Conservatism* (Princeton, NJ: Princeton University Press, 2005); Lewis Mumford, *The City in History: Its Origin, Its Transformation, and Its Prospects* (New York: Harcourt, Brace & World, 1961), especially 511–13; Michael Harrington, *The Other America: Poverty in the United States* (New York: Macmillan, 1962); and Howard P. Chudacoff and Peter C. Baldwin, eds., *Major Problems in Urban and Suburban History: Documents and Essays*, 2nd ed. (Boston: Houghton Mifflin, 2005).

14 For details and further analysis, see Bussard, *Unfamiliar Streets*, 78–97.

15 For more on urban housing, discrimination, and civil rights, see Janet Abu-Lughod, *New York, Chicago, Los Angeles: America's Global Cities* (Minneapolis: University of Minnesota Press, 1999); Martha Biondi, *To Stand and Fight: The Struggle for Civil Rights in Postwar New York City* (Cambridge, MA: Harvard University Press, 2003); Robert Fisher, *Let the People Decide: Neighborhood Organizing in America*, updated ed. (New York: Twayne; Toronto: Maxwell Macmillan Canada; New York: Maxwell Macmillan International, 1994); Noël A. Cazenave, *The Urban Racial State: Managing Race Relations in American Cities* (Lanham, MD: Rowman & Littlefield, 2011); Avila, *Popular Culture*; and Chudacoff and Baldwin, *Major Problems*. In New York specifically, Harlem and Bedford-Stuyvesant were home to significant concentrations of African Americans by the 1960s and therefore considered the city's predominant ghettos. Public housing played a crucial role in shaping these areas. As Janet Abu-Lughod points out: "By 1964, 9 projects with almost 50,000 (mostly black) residents were located in the Bedford-Stuyvesant ghetto, where the total population by then had climbed to an estimated 400,000." Abu-Lughod, *New York, Chicago, Los Angeles*, 202.

16 Jane Jacobs, *The Death and Life of Great American Cities* (New York: Random House, 1961), 71.

17 For an analysis of this specific to New York, see Daniel J. Monti, "Patterns of Conflict Preceding the

1964 Riots: Harlem and Bedford-Stuyvesant," *Journal of Conflict Resolution* 23 (March 1979): 41–69.

18 The absence of an author's name and, even more noticeably, a photographer's name is somewhat unusual for a magazine whose masthead listed photographers above reporters, indicating the value placed on their contributions.

19 Quoted in Kasher, *Civil Rights Movement*, 98. See also Arthur M. Schlesinger Jr., *A Thousand Days: John F. Kennedy in the White House* (Boston: Houghton Mifflin; Cambridge, MA: Riverside, 1965), 966.

20 James L. Baughman, "Who Read *Life*? The Circulation of America's Favorite Magazine," in *Looking at "Life" Magazine*, ed. Erika Doss (Washington, DC: Smithsonian Institution Press, 2001), 43.

21 For example, the February 1960 issue boasted a circulation of 6.5 million on its front cover; one month later, that number had increased by 200,000. Even in 1970, two years before its dissolution as a weekly magazine, *Life*'s circulation was strong at 8 million, with an estimated pass-along rate of four to five people. Ibid., 41–51; see also Erika Doss, introduction to *Looking at "Life" Magazine*, 1–4.

22 Doss indicates that in the postwar era *Reader's Digest* and *TV Guide* exceeded *Life*'s estimated circulation. Doss, introduction, 3.

23 Baughman, "Who Read Life?," 48.

24 Doss, introduction, 4.

25 There are dramatic differences between *Life*'s coverage of civil rights events in the 1960s—whether urban riots such as those in Harlem and Bedford-Stuyvesant or the peaceful 1963 March on Washington—and those in the immediate postwar years. For more on the overt and covert racism of earlier *Life* photo-essays about black Americans, see Wendy Kozol, "Gazing at Race in the Pages of *Life*: Picturing Segregation through Theory and History," in Doss, *Looking at "Life,"* 159–75.

26 The final toll in both areas involved significant property damage, more than five hundred arrests, about 150 people injured, and remarkably only one further death. It should be noted that the riots were quelled at different rates. Although Bedford-Stuyvesant could not be isolated by the police as efficiently as Harlem, the riot played out longer in Harlem. Details on this riot can be found in many sources, but Janet Abu-Lughod's analyses of it, especially in a comparative fashion with riots in Chicago and Los Angeles, are especially informative. See Abu-Lughod, *Race, Space, and Riots*, 13, and Abu-Lughod, *New York, Chicago, Los Angeles*, 209–11.

27 Regarding the use of the term *race* in this essay, I acknowledge, in Janet Abu-Lughod's footsteps, that race is socially constructed, its boundaries fluid. Similarly, I use the term *race riot* to suggest, as Abu-Lughod has, public and illegal actions taken by one group based on the presumed racial identities of at least one other group in a manner that makes it seem that authorities have lost control. To be considered a

riot, such actions must reach a certain level of intensity, commonly noted via duration, the number of people dead or injured, the number of arrests, the cost or amount of property damage, and geographic scope. For more, see Abu-Lughod, *Race, Space, and Riots*, 11–13.

28 Abu-Lughod, *New York, Chicago, Los Angeles*, 211.

29 For one analysis of the riots, published within a decade of the Harlem–Bedford-Stuyvesant riots of 1964, see John S. Adams, "The Geography of Riots and Civil Disorders in the 1960s," *Economic Geography* 48 (January 1972): 24–42, which discusses both "blocked opportunity theory" and "relative deprivation theory" in order to address the clash between expectations and capabilities in the 1960s.

30 Kozol, "Gazing at Race," 162.

31 The *New York Times* featured several "aftermath" photos on interior pages of its July 19 and July 20, 1964, editions, whereas the *Chicago Tribune* and the *Los Angeles Times* published images on their front pages (in addition to interior pages) on July 20 and July 24, respectively. Far more importantly, unlike the *Chicago Tribune* and *Los Angeles Times* photographs—to say nothing of the photographic coverage in the weekly magazines—those in the *New York Times* did not depict police brutality.

32 For more on Yorty's support of the police department and general resistance to civil rights demands, see Mike Davis, *City of Quartz: Excavating the Future in Los Angeles*, new ed. (London: Verso, 2006), 126.

33 Kenneth B. Clark, "The Wonder Is That There Have Been So Few Riots," *New York Times Magazine*, September 5, 1965, 10. For more on the political, economic, and social conditions that led to the Watts uprising, including statistics, see Fisher, *Let the People Decide*, 101; Funkhouser, "Trends in Media Coverage," 537; Cazenave, *Urban Racial State*, 9; Avila, *Popular Culture*, 29–31, 37–38; Janet Abu-Lughod, "Grounded Theory: Not Abstract Words but Tools of Analysis," in *The City, Revisited: Urban Theory from Chicago, Los Angeles, and New York*, ed. Dennis R. Judd and Dick Simpson (Minneapolis: University of Minnesota Press, 2011), 36–39; and Jack Schneider, "Escape from Los Angeles: White Flight from Los Angeles and Its Schools, 1960–1980," *Journal of Urban History* 34 (May 2008): 1005.

34 The relatively high-density confines of New York produced a different riot dynamic than did the low-density sprawl of Los Angeles. For more on the differences between race riots in the three largest U.S. cities in the 1960s, see Abu-Lughod, *Race, Space, and Riots*, and Abu-Lughod, "Grounded Theory," 21–50.

35 By its conclusion, the Watts uprising left thirty-four dead, more than one thousand people injured, nearly four thousand arrested, and more than $40 million in property damage. These numbers represent the most consistent figures, since statistics vary slightly. See Allen and Adair, *Violence and Riots*, 11; Schneider, "Escape from Los Angeles," 1001; Avila, *Popular Culture*, 54; and Abu-Lughod, *Race, Space, and Riots*, 25. Although the instigating event of the riot was a DUI

arrest just outside Watts, the subsequent arson and looting covered more than forty-five square miles of the city, so that even the label "Watts" for the riot is misleading. Abu-Lughod, *Race, Space, and Riots*, 14. The duration of the riot can be explained in part by the relatively low police presence (they cordoned off the area only to abandon it) until the California National Guard arrived, and they, together with local police, made heavy use of firearms, leading to reports of sniper fire and accidental killings. It took more than one day from the time the first National Guard units arrived to quell the main force of the riot.

36 Nowhere is the militarization of the city's response to its black ghettos more evident than in the Los Angeles Police Department's introduction of helicopters for systematic police surveillance by air in the aftermath of the Watts rebellion. Helicopters became foundational to policing in the inner city since they allowed nearly constant and coordinated surveillance. Mike Davis has pointed out that this was facilitated by rooftops painted with identifying street numbers. Mike Davis, "Fortress Los Angeles: The Militarization of Urban Space," in *Variations on a Theme Park: The New American City and the End of Public Space*, ed. Michael Sorkin (New York: Hill & Wang, 1992), 154–80.

37 Dick Turpin, "Slow School Integration Hit by NAACP Leader," *Los Angeles Times*, December 2, 1965.

38 National Advisory Commission on Civil Disorders, *Report of the National Advisory Commission on Civil Disorders* (Washington, DC: U.S. Government Printing Office, 1968), 6, 21.

39 Funkhouser, "Trends in Media Coverage," 535. Not incidentally, this study notes that articles on race relations peaked from 1965 to 1967 (536).

40 Mayor Lindsay, quoted in "Text of Mayor's State-ment on the Strike," *New York Times*, February 8, 1968. It was not the first sanitation workers' strike of the decade—there had been a two-day strike in 1960 and a five-day one in 1963—but it was destined to be the longest and highest profile. Other notable labor strikes and demonstrations in the three largest U.S. cities included: a twelve-day transit strike, a three-week school shutdown, a walkout in municipal health centers in New York; strikes by transit workers and the teachers union in Chicago; and strikes led by the Los Angeles Newspaper Guild, the teachers union, and the United Farm Workers.

41 This statistic is often cited, but for one example, see Damon Stetson, "City Seeks Fining of Sanitationmen as Strike Goes On," *New York Times*, February 6, 1968.

42 "Garbage Protest Closes Five Blocks: Lower East Side Residents Dump Trash in Streets," *New York Times*, February 7, 1968. What began as a labor dispute soon became a health emergency, as officially declared by municipal officials on February 8, the first such declaration since 1931, and a fire hazard. Trash fires in the city increased 1,000 percent during the strike.

43 Lindsay toured various neighborhoods on at least three separate days in order to assess the strike's effects. He found conditions the worst in Manhattan;

eventually he urged Governor Nelson Rockefeller to call in the National Guard, but Rockefeller declined for many reasons, among them the possibility that it would prompt "fighting in the streets." Damon Stetson, "Garbage Strike Is Ended on Rockefeller's Terms: Men Back on Job," *New York Times*, February 11, 1968.

44 Joseph Kraft, "The N.Y. Garbage Strike: A New Class Struggle," *Los Angeles Times*, February 14, 1968.

45 If Watts was Los Angeles's black ghetto, the Eastside had by the 1960s become synonymous with the barrio for its large concentration of Mexicans and Mexican Americans.

46 "Viva la Raza" conveys unity; although *raza* trans-lates as "race" in English, the slogan is more akin to "Long live my people."

47 As reported in the *Los Angeles Times*, the students' demands for equal education were supported by grim statistics: 20 percent of the city's students came from Mexican American homes, yet the dropout rate at their Eastside schools was 35 to 57 percent at its worst, or triple the dropout rate for white students in the same school district. "School Boycotts Not the Answer," *Los Angeles Times*, March 15, 1968, and Jack McCurdy, "Language Is Key Factor: East Side Dropout Rate Stressed in School Unrest," *Los Angeles Times*, March 18, 1968.

48 David Farber, *Chicago '68* (Chicago: University of Chicago Press, 1988), xiii. For other key texts on these events, see Daniel Walker et al., *Rights in Conflict: The Violent Confrontation of Demonstrators and Police in the Parks and Streets of Chicago during the Week of the Democratic National Convention of 1968* (New York: New American Library, 1968); Frank Kusch, *Battleground Chicago: The Police and the 1968 Democratic National Convention* (Westport, CT: Praeger, 2004); David Lewis Stein, *Living the Revolution: The Yippies in Chicago* (Indianapolis: Bobbs-Merrill, 1969); and Larry Sloman, *Steal This Dream: Abbie Hoffman and the Countercultural Revolution in America* (New York: Dell, 1998).

49 For more on both the general expansion of televised news coverage and coverage of the DNC in Chicago, see especially Castleman and Podrazik, *Watching TV*, 171, 181, 199. For summaries of each network's broadcast content during the DNC, see the Vanderbilt Television News Archive. ABC consistently offered the least amount of extra coverage, while CBS and NBC regularly offered an average of at least seven hours of additional coverage from August 26 to 29. Because this essay focuses on the most broadly circulating coverage during this period, it necessarily will not address other moving-image responses to the 1968 Democratic National Convention, among them *Medium Cool* (fig. 29) and *What Trees Do They Plant?* (fig. 158).

50 ABC, CBS, and NBC news broadcasts, August 23, 1968, summarized by the Vanderbilt Television News Archive.

51 The impending threat and previous experiences of urban disorder informed many of the decisions made by the authorities if not the demonstrators. Daley's

Chicago machine was self-contained, making fears about "outside agitators" in Chicago a way of signaling more profound fears about the threat of urban disorder based on issues of race, class, and ideology. Already that spring, Daley had contended with some of the worst riots in the United States in response to the King assassination, and he proved woefully indifferent, letting swaths of Chicago's West Side burn for days on end and giving his police "shoot to kill" orders in response to widespread looting. Kusch specifically labels Daley's show of force at the DNC a direct response to the "restraint" that he perceived among his officers during the earlier riots. Kusch, *Battleground Chicago*, 2.

52 The two main factions of demonstrators were the radical hippies known as the Yippies and the coalition behind the DNC demonstration, the National Mobilization Committee to End the War in Vietnam (known as MOBE).

53 Farber, *Chicago '68*, xv. It is key to remember that by the time of the DNC antiwar protests had been happening for four years, to no avail. Frank Kusch has also suggested that the demonstrations were effectively a class-based conflict between working-class police and middle-class youth. His book *Battleground Chicago* is the first to focus on those who were blamed for the turmoil—the police. As such, he reveals that few police lost control of themselves during protests and after arresting or subduing protesters, despite clear orders from the highest levels to physically attack protestors.

54 *NBC Evening News*, August 27, 1965, accessed via Vanderbilt Television News Archive.

55 *NBC Evening News*, August 29, 1965, accessed via Vanderbilt Television News Archive.

56 Norman Mailer, *Miami and the Siege of Chicago* (New York: D. I. Fine, 1986). Daley called for the city's entire twelve-thousand-man police force to work twelve-hour shifts for the convention week, in addition to calling in several thousand National Guard and army troops as well as at least one thousand federal agents.

57 These mobile barricades inspired Barnett Newman's 1968 sculpture *Lace Curtain for Mayor Daley*; see pages 160–61.

58 One remarkable detail from the article: "In a number of instances, the [newsmen] victims said their uni-formed attackers had removed their badges and name plates, contrary to police regulations, to prevent identifi-cation." "Police Assaults on 21 Newsmen in Chicago Are Denounced by Officials and Papers," *New York Times*, August 28, 1968. For more on Silverman and his attack by police, see Rebecca Zorach's essay in this book, pages 152–59.

59 The authors of that year's report to the National Commission on the Causes and Prevention of Violence (known as the Walker Report) branded the events a "police riot." As with the term *race riot*, the simplification of the cause of the disturbance fails to address more complex and contextualized under-standings. Nevertheless, by the standards of previous urban demonstrations, those during the Chicago DNC were mild. There were almost no serious injuries to

protestors or bystanders. During seven solid days of demonstrations, the police made only 668 official arrests. Much more commonly practiced was the policy not of arresting, but of "de-arresting," which involved corralling protestors in police vans in order to relocate them within the city far away from the demonstrations.

60 "Police Again Rout 'Village' Youths: Outbreak by 400 Follows a Near-Riot over Raid," *New York Times*, June 30, 1969.

61 One possible exception is the "Homosexuals in America" issue published by *Time* magazine months after Stonewall, on October 31, 1969. Citing Stonewall, the feature article, while sweeping in content, specifically addresses this "new militancy" as well as the urban nature of homosexuality. "Homosexuals with growing frequency have sought the anonymity and comparative permissiveness of big cities. It is this concentration of homosexuals in urban neighborhoods rather than any real growth in their relative numbers that has increased their visibility and made possible their assertiveness." Christopher Cory, "The Homosexual: Newly Visible, Newly Understood," *Time*, October 31, 1969, 56.

62 On June 28, 1970, known as Christopher Street Liberation Day, demonstrators assembled on Christopher Street and marched fifty-one blocks to Central Park. This is commonly considered the first Gay Pride march in U.S. history.

63 Initially Earth Day's organizers, the Environmental Action Coalition, based in Washington, DC, had requested Fourteenth Street for the march in an attempt to demonstrate what the city would be like without automotive traffic, which accounted for half of its air pollution, on a street that connected power plants to dramatically changing neighborhoods. Philosophically the environmental movement understood that the density of cities offered a powerful example of the impact that ecological change could have in one location. For example, air-pollution readings taken on Fourteenth Street—chosen specifically for its mix of commerce, housing, public-transportation hubs, and a public park—recorded thirteen parts of carbon monoxide for each million parts of air at the start of Earth Day and only two parts per million with the absence of traffic during the next several hours. David Bird, "In the Aftermath of Earth Day: City Gains New Leverage," *New York Times*, April 24, 1970. The Strike for Women's Equality was sponsored by a coalition of women's groups and coordinated by the feminist author Betty Friedan. Demonstrations planned for no fewer than forty U.S. cities were scheduled to coincide with the fiftieth anniversary of women's suffrage in order to bring attention to the ground lost, not gained, since then. Various actions in New York attempted to draw attention to these concerns, among them a "baby-in" at City Hall to draw attention to the need for day care and "Freedom Trash Cans" for discarding items of sexual oppression, including magazines and beauty products.

64 For the full week of Earth Day, prime-time television was dedicated to special features and providing live coverage of the events in New York City. Fred Ferretti, "Broadcasters Give Earth Day Special Attention: Networks, Public TV, and Local Stations to Emphasize Ecological Problems," *New York Times*, April 22, 1970.

Leading up to the Women's Strike for Equality, NBC dedicated that week's *Today Show* content to women's rights and switched to all female anchors.

65 Police estimated ten thousand, and this number appears in earlier coverage; later coverage consistently uses the twenty thousand figure. By comparison, five thousand women gathered to demonstrate in Chicago and Boston, two thousand in San Francisco, and only one thousand marched in the nation's capital.

66 *Life*, by this time, knew that its survival into the 1970s was very much at risk. For more, see Loudon Wainwright, *The Great American Magazine: An Inside History of "Life"* (New York: Knopf, 1986), 412–31, and John Gennari, "Bridging the Two Americas: *Life* Looks at the 1960s," in Doss, *Looking at "Life" Magazine*, 260–77.

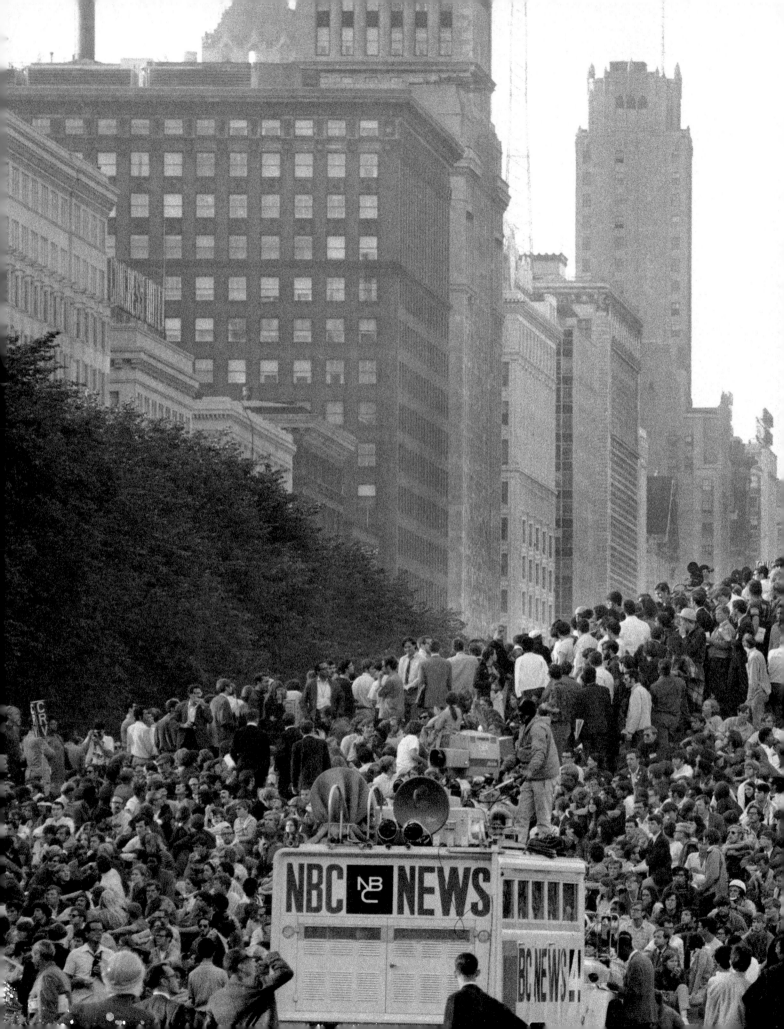

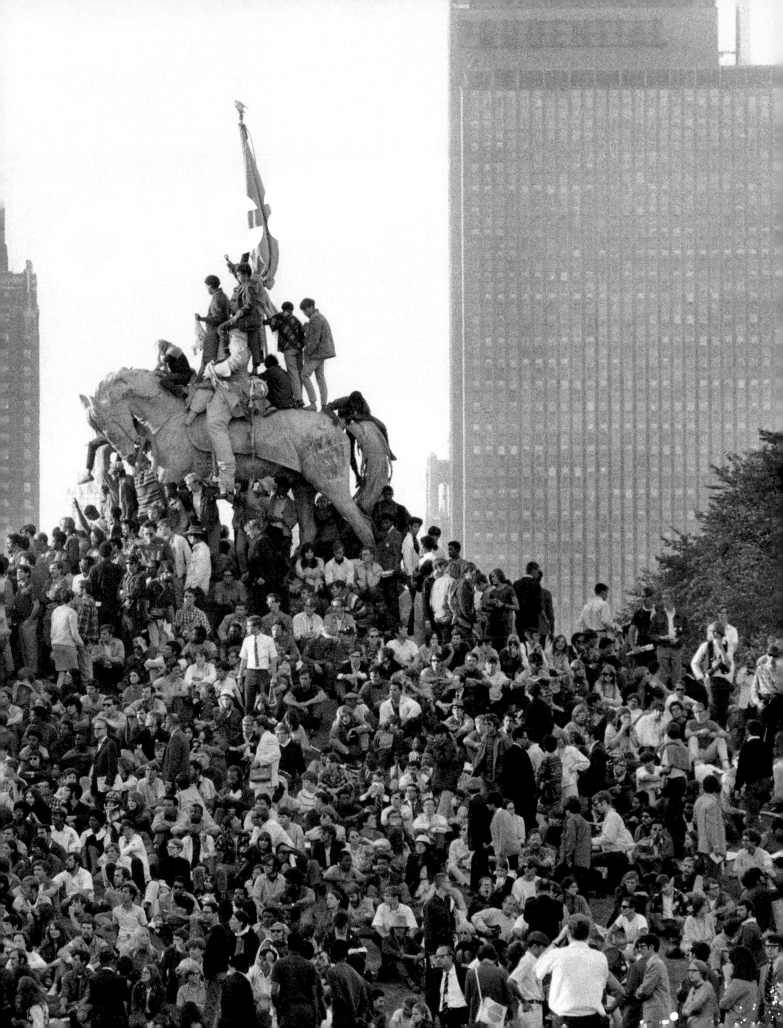

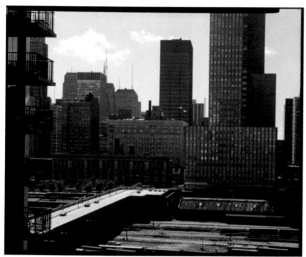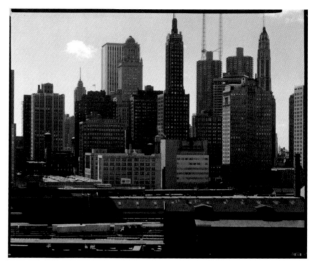

122

123

122 Art Sinsabaugh, *Chicago*,
1966. Chromogenic prints.
The Art Institute of
Chicago, Gift of Paul Siegel

123 Art Sinsabaugh, *Chicago
Landscape #117*, 1966.
Gelatin silver print. Art
Sinsabaugh Archive, Indiana
University Art Museum

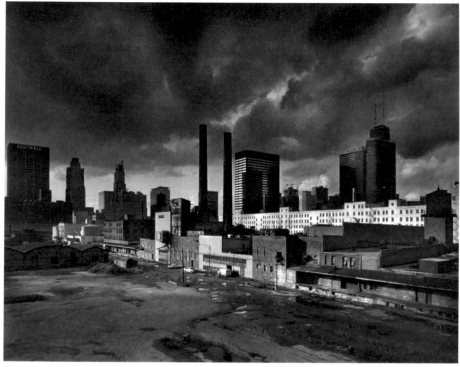

124

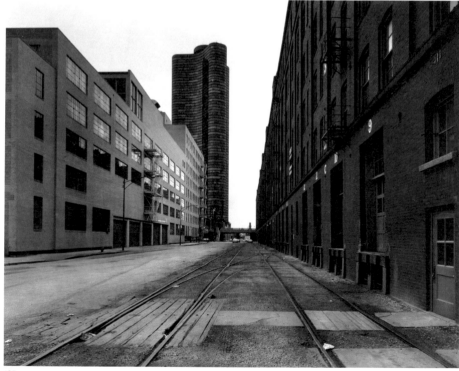

125

124 Patrice Grimbert,
Chicago, 1973. Gelatin
silver print. The Art
Institute of Chicago, Gift
of the Faculty and Graduate
Students of the Department
of Photography in the
School of the Art Institute
of Chicago

125 Patrice Grimbert,
Untitled, 1973. Gelatin
silver print. The Art
Institute of Chicago,
Restricted gift of Mr. and
Mrs. Gaylord Donnelley

126 Still from *The Corner*,
directed by Robert Ford
(Northwestern University,
Department of Radio/
Television/Film, 1962).
Courtesy of Chicago Film
Archives

127 Stills from *Now We
Live on Clifton*, directed
by Alphonse Blumenthal,
Jerry Blumenthal, and Susan
Delson (Kartemquin Films,
1974)

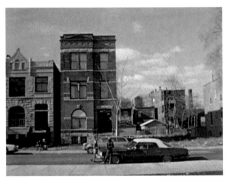

127

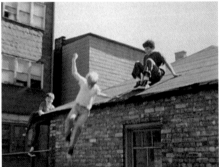

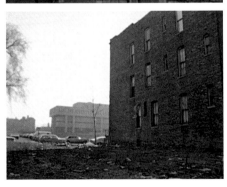

126

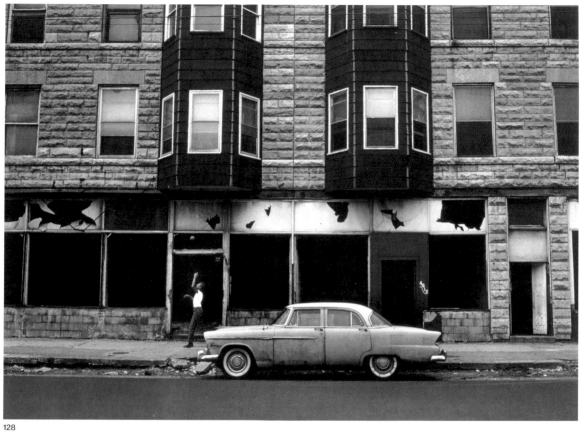

128

128 Yasuhiro Ishimoto,
Untitled, 1948/65 (printed
later). Gelatin silver
print. The Art Institute of
Chicago, Gift of Jack and
Bobby Jaffe

129 Yasuhiro Ishimoto,
Untitled, 1959/61 (printed
later). Gelatin silver
print. The Art Institute of
Chicago, Gift of Yasuhiro
and Shigeru Ishimoto

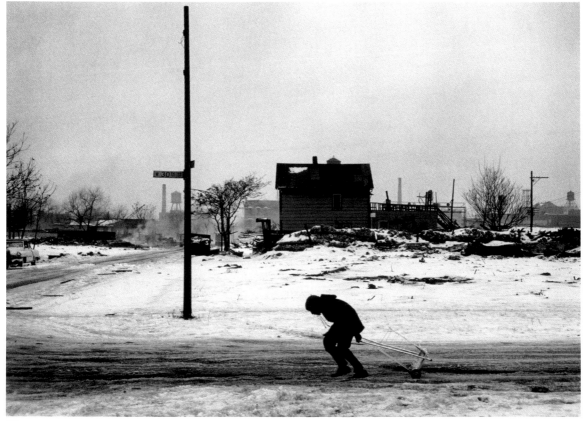

129

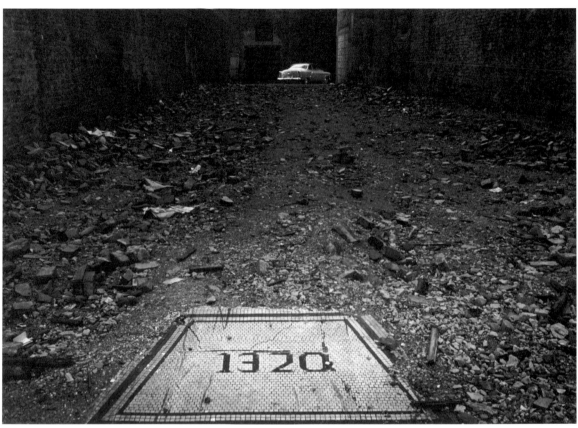

130

130 Yasuhiro Ishimoto,
Untitled, 1959/61. Gelatin
silver print. The Art
Institute of Chicago, Gift
of Jack and Bobby Jaffe

131 Kenneth Josephson,
Chicago, 1969. Photo
collage. The Art Institute
of Chicago, Gift of the
School of the Art Institute
of Chicago

132 Kenneth Josephson,
Postcard Visit, Chicago,
1969. Photo collage.
The Art Institute of
Chicago, Gift of Jeanne
and Richard S. Press

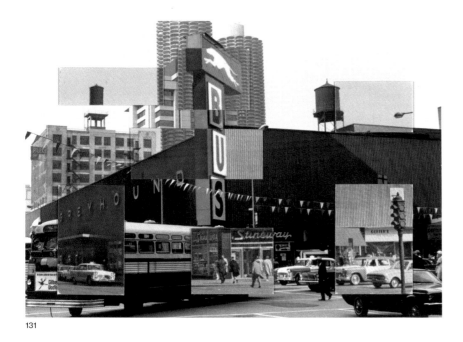

131

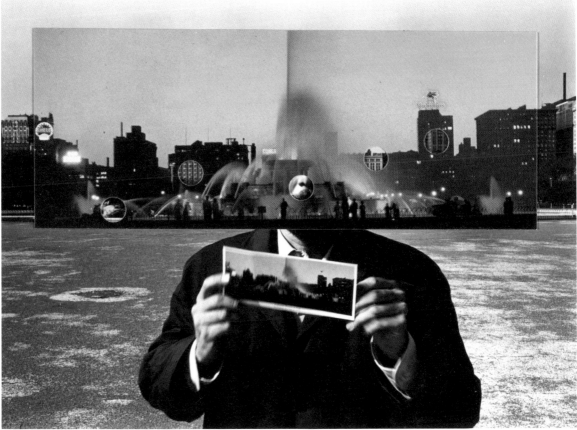

132

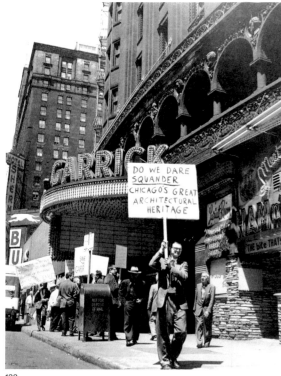

133

133 *Richard Nickel*
protesting the planned
demolition of the Garrick
Theater, June 8, 1960.
Photograph by Ralph Walters
for the *Chicago Sun-Times*

134 Richard Nickel,
Untitled (Garrick Theater),
ca. 1961. Gelatin silver
print. The Art Institute
of Chicago, Photography
Department Exhibition funds

135 Richard Nickel,
Untitled (Construction
of McCormick Place),
ca. 1970. Gelatin silver
print. The Art Institute
of Chicago, Photography
Department Exhibition funds

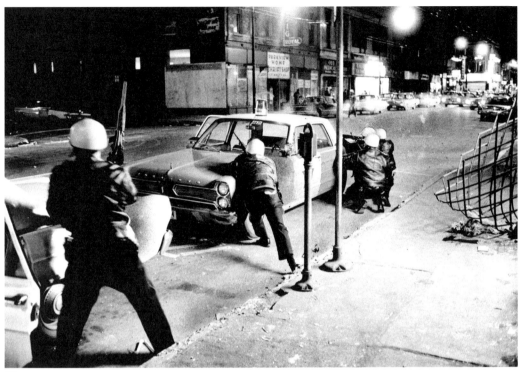

136

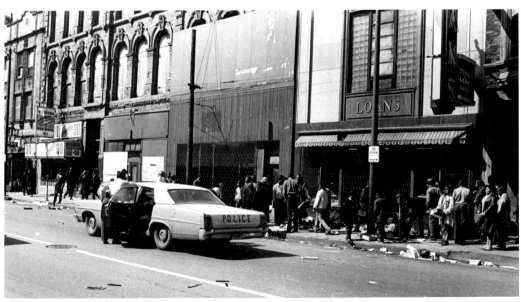

137

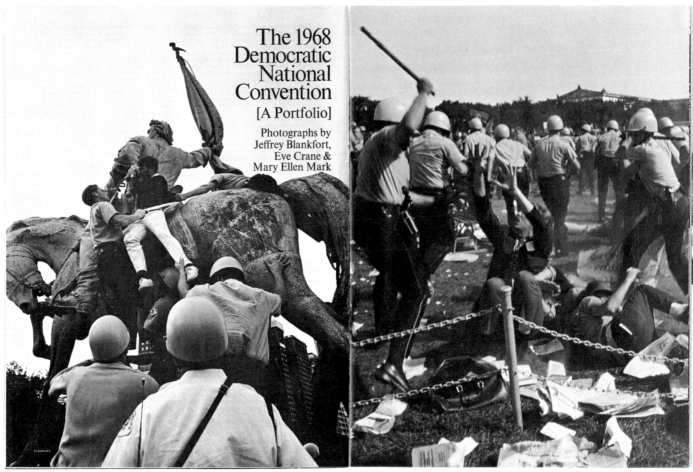

The 1968
Democratic
National
Convention
[A Portfolio]

Photographs by
Jeffrey Blankfort,
Eve Crane &
Mary Ellen Mark

138

136 Don Casper, Photograph
published in "3,000
Guardsmen in Riot Area,"
Chicago Tribune, April 4,
1968

137 Robert Abbott Sengstacke,
*1968 West Side [MLK] Riots,
Chicago*, 1968. Getty Images

138 Spread from "The
1968 Democratic National
Convention [A Portfolio],"
Ramparts, September 28,
1968. Photographs by
Jeffrey Blankfort

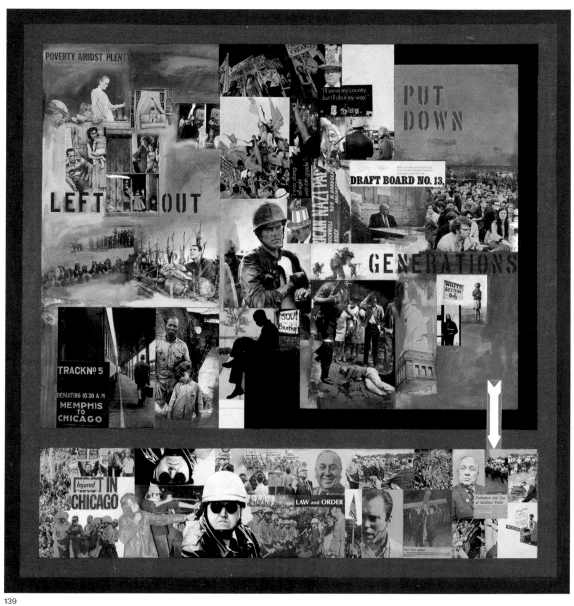

139

139 Ralph Arnold, *One Thing
Leads to Another*, 1968.
Collage and acrylic on
canvas. The Art Institute
of Chicago, Photography
Purchase Fund

140 Alvin Boyarsky, pages
from *Chicago à la Carte:
The City as an Energy
System*, 1970. Special issue
of *Architectural Design*,
December 1970. Alvin
Boyarsky Archive, London

◁ 632

The neo-classicising tendencies, for example, of the current post-Miesian school, and their preferred disengagement, is best epitomised in the recent orgy exhibited at the unveiling of the inflated rusty steel Picasso sculpture, fabricated by one of the world's largest steel mills, and which presides enigmatically over a civic centre of Siennese hardness and imperial scale; a site which today is as often as not paced by restless demonstrators who remain dissatisfied with the symbolism offered, triggered, perhaps, by the events of August, 1968, which took place on the geometrically landscaped Grant Park, a part of the realised Burnham collage which has been systematically overlaid on the heart of contemporary Chicago.
639 ▷

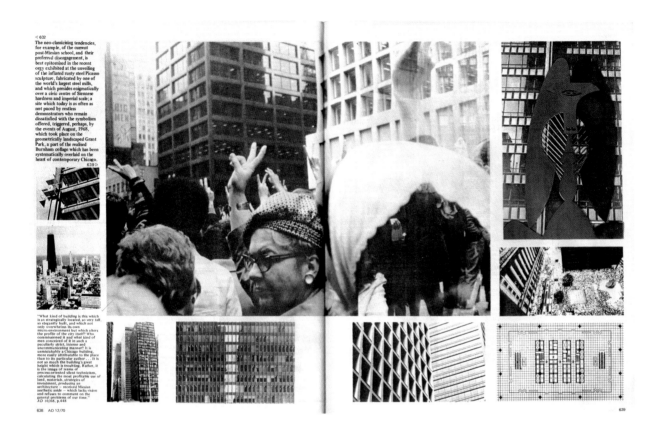

"What kind of building is this which is so strategically located, so very tall, so elegantly built, and which not only overwhelms its own micro-environment but which alters the profile of the city itself? Who commissioned it and what kind of men conceived of it in such a peculiarly strict, intense and uncommunicating manner? It is unmistakably a Chicago building, more easily attributable to the place than to its particular author . . . It is not so much the building's great height which is troubling. Rather, it is the image of teams of process-oriented silent technicians, calculating the most profitable use of land, materials, strategies of investment, producing an architecture — received Miesian aesthetic aside — which lacks vision and refuses to comment on the general problems of our time."
AD 10/68, p.448

638 AD 12/70 639

◁ 638

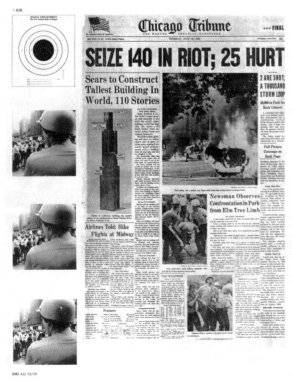

640 AD 12/70

141 C. F. Murphy, *Chicago
Civic Center (Richard J.
Daley)*, 1963. Watercolor
and gouache on board. The
Art Institute of Chicago,
Gift of Helmut Jahn

143

142 Gene Summers for C. F.
Murphy, *McCormick Place*,
ca. 1967. Collage with
print and line drawing. The
Art Institute of Chicago,
Gift of Helmut Jahn

143 Wolf Vostell, *Proposal
for Concrete Cadillac*,
1970. Photostat, cement,
internal dye-diffusion
transfer process prints,
thermometer, pencil, and
board on plywood. Museum of
Contemporary Art Chicago,
Gift of Jan and Ingeborg
van der Marck, 1977

Wall Of Respect

Artists paint images of black dignity in heart of city ghetto

Except for routine gang inscriptions, the side wall of an old building at 43rd and Langley Ave. (above), in the heart of Chicago's near South Side, was simply another barren symbol of slum life before the creative efforts of Jeff Donaldson (below) and fellow artists from the city's Organization of Black American Culture.

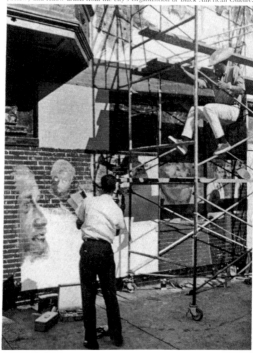

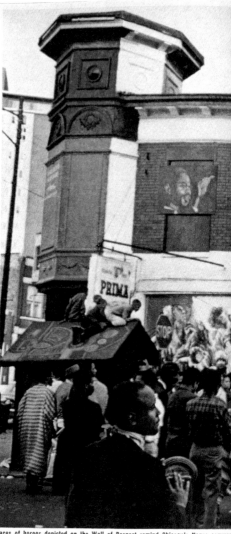

Faces of heroes depicted on the Wall of Respect remind Chicago's Negro communi

FORTY-THIRD Street and Langley Avenue on Chicago's near Sou Side, an area where storefront churches outnumber laundroma is a corner whose beauty is largely unseen and too often unspoke Marcus Garvey proclaimed that beauty, "Bird" celebrated it, and M colm dared to believe in its possibilities. But none of them lived see The Wall.

However, when the side wall of a typical slum building on the corn of 43rd and Langley became a mural communicating black dignity th summer, the faces of those three giants were joined with others remind a people that the blackness and beauty that is their own h always been one. A group of black men and women—painters ar photographers from the Organization of Black American Cultu (OBAC)—in creating this newest of Chicago's landmarks, chose their heroes persons who had incurred both the plaudits and sco of the world of whiteness, but who, in their relation to black peopl could by no account be considered other than images of dignity.

Rising two-stories above ground long grown barren, the mural de picts the intense intellectualism of W.E.B. DuBois who was a blac prophet; the rare physique of Muhammad Ali who *is* a black champio the folksiness of Nina Simone who sings with black simplicity; and th gentle rage of LeRoi Jones who writes poems about black love. Th names seem endless—John Coltrane, Stokely Carmichael, Sara

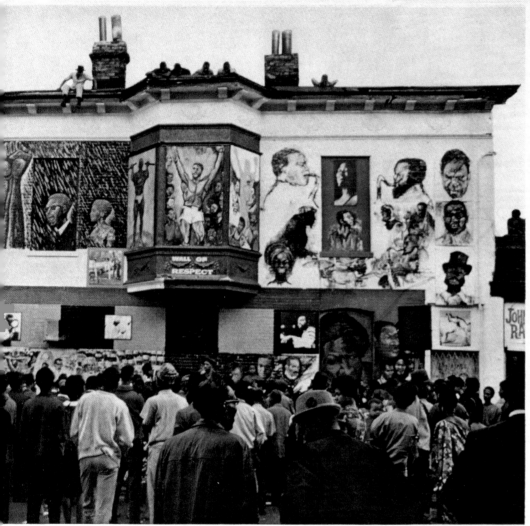

and the world, that out of the black experience have emerged great creators of music and literature, mighty athletes, religious leaders, intellectuals and eloquent statesmen.

Vaughn, Thelonius Monk, Gwendolyn Brooks, Wilt Chamberlain, Max Roach, John Oliver Killens, Ornette Coleman, and Rap Brown among them—and at the end of the names and the painting, the artists were perhaps left no choice but to call their work the "Wall of Respect."

In this era of the "happening," The Wall just might be called a "black-hap." OBAC, which includes writers and community workshops as well as an artists workshop, was formed early this year to enhance the spirit and vigor of culture in the black community of Chicago. Bill Walker, a member of the artists workshop, was given permission by the owner to paint on the wall. Walker introduced the idea to his workshop fellows, and history evolved.

"Because the Black Artist and the creative portrayal of the Black Experience have been consciously excluded from the total spectrum of American arts, we want to provide a new context for the Black Artist in which he can work out his problems and pursue his aims unhampered and uninhibited by the prejudices and dictates of the 'mainstream,'" concludes the OBAC statement of purposes. Thus black artists whose particular talents and skills might have, in another time, taken them far away from 43rd and Langley, directed their genius to the community of their roots. In essence they told a community: "Our art is yours, you are us, and we are you."

Lerone Bennett Jr., who confides that he has received no honor as

meaningful as being portrayed on The Wall, believes that the event marks a significant breakthrough in terms of black people, instead of white people, legitimizing black culture and black history. He notes, moreover, that The Wall is where it should be—in the midst of the people—as opposed to being in a museum or a special, out-of-the-way place. Adds Bennett: "For a long time now it has been obvious that Black Art and Black Culture would have to go home. The Wall is Home and a way *Home*."

In their initial venture towards the objective of seeking themes, attitudes and values that will unite black artists and the masses of black people, OBAC inspired reciprocal identification. The people of the community surrounding The Wall have become not only its praisers, but also its protectors. Novelists James Baldwin and Ronald L. Fair, viewing in appreciation this monument which includes them in its tribute, were taken aback by a youngster who asked: "How do you like *our* Wall?"

The creation, finally, is an authentic landmark signifying a specific development in the experience—"Black Experientialism," in the words of OBAC—of a people. The Wall, as young Don L. Lee ended his poem of the same name, is "layen there." Which in the idiomatic language of the poet, and the black life style, means something more than simply standing there.

Continued on Next Page 49

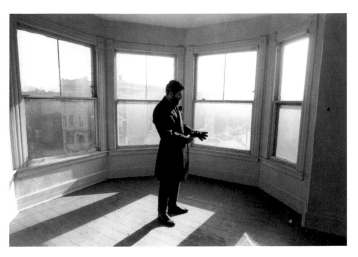

MOVING

A HAPPENING BY ALLAN KAPROW
(POR MILAN KNÍŽAK)

SOME UNUSED HOUSES IN DIFFERENT PARTS OF THE CITY. ON EACH OF FOUR DAYS, OLD FURNITURE IS OBTAINED, AND IS PUSHED THROUGH THE STREETS TO THE HOUSES. THE FURNITURE IS INSTALLED,

ON THE FIRST DAY, BEDROOMS ARE FURNISHED, AND SLEPT IN THAT NIGHT.

ON THE SECOND DAY, DINING ROOMS ARE FURNISHED, AND A MEAL IS EATEN.

ON THE THIRD DAY, LIVING ROOMS ARE FURNISHED, AND GUESTS ARE INVITED TO COCKTAILS.

ON THE FOURTH DAY, ATTICS ARE FILLED AND THEIR DOORS ARE LOCKED.

THOSE INTERESTED IN PARTICIPATING, SHOULD ATTEND A MEETING AT THE MUSEUM OF CONTEMPORARY ART, 237 E. ONTARIO STREET, CHICAGO, AT 8 PM, NOVEMBER 27, 1967.

145

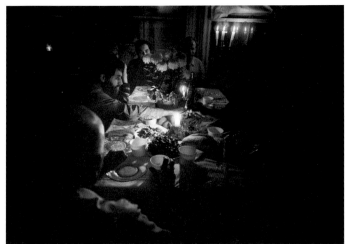

145 Allan Kaprow, poster invitation for *Moving* in conjunction with the exhibition *Two Happening Concepts: Allan Kaprow and Wolf Vostell*, Museum of Contemporary Art Chicago, 1967. Museum of Contemporary Art Chicago

146 Peter Moore, photographs of Allan Kaprow's *Moving*, 1967. Gelatin silver prints. Courtesy Paula Cooper Gallery, New York. © Barbara Moore / Licensed by VAGA, New York

147 Luis Medina, *Gang Member*, 1979. Gelatin silver print. The Art Institute of Chicago, Luis Medina Memorial Fund

148 Luis Medina, *Latin Kings, near Wilson Avenue, Chicago*, ca. 1980. Silver dye-bleach print. The Art Institute of Chicago, Luis Medina Memorial Fund

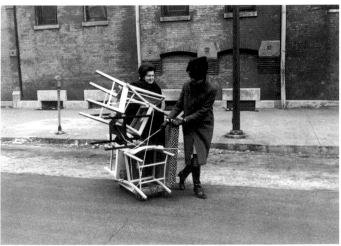

146

147

148

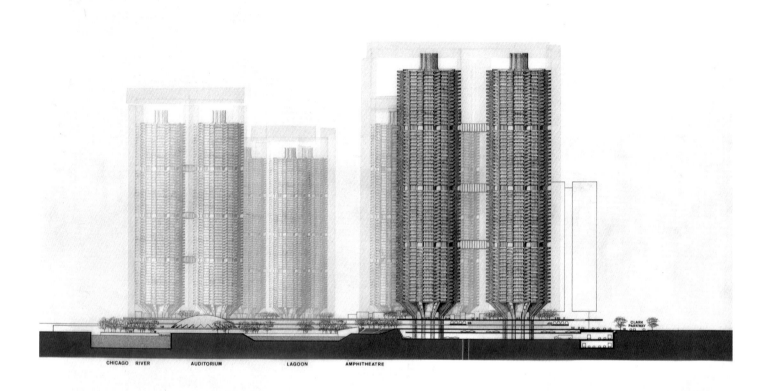

CHICAGO RIVER AUDITORIUM LAGOON AMPHITHEATRE CLARK PARKWAY

149

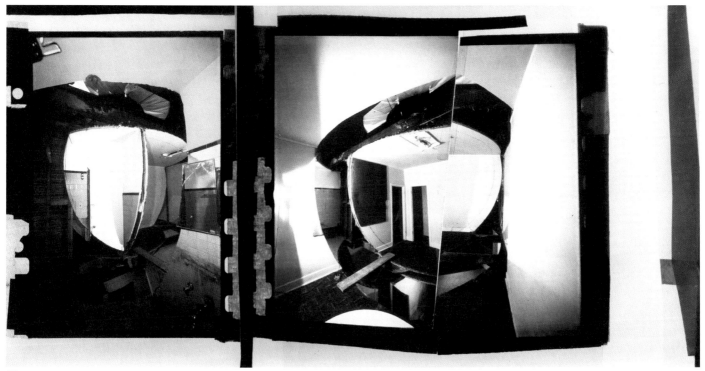

150

149 Bertrand Goldberg,
*River City I, Chicago,
Illinois*, 1972/79.
Blackline on Mylar collage.
Goldberg Family Archive

150 Gordon Matta-Clark,
*Circus, or The Caribbean
Orange*, 1978. Cibachrome.
Courtesy of Rhona Hoffman
Gallery, Chicago

Kenneth Josephson, *33rd and LaSalle* (1962)

Greg Foster-Rice

Kenneth Josephson's *33rd and LaSalle* is an experimental documentary film about the demolition of a building in the Bronzeville neighborhood of Chicago's South Side. The film begins with an establishing shot of an iconic Chicago lamppost and street signs that situates the action at the eponymous intersection, followed by a montage of titles composed using collaged scraps of text from the *Chicago Tribune*, further associating the film with the "news of the day" but also identifying it with the popular collage aesthetic of the IIT Institute of Design, where Josephson had recently completed his studies in photography. We are then presented with the chief protagonist of the film: a recently vacated apartment building undergoing demolition. After another establishing shot of the building's exterior, in which the sun brilliantly reflects off the corner windows, reflexively mirroring the act of cinematic projection itself, we are led upstairs, where the camera sifts through the remnants of lives quickly abandoned. Shoes, calendars, and other ephemera litter the dwellings, implying a forcible and hasty evacuation by the inhabitants. Although the film does not directly address this situation, the building was in fact secured by eminent domain and demolished to make way for the Dan Ryan Expressway, a massive construction project that was also accompanied by the construction of some of the largest public housing projects in the city.[1]

The remainder of the nearly ten-minute silent film tracks the process of demolition over the course of an afternoon, focusing on the building's exterior, which displays posters for the film *Solomon and Sheba* and the musical *West Side Story*. The violence of the demolition is reinforced by Josephson's concentration on the wrecking ball puncturing, tearing, and ripping through the skin of the brick wall and the posters laid on top of it. His rapid jump cuts to the decontextualized faces of the movie characters transform their intended gestures of ecstasy, triumph, and joy into expressions of anxiety, defeat, and anguish as the wrecking ball crashes into their bodies. The film ends with the remnants of the building on fire as a light snow drifts downward, concluding with another establishing shot of the street signs, which helps to relocate viewers to the lived social reality of contemporary Chicago after witnessing the surreal dismemberment of the posters' star-crossed lovers.

If the posters were found objects, Josephson must have been acutely aware of their symbolism, especially since *West Side Story* was about the territorial battles of youth gangs in a neighborhood that by 1959–60 was undergoing its own slum clearance to make way for Lincoln Center, bringing national attention to the virtues and vices of urban renewal.[2] *Solomon and Sheba* might seem less apropos, except that a 1960 *Ebony* magazine review interpreted the movie as a parable of thwarted interracial romance between the "swarthy" Queen of Arabia and Abyssinia (modern-day Ethiopia) and King Solomon.[3] Given the location of Josephson's film, on the edge of the historic "black metropolis" of Bronzeville, and the Dan Ryan Expressway's dual function as both transit corridor and border between the historically white ethnic enclave of Bridgeport to the west and the predominantly African American neighborhoods to the east, the poster's inclusion in *33rd and LaSalle* hints at the ways in which urban renewal and infrastructure projects of the early 1960s reinforced and even strengthened existing patterns of segregation.[4]

1 Sylvia Wolf, *Kenneth Josephson: A Retrospective* (Chicago: Art Institute of Chicago, 1999), 24. A similar story of eminent domain and forced eviction to make way for the Dan Ryan Expressway can be found in Ernestine Cofield, "Widow, 67, Who Lost Home Faces Bleak Future Here," *Chicago Defender*, November 9, 1963.

2 Samuel Zipp, "Culture and Cold War in the Making of Lincoln Center," in *Manhattan Projects: The Rise and Fall of Urban Renewal in Cold War New York* (Oxford: Oxford University Press, 2010), 157–96.

3 "Solomon and Sheba," *Ebony*, February 1960, 85–88.

4 Dominic Pacyga, *Chicago: A Biography* (Chicago: University of Chicago Press, 2009), 293–94.

151 Kenneth Josephson, stills from *33rd and LaSalle*, 1962. 16 mm film, black and white, silent; 8 min. Courtesy of Kenneth Josephson

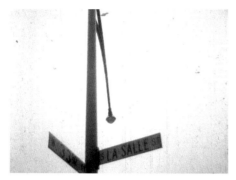

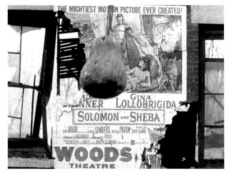

151

Allan Kaprow, *Moving* (1967)

Joshua Shannon

Within weeks of opening to the public in the fall of 1967, Chicago's Museum of Contemporary Art hosted *Moving*, a now largely forgotten Happening by Allan Kaprow. For four days the artist and volunteer participants furnished and occupied three empty apartments in the city, in Old Town, Lincoln Park, and the West Loop (then the city's skid row).[1] According to Kaprow's efficient retrospective description, this act of "playing house"[2] involved the following:

> Some unused houses in different parts of the city. On each of four days, old furniture is obtained, and is pushed through the streets to the houses. The furniture is installed.
>
> On the first day, bedrooms are furnished, and slept in that night.
>
> On the second day, dining rooms are furnished, and a meal is eaten.
>
> On the third day, living rooms are furnished, and guests are invited to cocktails.
>
> On the fourth day, attics are filled and their doors are locked.[3]

Kaprow and the other Happening participants—who included "an intern . . . two Rockford housewives, students, hippies, and . . . a tavern owner"—oversaw an odd blend of everyday banality and festive counterculture high jinks. If one unusually dressed participant "invoked mumbo-jumbo over the furniture . . . and shook bells," the women from Rockford saw to a cheese and wine luncheon. A reporter observed "children waving [and] passers-by smiling" as well as "appalled looks . . . hostile snickering," and even a cutting declaration: "I think they're sick. . . . They're not conforming to society."[4] A related film, commissioned by the museum and made by Bruce Breland, emphasizes the modest but loose playfulness of

Moving, in which participants use the furniture of "desperation" to stage a version of bourgeois life.[5] Two young women in one of the apartments make a show of putting on gloves before eating a meager meal from paper plates. The sundaes they prepare for dessert are made from shaving cream. Kaprow in fact stressed the ambivalent relations in *Moving* between play and work, between festival and banality. "A Happening," he ambiguously declared, "is not art. . . . It is play. . . . But it is purposeful. . . . In the Happening you do real things in the real world. Unlike drugs or dropping out, the Happening affirms reality."[6]

In retrospect, *Moving* reads as, among other things, a critique of the social failure of America's deindustrializing cities: the lasting images from Peter Moore's photographs of the event are the rows of mattresses in the thrift shop and the forlorn look of the streets (fig. **152**). But—in keeping with a tradition stretching back at least to Manet—there is delight in the abandoned spaces too, even an aestheticization of decay. *Moving*, however, refracted these urban modernist dynamics into the context of Happenings and that of the counterculture. If it skirted class and race somewhat, it did so through a lens of late-1960s idealism. In San Francisco a few months earlier, hippies had claimed a neighborhood in postindustrial decline—Haight-Ashbury—to make it over into a messy set of pictures of invention and utopia.

Kaprow too was manically intertwining the ordinary and the radical, isolating four days in order both to escape the mundane and to reaffirm it. Surely it is mere coincidence that these activities took place only blocks from the area that a few months later would witness, during the Democratic National Convention, one of the most dramatic standoffs of the 1960s. But *Moving* did push at social failure,

inviting its small and diverse group of participants to pretend, playfully, that everything was going to be all right.

I thank Alison Fisher, Greg Foster-Rice, and Brynn Hatton for obtaining rare archival materials relating to *Moving*.

1 *Moving* took place November 29 through December 2, 1967. Kaprow was planning to use five addresses, but it appears that only a basement apartment at 1709 North Wells and apartments at 2602 North Racine and 555 West Adams were used. Volunteer sign-up sheets for *Moving* and letter to Louis Thoelecke of the Great Northern Insurance Co. from Karin Carlson, December 5, 1967, Museum of Contemporary Art Chicago archives (hereafter cited as MCA archives).

2 An unsigned description of the work begins simply: "4 days of playing house" (MCA archives).

3 Allan Kaprow and Peter Moore (photographer), *Moving: Photoalbum; A Happening* (Chicago: Museum of Contemporary Art, 1967). Although this publication appeared with a credit line for the museum and a 1967 date, it was in fact self-published by Kaprow the following year. Jan van der Marck (director of the museum) to Allan Kaprow, October 3, 1968, MCA archives.

4 John Adam Moreau, unidentified clipping, *Chicago Sun Times*, [early December 1967], MCA archives.

5 Bruce Breland, dir., *Moving: A Happening by Allan Kaprow*, 8 mm film, 14 min., 1968. One reporter characterized the period of the furniture as "Early Desperation" (Moreau, unidentified clipping).

6 Moreau, unidentified clipping.

152 Peter Moore, contact sheet of *Moving*, in conjunction with the exhibition *Two Happening Concepts: Allan Kaprow and Wolf Vostell*, 1967. Gelatin silver print. Museum of Contemporary Art Chicago. © Barbara Moore / licensed by VAGA, New York

153 Allan Kaprow, *Moving: Photoalbum; A Happening*, with photographs by Peter Moore. Published by Allan Kaprow, 1968. © Barbara Moore / licensed by VAGA, New York

152

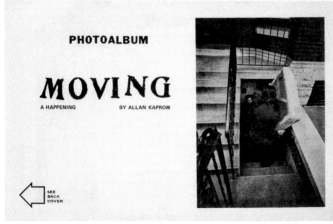

PHOTOALBUM

MOVING

A HAPPENING BY ALLAN KAPROW

SEE
BACK
COVER

SOME UNUSED HOUSES IN DIFFERENT PARTS OF THE CITY. ON EACH OF FOUR DAYS, OLD FURNITURE IS OBTAINED, AND IS PUSHED THROUGH THE STREETS TO THE HOUSES. THE FURNITURE IS INSTALLED.

On the first day, bedrooms are furnished, and slept in that night.

On the third day, living rooms are furnished, and guests are invited to cocktails.

On the second day, dining rooms are furnished, and a meal is eaten.

On the fourth day, attics are filled and their doors are locked.

Commissioned by the Museum of Contemporary Art, Chicago, November 29 to December 2, 1967. Dedicated to Milan Knizak. Photographed by Peter Moore.

153

Seizing the Camera

Chicago's Arts of Protest in and around 1968

Rebecca Zorach

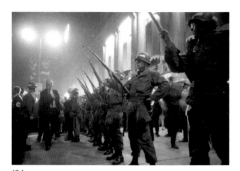

154

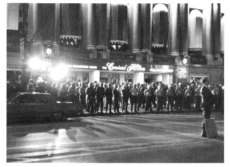

155

Barton Silverman's photograph *Troops Lined Up outside the Conrad Hilton Hotel in Chicago* (fig. **154**) and Fred McDarrah's *Guarding the Hilton during the 1968 DNC* (fig. **155**) give a sense of the show of force presented to demonstrators and city residents by the Chicago Police Department at the Democratic National Convention in August 1968. Anyone paying attention could have expected clashes between protesters and police, but the intensity and lawlessness of the police actions were a shock to many who experienced them and many who saw them on the nightly news. It was a year of intense political emotion: rage and sadness had followed the assassinations of Martin Luther King Jr. and Robert F. Kennedy, and tense expectations of a difficult convention had built over the months. Numerous groups and individuals had long planned to converge on Chicago, in particular to mark their opposition to the Vietnam War. Groups organiz- ing protests included the National Mobilization to End the War in Vietnam

(MOBE), the Poor People's Campaign, Women Strike for Peace, the American Friends Service Committee, the Black Panther Party, and, famously, the Youth International Party, or Yippies, with the tricksters Abbie Hoffman and Jerry Rubin at the helm. A raft of provocations had been issued through the media; the fantastical rumor that LSD would be released into the water supply, which may not have come from the Yippies at all, doubtless raised the emotional temperature within the police ranks.[1] But the unrestrained police response clearly went beyond any explicable bounds—officers indiscrim- inately beat peaceful demonstrators, bystanders, and journalists alike.

Chicago had a rich history of public street activism. In the 1950s and 1960s demonstrations visibly shaped the city's landscape. Marches, pickets, and sit-ins were an established part of civic life by which residents established pres- ence in public spaces and expressed concerns that they felt were not otherwise being addressed in the city's political culture. In 1961, for example, a group largely composed of Italian American women staged a sit-in at Mayor Richard J. Daley's office, among other actions, to protest the choice of their neighborhood for demolition to build the University of Illinois's new Circle Campus. Most of the activism around this issue was confined to street protests and actions within civic spaces, including the Supreme Court case that finally decided the issue in favor of the city's plans. But there were also cases of private violence: protest leader Florence Scala's house was bombed, and an unidentified activist threw a knifed life-size dummy out of a car at Daley's home.[2] Alongside labor union activities and civil rights pro- tests for open housing, against school segregation, and against discrimination in public accommodations such as hospitals and entertainment venues, Chicagoans also picketed against

fluoridation, the city budget, quarry blasting, water shortages, and cigarette taxes; against expressway construction, school busing, and rats; and against the policies of visiting foreign dignitar- ies and U.S. presidents.[3]

Protest was, in a sense, business as usual. But the DNC events were remarkable not only for the violence exercised by police officers but specifi- cally because that violence was clearly directed against members of the press. On Monday, August 26, before the convention even began, a "TV reporter was warned by two police detectives, separately, that 'the word is being passed to get newsmen' and 'be careful—the word is out to get news- men.'" Police were heard yelling things like "get the camera" and "beat the press."[4] Silverman himself appears in McDarrah's photograph *Photographer Silverman Arrested at 1968 DNC* (fig. **156**), and he captured a cop about to strike him with his club in one of his photographs (fig. **157**).[5]

Did the police react against jour- nalists like Silverman because they thought the media were too sympa- thetic to protesters? Did they react in spite of the fact that "the whole world [was] watching" (as protesters chanted)

154 Barton Silverman, *Troops Lined Up outside the Conrad Hilton Hotel in Chicago*, August 28, 1968

155 Fred W. McDarrah, *Guarding the Hilton during the 1968 DNC*, 1968. Estate of Fred W. McDarrah / Getty Images

156 Fred W. McDarrah, *Photographer Silverman Arrested at 1968 DNC*, 1968. Estate of Fred W. McDarrah / Getty Images

157 Barton Silverman, photograph published in "Police Assaults on 21 Newsmen," *New York Times*, August 28, 1968

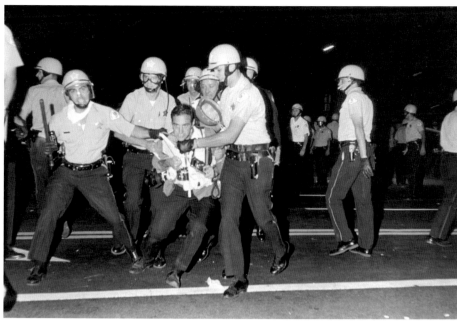

156

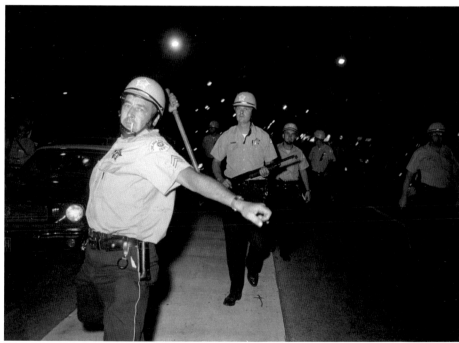

157

or because of it? Did they think it wasn't? Or did they just not think about it at all? These may be unanswerable questions; it is noteworthy, however, that the mayor himself had developed a theory of media responsibility, which he expressed in September 1966 to a luncheon meeting of the Radio and Television News Directors Association. It was "haters, kooks, and psychotics" who populated news media reports of civil rights marches and political events: "Frequently, the news is 'managed' by certain individuals and organizations who understand the nature of the media. With full knowledge that cameras are present, these individuals will make charges and outrageous statement [*sic*]. They stand a very good chance of being on television, whereas the calm, responsible statement will go unheeded."[6] Media representatives, the mayor believed, allowed themselves to become the passive vehicle for these kooky points of view.

Daley's view of this phenomenon was obviously negative. But perhaps we can put another spin on it, giving us room to think differently about the agency of protesters and other populations excluded from political and other privilege to metaphorically seize the camera and its operations—not only becoming visible but even becoming active image makers, makers of the city, even makers of art.

The mayor had his chance to attempt his own media manipulation of events with *What Trees Do They Plant?* (fig. **158**), a film broadcast by WGN in Chicago and around the country on 130 stations on September 15, a scant two weeks after the convention. Although the film was originally conceived as an objective account, in the end Daley's press secretary, Earl Bush, oversaw the editing. Bush transformed an evenhanded document into a piece of propaganda, justifying the use of force by police by stressing the militant and anti-American character of

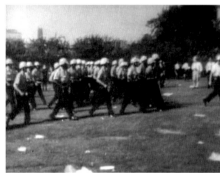

158

the protesters and the long buildup of threats of disruption that had police on edge as the convention began. The visual material doesn't always support the points being made by the voice-over: shots of protesters that seem intended to highlight the radicalism of their rhetoric instead demonstrate the peacefulness of their activities. Paired with an unremarkable shot of convention delegates arriving at the Conrad Hilton is the voice-over comment: "As convention delegates arrived, one could almost detect a preplanned time schedule to culminate in a massive confrontation with police in front of network television lights and cameras at the Hilton on nomination night."[7] Tethering an undeniable visual fact (convention delegates arrived at the Hilton) to a melodramatic assertion about how later events were foreshadowed, the film seeks to lock together a temporal narrative that justifies police actions on the basis of the protesters' imagined prior plans.

Early in the film, as the voice-over describes the location of the Yippies' "Festival of Life" in Lincoln Park as "close to Chicago's Loop" (these neighborhoods are in fact more than three miles apart), the shot that accompanies the words "Chicago's Loop" is a close-up of the Picasso sculpture in Civic Center Plaza, now Daley Plaza. The Picasso, installed in the plaza in August 1967, was already becoming an icon of the city. A subsequent longer shot presents a crowd of people—apparently protesters—in front of the Picasso, and another shows helmeted policemen at the same site, intercut with shots of protesters streaming through the city's downtown streets. One of the first monumental abstract sculptures sited in a public square in the United States, the Picasso represented planners' and architects' efforts to reinvent the city as a cultural hub, drawing on its distinguished architectural history. With its location at the

seat of city government and its highly ceremonial unveiling, the sculpture suggested a tight bond between public art and public life: art as civic spectacle, an ornament to the political life of the city.

The idea that art had civic significance also underpinned some of the responses to the DNC events. By the time *What Trees* aired in mid-September, the story had gotten away from Daley. The scenes of violence that viewers near and far saw on television had an immediate impact. One set of responses came from artists around the country, a number of whom reacted to the police brutality they had seen on television by joining together in a boycott of the city. Their statement, which appeared in the *New York Times*, read in part, "We express our disgust and revulsion by refusing to make available any of our work for exhibition in Chicago, at public or private galleries, for the next two years."[8]

The boycott was undermined almost immediately by another form of artist protest, as Claes Oldenburg and the gallerist Richard Feigen negotiated a transformation of Oldenburg's planned solo show. Oldenburg, who reported being "tossed to the ground by six swearing troopers who kicked me and choked me and called me a Communist," told Feigen that he could not go through with "a gentle one-man show about pleasure," which now seemed "obscene" in the new context.[9] Feigen persuaded him to participate

158 Stills from *What Trees Do They Plant?*, directed by Earl Bush (City of Chicago, first aired September 15, 1968). City of Chicago; courtesy of Museum of Broadcast Communications

159 Broadsheet for the exhibition *Violence in Recent American Art*, Museum of Contemporary Art Chicago, 1968. Museum of Contemporary Art Chicago

in a reimagined group exhibition addressed directly and aggressively to the mayor and titled simply *Richard J. Daley*. Some of the most famous names in the art world participated, including Barnett Newman, whose *Lace Curtain for Mayor Daley* (1968; fig. **164**) turned the modernist grid into a frightening fence of barbed wire, with blood-red paint spattered on it.[10]

This was not the only Chicago art-world response to the events of the DNC. A group of galleries came together to organize a joint program called Response with individual thematically linked exhibitions, and the Museum of Contemporary Art's already scheduled exhibition *Violence in Recent American Art* (fig. **159**) became newly charged with meaning. Ralph Arnold, whose collage *One Thing Leads to Another* (1968; fig. **139**) also addresses convention events, exhibited related work in the *Violence* show. Artists responded in other ways as well. Barbara Jones (now Jones-Hogu) was inspired by convention events to make the silk screen *Be Your Brother's Keeper* (1968; fig. **160**), which combines startlingly bright "coolade" colors with scenes of strife drawn from convention events. Text on the print reads, "Resist Law and Order in a Sick Society."

Artists showing and making work in Chicago were able to engage more directly and concretely with the issues than boycotting artists could by their absence. Certainly, in conception and execution, the boycott had some difficulties. It punished the innocent art world of Chicago more than it punished the mayor; it assumed too that the withdrawal of support from outside Chicago would have a major impact, as if it was the role of New York and California to provide art for the benighted Midwest. But the boycott had one advantage: it was immediate. It was dramatic and could grab media attention without requiring much organization. Events were moving quickly, as Newman

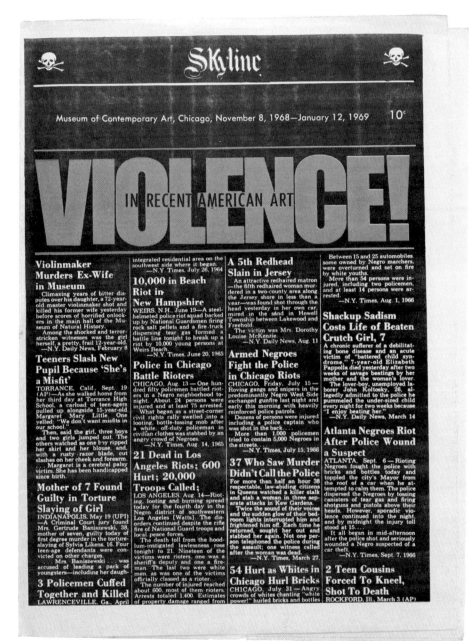

159

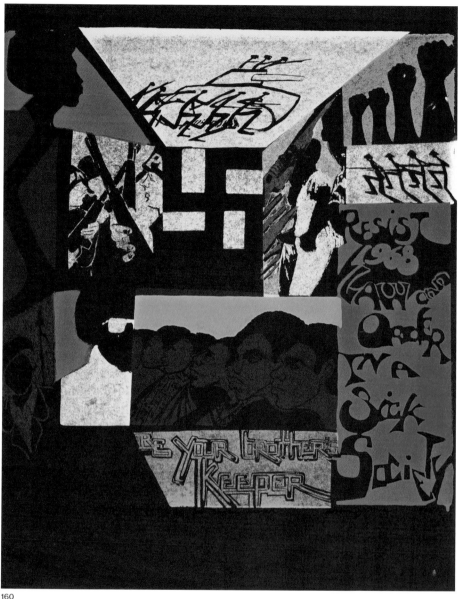

160

station is systematically turning over news footage to the FBI for review.

In its "black militants" sequence, the film explores a different challenge to journalistic practice. After an African American cab driver, Frank Baker, turns in $10,000 that he found in the back of his car, he becomes an instant object of media attention that makes his life hell. Cassellis goes to his home to attempt a follow-up story on him and is thrust into an uncomfortable series of confrontations with some of Baker's more militant friends. Jeff Donaldson's character insinuates first that Cassellis's soundman, Gus (played by Peter Bonerz), is a cop and then that he's a lackey. Other characters develop the critique: white journalists inevitably "brought LaSalle Street [the financial district] and City Hall, and all the mass communications media. And you are the exploiters, you're the ones who distort, ridicule and emasculate us. And that ain't cool."

At the end of the sequence, an unnamed character played by Felton Perry (who went on to an extensive Hollywood career) delivers a monologue that we're allowed to imagine is being filmed by Cassellis. In a way he echoes Daley's own position on the media. The only way for poor African Americans to make their concerns visible, he argues, is to commit acts of violence:

> You don't want to know, man. You don't know the people. You don't *show* the people, Jack. I mean, dig, here's some cat who's down and out, you dig, I mean he's nobody, you know. So he says to his old man, you know, he says, man, like I'm nobody. And I'm gonna die, man, and ain't nobody gonna even know I lived. Dig? So the cat finds a brick, throws it through Charlie's window, you understand? Or he takes a gun and shoots. And the cat lives, man. He really lives, you dig? A hundred million people see the cat on the tube, man. And they say, "Woo, the former invisible man

must himself have realized when he ordered the *Lace Curtain* by phone from Donald Lippincott, his fabricator.[11] Telecommunication was the order of the day. Robert Morris participated in the Feigen exhibition by sending a telegram with a simple suggestion: "redo the Chicago fire of 1871."[12]

Haskell Wexler's *Medium Cool* (1969; fig. **29**) also seized on the pace of events. Filmed partly in the midst of the chaos that surrounded the convention,

it famously blends fact and fiction. It also chronicles the inevitable muddying of the ostensibly "objective" view of the news media. The film initially presents the position of journalistic objectivity as callous: when faced with suffering, the story comes first. But it also reveals politically imposed directives to cover certain stories or not, and a key plot point turns on the discovery by the main character (cameraman John Cassellis, played by Robert Forster) that his

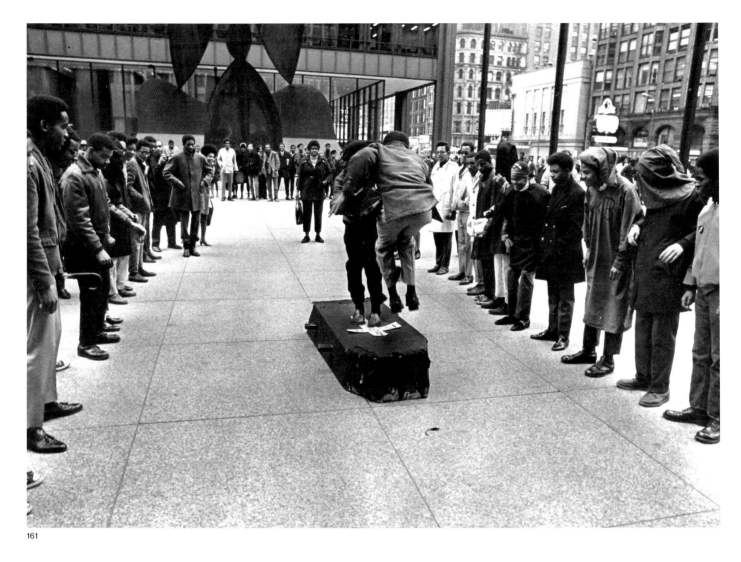

161

lives." Everybody knows where he went to school; they know about his wife and kids, everything. Dig? 'Cause the tube is life.

Members of the group of "militants" were played by actors and nonactors, many of whom were visual artists and musicians Wexler recruited for the film after they protested the exclusion of local black artists from Columbia College's "Arts and the Inner City" conference in May 1968.[13] Jeff Donaldson was a painter, a cofounder of the group AfriCOBRA, and a key theorist of the Black Arts Movement in Chicago. Another cofounder of AfriCOBRA,

Barbara Jones, is briefly seen seated in the background. As Wexler put it in an interview with Roger Ebert, they "didn't want to 'act.' They would only agree to be in the scene if they could say what they believed about the way the media treat black people."[14] Just as the down-and-out cat seizes the attention of the media, so too did the actors in this sequence seize the filmmaker's camera to amplify the points they wanted to make.

The artists Wexler filmed were savvy intellectuals, already skilled at image making. But two more examples can help us see news photographs of political events as collaborations between

photographer and subject or even as acts of seizing the camera. First, let's return briefly to the Picasso. Situated in Civic Center Plaza, the sculpture articulates a tension in the very definition of the "public" as *the people*

160　Barbara Jones-Hogu, *Be Your Brother's Keeper*, 1968. Silk screen. South Side Community Art Center, Chicago

161　Jack Dykinga, photograph published in "Black Student Demonstration at Civic Center Plaza," *Chicago Sun-Times*, October 28, 1968

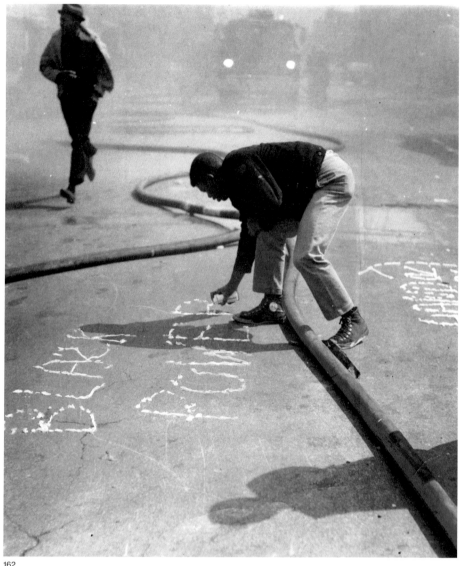

162

162 Kenneth Lovette,
photograph published in
the *Chicago Sun-Times*,
April 7, 1968. Gelatin
silver print. Collection
of Rebecca Zorach

and then stomped on it. They must have sensed that it would make for a good photo.

Second, while the DNC offers the year's most notorious scenes of protest, another event was on the minds of Chicagoans that summer. While (famously) no one was killed in the DNC disturbances, people certainly *were* killed in the uprising on the West Side of the city that followed the assassination of Martin Luther King Jr. that April. As the 1968 Walker report to the National Commission on the Causes and Prevention of Violence pointed out, the police response to the DNC was conditioned by reactions to the uprising. Daley had openly rebuked the police for showing restraint, declaring that police should shoot to maim looters and shoot to kill arsonists.[15] Although the police leadership still sent out a directive that trod a careful legal line, many in the rank and file must have been well aware of the mayor's words.

The West Side uprising and other "riots" are often seen as expressions of the raw, undirected rage of an excluded class: a futile gesture that accomplished nothing but the destruction of numerous black-owned businesses. But Kenneth Lovette's *Sun-Times* photo of a young man writing "Black Power" in shaving cream on a West Side street during the uprising tells a somewhat different story (fig. **162**). The statement itself, "Black Power," suggests a certain political consciousness. One could see it as an artistic or activist gesture. Even destruction could be framed in multiple ways. We might say that Morris's telegraphed participation in the Feigen show, a call to destruction, revealed the negation at work in modern art, but as a call to violence, how sincere was it—indeed, how irresponsible? Redoing the Chicago fire would be perilously close to what had actually happened on the West Side of the city in April 1968. If refusal to show art was an extended

versus the public as *the government*. Picasso declared in his deed of gift that he was giving the sculpture to the people of Chicago, but installed in Civic Center Plaza—which was to become Daley Plaza—it could easily seem like an organ of official policy. Scenes of

protesters congregating near it suggest, however, that citizens believed that they could stake a claim of ownership of the space. And the Picasso may have contributed to the visualization of protest in a more than accidental way. It makes scenes of protest—of which many were photographed in front of the Picasso in the late 1960s—picturesque. This was not lost on the student protesters who placed a casket representing the Chicago Board of Education in a direct line before the center of the sculpture in October 1968 (fig. **161**)

modernist gesture of negation, was destruction too? Could we understand the riots themselves as an artistic gesture—or a kind of mimicry of the operations of power that had, a few years earlier, destroyed West Side neighborhoods to build the Eisenhower Expressway and the University of Illinois at Chicago? Gwendolyn Brooks, certainly, saw a very precise homology between art making and the seemingly wanton destruction carried out by young ghetto dwellers in her poem "Boy Breaking Glass" (1967):

> Whose broken window is a cry of art . . .
> is raw: is sonic: is old-eyed première. . . .
> "I shall create! If not a note, a hole.
> If not an overture, a desecration."[16]

And in Lovette's photograph we might see this seeming futility in the gesture of writing in the highly ephemeral medium of shaving cream—not even spray paint. But consider what consciousness of the power of the media is embedded in this act. Writing in shaving cream is not a way to make a lasting statement—*unless it's photographed*. An ephemeral medium, totally of its moment, but it needs only to be performed, there, for the brief moment that the anonymous young man can take hold of the opportunity of the newsman's camera. Seizing that moment, he magnifies his intervention. He makes "Black Power" into a caption for the experience of the riots, asserting that it is what they put on view. From the now infamous events of the DNC to the multifarious artist responses, people on all sides acted—they performed—with an acute consciousness of the media eye. The young man in Lovette's photograph demonstrates that this awareness was not only the property of the privileged. It may have been rare, as Felton Perry's monologue suggests, that the camera *really* saw "the people." But the people saw the camera.

1 The rumor is mentioned in most accounts of the DNC. Abbie Hoffman denied having started it; see his *Revolution for the Hell of It* (1968; Cambridge, MA: Da Capo, 2009), 191. The earliest mention in the press may be in a *New York Times* article published on the eve of the convention, in which a thirteen-year-old boy in Daley's neighborhood—where many police officers also lived—mentions the rumor: J. Anthony Lukas, "Mood Is Hostile in Back of the Yards Area: White Sections near Parley Site Oppose War Foe Protests," *New York Times*, August 24, 1968.

2 On Florence Scala and the fight against the siting of the University of Illinois campus, see Sharon Haar, *The City as Campus: Urbanism and Higher Education in Chicago* (Minneapolis: University of Minnesota Press, 2011), especially chapter 4 ("Classrooms off the Expressway: A New Mission for Higher Education"), 69–95; see also "Florence Scala," in Studs Terkel, *American Dreams: Lost and Found* (New York: Ballantine, 1980), 114–17.

3 Protests compiled from Proquest Historical Newspaper databases for the *Chicago Tribune* and *Chicago Defender* from the 1950s and 1960s.

4 Daniel Walker, *Rights in Conflict: The Violent Confrontation of Demonstrators and Police in the Parks and Streets of Chicago during the Week of the Democratic National Convention of 1968* (New York: Signet, 1968), 274–77.

5 Silverman said: "I didn't want to get arrested. I just happened to see these demonstrators being dragged—they were dragging them by their collars and their feet. What was I supposed to do?" Quoted in James Estrin, "Dodging the Police at the 1968 Democratic Convention," *Lens* (blog), *New York Times*, http://lens.blogs.nytimes.com/2012/09/03/dodging-cops-and-tear-gas-at-the-chicago-1968-democratic-convention.

6 "Daley Blames News Media for Violence: Says Demonstrators Seek Coverage," *Chicago Tribune*, September 29, 1966.

7 On *What Trees Do They Plant?*, see http://www.richsamuels.com/nbcmm/vault/20081018trees.html.

8 Therese Schwartz, "The Politicalization of the Avant-garde II," *Art in America* 60 (March–April 1972): 70.

9 The quotation was widely circulated and was reproduced on the exhibition invitation.

10 It was a politicized twist on a familiar mode of modern art, suggesting that abstraction could, with only very minute modification, suddenly look extremely political indeed. In Thomas Hess's 1971 catalogue raisonné of Newman's work, *Lace Curtain* is illustrated but is discussed only in a footnote. Hess omits it from the chronology of the artist's oeuvre because it is "isolated from the rest of Newman's work." Thomas Hess, *Barnett Newman* (New York: Museum of Modern Art, 1971), 123n8.

11 Ibid.

12 "The Politics of Feeling," *Time*, November 1, 1968, online at http://www.time.com/time/magazine/article/0,9171,839608,00.html, accessed December 18, 2010.

13 According to the textile artist Robert Paige, the photographer Billy Abernathy introduced him to Haskell Wexler at the end of the conference, after participating in the protest as COBRA (Coalition of Black Revolutionary Artists). COBRA had originally met "all night" at Gwendolyn Brooks's apartment prior to the conference. After meeting him, Wexler visited Paige's studio and invited him, Jeff Donaldson, Barbara Jones, and others to participate in the film. Robert Paige, discussion following a screening of *Medium Cool*, part of the Revolution on Film series, David and Reva Logan Center for the Arts, University of Chicago, July 12, 2013.

14 Roger Ebert, "Haskell Wexler: See, Nothing Is 'Real,'" *Roger Ebert Interviews* (blog), August 10, 1969, http://www.rogerebert.com/interviews/haskell-wexler-see-nothing-is-real.

15 Walker, *Rights in Conflict*, 1–2.

16 Gwendolyn Brooks, "Boy Breaking Glass," *Negro Digest*, June 1967, 53.

Barnett Newman, *Lace Curtain for Mayor Daley* (1968)

Erin Reitz

Barnett Newman's *Lace Curtain for Mayor Daley* was the centerpiece of the Richard Feigen Gallery's fall 1968 group show, *Richard J. Daley*. Co-organized in Chicago by Feigen and Claes Oldenburg in protest of Mayor Daley's heavy-handed oversight of the Democratic National Convention that August, the exhibition brought together contributions from more than fifty contemporary artists, including Lee Bontecou, Donald Judd, Roy Lichtenstein, and Robert Morris.[1] According to Feigen, the exhibition was intended "to make known where the creative and thinking people of the world stand vis-à-vis the Chicago political system."[2] Although more than half the participants submitted previously exhibited works, Newman created his sculpture specifically for the exhibition, where it towered above two cinder blocks in the middle of the Feigen Gallery's front room.[3]

Because *Lace Curtain for Mayor Daley* is exhibited in the round, its striking steel border reframes whatever can be seen through its central barbed-wire grid, thus disrupting the customary relationship between an artwork and its frame. Yet for anyone familiar with the circumstances of the 1968 Democratic National Convention, the work's threatening silhouette calls to mind far more unsettling associations than the Minimalist interrogation of art's spatial and ontological boundaries. In Chicago that August, military jeeps—outfitted with large panels of barbed-wire fencing—patrolled the city's streets and parks, displacing protesters from the key sites of the proceedings and from the cameras of the news media (fig. **163**).[4] To the extent that Newman's dramatically framed grid made up of ninety-six squares exaggerates the precision of the panels of somewhat loosely assembled barbed wire that projected at an angle from the jeeps, his sculpture's aggressive Minimalism heightens viewers' perceptions of the authority exercised by Daley during the convention.

The pointed sarcasm of the work's title ensures that its condemnation is clear.[5] Through its appropriation of the ethnic slur "lace-curtain Irish"—which mocks the supposed pretensions, decorative or otherwise, of upwardly mobile Irish Americans—the title throws into relief the harshness of the factory-manufactured sculpture's industrial materials and, by extension, Daley's leadership while also underscoring the artist's contempt for the mayor. The title's allusion to Daley's bloody careerism is made explicit by the spatters of red paint that glisten on the sculpture's surface, in simultaneous defiance and accentuation of its Minimalist commitments.

Unlike a photograph, newsreel, or political cartoon, Newman's sculpture stages viewers' *physical* encounter with the policing of public space during the convention: its intimidating scale, stark materials, exacting geometry, and blunt symbolism evoke the overwhelming force that the city mobilized in order to deter public protest. Yet even as the sculpture directs attention to the obstruction of political expression in Chicago, it also questions the place of politics in contemporary art. In its representational austerity, *Lace Curtain for Mayor Daley* challenges viewers to consider how—that is, according to what forms, strategies, and contexts—an artwork's relationship to politics is framed and to what ends. Because its condemnation of Daley takes shape through its complicated engagement with Minimalism, it stands in marked defiance of the logic that holds that critically rigorous art—in its attentive exploration of material, medium, or exhibition environment—cannot be political (or political enough) and vice versa. As a result, more than a vantage point on the repression of public protest during the convention, *Lace Curtain for Mayor Daley* is a window on the

163

concerns and anxieties that consumed artistic practice and criticism amid the upheavals of the late 1960s and that continue to reverberate today.

1 The exhibition ran from October 23 to November 23 in Chicago and then traveled to the Contemporary Arts Center in Cincinnati and to Feigen's Greene Street gallery in New York. For a list of the participating artists and included artworks, see *Richard J. Daley* (Cincinnati: Contemporary Arts Center, 1969).

2 Ibid., 4.

3 According to Donald Lippincott, the owner of the factory that fabricated *Lace Curtain*, Newman originally intended the sculpture to be suspended from the steel eyelets atop its frame. "Lace Curtain for Mayor Daley," in *Barnett Newman*, ed. Ann Temkin (Philadelphia: Philadelphia Museum of Art, 2002), 298.

4 The sculpture's resemblance to police barricades was widely noted in reviews of the exhibition published between 1968 and 1969. However, Patricia Kelly established the sculpture's specific reference to the jeeps in "When Push Comes to Shove: Barnett Newman, Abstraction, and the Politics of 1968," *Sixties: A Journal of History, Politics and Culture* 1 (June 2008): 27–47.

5 This contempt is reiterated in the title of Newman's unrealized proposal for a follow-up sculpture, *Mayor Daley's Outhouse*. See Thomas Hess, *Barnett Newman* (New York: Museum of Modern Art, 1971), 123.

163 Press photograph
of jeeps with barricades
during the Democratic
National Convention,
August 1968. Chicago
History Museum

164 Barnett Newman, *Lace
Curtain for Mayor Daley*,
1968. Cor-Ten steel,
galvanized barbed wire,
and enamel paint. The Art
Institute of Chicago,
Gift of Annalee Newman

164

Rising Up Angry (1970)

Brynn Hatton

Rising Up Angry (RUA) was a community organization and underground newspaper founded and staffed by members of the white, urban working class, ambassadors for the "hard, low-down, dirty, straight-on Chicago" that extended the counterculture beyond elite universities and into the heart of the industrial city.[1] With blue-collar grass roots and radical-left proclivities, RUA's political voice was styled by a proto-punk greaser aesthetic that celebrated youth aggression and targeted violence. The members' attire—leather jackets, dark T-shirts, baggy slacks, and pointed boots—contrasted starkly with the tie-dye and buckskin of their hippie contemporaries, as did their engagement with the city.[2] Instead of holding large political demonstrations at civic centers and campus squares, they hung around hot-dog stands and high schools, threw block parties and picnics, and established a sizable following around genuine connections with neighborhood people and issues: police harassment, local job programs, women's advocacy work, and the displacement of low-income people by real estate developments.[3]

RUA's newspaper differed significantly from many others in the underground press of the early 1970s, which had begun to reflect a kind of mainstreaming intended to ease tensions and unify an already fractured left.[4] RUA chose a raised fist and the unequivocal slogan "To Love We Must Fight" for its masthead, executed with a clean graphic treatment imbued with comic book–style dynamism. The front page of this issue from the summer of 1970 features a photo collage on a ground of bright yellow. The silhouetted image in the bottom horizontal register of a young man in a guerrilla crawl poised to fire his weapon is paired with a closely cropped photograph of the side of a traditional Chicago apartment building so that the man appears to lie in wait on the sidewalk.

This setting is typical of gritty 1970s-era Uptown, the neighborhood where RUA members focused their leadership as the second wave of community-centered activism that first developed in the 1960s with the Students for a Democratic Society, or SDS.[5] The simple replacement of the ubiquitous antiwar slogan "Peace Now" with the uppercase, faux-graffiti message "PIECE NOW!" signals a shift in tone from generalized nonviolence to specific acts of aggression. *Piece* is of course slang for a firearm, and a crudely painted image of one appears between the two words. But this phrase also suggests that fractured, fragmented, and localized action is now the guiding principle of the day: the movement is in pieces but potentially stronger and more potent as a result. Like other neighborhood-based social actions and cultural works in Chicago, including public art projects like the *Wall of Respect* (figs. **10**, **144**) and community programs developed by the Conservative Vice Lords, Rising Up Angry's efforts resonated with the national tenor of protest of the period but drew their energy from the specificity of the streets and the neighborhood that the group lived in and defended.

1 Abe Peck, *Uncovering the Sixties: The Life and Times of the Underground Press* (New York: Pantheon, 1985), 186.

2 Hank De Zutter, "Group Efforts: Rising Up Angry and the Greasers' Revolution," *Chicago Reader*, September 21, 1989, http://www.chicagoreader.com/chicago/group-efforts-rising-up-angry-and-the-greasers-revolution/Content?oid=874469.

3 Peck, *Uncovering the Sixties*, 260. RUA encouraged cooperation among the races and subclasses disenfranchised (and thus socially subdivided) by capitalism and the political machine. As first-generation Chicagoans born to former Appalachian coal miners, its leaders teamed up with the local Black Panthers and parted notably from Chicago's foremost underground paper, *Seed*, on the issue of gangs and whether they could be seen as valuable community resources rather than mere instigators of racial violence.

4 "Although historians are generally fond of referring to an overarching 'youth community' in the 1960s . . . the youth revolt was marked more by fragmentation than cohesion." John Campbell McMillian, *Smoking Typewriters: The Sixties Underground Press and the Rise of Alternative Media in America* (New York: Oxford University Press, 2011), 73.

5 For more on RUA, see Dan Berger, ed., *The Hidden 1970s: Histories of Radicalism* (New Brunswick, NJ: Rutgers University Press, 2010).

165 Cover of *Rising Up Angry* 1, no. 10 (1970). Charles Deering McCormick Library of Special Collections, Northwestern University

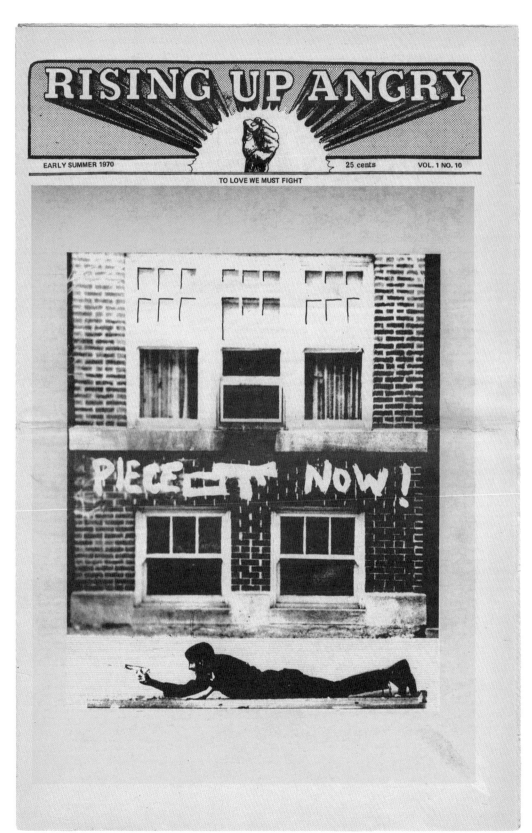

DeWitt Beall, *Lord Thing* (1970)

Jacqueline Stewart

DeWitt Beall's *Lord Thing* (1970) represents Chicago's ongoing patterns of racial segregation and class inequality within a complex layering of past, present, and future by tracing the evolution of the Vice Lords, a Black "gang" (or "club," depending on one's preferred terminology) that rose to power on Chicago's West Side during the 1960s. We learn that the group became the *Conservative* Vice Lords, Inc. (CVL), in 1967, moving away from petty, violent turf wars by developing Black-owned businesses and fostering unification with rivals.

In the film, the maturing of the CVL's founding generation is presented alongside the perpetual presence of younger Black men and boys. For example, in black-and-white sequences, young CVL members reenact past gang wars narrated by adult members. "Gang fighting was a sport, the all-American ghetto pastime," one observes. "The object was not to kill people but to prove manhood, to command respect." In the absence of healthy recreational options, Black youth prey on one another. Long and wide shots of baseball games and rival gangs walking turn into rapidly edited, claustrophobic tight shots, as a handheld camera takes us inside chaotic scuffles with bottles, bats, and guns.

These alternate with color sequences of self-reflective CVL leaders speaking eloquently about causes and solutions. In a pool hall, the founders lament the negative example they have set for younger generations, which continue to suffer and to inflict suffering on their communities. In a montage we see the group's efforts to revitalize the West Side with new opportunities and hope through business ventures like the Teen Town snack shop and CVL's colorful African Lion clothing store. Black boys and men clear dirty lots and tend new grass. A CVL muralist paints Frederick Douglass while discussing his legacy with neighborhood children. Slow panning and zooming shots showcase CVL's moves from self-destructive infighting to a broadened social and economic vision.

This constructive energy is shown to be a result of maturing political consciousness. In the film, CVL members participate in marches and join with diverse progressives seeking to critique and ameliorate race- and class-based oppression. They reflect on 1968's fiery West Side "riots" (or "rebellion"), as we see footage of Black rage and police occupation after the assassination of Martin Luther King Jr. As CVL's activities expanded from Black-on-Black crime to threats to white property, safety, and authority (via public protest, racial unification, and business ownership), Mayor Richard J. Daley declared a "war on gangs" at a moment when gang violence was actually declining. As Black Chicagoans displayed increased self-determination, the Daley machine conducted a smear campaign and created a leadership vacuum by imprisoning and eliminating key leaders, such as the Black Panther leaders Fred Hampton and Mark Clark, who were killed by Chicago police.

The film leaves us with contradictory visions of the future. CVL's attempts to go "legit" are presented as radical and admirable appropriations of white norms. A CVL member fantasizes that his generation will "sit up on porches smoking pipes ten, fifteen, twenty years from now, saying, 'By god, boy, we sure started a good thing.'" But such comfortable occupation of space is challenged in the film's closing scene, in which a boy who appears to be about ten refuses to echo the familiar motto "Right on!" to an elder. Leaning against a boarded-up storefront, wearing a red beret, the "junebug" schools the seasoned gang member: "'Right on' means you go on and on. We want ours 'Right off,' right now."

We know that material change does not come "right off" for these boys or for the voiceless girls glimpsed across the film. How far is this generation willing to go to demand adequate education, employment, recreation, health care, and housing for Black people? Is this what the boy means by wanting "ours"? We might read this scene as an acknowledgment of the limits of Black capitalist space making and as a questioning of what knowledge and power, if any, can be transmitted across Black generations subjected to ongoing spatialized oppression.

166 Stills from *Lord Thing*, directed by DeWitt Beall, 1970. Courtesy of Chicago Film Archives. *Lord Thing* was preserved with a grant from the National Film Preservation Foundation.

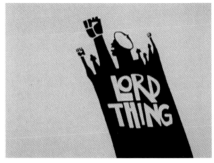

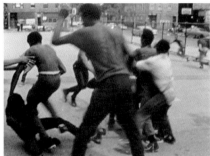

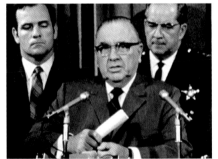

166

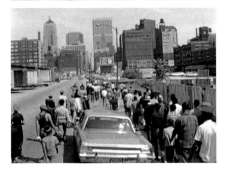

Jonas Dovydenas, *Inside Our Homes, Outside Our Windows* (1977–79)

<div style="text-align: right">

Leslie Wilson

</div>

Shown in a 1979 exhibition at the Museum of Contemporary Art Chicago titled *Inside Our Homes, Outside Our Windows*, Jonas Dovydenas's photographs of Chicago's ethnic communities offer a journey of impressive scope through the city—from informal gatherings on the steps of row houses to lively festivals in the streets to quiet living rooms filled with soft furnishings, family photos, and objects of worship. Representing Chicago as a city thriving in difference, these photographs first accompanied a survey of Chicago cultural communities undertaken by the American Folklife Center in 1977 as part of the ambitious Chicago Ethnic Arts Project.[1]

The 1979 exhibition featured 118 black-and-white photographs selected from the thousands of images that Dovydenas made, a substantive collection of encounters with the everyday lives of Chicago's diverse residents that are infused with a tone of optimism. Although undoubtedly influenced by mid-twentieth-century documentary and street photography, Dovydenas's images are not intrusive, anguished, or meanly surreptitious. Instead, they seem to tell us, "Chicago is what it is ... and we like it."

In this way, the exhibition encouraged viewers to consider the often unacknowledged layers and juxtapositions of identity, culture, values, and needs that emerged in Chicago's communities over time, following the many successive waves of immigration to the city during the nineteenth and twentieth centuries. In Dovydenas's photographs, the legacy of the idiosyncratic development of the city fabric suggests a kind of acceptance and even pride. As the art critic Alan Artner observed: "It does not matter that a used car lot blocks the view of the cathedral. No one is ashamed."[2] It's just these incongruities that Dovydenas highlighted as the reality of the cityscape in Ukrainian Village.

In a photograph of a solitary man walking on a sidewalk strewn with litter, *Monterrey Supermercado, West 26th Street* (fig. **167**), we are met not so much with the lonely condition of urban life as with a moment of fortuitous cultural convergence. As the man passes by a mural featuring Cerro de la Silla—the mountain that looms over the Mexican city of Monterrey—his feet are firmly on Chicago's flat streets while his head appears to be in the mountains. In the context of Dovydenas's project, the man is included as part of the city's "many networks of allegiance and affection," contributing to and shaped by its distinctive cultural mix.[3] Dovydenas's Chicago is a city of front porches, street gatherings, community halls, and cafés, a landscape in which people affirm their connections to multiple identities and places of origin while also transforming the urban environment.

1 In addition to photographs, the Chicago Ethnic Arts Project included audio recordings, manuscript materials, publications, ephemera, and accompanying documentation of a field survey that examined more than twenty ethnic communities. The project was co-organized by the Illinois Arts Council and the American Folk Life Center at the Library of Congress, taking advantage of a unique opportunity "to document ethnic folklife in an urban context." American Folklife Center, *A Report on the Chicago Ethnic Arts Project* (Washington, DC: Library of Congress, 1978), 6. This focus mirrors the work on diverse inner-city communities in Documerica, a national photography project undertaken by the Environmental Protection Agency from 1971 to 1977. For more on Documerica, see the introduction and the essay by Lawrence J. Vale in this volume, pages 168–71.

2 Alan G. Artner, "Through the Viewfinder: MCA's Show of Purity," *Chicago Tribune*, September 9, 1979.

3 Alan Jabbour, introduction to *Inside Our Homes, Outside Our Windows: Photographs of Chicago Ethnic Communities* (Chicago: Museum of Contemporary Art, 1979), 5.

167 Jonas Dovydenas, *Monterrey Supermercado, West 26th Street*, from *Inside Our Homes, Outside Our Windows: Photographs of Chicago Ethnic Communities, 1977-79*. Gelatin silver print. American Folklife Division, Library of Congress

168 Jonas Dovydenas, *Watching the St. Joseph Athletic Association's 51st Annual Parade, Bridgeport*, from *Inside Our Homes, Outside Our Windows: Photographs of Chicago Ethnic Communities, 1977-79*. Gelatin silver print. American Folklife Division, Library of Congress

167

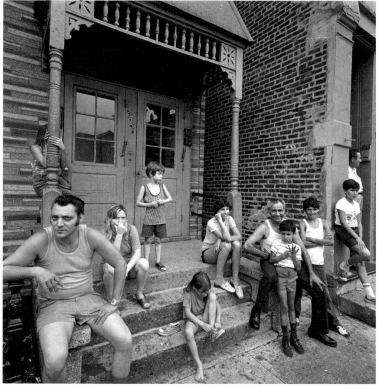

168

Housing and Renewing Chicago, 1960–80

<div align="right">

Lawrence J. Vale

</div>

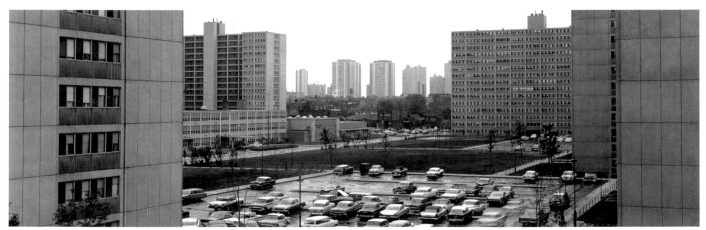

169

Following the relentless aerial perspectives that heralded the top-down urban renewal ideals of the 1950s, the world of urban image-makers returned to the street in the 1960s and 1970s. For a Chicagoan, perhaps the most iconic images of the era depict the police response to anti–Vietnam War protestors in Grant Park as the nation's cameras gathered to focus on the 1968 Democratic National Convention. Coming so soon after the neighborhood destruction that transpired after the assassination of Martin Luther King Jr. the previous April (figs. **136**, **137**), Chicago faced an extended period of social, political, and economic uncertainty. This deindustrializing metropolis of struggle—which the political scientist Larry Bennett has usefully characterized as Chicago's "second city"—marked the transition between a "first city" premised on industrial production and a "third city" of post-industrial reinvention that emerged in tandem with the election of mayor Richard M. Daley in 1989.[1]

Much of this transitional landscape of work and production can also be viewed through the lens of housing, both public and private. The heady early years of Chicago's public housing projects are remembered in oral histories as a time "when public housing was paradise," but more sober assessments

of the 1950s already identify a "blueprint for disaster" as the Chicago Housing Authority (CHA) began its spiral into legendary dysfunction.[2] Still 1960 could plausibly seem a time of flickering hope for the modernist project of renewal. By 1980, however, Chicago's housing stock, both public and private, showed increased signs of disinvestment.

In his series of horizontal slices through Chicago's urbanism, Art Sinsabaugh captured an auto-oriented new world of highway infrastructure and pedestrian-defying expanses of open space. Sinsabaugh's ledger for *Chicago Landscape #12* (1964; fig. **169**) reads: "4/3/64 / Ogden at Division / Looking East / Public Housing / Might Need to be Redone / 6:00pm." His image captures a peaceful early moment in the troubled life of the William Green Homes, completed in 1962 as the last high-rise phase of the 3,600-unit housing project that became known as Cabrini-Green. In 1964 the towers neatly set off a landscape of newly planted trees and tended lawns, as well as a new school constructed to serve the influx of neighborhood children. We also see an ample parking lot mostly filled by the cars owned by residents, who have presumably just returned from their jobs. Sinsabaugh's annotation

in his ledger that this scene "might need to be redone" ostensibly refers to the photograph itself rather than the housing, but it nonetheless proved unintentionally prescient.

The earliest portents of Cabrini-Green's demise, however, are already apparent in Sinsabaugh's photo. Although *Chicago Landscape #12* is primarily an image of public housing, the more distant high-rises at its center are not part of Cabrini-Green. Instead, the Green homes neatly frame the contemporaneous Carl Sandburg Village. Deliberately poised between the starkly separate worlds of Chicago's erstwhile gold coast and its slum,[3] Sandburg Village emerged in 1963 and expanded throughout the next decade as a decidedly more gilded intermediary. Urban renewal funds and processes replaced a predominantly working-class Puerto Rican neighborhood with an enclave of housing for moderate-income young professionals. As the *Chicago Reader* put it in 1978: "There are those who say that without Sandburg Village Chicago would be like Detroit today, a dreary, dying city, surrounded by frightened suburbs. And there are those who say that the people who built Sandburg Village stole the homes of poor people and [built] homes for the wealthy in their place."[4] As Carl Sandburg himself might have put it, the

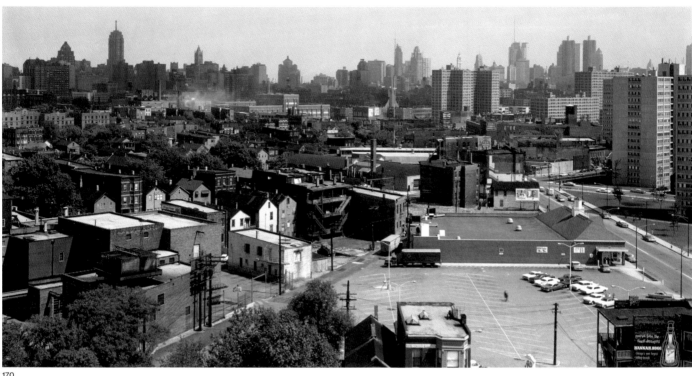

170

"City of the Big Shoulders" could also wield sharp elbows.[5]

Another of Sinsabaugh's Cabrini area photos from 1964, *Chicago Landscape #62* (fig. **170**) shows the uneasy juxtaposition of public housing and private profits. Observing the ragged rear edges of the older residential neighborhood fabric while looking southeast toward a skyline stretching from the beacon-topped Palmolive Building to the Prudential Building to the double corncob of the just-completed Marina City, it is still possible to read the concrete frame tower blocks of the middle ground as symbols of progressive modernity.

Sinsabaugh's photos of Cabrini-Green's evolving environs reveal the part of Chicago facing the opportunities and discomfits of contested renewal, but other parts of the city faced far less attention from the real estate community during the 1960s and 1970s and often remained out of camera range for

all but the most intrepid. John White, an African American longtime staff photographer for the *Chicago Sun-Times*, chronicled the everyday life of the less affluent parts of the city, devoting his own time to places that experienced all too little other outside investment. Before he joined the *Sun-Times*, the Environmental Protection Agency (EPA) hired White in 1973–74 as part of its Documerica project (1971–77). The EPA charged its team of nearly one hundred freelance photographers with photographing everyday life, intending the project to establish a kind of baseline of environmental problems from which to measure future improvements.[6] To White, Chicago's South Side ghetto and its rapidly aging housing projects revealed both challenges and hopes.

While playing basketball without a net is not a particularly dangerous venture, the netlessness of the Stateway Gardens project typified the CHA's growing inattention by the early 1970s to the public realm of the projects

(fig. **171**). More hopefully, as seen through White's lens, Stateway's youth nonetheless seem in control of their environs, with towers framing their own personal stadium (while the light towers of Comiskey Park rise in the distance).

Perhaps on the same day in May 1973, White's camera explored the privately owned housing at Thirty-Seventh and Prairie, about four blocks away. This alternative landscape of abandonment became its own play area, with one youth clinging to the worn-out brick facade while another races along the street that parallels a sidewalk lost to

169 Art Sinsabaugh, *Chicago Landscape #12*, 1964. Gelatin silver print. Art Sinsabaugh Archive, Indiana University Art Museum

170 Art Sinsabaugh, *Chicago Landscape #62*, 1964. Gelatin silver print. Art Sinsabaugh Archive, Indiana University Art Museum

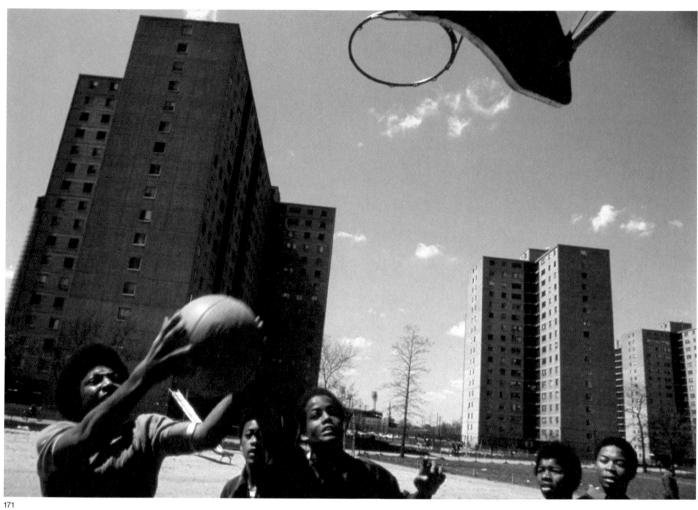

171

untrimmed verge (fig. **172**). Like the open space of the project, this streetscape is a residential world uneasily inhabited as a binary realm in which every space is either all public or all private. In contrast to the complex and multilayered realm of porches, balconies, stoops, front yards, gardens, and low fencing that characterizes a more typical middle-class urban streetscape, here there is nothing to mediate the space between the purely private domain of the home and the purely public domain of the asphalt. In 1972, with publication of *Defensible Space: Crime Prevention through Urban Design,* the urbanist Oscar Newman called for greater attentiveness to the human need for territoriality, expressed through explicit provision of such semipublic and semiprivate intermediary domains.[7] White's photographs remain poignant because they show the possibilities for highly visible human coping, even under the extreme conditions of environmental neglect that Documerica calibrated. Viewed through White's lens, Chicago's post-riot world of the 1970s is still a place for resilience.

171 John H. White, *Black Youths Play Basketball at Stateway Gardens' Highrise Housing Project on Chicago's South Side*, May 1973, from the Documerica project, 1971-77

172 John H. White, *37th and Prairie Streets*, May 1973, from the Documerica project, 1971-77

172

1 Larry Bennett, *The Third City: Chicago and American Urbanism* (Chicago: University of Chicago Press, 2010).

2 J. S. Fuerst, *When Public Housing Was Paradise* (Urbana: University of Illinois Press, 2005); D. Bradford Hunt, *Blueprint for Disaster: The Unraveling of Public Housing in Chicago* (Chicago: University of Chicago Press, 2009).

3 Harvey William Zorbaugh, *The Gold Coast and the Slum: A Sociological Study of Chicago's Near North Side* (Chicago: University of Chicago Press, 1929).

4 Denise DeClue, "The Siege of Sandburg Village," *Chicago Reader*, January 20, 1978, http://www .chicagoreader.com/chicago/the-siege-of-sandburg -village/Content?oid=3295234.

5 In September 2010, carrying only a cell phone and drawn by the presence of a demolition crane systemati- cally removing Cabrini-Green's penultimate tower, I inadvertently rephotographed much of Sinsabaugh's scene from a similar vantage point and at a similar time of day. That the photographs look even remotely similar

is due, of course, to some aggressive cropping, but the most important cropping had already occurred through the "redoing" of the housing project itself (a protracted deconstruction/transformation that has already lasted more than twenty years). Were this scene to be photographed yet again, after 2013, the foreground would show a brand-new Target store, emblematic of the "third" Chicago. See Lawrence J. Vale, *Purging the Poorest: Public Housing and the Design Politics of Twice-Cleared Communities* (Chicago: University of Chicago Press, 2013), chap 7.

6 Bruce I. Bustard, "The DOCUMERICA Project, 1971–1977: John White—Portrait of Black Chicago," *American Suburb X* (ASX), http://www.americansuburbx .com/2009/10/theory-documerica-project-1971-77 -john.html.

7 Oscar Newman, *Defensible Space: Crime Prevention through Urban Design* (New York: Macmillan, 1972).

Bob Thall, *Columbus Drive at East Wacker Drive, View South* (1979)

<div align="right">Craig Lee</div>

As a hometown and an archetype, "the city" in Bob Thall's life and work has always been Chicago. The photographs in his first book, *The Perfect City* (1994), selected from more than four thousand images that he has taken since 1972, document twenty years of change in the metropolis. The stillness in *Columbus Drive*, and in Thall's work overall, reflects his technique and timing: he sets up a view camera during the early-morning or late-evening hours, when the sidewalks are relatively vacant, which accommodates the necessary tripod and long exposures required.

Stillness, though, should not be mistaken for calmness. Instead the quiet state presents a frozen moment in the perpetually unfinished enterprise of "the perfect American city," whose artificial formation on the prairie—which involved imposing a cardinal grid, extending the shoreline, and not just shifting the location of the river but also reversing its flow—is a point of civic pride.

This urban vista looks out onto Illinois Center, a mixed-use development project in an area of the north Loop bounded by Randolph Street to the south, Michigan Avenue to the west, the Chicago River to the north, and Lake Shore Drive to the east, with Columbus Drive bisecting it. Here, at a fleeting instant of creation, Thall captures the exposed triple-level street system of this area—new infrastructural strata built atop the old infrastructural bedrock of the Illinois Central train yard, previously on this site.

Three monolithic buildings, whose vertically oriented facades thrust up beyond the top edge of the image from the street-level view, organize the photograph into even strips. These towers—the Standard Oil building (middle), Three Illinois Center (left), and the Hyatt Regency (right), completed in 1973, 1979, and 1974, respectively—are the present in Thall's urban register of continual transformation. The voids of sky between the towers are punctuated by construction cranes and the Prudential Building, with its broadcast antenna. Such open expanses and the underground structures visible in the foreground signal the current process toward completion and the potential for further development as these projects joined the Prudential Building, long the only symbol of progress in a city that had last witnessed a downtown construction boom in the 1930s.

This ambitious past spirit seemed to reinvigorate Chicago during the 1970s, when the skyline changed dramatically, with buildings reaching ever taller, record-setting heights. The Standard Oil Building briefly held the title as the city's tallest building, before it was eclipsed a year later by the Sears Tower, which stood as the tallest building in Chicago—and the world. Indeed, other superlative construction projects at the time, such as O'Hare Airport, the McCormick Place convention center (figs. **135**, **142**), and the Circle Interchange (fig. **123**), all under the civic aegis of Mayor Richard J. Daley, deepened the city's mythic tradition as a modern metropolis on the prairie undergoing constant reformulation.[1] In such still photos then, they contain the "perfect" dynamism that makes the city appealing as a subject for Thall: "Chicago is never meant to be finished; like any landscape, it is predicated on a continuous, sweeping change. The city is big, energetic, thoughtless, crass—and proud of it."[2]

1 For more about Mayor Daley's political power in this period and the reshaping of Chicago in these projects, see Adam Cohen and Elizabeth Taylor, *American Pharaoh: Mayor Richard J. Daley; His Battle for Chicago and the Nation* (Boston: Little, Brown, 2000); Ross Miller, "City Hall and the Architecture of Power: The Rise and Fall of the Dearborn Corridor," and David Brodherson, "'All Airplanes Lead to Chicago': Airport Planning and Design in a Midwest Metropolis," in *Chicago Architecture and Design, 1923–1993: Reconfiguration of an American Metropolis*, ed. John Zukowsky (Munich: Prestel; Chicago: Art Institute of Chicago, 1993), 247–63, 75–97; and Carl W. Condit, *Chicago 1930–1970: Building, Planning, and Urban Technology* (Chicago: University of Chicago Press, 1974).

2 Bob Thall, *The Perfect City* (Baltimore: Johns Hopkins University Press, 1994), 106.

173 Bob Thall, *Columbus Drive at East Wacker Drive, View South*, 1979. Gelatin silver print. The Art Institute of Chicago, Restricted gift of David C. and Sarajean Ruttenberg

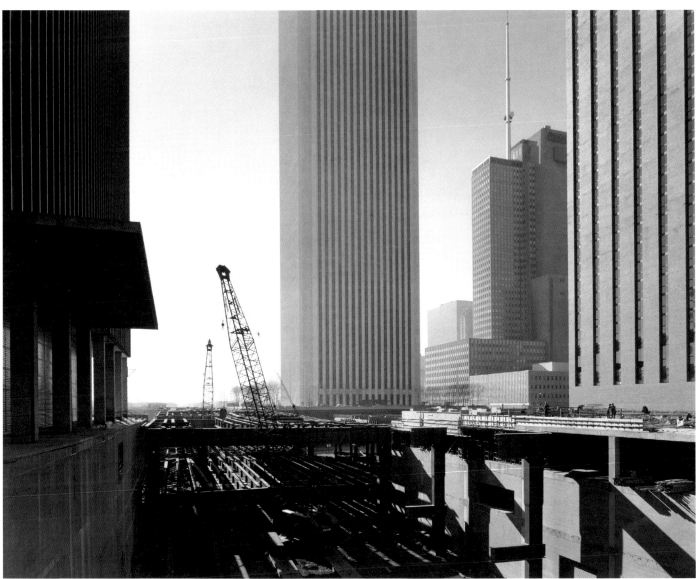

The Contextual Megastructure: Design after Urban Renewal

Alison Fisher

Renewed attention to the street among artists, activists, and policy makers during the 1960s and 1970s was part of a dynamic series of actions and reactions to the many social and economic challenges facing American cities. For architects and planners, this shift was also part of a longer history of twentieth-century experimentation in urban design that turned away from the historical grid to advance new forms of superblock development, including the tower-in-the-park and tower-and-plaza forms that came to dominate urban renewal projects of the post–World War II period. Carrying on the legacy of Jane Jacobs and other critics in the 1960s, architects' return to the street was part of a widespread denunciation of urban renewal and its associated urban and architectural forms.[1] Yet, in the face of a general crisis of confidence in architecture and planning, the need for vision and new ideas was greater than ever. This essay explores the work of architects and planners in New York, Chicago, and Los Angeles who attempted to correct, rather than reject, mechanisms of urban planning and design using an unlikely model, the megastructure. Although at times deemed unfashionable, impractical, or retrograde, these late megastructural developments represent bold refusals to abandon the political and social project of cities.

Megastructure was an international movement and building typology that arose from modern architecture's totalizing impulses and fascination with technology to advance forms of urbanism that rejected traditional streets and blocks for flexible and customizable structures that could be achieved at the scale of a whole block, neighborhood, or city. This typology and phenomenon were explored in many texts throughout the 1960s and 1970s, the most famous being the British architectural historian and critic Reyner Banham's book *Megastructures: Urban Futures of the Recent Past* (1976).[2] Megastructures were found around the world, and Banham's book reveals the strong concentration of work outside the United States—especially in Great Britain, France, and Japan—with a large number of examples falling in the realm of visionary architecture.

With its focus on projects proposed for real sites in New York, Chicago, and Los Angeles, my argument in this essay will strain certain definitions and histories of the megastructure. However, as important attempts to overcome serious problems of scale, context, and discontinuity in the American city, the projects featured here have the potential to extend and complicate the megastructural moment and enrich our understanding of a genre whose bombastic attitude—as Banham put it, "Whence came the self-confidence, the sheer nerve, to propose works of such urban complexity and vast scale …?"—would seem to belie such considerations.[3] Authored primarily by architects and planners, the projects that I discuss began as serious reconsiderations of social and spatial relationships in cities and reflect a general concern about the disparate scales present in the postwar city, which stemmed from and extended out into other realms of imbalance and inequity.[4] Like the activities of photographers, protesters, filmmakers, and performance artists during this period, these designs reflect a desire to better integrate the functions, infrastructure, and social fabric of cities and represent another facet of the return to the historical street and neighborhood as a critical model during the 1960s and 1970s.

Prehistory

By the 1970s modern architecture had been tried and convicted for the negative outcomes of post–World War II renewal and redevelopment

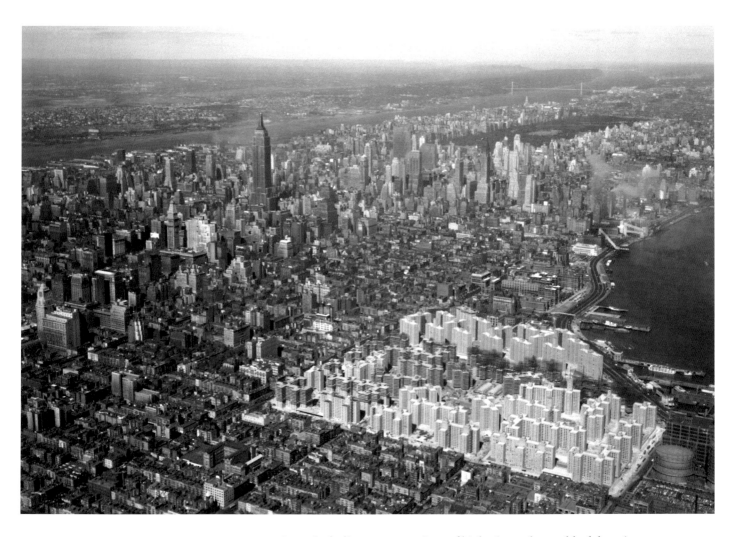

174 *Stuyvesant Town-Peter Cooper Village*, 1947. Fairchild Aerial Surveys, Inc.

projects, including concentrations of high-rise and superblock housing as well as the monotonous corporate towers and plazas built across the United States.[5] Both these types were based on the superblock, a form of urbanism in which buildings are set back from the street and removed from direct connections with their immediate context. This quality of disengagement was emphasized visually in planning techniques of the period that employed aerial photography and photo collage, highlighting the radical rupture between the dense and often messy historical fabric and the superblock developments, as bright and crisp new buildings replaced indistinct blocks of "blight" (fig. **174**).

Even the most sophisticated and well-meaning planners of the postwar era were captivated by the idea of identifying and isolating areas of historical cities for removal and rebuilding, in the hope that this kind of intervention would prevent further decline and restore order and health to the wider community. For example, Elizabeth Wood, the first director of the Chicago Housing Authority, understood the stakes of renewal to be related to the question of scale: "[Planning] must be bold and comprehensive—or it is useless and wasted. If it is not bold, the results will be a series of small projects, islands in a wilderness of slums beaten down by smoke, noise, and fumes."[6] Because of new federal funding and legal mechanisms for acquiring land made available through the Housing Act of 1949, such ideas about cities were implemented

widely, and at the height of this push for urban renewal, whole neighborhoods were razed for public and private development and highways.

As early as the first few years of the 1960s, however, it was clear that these policies had not remedied and had even exacerbated problems of poverty, crime, and social disintegration in large cities.[7] The removal of streets and neighborhoods also endangered family ties, local businesses, and historical enclaves that had evolved over many generations. The new developments were often visually appealing but proved alien and hostile to the established ways of life and social networks of urban communities (fig. **175**). As displacement outstripped construction, urban renewal often worsened existing housing shortages, with the poorest and least powerful residents—many of whom were minorities and recent immigrants or migrants—bearing the brunt of the impact, leading to further political and social disenfranchisement.

In the face of this crisis, Jane Jacobs's *Death and Life of Great American Cities* (1961) made the bold argument that in order to survive, American cities must stop and even reverse the work of urban planners. In her narrative, the contemporary crises were caused by the obstinate vision of architects and planners and their relentless pursuit of visual and, by implication, moral order. Not only was the planners' ideology to blame for this failure but also their methodology, including a fascination with scale models and bird's-eye views, which created another layer of distancing and "a vicarious way to deal with reality."[8] Jacobs questioned the underlying premises of urban renewal and also argued that a degree of "slumming"—a mix of buildings of different scales, ages, and degrees of imperfection—was the key to a thriving city, as it supported neighborhood diversity and allowed for the low-earning yet vibrant businesses and services essential for healthy communities.[9] She proposed slow change, gradual infusions of funding, small blocks, old buildings, sidewalks, and, most importantly, to be rid of the "pseudoscience of city planning and its companion, the art of city design," which in her analysis had never moved out of the easy realm of "superstition, oversimplification, and symbolism" to actually engage with the real world of cities.[10]

The situation for architects was complicated. The disciplinary gap between architecture and planning had steadily widened during the twentieth century, with planners progressively shifting focus from the physical shape of the city to policy, land use, and economics, leaving architects to pioneer what came to be known as urban design.[11] As a new blend of considerations and training found in the disciplines of architecture, urban planning, and landscape architecture, urban design was necessarily and fundamentally linked to the problem of the American city and was specifically created to address the lacunae and ruptures in scale that had resulted from the fragmented reconstruction of the urban environment.[12]

Beyond this nascent movement in urban design, the architecture profession experienced a sense of crisis and stalemate that contributed to an explosion of fantastic, visionary, and alternative architecture (including megastructures) in the 1960s, from proposals for floating and underground cities to shape-shifting technological utopias issuing from a diverse group of designers, among them the Marxist avant-garde of Europe and countercultural communities of the American West.[13] What united these disparate proposals was an absolute disengagement from the historical fabric of cities and a strong sense of doubt or cynicism about the continued viability of conventional tools of urban design and planning.

175 Julius Shulman, *Century City*, 1968. Gelatin silver print. Julius Shulman Photography Archive, Getty Research Institute, Los Angeles

177

176 McMillan, Griffis, Mileto, Architects, *Linear City*, 1967. Reproduced in Ada Louise Huxtable, "How to Build a City, If You Can," *New York Times*, March 12, 1967

At the same time, the late 1960s witnessed the emergence of a project of architectural autonomy, a movement born out of criticisms of the social project of the twentieth-century avant-garde and marked by an inward focus on architecture's own disciplinary tools, history, and discourse.[14] Indeed, as early as 1973 one of the most astute, if pessimistic, observers of this phenomenon in the United States, the Italian Marxist theorist and historian Manfredo Tafuri, pointed to the progressive retreat of both these camps (visionary and formalist) from the ideal of the architect as "active ideologist" in the struggle for the city.[15] The situation was so extreme that it effectively (with the assistance of a major recession) pushed the best young architects of the next generation into the production of writing, drawing, and theory and out of the work of planning and rebuilding the country's crumbling cities.[16] The paradox of the late 1960s, then, is that amid the period's ambitious thinking and experimentation with social movements, art practice, and political mobilization in the city, many vocal and provocative architects in the United States were moving away from the urban question in different directions: inward to focus on issues related to the discipline, and outward through escapist forms of visionary architecture.

In an article titled "How to Build a City, If You Can," the influential *New York Times* architecture critic Ada Louise Huxtable warned of the danger of another kind of inertia, the reactionary desire to preserve all aspects of the status quo.[17] While fine for stable neighborhoods (it is important to remember that Jacobs's Greenwich Village was actively gentrifying at time of her book's publication in 1961), this situation trapped others in decaying neighborhoods without access to basic services. Instead Huxtable argued for comprehensive strategies to address the city's diverse social and physical problems, including, in this case, a project she described as a "super road" or "city-as-building," for the proposed Cross Brooklyn Expressway.[18] She argued that this integration of transportation, infrastructure, schools, retail, and housing offered important solutions to deficiencies in the urban environment, even as she understood that the project could be seen to embody a kind of gigantism, a "dreaded and deplored" aspect of modern architecture and development (fig. **176**).

Huxtable offered up the megastructure as a novel urban ideal in 1967, but by 1976 Banham framed his study as a kind of postmortem: "Megastructure, deserted by the avant-garde, was left to the despised Establishment as a conventional method of maximizing the returns from urban redevelopment."[19] His ambivalent attitude toward the history of the megastructure is evident throughout the study's survey of high-tech buildings such as the Centre Pompidou in Paris, unbuilt visionary schemes, and large redevelopment projects, and Banham ultimately discounted the genre as a force for innovation or remedy in the city. Megastructure, it seems, was nothing more than another hyperscale modernist misadventure in the ongoing urban revolution:

> Megastructure, almost by definition, would mean the destruction or over-shadowing of small-scale urban environments; those who had just rediscovered "community" in the slums would fear megastructures as much as any other kind of large-scale urban renewal programme, and would see to it that the people were never ready. For the flower-children, the dropouts of the desert communes, the urban guerrillas, the community activists, the politicized squatters, the Black Panthers, the middle-class amenitarians

and the historical conservationists, the Marcusians, the art-school radicals and the participants in the street democracies of the *événements de Mai*, megastructure was an almost perfect symbol of liberal-capitalist oppression. It was condemned before it even had a chance to happen.[20]

Megastructures certainly became less "pure" in the 1970s, as architects and urban designers employed this form in the context of the real problems and possibilities of American cities. For the first time, projects of this type began to mingle and engage with the concerns of Banham's preservationists, community activists, and art radicals. For this reason, I will argue for the ambition, even vision, of these efforts through an examination of a series of projects developed and proposed as large urban schemes for New York, Chicago, and Los Angeles between 1965 and 1970.

New York

With its abandoned piers, aging industrial buildings, and trash-strewn parking lots, Lower Manhattan was an important focus of urban renewal plans in the late 1960s and 1970s, including the Lower Manhattan Expressway, a proposed highway linking the Holland Tunnel to the Manhattan and Williamsburg Bridges.[21] The project had first been proposed in the late 1920s and was repeatedly delayed before finally emerging again in the early 1960s as a highly controversial remedy to the neighborhood's failing manufacturing base. When discussing the expressway, Huxtable saw fit to remind her readers that the long-deferred nature of the plan was actually one of the reasons for the decay in this area, as the uncertainty of the future had made investors and owners reluctant to improve their properties.[22] Architects, however, were intrigued by the vast potential of the neighborhood's existing fabric and communities. Proposals by Paul Rudolph and Shadrach Woods took cues from different aspects of the megastructural mode of urban design to advance models for the potential transformation of this problem area.

Known for his high-tech expressionist buildings in rough concrete, the architect Paul Rudolph began work on a study for the Lower Manhattan Expressway following his tenure as dean of the Yale School of Architecture from 1958 to 1965. Rudolph's interest in the design problem posed by the expressway began in 1965, when Mayor Robert Wagner announced that it would be constructed as an elevated structure.[23] Although not commissioned by the city, Rudolph's work on the expressway was the product of new interest in the design of cities and support for the project among powerful members of the business community.

Rudolph also had a series of conversations with the director of the Ford Foundation's Division of Humanities and the Arts in 1965, a pivotal moment when the foundation was beginning to express interest in problems of urban design, having previously been wary of the complexity and "refractory order" of this issue on the national scale.[24] With the architect Ulrich Franzen, Rudolph received a large grant from the foundation in 1967 to fund two years of research and design on "New Forms of the Evolving City," as well as the production of a film, a traveling exhibition, and a book. Although a departure for the division, this grant's goal of assisting in "the rebuilding of urban America" was in keeping with the Ford Foundation's funding priorities during these years, as it was one of the most active supporters of programs addressing problems in American inner cities.[25]

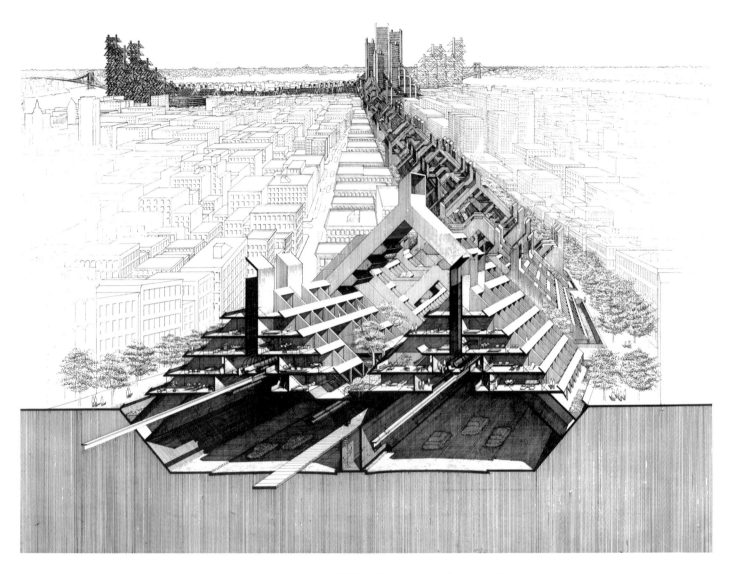

177 Paul Rudolph, *Lower Manhattan Expressway, New York City, perspective section,* ca. 1970. Ink on Mylar. Prints and Photographs Division, Library of Congress

For Rudolph and Franzen, this research was a reaction to the perceived poverty of recent rebuilding efforts and aimed to create an alternative "three-dimensional vision" for the twentieth-century city. They attributed the unfortunate outcome of urban renewal projects to a prevalent statistical attitude in planning and the widespread adoption of a monotonous vision for architecture—largely based on a model of "antiurban" towers and superhighways exemplified by Le Corbusier's 1924 Ville Radieuse.[26] Instead, they called for the reform of zoning laws that encouraged developers to build barren plazas and argued in favor of rewarding those who promoted the street by building up to the curbline.[27] Rudolph described the project as a way to confront some of the "most difficult and urgent design problems" in the United States, including traffic, "widely ranging scales," and questions of the "preservation, continuity, and evolving forms" of contemporary urbanism.[28]

In order to remedy urban design, the three-dimensional image of the city becomes the "generator of action" rather than two-dimensional plans, diagrams, or charts, in much the same way, Rudolph argued, that Daniel Burnham's seductive vision of the City Beautiful at the World's Columbian

Exposition of 1893 shaped the history of American cities.[29] While proposing a dramatic shift from the abstraction of modern architecture, Rudolph remained dedicated to the image of the city, an ideal that the powerful city administrator Robert Moses, for one, had dismissed as incapable of dealing with the real problems of the American city: "You can draw any kind of pictures you like on a clean slate and indulge your every whim in the wilderness in laying out a New Delhi, Canberra or Brasilia, but when you operate in an overbuilt metropolis you have to hack your way with a meat axe."[30]

Rudolph's call to action was also a general critique of more than three decades of massive development—including thousands of units of public housing, massive highways, and cultural renewal projects such as the United Nations and Lincoln Center—driven by Moses's strong hand and reflecting his limited interest in architecture and the visual and experiential qualities of the city.[31] The election of John Lindsay as mayor in 1965 was a dramatic interruption of this worldview, as he specifically called on designers to help him address urgent problems facing urban neighborhoods and to find ways to improve the quality of life in New York. Within his first months in office, Lindsay convened a task force that included architects, like-minded business leaders, and philanthropists to study the question of urban design, resulting in the 1967 report *The Threatened City*. This report advocated restructuring New York's City Planning Department to include a council on urban design, creating a master plan for the city, and fostering a new ethos in the administration that understood design as an ambassador, that is, as a way to bring issues of planning down to the street and to the "people of each community"— a list that neatly summarizes Lindsay's future efforts in this arena.[32] Given these dramatic changes in policy at the start of Rudolph's project, administrators at the Ford Foundation understood that its goal was to serve as a potentially influential example of new urban design principles rather than as a specific proposal.[33]

Although a far cry from the "meat axe" strategy employed by Moses for projects like the Cross Bronx Expressway, Rudolph's plan did involve a dramatic transformation of the urban landscape, including the removal of approximately eleven dense blocks of buildings between Broome and Spring Streets. He proposed a below-grade road surmounted by a large, continuous residential structure of varying heights built on air rights that would protect the surrounding neighborhood from the pollution and noise of the highway (a concern that Jane Jacobs also raised). The design (fig. **177**) is certainly a megastructure—reflecting the canonical combination of repeating prefabricated elements and a massive structure—but is also about something new: the street.

In contrast to the abstraction of Moses's plan for the expressway— depicted as an impossibly smooth, bright red ribbon snaking through the city, seen in an aerial view (fig. **178**)—dozens of sketches and renderings in the Rudolph archive show a high degree of attention to the way the expressway would meet the dense urban fabric of Lower Manhattan. While depicting the sweep of the linear structure, his drawings shift perspective to offer a view of pedestrian-level experience, down to a precise depiction of trees and cast-iron facades on buildings flanking the structure, a stark contrast to the many futuristic projects of the era that hover over the city or meet the ground in an approximate way (fig. **179**). In addition, Rudolph precisely scaled the total height of the structure to the surrounding five- to seven-story loft buildings, and his terraced

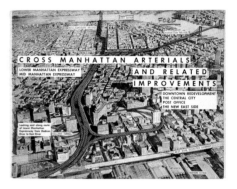

178 Cover of *Cross Manhattan Arterials and Related Improvements*, 1959. Robert Moses and Triborough Bridge and Tunnel Authority. Avery Architectural & Fine Arts Library, Columbia University

179 Buckminster Fuller and Shoji Sadao, *Dome over Manhattan*, 1960. Photo collage. Stanford University Libraries

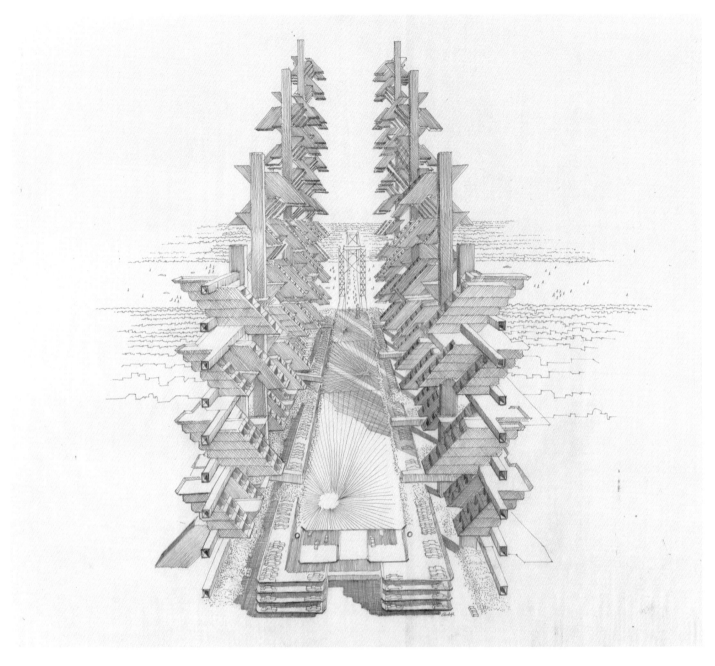

180 Paul Rudolph, *Lower Manhattan Expressway, New York City, view to Williamsburg Bridge*, 1967-72. Brown ink on paper. Prints and Photographs Division, Library of Congress

structures allow for entrances and gardens at grade along the existing streets, a far cry from the blank walls created by many contemporary developments of this size.

Aside from addressing problems of scale, Rudolph's megastructure was also designed to resonate with established functions and symbolic elements of the city. For example, the structure varies in shape and height based on its location in the neighborhood, beginning as high-rise towers, then dropping down to midrise terraced housing built over the highway and an elaborate mass-transit infrastructure—all produced from the same standard, prefabricated concrete module (fig. **180**). His high-rise buildings, composed of slender vertical structures and tiers of the angled module, flank the towers and side spans of the Manhattan and Williamsburg Bridges like monumental gates to the city, just like the bridges themselves.

It is in this respect that Rudolph's work on the expressway relates most closely to his earlier projects for nonurban contexts that incorporate large structures and prefabricated elements, including many commissions for college campuses during the 1960s. He drew a connection between his work in Lower Manhattan and his long-standing engagement with "topographic architecture," a kind of site-specificity in which "scale, bulk and sequence can be used to create a condition that is meaningful to both the overall urban arrangement and to activities which occur at specific points."[34] This idea is similar to a subgenre or variant of the megastructure, the *megaform*, described by Kenneth Frampton as combining a "topographic, horizontal" orientation with "a programmatic place-creating" character.[35] Frampton's definition seems to refer only to the external shape of an individual building, however, while Rudolph insisted that that form was a means of critical engagement with the broad context, or the "environment of the building," including the site and surrounding structures.[36] Instead of creating stylistic references to historical architecture, as was common in the postmodern architecture of the 1970s, Rudolph developed his contextual idea through a building's scale, proportions, texture, space, and relationships—above all its ability to create places that "define and render eloquent [their] role in the whole city scheme."[37] Crucial to this effort was Rudolph's willingness to look forward as well as backward to better understand the historical fabric of the city, create meaningful urban sequences and contrasts, and avoid the pitfalls of modernist understandings of monumentality.[38]

Published just as Rudolph began work on the expressway, the 1966 *Lower Manhattan Plan* was an important precedent for advanced planning in this area. First imagined as a traffic study, the plan was quickly expanded to include broad goals for land use, development, and preservation by a team that included architects from the firm Whittlesey, Conklin & Rossant; the planning firm Wallace, McHarg, Roberts & Todd; and the transportation planners Alan M. Voorhees & Associates.[39] Among many prosaic recommendations about transportation, zoning, and the phasing of new developments, the authors of the plan explored alternative concepts in urban design that rejected tower-in-the-park development ("sterile and anti urban, a relic of obsolete design concepts and standards") for a more cohesive urban fabric and contextual guidelines for development, with special considerations for waterfront areas (fig. **181**).[40]

Given the many holes and ruptures in the existing landscape of Lower Manhattan and the waterfront, the architects and planners who drafted the 1966 plan sought out a new building typology that could serve as a "transition" between the scale of the older buildings and nearby towers, chiefly the World Trade Center, which would soon begin construction. The architects' recommendations took the form of a combination of residential and commercial buildings that they likened to San Gimignano in Italy.[41] Like the terraced form of this medieval hill town in Tuscany, their form of urbanism began at grade near the water's edge and then rose to tiered bands of housing framing well-proportioned "community plazas" and courtyards at the base of residential towers matched in scale to the historical skyscrapers downtown (fig. **182**).[42] This form of development was well suited to the chaotic variety of existing structures and spaces in Lower Manhattan and encouraged a physical and social integration of offices and housing and a mix of new and old development that would appear interwoven and "not just grafted on."[43]

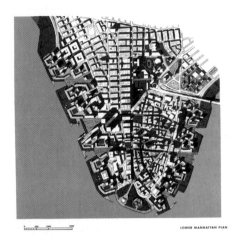

181 Illustration from *Lower Manhattan Plan*, published by New York City Planning Commission, 1966. Collection of the Skyscraper Museum, New York

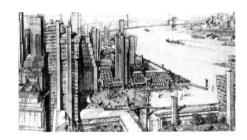

182 James Rossant and Whittlesey, Conklin & Rossant, drawing from *Lower Manhattan Plan*, published by New York City Planning Commission, 1966. Collection of the Skyscraper Museum, New York

HOUSE	STREET	RELATIONSHIP	CIAM 9	HOUSE	STREET	DISTRICT	CITY

183 Alison Smithson, *CIAM Grille, Aix-en-Provence*, 1952-53. Presentation panel; collage. Musée National d'Art Moderne, Centre Georges Pompidou, Paris

Although the plan was sponsored by the local business community, it appears that its architects and planners retained a fair degree of autonomy, as the details of their argument pose a substantial challenge to the city's history of planning in this area as well as recent projects by powerful developers, including the sponsor of the plan, David Rockefeller, whose 1961 tower-and-plaza Chase Manhattan Building by Skidmore, Owings & Merrill exemplified the type of development that would be restricted in the plan's recommendations.[44] Nevertheless, by the time of its publishing, the Lindsay administration was in City Hall, and the 1966 plan and its design proposals were fully incorporated into the city's 1969 master plan, *The Plan for New York City*, and implemented through the newly created Office of Lower Manhattan Development.[45]

The turn to historical urbanism to provide new solutions for contemporary problems of scale and integration was an idea that was first developed in the 1950s by Team 10, a circle of young, experimental European architects that emerged from CIAM, an established international group of modern architects.[46] Just as the New York planners evoked Italian hill towns, the architects of Team 10 began to structure new forms of urbanism based on close examinations of traditional and vernacular architectures, from the North African casbah to London's East End, including the British architects Alison and Peter Smithson's exploration of "levels of association" and clusters in the built environment and the ideas of "web" and "stem" urbanism advanced by the firm Candilis-Josic-Woods (fig. **183**).[47] Their research focused on nonhierarchical types of informal housing and urban fabric built over time, with the goal of discovering generative structures for new development that were guided by social relationships, communication, and points of activity, not unlike the idea of "collective form" advanced by Fumihiko Maki, one of the first theorists of the megastructure, in 1964.[48] This point is particularly significant as Team 10 was one of the most important "proto-megastructural" groups of the 1960s. Its members included the American expatriate architect Shadrach Woods, the author of another project for the Lower Manhattan Expressway that used the existing fabric as a springboard for a very different type of intervention.

In 1969 Woods was given a one-year contract by the city to evaluate the social, economic, and environmental impact of the expressway and to create specific urban design proposals for the air rights within SoHo, an area of high residential density and sites of historical and cultural interest.[49] For this project, the last of his career, Woods employed a

variation of the models that he had developed in France with partners Georges Candilis and Alexis Josic for "textbook" megastructures built in Berlin and Toulouse combined with observations gleaned from his research and writing on the city.[50] From 1966 until his death in 1973, Woods explored the future of architecture in an "open society," seen from the point of view of the "man in the street."[51] One of the central themes of this study was the failure of contemporary cities to accommodate growth and change. In contrast, his ideal of a "radical progressive urbanism" was intended not merely to accommodate changing needs and attitudes over time but also to "contain many visions of the city," a synchronous view of the urban condition that also gestures to the impossibility of representing something as complex as New York.[52]

　　　During the course of his work on the expressway, the political situation shifted, and Woods based the recommendations in his final report on the correct assumption that the project would be abandoned by the Lindsay administration. Instead he proposed a mixed-use "experimental district" structured by new zoning regulations designed to promote the integration of industrial, commercial, and residential uses in Lower Manhattan. This program would not change the character of the district but rather would recognize and legalize its existing hybrid condition (fig. **184**).[53] Woods's survey extended special consideration to existing historic industrial structures in the area, including the nineteenth-century cast-iron facades along Greene and Broome Streets, which had recently been appropriated by artists as studios and live-work lofts.

184 Shadrach Woods, *Lower Manhattan Manufacturing District Renovation*, 1970. Ink drawing on paper. Avery Architectural & Fine Arts Library, Columbia University, New York

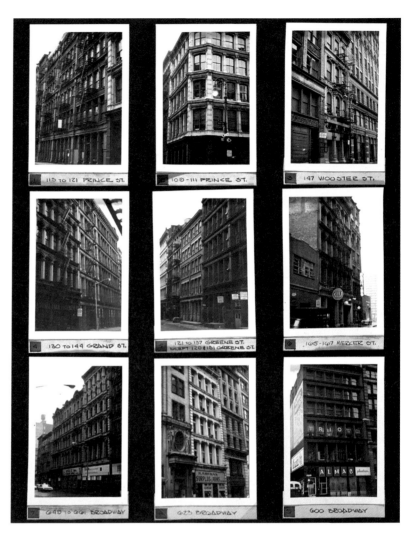

Woods's main source of information about these structures seems to have been an extensive photographic survey of two hundred cast-iron buildings in SoHo undertaken in 1964 by Giorgio Cavaglieri, an architect who specialized in historic preservation and alterations of older structures, and subsequently presented to the city's planning and housing officials.[54] Unlike preservationists who aimed for "purist" interpretations of historic buildings, Cavaglieri was known for his dramatic mixing of old and new elements, including a proposal in the late 1960s for a new housing project in SoHo that preserved one "landmark" cast-iron building as a freestanding structure.[55] Although the two architects may never have been in direct contact, it is clear that Woods's design process was greatly impacted by Cavaglieri's taxonomy of SoHo's cast-iron treasures, cataloged in their raw specificity by black-and-white snapshots of individual buildings, photographed in a deadpan style from the street (fig. **185**).

Just as Paul Rudolph had carefully adapted his "environmental architecture" to the context of Lower Manhattan, Woods's final urban design proposals for the Lower Manhattan Manufacturing District show a remarkable conceptual balance between conservation and redevelopment, incorporating not only a shift in scale but also one in temporality. This proposal replaced thirty-two existing blocks in SoHo with nine new superblocks offering optimal conditions for industrial and residential use.

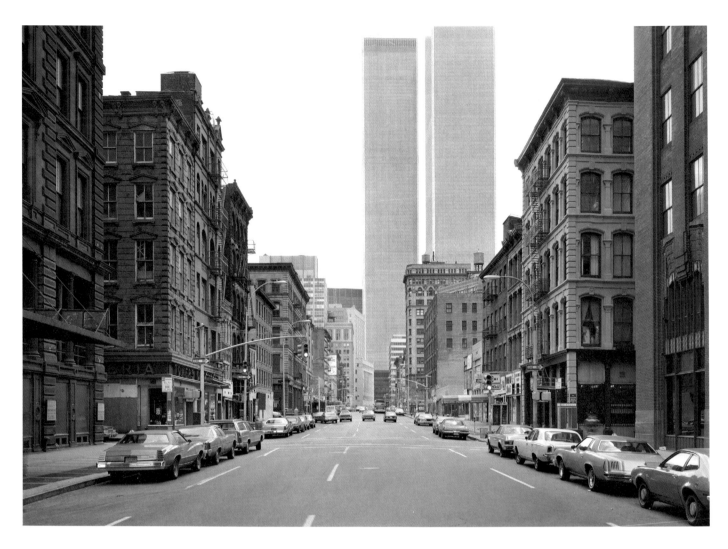

These superblocks would allow for expanded street width, large interior spans, modern loading facilities, and below-grade parking for factories while creating large raised "platforms" supporting new midrise housing blocks and decks for schools and community uses (see fig. **184**).

Instead of preserving cast-iron facades as sterile museum pieces adjacent to new construction, as in Cavaglieri's proposal, Woods deployed these historic structures as symbolic and functional bridges between the past and present in his mixed-use megastructure. He literally embedded these important icons of nineteenth-century American manufacturing into modern platforms housing new industries, allowing the older structures to continue to function as highly versatile live-work studios, offices, and galleries for artists. Woods's plan for these buildings reflected their multiple functions and took steps to encourage new uses for obsolete industrial buildings as a form of secondary economic activity within the revitalized industrial district, an ethos that he hoped might serve as an "essential prototype for the 21st century."[56]

This is but one example of the complex relationship between past and present in American cities during the 1960s and 1970s, in which the specificity and insistence of photography served as an important proxy for historical and social memory. Not limited to memorials, like Danny Lyon's elegiac project *The Destruction of Lower Manhattan*

186 Thomas Struth, *West Broadway, Tribeca, New York*, 1978. Gelatin silver print. Collection of Ann and Steven Ames, New York

187 Thomas Struth, *Dey Street, Tribeca, New York*, 1978. Gelatin silver print. Courtesy of Marian Goodman Gallery, New York

(1967; figs. **40–44**), photography could also embody a kind of accusation and demand. This quality links Woods's response to Cavaglieri's survey photographs and the complex nature of photographic "identification" or "evidence" in works such as Hans Haacke's *Sol Goldman and Alex DiLorenzo Manhattan Real Estate Holdings, a Real-Time Social System, as of May 1, 1971* (1971; figs. **93–95**). Although many artists and critics during this period lamented the loss of working-class communities and businesses in New York, Woods's project for Lower Manhattan was virtually unique in its goal to create a new kind of preservation, one that allowed for the potentially rich (even if cacophonous) clash of old and new in the built environment to avoid a total transformation of the existing community and historical identity of this neighborhood.[57]

From the megastructure's brush with environmental architecture and guerrilla preservation tactics, this critical engagement with the many scales and histories of New York expanded well beyond architecture to frame questions posed by photographers, filmmakers, performance artists, and many others. The stakes of these interventions were clear to artists in the late 1970s who took over the "beach" of landfill that would one day be Battery Park City and for Thomas Struth, a German photographer whose haunting photographs of New York, taken in 1978, demonstrate the unbelievable rupture in scale and history taking place between the newly completed World Trade Center and the surrounding streets (figs. **186, 187**).[58] Here the mammoth twin office buildings appear in the distance as a mirage, rendered completely undimensional and otherworldly against Struth's exploration of detail and diversity in the foreground of the photographs, including the vermiculated quoins of aging nineteenth-century buildings on Broadway and the concert posters and faded neon signage on Dey Street, marking a very different history of the street in Lower Manhattan.

Chicago

Chicago is distinguished among American cities for its tradition of visionary urban planning and modern architecture, including Daniel Burnham's 1909 Plan of Chicago, Ludwig Mies van der Rohe's design for the Illinois Institute of Technology campus (1939–58), and the John Hancock Center (1965–69) and Sears Tower (1970–73), groundbreaking skyscrapers that were among the tallest in the world. The centralization of power under Mayor Richard J. Daley formed a new chapter in this history and resulted in public projects of an unprecedented scale and impact, including new highways, airports, and public housing. Daley's transformations of Chicago's built environment also led to massive displacements of minority residents and the destruction of historic neighborhoods, just like Moses's infrastructure projects in New York.

By the late 1960s, however, Daley's interest in large-scale planning projects had weakened considerably due to a number of high-profile incidents, including public demonstrations and riots in the city, corruption charges against senior members of the administration, and pressure for social change following Martin Luther King Jr.'s movement for open housing in Chicago.[59] This uneven history of development left the city with large physical and psychological holes, including vast parking lots and vacant land just outside the densely built Loop and huge swaths of public housing to the south, west, and northwest that were physically cut off from more affluent areas of the city.

188 Art Sinsabaugh, photograph from *The Comprehensive Plan of Chicago*, published by the City of Chicago, Department of Development and Planning, 1966

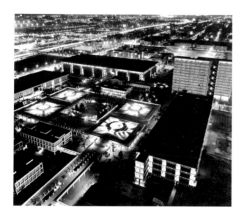

189 *University of Illinois Circle Campus*, ca. 1965. Courtesy of Skidmore, Owings & Merrill

In the face of this friction between the failures of the contemporary city and the great historical capacity for vision and large public works, the city's Department of Planning undertook a six-year study—the first master plan since the Burnham Plan—that resulted in *The Comprehensive Plan of Chicago* (1966), unique at the time for its clear focus on social goals in addition to recommendations about physical and economic planning.[60] Anticipating the innovative use of the work of Magnum photographers in the 1969 *Plan for New York City*, this document reinforced its attention to these goals with work by Art Sinsabaugh, a noted photographer who was also a general consultant on the plan.[61] Sinsabaugh's color photographs are a departure from his panoramic urban views, focusing on intimate scenes of daily life as well as on new forms of movement and communication in the city, such as the pedestrian space on the campus of the University of Illinois at Chicago (fig. **188**).

The University of Illinois Circle Campus (now UIC) would likely have fallen under Banham's subcategory of "Megastructure in Academe," which acknowledged universities as the most consistent clients for this type, in part for its promise (which often proved elusive) of building a city, or urban campus, ex nihilo. UIC's campus shared this origin, constructed after a particularly painful episode of protests and the expropriation and ultimate razing of the Harrison-Halsted neighborhood.[62] Although contemporary photographers were drawn to the unique spaces created by the megastructural layering of the raised amphitheater, towers, and monumental pedestrian ramps of the campus, it is clear that its driving inspiration was not the city street but the nearby highway and Circle Interchange (fig. **123**). This marvel of postwar transportation infrastructure provided the architect Walter Netsch of Skidmore, Owings & Merrill (SOM) with the scale and formal references to create an entirely new model of a campus for the twentieth-century commuting student, a goal he achieved to spectacular and alienating effect (fig. **189**).

More ambitious, albeit providing a less striking megastructural image, was another project by SOM that grew out of the 1966 *Comprehensive Plan*, as a set of planning guidelines and design proposals produced in a private-public partnership similar to the one that created the *Lower Manhattan Plan*. By 1970 the Chicago Plan Commission had published planning guidelines for all sixteen "development areas" designated in the *Comprehensive Plan* except the Loop, prompting the Central Area Committee, a group of businessmen, to sponsor a final study, titled Chicago 21.[63] The plan included remarkably prescient proposals for improved public transit and a reduction of downtown traffic, a Loop pedway linking high-rise buildings, expanded green space, and specific development recommendations for neighborhoods immediately north, west, and south of the Loop.

The major focus of this project was the redevelopment of six hundred acres of vacant land to the south once occupied by three passenger railroad stations. By the early 1970s these stations had closed, and the formerly busy tracks and rail yards had become a wasteland of decrepit warehouses, junkyards, and vacant lots at the foot of the tallest skyscraper in the world, the Sears Tower, which was nearing completion at this time (fig. **190**). Couched in rather bland language describing new housing and expanded city services, Chicago 21 advanced a plan for a complete South Loop "new town in town" (fig. **191**) for more than one hundred thousand residents in the form of a network of interconnected super-blocks with long bars of prefabricated terraced housing and high-rise

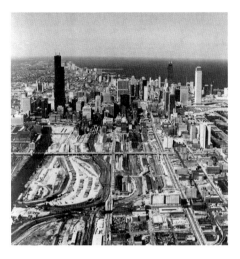

190 *View of South Loop, ca. 1974. Courtesy of the Chicagoland Chamber of Commerce*

191 Skidmore, Owings & Merrill, *Chicago 21, 1973*

192 Skidmore, Owings & Merrill, *Chicago 21*, 1973

towers, integrated retail, minitrain, and street-level and raised pedestrian systems, the latter enclosed in transparent Plexiglas tubes—in short, a megastructure (fig. **192**).[64]

The plan cautioned readers to understand this design as merely a framework for new neighborhood principles, yet the elaborate renderings of the streetscapes and the large accompanying model of the project displayed at the Chicago Civic Center were received as concrete design proposals, and local newspapers were quick to identify the plan's "futuristic superblocks" as a great departure from the history of Chicago development and a vision of the "inner city of the future."[65] The South Loop New Town was also a remarkable departure for the firm itself, which was better known for singular buildings, modernist housing, and conventional master plans. SOM had produced at least one other design study for the site in 1964, the South Central Opportunity Area, which responded to goals similar to those of Chicago 21, including the desire to get beyond "outmoded, static, narrow and unexamined" efforts in urban renewal and focus on urbanism that could promote diversity and social interaction and work against forces of economic stratification.[66] However progressive these social objectives, the drawings for this earlier study present plans for a single repeating group combining low bars and high-rise slabs on a field of open space that does not move beyond the mixed-height public housing projects developed in Chicago in the 1950s.

Instead the superstructure of the Chicago 21 plan was designed to engage with and repair the existing landscape, fabric, and networks of the city. Low-rise terraced housing defined a new continuous greenbelt along the river, and the scale of the major superblocks aimed to reestablish a pedestrian-friendly network of streets on the original Chicago grid, which had been erased through a century of industrial development. There is evidence that other, more experimental versions of the plan pushed this ideal of continuity and integration even further, and in one unpublished scheme for the project, the superblocks mimic the plan of formal gardens in the adjacent Grant Park, resulting in monumental stepped volumes with irregular massing the size of a city block (fig. **193**).[67]

The new neighborhood is resolutely urban, with linear bars of housing forming the street edge around the perimeter of each superblock and residential towers rising thirty stories above the bars to mark the corners of major intersections. The high-rises themselves vary in orientation to avoid a canyon effect and are most densely concentrated on State Street, a major commercial artery in the Loop as well as a corridor of high-rise public housing to the south.[68] As with Woods's proposal for Lower Manhattan, facilities for public use—including schools, clinics, shops, and office space—would be integrated into the street side of the terraced blocks, thus providing a contemporary version of the traditional American practice of "living above the store," ensuring that the development would provide a viable option for families.

In studies done for the project, Roger Seitz, the lead project architect, found that the public's resistance to high-rise living had less to do with the building type per se than with its failure to contribute to the neighborhood environment through strong "contact with the ground."[69] This explains in part the attention paid to the progression of scale and spaces from the street level to the high-rise, a quality that SOM partner William Hartmann likened to Moshe Safdie's visionary Habitat megastructure for Expo 67 in Montreal.[70] On the vertical plane then, the scale of Chicago 21 is modulated to provide public and private spaces with integrated shops and housing in five- to six-story bars lining the streets, and inside the blocks are terraced parks with recreation space and playgrounds.

Perhaps unsurprisingly, the plan evoked passionate responses in the public and professional communities concerning the issue of density, on both sides of the argument. Increased density for all the city's central areas was a major principle of Chicago 21, and the recommendations included the seemingly radical proposal to make the Cabrini-Green housing project on the Near North Side denser, with infill housing constructed in some of the vast and empty parks surrounding the high-rise towers to repair holes in the neighborhood's urban and social fabric.[71] Some architects criticized the South Loop plan's lack of single-family housing, and the controversial geographer and champion of the suburbs Pierre de Vise summarily declared the plan a failure as he saw no market for "high density urban living."[72]

In contrast, the architect Bertrand Goldberg felt that the project was not dense *enough* to support an affordable, mixed-income community with comprehensive educational, recreational, and commercial services. This was the ambitious goal of Goldberg's River City, which was among the first projects designed for the South Loop beginning in 1968, with a proposed density of 250 dwellings per acre versus Chicago 21's 110- to 185-per-acre range.[73] Goldberg's project—originally planned

193 Skidmore, Owings & Merrill, *Chicago 21*, 1973

194 Bertrand Goldberg,
Model for *River City I*,
Chicago, ca. 1974-76.
Gelatin silver print.
Bertrand Goldberg Archive,
Ryerson and Burnham
Libraries, Art Institute
of Chicago

195 Bertrand Goldberg,
River City I, Chicago,
sectional diagram, n.d. Ink
and Zip-A-Tone on tracing
paper. Art Institute
of Chicago, Gift of the
Goldberg Family

196 Alvin Boyarsky, *Chicago
à la Carte: The City as
an Energy System*, 1970.
Cover of a special issue
of *Architectural Design*,
December 1970. Alvin
Boyarsky Archive, London

for the same core area as the Chicago 21 plan—was deliberately megascale to house what he described as the necessary "critical mass of urbanism" in thirty seventy-two-story round towers clustered in triads on a large base plinth (fig. **194**).[74] The towers were proposed as a new kind of urban structure or organism, subdivided horizontally into three semi-independent neighborhoods spanning the tower clusters, with "community bridge" levels connecting the towers every eighteen floors to provide each group with its own post office, shops, and primary school (fig. **195**). While typologically linked to the modernist "tower in the park," Goldberg's project revamped this model through the networking of spaces and functions in the large substructure, including accommodations for transportation, health care, education, recreation, and commercial services; a pedway; and even light industry. Although the project had funding and was backed by many prominent academics and community leaders, the head of Chicago's City Planning Commission publicly and summarily rejected Goldberg's high-rise proposal as inappropriate for family living.[75]

The concept of the city as organism emerged alongside the megastructure during this period as a way to deal with the increasing complexity and interconnections of technology and communication and was informed by the ideas of thinkers and architects such as Marshall McLuhan, Buckminster Fuller, Christopher Alexander, and the Japanese Metabolists.[76] One exceptional project in this vein was the British architect Alvin Boyarsky's exploration of "the city as an energy system," tracing a hidden history of Chicago's built environment, published as an illustrated article in the journal *Architectural Design*.[77] Boyarsky created the project, titled "Chicago à la Carte," during his tenure as a professor and dean at the UIC School of Architecture during the late 1960s, drawing on an extensive archive of historical postcards, newspaper clippings, and ephemera. The notion of the palimpsest not only informed his distinctive approach to collage but also provided a way for him to describe the push and pull of history in the city, collapsing the temporal distance between the rise of canals and rail yards and the apotheosis of the Chicago Loop as "the tumultuous, active, mobile and everywhere dynamic centre of a vast distribution system."[78]

On the pages of the magazine, photographs of the muscular double-decker highway and bridges of Wacker Drive abut fantastical sketches by the Italian Futurist architect Antonio Sant'Elia for his La Città Nuova of 1914, illustrating the flow of ideas and images from the vernacular American city to experimental European architects. The fluidity of history and precedent allows us to imagine a similarly multivalent identity for Boyarsky's striking photo collage on the cover of the journal featuring a vivisection of Chicago's State Street exposing the subway tunnels belowground (fig. **196**). The image retains its identity as an early twentieth-century postcard focused on the novelty of State Street's dynamic layering of systems—including subway tunnels, sidewalks, El tracks, and skyscrapers—yet it also provides a visual and functional parallel to megastructural projects by Cedric Price and Alison Smithson published in neighboring issues of the same journal. This suggests yet another way in which the architecture of the megastructure can be understood to be already a part of the history of cities, endlessly repeating.

In the end, however, the visionary approach to scale and the urban complexity of Chicago 21 and River City failed to meet city approval, and they were executed only as vastly altered designs on small, self-contained sites (River City at forty-five and Chicago 21 at fifty-one acres). The SOM

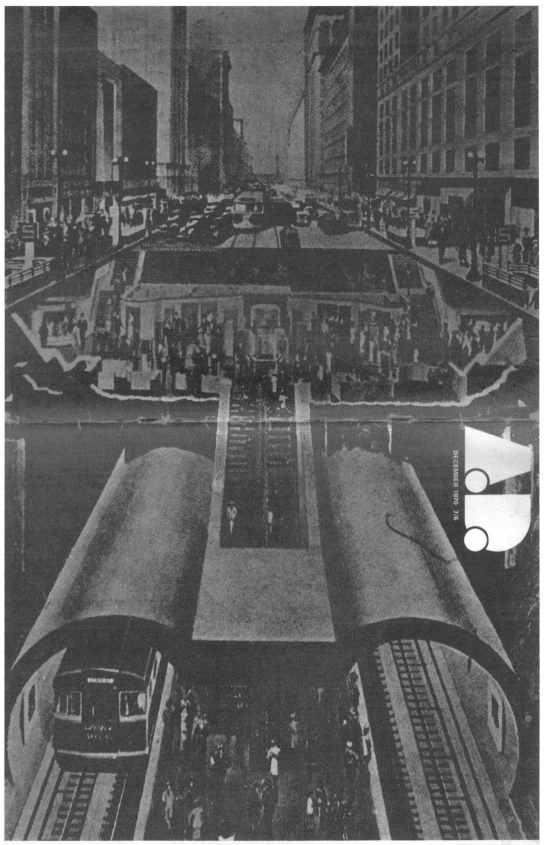

CHICAGO *à la carte* THE CITY AS AN ENERGY SYSTEM

196

designers were pressured by developers to make many revisions to their Chicago 21 plan, each one less dense and less integrated with the city than the one before.[79] Renamed Dearborn Park, the first stage of the built project consisted of two parks and fifteen hundred units of uninspiring housing in town houses and midrise buildings hidden from the neighborhood behind gates and fences, with none of the transportation improvements or public amenities envisioned in the original plan.[80] In many ways the greater South Loop remains a broken form of urbanism, with vast stretches of vacant lots and parking between discrete areas of housing, often in cul-de-sac or gated communities that only reinforce their rupture with neighboring streets and the lack of communication with the rest of the city through a common grid.

Los Angeles

It is hard to imagine anything more antithetical to the commonly held idea of Los Angeles, with its sprawling form and laissez-faire attitude toward development, than the megastructure. In fact, in his sweeping survey of megastructural activities, Banham was able to locate only a few examples of "mégastructures trouvées" with a connection to Los Angeles, including the Santa Monica Pier and the industrial landscape at Redondo Beach, which certainly, he argued, could have served as an inspiration for the "clip-on" aesthetic of some experimental architecture of the period.[81] Yet, like New York and Chicago, the city was engaged in a multiphase process in the late 1960s to define guidelines for growth and ideas about how the city might be "restructured" to find new solutions for social and environmental problems.[82]

The resulting plan revolved around the idea of "Centers," which served as shorthand for the plan's proposed creation of a large network of high-density, high-activity hubs in the city and region. Centers was one of four urban "concepts" studied as planning alternatives for the Los Angeles region, chosen over Dispersion, Corridors, and Low Density.[83] Set against the sprawling suburbs, *Concept Los Angeles* proposed a bold vision with high-density housing; the proximity of work, cultural, and recreational activities; and a focus on pedestrian life and mass transit. In Los Angeles, master planning for the "Centropolis"—the name of an earlier study exploring these themes—took on a new level of futurism, projecting a whole new way of life in the city: "Los Angeles, famous as the first great city to adapt to the automobile, can attain even greater fame as the first great city to adapt technology to man and make the pedestrian king."[84]

Concept Los Angeles was the first comprehensive plan undertaken by the City of Los Angeles, instigated in part by Calvin Hamilton, the new director of the Department of Planning, who had come to California after holding planning positions in Pittsburgh and Indianapolis.[85] Recent scholars have done much to dispel the myth that urbanism in Los Angeles amounts to unplanned sprawl extending from the arrival of the railroads in the late nineteenth century to the massive growth of new suburban developments at the urban periphery after World War II.[86] Nevertheless, it is true that the work of setting regulations and zoning for new growth was carried out in a much less centralized way than in other American cities in the twentieth century, largely by members of the city council and local municipal officials. The period of urban renewal in the 1950s and 1960s proved an exception of sorts, setting in motion plans for large-scale urban projects in areas near the downtown—including Chavez Ravine and Bunker Hill—many of which would be severely compromised, delayed, or

defeated due to political and economic conflict.[87] This situation led to a uniquely attenuated form of urban development, one that as early as 1922 was recognized as having developed "satellite sub-centers" around the greater downtown, each with its own individual character and identity.[88]

Concept Los Angeles identified as many as forty-eight potential centers in the City of Los Angeles and the greater metropolitan area, building on these historical areas of density and prioritizing five existing centers—downtown, Wilshire, Miracle Mile, Hollywood, and Beverly Hills—identified as "the regional core."[89] Although the plan did not seek to eliminate the typical form and character of Los Angeles urbanism, chiefly its horizontal spread, the major goal was to use these centers to knit together not only existing neighborhoods but the whole metropolitan region as well. The plan translated this concept into a bold graphic showing the centers as circles of varying sizes spanning Los Angeles County, from Long Beach to Burbank, all connected to the bright red circle of downtown through a dynamic network of radiating lines (figs. **197**, **221**). While not a diagram of a megastructure, this is most certainly a meganetwork, like the "ideograms" of Peter Smithson or collage diagrams by the British group Archigram.[90] The drawing of Los Angeles suggests a high degree of interaction, communication, and indeed a certain interdependence among the many centers or nodes, traits that would characterize architects' ideas about cybernetics and systems theory during this period as well as help define new ideas about communication and relationships in cities.[91] The form of the *Concept Los Angeles* Centers plan also took inspiration from its most proximate source of these ideas, the planner Kevin Lynch, who served as a special consultant on the preliminary *Concepts for Los Angeles* plan as well as for a plan on the visual environment of Los Angeles.

Lynch was best known for his 1960 book *The Image of the City*, which examined the question of the legibility of cities, understood here as the ability of individuals to navigate, understand, and identify with urban form. Through surveys that asked participants to describe (and draw) their "mental maps" of a certain neighborhood or urban area, he came up with a number of elements or functions of a city that impact its indelibility (the ability to provide a strong mental image) and ease of navigation, including paths, edges, districts, nodes, and landmarks. Although Lynch was hesitant to create firm rules for these elements at the scale of a city, he understood them as most impactful when considered as a whole, through principles of continuity as well as vividness and differentiation of character tuned to "functional and symbolic differences."[92]

It seems likely that these ideas helped develop the criteria for urbanism in *Concept Los Angeles*, and indeed the final report performs a Lynchian case study of the Miracle Mile—identified as a "conceptual activity diagram" showing different densities, nodes of activity, pedestrian paths, important public buildings, and hard edges of the freeway.[93] This exercise was to be repeated in each of the proposed centers to allow the city and region to take shape around streets rather than freeways and to provide a new network of points of intensity, continuity, and gradations of scale, much like the older forms of pedestrian-based urbanism. In aggregate, these centers would reduce commutes and traffic congestion and offer opportunities for social activity while creating a new rhythm and web of complexity in the city fabric.

Although the *Concept Los Angeles* report lacks the vivid documentary photographs and perfected prose found in other comprehensive

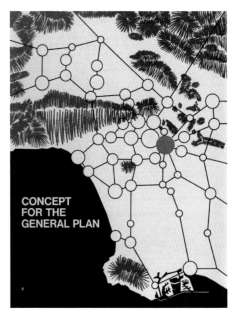

197 Page from *Concept Los Angeles: The Concept for the Los Angeles General Plan*, published by the Department of City Planning, Los Angeles, 1970

Fig. 6 Miracle Mile today

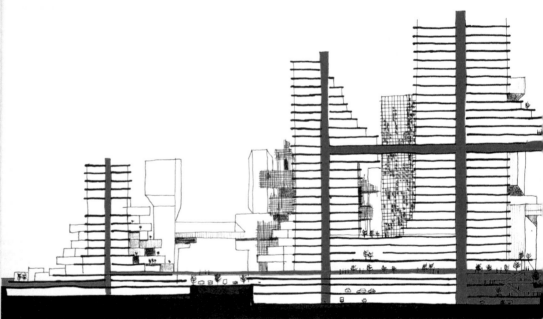

Fig. 8 Sectional view of center core

198 Spread from *Concept Los Angeles: The Concept for the Los Angeles General Plan*, published by the Department of City Planning, Los Angeles, 1970

16

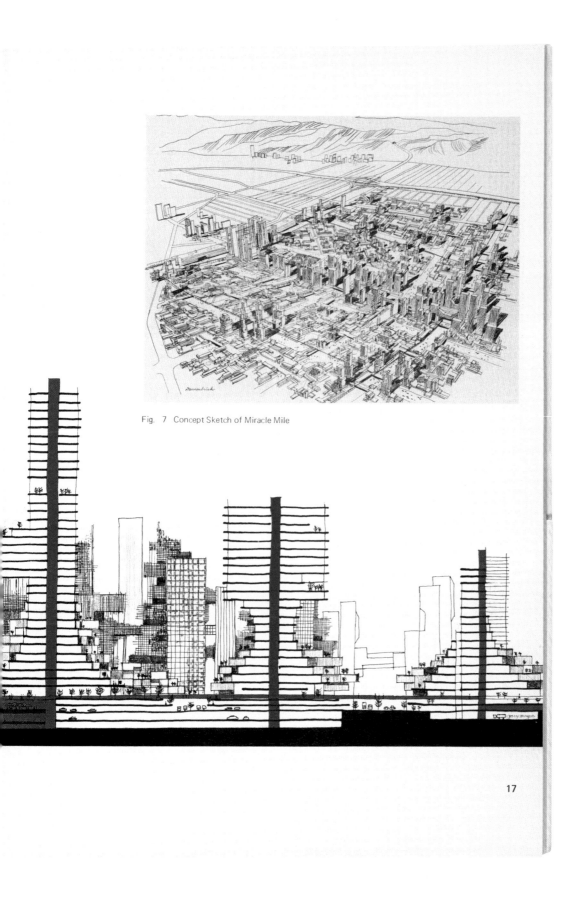

Fig. 7 Concept Sketch of Miracle Mile

199 Detail of a page from
Concept Los Angeles: The
Concept for the Los Angeles
General Plan, published
by the Department of City
Planning, Los Angeles, 1970

plans of the period, when it begins to move closer to the ground, it presents a very powerful, even visionary ideal for Los Angeles.[94] A spread in the center of the plan continues the case study of Miracle Mile, featuring a line drawing spanning two pages and paired with an aerial photograph of the present day and a concept sketch of its future growth (fig. **198**). The photograph on the left shows a distant view of this district, with a regular expanse of single-family houses interrupted only at the foot of the Hollywood Hills and by a few tall towers lining Wilshire Boulevard in front of huge parking lots. The "after" image shows the same view with the boulevard's linear form—Los Angeles's distinctive form of urban development[95]—transformed into a full-fledged center. Massive stepped buildings at the base of towers take the place of sprawling parking lots, and the residential fabric of the foreground is replaced by an interconnected low-rise, high-density mat building, constructed around and partially decking over San Vicente Boulevard.[96] (The Park La Brea apartment complex [1941–52] was apparently sufficiently distinctive and dense to survive this transformation intact.)

Given the logic of the page layout, the remarkable rendering at the bottom of the spread, simply identified as "sectional view of center core," would seem to illustrate a more generalized extrapolation of the lesson illustrated above. However, I would argue that this drawing functions as a kind of summa for the Centers concept, condensing its new structures and relationships into one megastructural core. On the most basic level, this cross section provides a view into the dense environment created by "three-dimensional" planning (à la Rudolph), cutting across three streets to extend a quarter mile from the central transit hub.[97] In the foreground, schematic sections of a variety of large towers grow from a common base containing transportation, parking, and rooftop terraced gardens. Bright red lines indicate the most important element of the plan—the pedestrian circulation network—just as Robert Moses signaled his own priorities in building new highways in Manhattan in 1955 (see fig. **9**).

As the viewer advances through the picture plane, a new scale emerges from two principal urban types, an array of midrise cantilevered buildings that are identified in perspective vignettes on subsequent pages as "high density residential nodes" organized around an elevated train and small shops and a "rapid transit station" depicted at the center of the master drawing (fig. **199**). The detail of this area reveals an urban center of great complexity, with three levels of transportation, including subway, conventional surface street, and elevated train or monorail system. The surrounding towers are massive, but the fabric is carefully modulated, with terracing and pedestrian bridges that step down in scale to the level of a quite traditional city street, complete with sidewalks, plantings, and street parking. Although visionary in its presentation of a new urban image, this modified megastructure seems to have more in common with Boyarsky's found image of the Chicago Loop's layered urbanism (see fig. **196**) than with any of the experimental architectures of the period.

Like many large-scale urban plans in Los Angeles, *Concept Los Angeles* was largely unrealized. The most visible symbol of this uneven history of planning, however, was Bunker Hill, an area whose long-deferred development left a raw and visible wound on the landscape that exists to the present. As early as 1950, the age-worn residential neighborhood was identified as "redevelopment area number one," and its complete rebuilding was the top priority for the Community Redevelopment

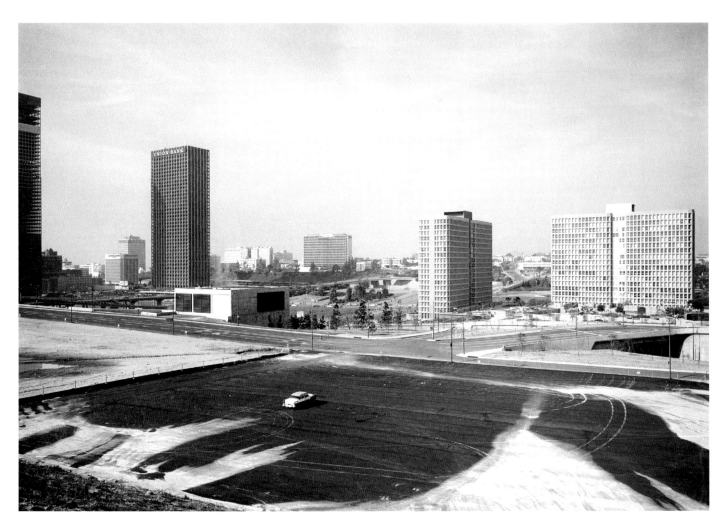

Agency (CRA) of Los Angeles.[98] The neighborhood was razed over the course of the next two decades and remained largely vacant until the 1980s while the city produced plan after plan for its redevelopment, resulting in a landscape that proved fascinating for photographers even as it stood for the failure of political will and planning (fig. **200**).

Several large buildings were constructed on the Bunker Hill "acropolis" during the 1960s and 1970s—most importantly John Portman's Bonaventure Hotel (1974–76; fig. **215**), a self-enclosed mega-structure of sorts—joined only by their common qualities of minimal engagement with and even hostility to the street.[99] Even Reyner Banham, who rejected standard narratives about cities in his study *Los Angeles: The Architecture of Four Ecologies*, paused to lament this fragmented and "gutless collection of buildings" before rejecting the idea of downtown as completely irrelevant in the face of the city's proven power of ad hoc regional development.[100] In 1979 the CRA pooled the last four uncommitted blocks of Bunker Hill and launched an open competition for the design of an office, commercial, residential, and recreational development anchored by an art museum and a "people mover," or monorail—representing the largest effort in the "20-year struggle to rebuild the former downtown slum."[101]

Early the following year, developer-led teams submitted proposals created by some of the most prominent architects, developers,

200 William Reagh,
Bunker Hill to soon be developed, 1971 (printed later). Inkjet print. Los Angeles Public Library

and consultants in North America. For example, the so-called All-Stars team, working with Maguire Partners, included the landscape architect Lawrence Halprin; the UCLA sociologist Harvey Perloff; and the architects Barton Myers, Cesar Pelli, Charles Moore, and Frank Gehry (who was then relatively unknown).[102] As was its customary approach, the board of the CRA served as the sole arbitrator of the competition and, as anticipated, selected the team assembled by the best-funded developer, notwithstanding the bland and rather undeveloped design submitted by the Bunker Hill Associates—working with the architects Arthur Erickson, Victor Gruen, and Kamnitzer, Cotton, Vreeland—and the massive public and professional support for the Maguire plan.[103]

However, these two finalists share a similar guiding ethos of postmodern, pedestrian-friendly urbanism. For the team assembled by Erickson, this focus stemmed from Gruen's experience designing malls and downtown plans.[104] The Maguire team, in contrast, was guided by ideals of diversity and complexity and a goal of capturing "the highly informal order" of streets and vernacular urbanism so celebrated by Jane Jacobs nearly twenty years earlier.[105] To this end, different architects on the Maguire team were responsible for the design of individual buildings, with the goal of emulating the effect of cities that grew up building by building over time, with no overarching guidelines or plan (fig. **214**). In this way, the Maguire team sought to realize the large-scale development that "looks and works like a real city."[106] A collective approach to urban design seems to push against the totalizing tendencies of the megastructure, yet Barton Myers, the project director, chose to illustrate the basic conception of the project with the dynamic layering of systems and functions of Rockefeller Center in New York, the proto-megastructure par excellence.[107]

This affiliation is most evident in the form of the complex's common stepped base and the continuous pedestrian system that weaves in and out of the diverse collection of towers and courtyards and is transformed on Grand Avenue into a different urban form: the arcade. The arcade functioned historically as a unifying urban structure tied to both buildings and the street, and the team took inspiration from the famous arcades of Bologna, Italy, or, in a more proximate example, from the wide public colonnade of the then recently restored Los Angeles Biltmore Hotel. In the Maguire team's plan, the arcade begins as a portico in an apartment building by Myers and extends through the ground levels of towers by Pelli and Ricardo Legorreta. Freestanding "portals" by Halprin and Moore reinforce this continuous passageway while signaling the entrance to public courtyards in between the tall buildings featuring gardens, fountains, and stepped seating.

The team's presentation stressed the importance of the lived experience of space rather than the design of any one building, a quality that they illustrated though a series of impressionistic sketches, or a "walking tour," by delineator Carlos Diniz. This tour begins at the border between the historic and new downtown areas, with the proposed complex seen in Diniz's sketch behind an intact block of early twentieth-century urban fabric (fig. **201**), before drawing the viewer into sequential vignettes of the lively pedestrian culture that would be fostered by arcades and squares (fig. **202**). Through the vivid depiction of street life, these renderings function rather like the "snapshot" photographs of everyday city life that appeared in planning documents of the late 1960s and early 1970s as well as the images of happy pedestrians in marketing brochures for the malls designed by Gruen.

201, 202 Carlos Diniz for Maguire Partners with Harvey Perloff, Barton Myers, Edgardo Contini, Charles Moore, Lawrence Halprin, Cesar Pelli, Hardy Holzman Pfeiffer, Ricardo Legorreta, Frank Gehry, Sussman/Prejza, and Robert Kennard. Renderings for *A Grand Avenue: The Maguire Partners Proposal, Bunker Hill, Los Angeles*, 1980. Ink on paper. Archive of Carlos Diniz / Family of Carlos Diniz

202

The All-Stars' extraction (or co-option) of historical urban elements or qualities of the unplanned city in *images*, rather than in their essential function, marks a definitive shift in the history of American urban development. In his review of the two finalist projects for Bunker Hill, the architect Rem Koolhaas, one of the most important critical voices of the following generation, recognized a reversal of conventional urban roles. The street, which would usually provide continuity and unity as the backdrop for buildings, becomes hyperdifferentiated—with a profusion of fountains, arcades, and gardens—while the towers remain neutral, exerting an "iconographic pressure" that pushes the street to "the 'interior' of the project."[108] Koolhaas's analysis goes on to argue that both projects failed because of their fear of being what they were, namely "large-scale developments," and, in doing so, ignored the model most capable of dealing with complex urban questions: the megastructure.[109]

· · ·

Born at a crucial moment of transition, the Maguire Grand Avenue proposal adopts in a rather unsatisfactory way aspects of both the megastructural moment and the New Urbanism to come.[110] In its stylized arcades, we can see the postmodern reliance on abstracted architectural elements from the historical city to reintroduce the pedestrian scale in the contemporary city or, more cynically, to reproduce the look of diversity without having to grapple with the complex entanglements of social and economic diversity found in mixed-income neighborhoods.[111]

In the end, it was not the megastructure, as Banham predicted, but new-old historical centers—from Battery Park City to the glittering district of the revitalized SoHo—that would become the preferred model for "maximizing the returns from urban redevelopment."[112] Yet at a critical moment in the 1960s and 1970s the megastructure succeeded in entering the fray over the future of publics, spaces, and streets in American cities. These projects were both products of the period's general interest in new urban forms and systems and unique to their specific contexts and histories. Successful or not in their application, they went against the grain of disciplinary trends and developers' tastes to engage with the problems of the contemporary city, imagining more integrated forms of urban development that could relate to historical cities yet insist on the vital force of the new.

1 See, among other books by architects, Bernard Rudofsky, *Streets for People: A Primer for Americans* (New York: Doubleday, 1969); Shadrach Woods, *The Man in the Street: A Polemic on Urbanism* (New York: Penguin, 1975); and Stanford Anderson, ed., *On Streets* (Cambridge, MA: MIT Press, 1978).

2 The planning librarian Ralph Wilcoxon published the first "official" definition of the term *megastructure* in his "Megastructure Bibliography" of 1968, cited by Reyner Banham, *Megastructures: Urban Futures of the Recent Past* (New York: Harper & Row, 1976), 8. The other important early study of this movement is the Japanese architect Fumihiko Maki's *Investigations in Collective Form* (St. Louis: Washington University School of Architecture, 1964).

3 Banham, *Megastructures*, 10.

4 The participatory community programs of President Johnson's Great Society were also structured around questions of scale and influence in politics and social policy. See, among others, Robert Halpern, *Rebuilding the Inner City: A History of Neighborhood Initiatives to Address Poverty in the United States* (New York: Columbia University Press, 1995).

5 See, among many others, Charles Jencks, *The Language of Post-modern Architecture* (New York: Rizzoli, 1977), 9–10, and Peter Blake, *Form Follows Fiasco: Why Modern Architecture Hasn't Worked* (Boston: Little, Brown, 1977).

6 Elizabeth Wood, "Realities of Urban Redevelopment," *Journal of Housing* 3 (December 1945): 13–14. Of course modern architects had always dreamed of total control, from Daniel Burnham's 1910 exhortation to "make no little plans," to the tabula rasa approach of Le Corbusier's Ville Radieuse of 1924, to Walter Gropius's book *Scope of Total Architecture* (New York: Harper, 1955).

7 The bibliography on urban renewal is too vast to summarize here. Critical views on the topic came from many political perspectives, including those of the classic urban liberal Jane Jacobs (*The Death and Life of Great American Cities* [New York: Random House, 1961]); the Marxist architect Robert Goodman (*After the Planners* [New York: Simon & Schuster, 1971]); and supporters of free-market capitalism like Martin

Anderson (*The Federal Bulldozer* [Cambridge, MA: MIT Press, 1964]).

8 Jane Jacobs, "Downtown Is for People," in *The Exploding Metropolis*, ed. William H. Whyte Jr. (Garden City, NY: Doubleday, 1958), 141.

9 Jacobs, *Death and Life*. See especially the chapters "The Need for Aged Buildings," 187–99, and "Slumming and Unslumming," 270–90.

10 Ibid., 13.

11 Banham, *Megastructures*, 130. This ambiguity of roles is a by-product of the complex history of planning in the United States. As late as the 1960s, the American profession of urban planning was in a state of relative infancy, having developed during the course of the twentieth century through the work of a varied group of professionals, including architects, landscape architects, engineers, social reformers, politicians, housing advocates, sociologists, and writers and critics. There were only two planning programs in the country until the 1940s (most were established in the late 1960s and 1970s), but as early as the 1930s the discipline had begun to shift away from the physical aspects of planning, leaving this activity to architects. See Mel Scott, *American City Planning since 1890* (Berkeley: University of California Press, 1971), and M. Christine Boyer, *Dreaming the Rational City: The Myth of American City Planning* (Cambridge, MA: MIT Press, 1986).

12 Urban design was a fledgling field during this period, having first been established as a university program at Harvard in 1960. A seminal conference on urban design at Harvard in 1956 set the stage for the foundation and goals of the new discipline, such as addressing problems of scale in contemporary practices of architecture and urban planning. See "Report of Harvard Conference," *Progressive Architecture* 37 (August 1956): 97–112, and "The Origins and Evolution of 'Urban Design,' 1956–2006," special issue, *Harvard Design Magazine*, no. 24 (Spring–Summer 2006).

13 The bibliography on this phenomenon is vast, but strong contemporary coverage can be found in architectural journals of the period as well as in books by the French critic Michel Ragon. See also Larry Busbea, *Topologies: The Urban Utopia in France, 1960–1970* (Cambridge, MA: MIT Press, 2007);

Terence Riley, ed., *The Changing of the Avant-garde: Visionary Architectural Drawings from the Howard Gilman Collection* (New York: Museum of Modern Art, 2002); Simon Sadler, *Archigram: Architecture without Architecture* (Cambridge, MA: MIT Press, 2005); and Felicity Scott, *Architecture or Techno-Utopia: Politics after Modernism* (Cambridge, MA: MIT Press, 2007).

14 This ideal of "autonomous and self-referential" architectural practice and theory—positioned against the modernist traditions of functionalism and socially engaged practices—made a splashy public debut in the 1969 Museum of Modern Art (MoMA) exhibition and subsequent publication *Five Architects: Eisenman, Graves, Gwathmey, Hejduk, Meier* (New York: Museum of Modern Art, 1972), organized by Arthur Drexler and Colin Rowe. This project of autonomy continued to mutate and gain traction throughout the second half of the twentieth century and was identified (correctly or incorrectly) by labels such as neorationalism, neo-avant-garde, postmodern, deconstruction, postfunctionalism, and postcritical. See Michael Osman et al., eds., "Mining Autonomy," special issue, *Perspecta*, no. 33 (June 2002), and Robert Somol, ed., *Autonomy and Ideology: Positioning an Avant-garde in America* (New York: Monacelli, 1997).

15 Manfredo Tafuri, *Architecture and Utopia: Design and Capitalist Development*, trans. Barbara Luigia La Penta (Cambridge, MA: MIT Press, 1976), 176, 171.

16 For most architects, the move to autonomy was gradual. Peter Eisenman, for example, was involved with urban projects in the mid-1960s, including his Linear City or Jersey Corridor Project, published in the December 1965 special issue of *Life* magazine, "The U.S. City: Its Greatness Is at Stake." His project for the Manhattan waterfront was included in the 1967 MoMA exhibition *The New City: Architecture and Urban Renewal*.

17 Ada Louise Huxtable, "How to Build a City, If You Can," *New York Times*, March 12, 1967.

18 In the postwar period Robert Moses was the mastermind behind plans to build a number of highways through densely populated parts of New York, including the Cross-Bronx Expressway and the unrealized Mid-Manhattan and Lower Manhattan Expressways. For more, see Robert A. Caro, *The Power Broker:*

Robert Moses and the Fall of New York (New York: Vintage, 1975).

19 Banham, *Megastructures*, 10.

20 Ibid., 209.

21 By the time of Rudolph's design, the expressway was already the subject of extraordinary public criticism, led by Jane Jacobs, the chairman of the Stop the Lower Manhattan Expressway Committee. See Anthony Flint, *Wrestling with Moses: How Jane Jacobs Took on New York's Master Builder and Transformed the American City* (New York: Random House, 2009), 181.

22 Ada Louise Huxtable, "Where It Goes Nobody Knows," *New York Times*, February 2, 1969.

23 Paul Rudolph to W. McNeil Lowry, June 1, 1965, Ford Foundation Archives, Reel C1479, Rockefeller Archive Center.

24 Sigmund Koch to Paul Rudolph, July 9, 1965, Ford Foundation Archives, Reel C1479, Rockefeller Archive Center.

25 Ibid. In the 1960s and 1970s the Ford Foundation funded a variety of programs in urban neighborhoods, including antipoverty and education initiatives, programs to combat racial discrimination in housing and voting, and community development corporations. Despite the real social value of these programs, it is also clear that one of the foundation's overarching goals was to make large cities in the United States socially and politically stable enough for private investment, including "problem areas" such as the Lower East Side, where a close ally of the foundation, David Rockefeller, had made major real estate investments. See G. William Domhoff, "The Ford Foundation in the Inner City: Forging an Alliance with Neighborhood Activists" (September 2005), http://www2.ucsc.edu/whorulesamerica/local/ford_foundation.html, and Joan Roelofs, *Foundations and Public Policy: The Mask of Pluralism* (Albany: State University of New York Press, 2003).

26 Paul Rudolph and Ulrich Franzen, "A Proposal to Study New Forms of the Evolving City," 1–3, part of the grant proposal dated March 21, 1967, Ford Foundation Archives, Reel C1540. Rudolph's reference to Le Corbusier as the source of contemporary problems in American cities was (and is) as widespread as it was inaccurate. Among the very few scholars to point out the independent development of superblock urbanism in the United States is Jonathan Barnett in his very lucid history *The Elusive City: Five Centuries of Design, Ambition, and Miscalculation* (New York: Harper & Row, 1986).

27 Rudolph and Franzen, "Proposal," 3–4.

28 Ibid., 10.

29 Ibid., 4.

30 Robert Moses, quoted in Caro, *Power Broker*, 849. The authors of the catalogue of an exhibition on the project claim that Rudolph intended the expressway to be inserted in the rear yards behind buildings fronting Broome and Spring Streets, but this seems unlikely

given that any existing yards would run perpendicular to the path of the new development. Steven Kilian, Ed Rawlings, and Jim Walrod, *Paul Rudolph: Lower Manhattan Expressway* (New York: Drawing Center, 2010), 32.

31 Although recent reevaluations have upheld the ambition of Moses's plans for New York, he did not encourage innovative architectural design, leaving such decisions to developers, and favored a traditional style for public projects. For a revisionist view, see Hilary Ballon, *Robert Moses and the Modern City: The Transformation of New York* (New York: Norton, 2007).

32 *The Threatened City: A Report on the Design of the City of New York* (New York: Mayor's Task Force on Urban Design, 1967). Lindsay established the Urban Design Group, staffed by architects from Yale University, in April 1967. See Jonathan Barnett, *Urban Design as Public Policy* (New York: Architectural Record, 1974). See also Paul Goldberger, "A Design-Conscious Mayor: The Physical City," in *Summer in the City: John Lindsay, New York, and the American Dream*, ed. Joseph P. Viteritti (Baltimore: Johns Hopkins University Press, 2014), 139–62.

33 Lowry to Bundy, grant action request, 3. They do, however, mention Rudolph's discussions with Mayor Lindsay.

34 *The Evolving City: Design Proposals by Ulrich Franzen and Paul Rudolph* (New York: American Federation of Arts, 1974), 61.

35 Kenneth Frampton, *Megaform as Urban Landscape* (Urbana: University of Illinois, 2010). This study builds on Frampton's 1978 essay "The Generic Street as a Continuous Form," in *On Streets*, 308–37.

36 Paul Rudolph, "The Six Determinants of Architectural Form," *Architectural Record* 120 (October 1956): 183.

37 Ibid., 194.

38 Ibid., 186.

39 The Lower Manhattan Plan was commissioned by the Downtown–Lower Manhattan Association— a group of local businessmen that included heads of banks, public utilities, and shipping companies—and executed by a team of consulting architects, planners, and transportation experts under the direction of the Planning Commission chairman under the Wagner administration, William Ballard. See Carol Willis, ed., *The Lower Manhattan Plan: The 1966 Vision for Downtown New York* (1966; New York: Princeton Architectural Press, 2002).

40 Ibid., 71.

41 Ibid., 72.

42 A very similar design and planning strategy, also developed by a team that included Conklin & Rossant, was undertaken for the unrealized 1969 Battery Park City Plan. See David L. A. Gordon, *Battery Park City: Politics and Planning on the New York Waterfront* (Amsterdam: Gordon & Breach, 1997).

43 *Lower Manhattan Plan*, 72.

44 The Chase Manhattan Bank was among the first of an influential new generation of tower-and-plaza developments in New York (immediately followed by the 1958 Seagram Building by Ludwig Mies van der Rohe) responsible for changes in the city building code allowing for taller towers offset by open public space, usually in the form of a plaza. For more on this change, see Phyllis Lambert, *Building Seagram* (New Haven, CT: Yale University Press, 2013).

45 City Planning Commission, *The Plan for New York City: A Proposal*, vol. 4, *Manhattan* (Cambridge, MA: MIT Press, 1969), 20–28.

46 CIAM, the Congrès International d'Architecture Moderne, was founded in 1928 by a group of modern architects that included Le Corbusier and later Walter Gropius. See Eric Mumford, *The CIAM Discourse on Urbanism, 1928–1960* (Cambridge, MA: MIT Press, 2002), and Max Risselada and Dirk van den Heuvel, eds., *Team 10, 1953–1981: In Search of a Utopia of the Present* (Rotterdam: NAi, 2005).

47 For more on Italian hill towns as a model for experimental and megastructure architects during this period, see Hermann Schlimme, "The Mediterranean Hill Town: A Travel Paradigm," in *Travel, Space, Architecture*, ed. Miodrag Mitrašinović and Jilly Traganou (Farnham, UK: Ashgate, 2012). See also Alison and Peter Smithson, *Ordinariness and Light: Urban Theories, 1952–60, and Their Application in a Building Project, 1963–70* (London: Faber & Faber, 1970), and Tom Avermaete, *Another Modern: The Post-war Architecture and Urbanism of Candilis-Josic-Woods* (Rotterdam: NAi, 2005).

48 Maki, *Investigations in Collective Form*.

49 Contract draft, January 24, 1969, D&A Woods, box 3, Department of Drawings & Archives, Avery Architectural & Fine Arts Library, Columbia University.

50 Candilis-Josic-Woods's Free University Berlin (1963) and New Town Toulouse–le Mirail are featured in Banham's *Megastructures*. For more on their work, see Avermaete, *Another Modern*.

51 Shadrach Woods, "The Man in the Street," *Bauen + Wohnen* 20 (July 1966): 268–76. His book of the same title, published posthumously as *The Man in the Street: A Polemic on Urbanism* (New York: Penguin, 1975), builds on earlier research, including his proposal for SoHo.

52 Woods, *Man in the Street*, 28.

53 Woods, untitled report, 14, box 3. Much of the study is geared toward ideas that would save SoHo's potential for light industry and create a renewed concentration of blue-collar jobs, which Woods believed should be the first priority of a city plagued by deindustrialization and pressures on housing and welfare programs.

54 See letters by Cavaglieri and a copy of his SoHo album (dated February 13, 1967, and July 15, 1964, respectively) in the Shadrach Woods collection, D&A Woods, box 3, Department of Drawings & Archives,

Avery Architectural & Fine Arts Library, Columbia University. I suspect that Woods was simply given this material by planning officials as background at the time of his commission.

55 Christopher Gray, "Near 88, Preservationist Is Still a Maverick," *New York Times*, July 25, 1999.

56 Woods, untitled report, 19.

57 Ibid., 2. Woods explicitly stated his belief (now proved) that if the district was not redeveloped and was allowed to lose its remaining manufacturing jobs, SoHo would be under severe pressure to transform to a "higher economic use" and stood to lose any link to its historical identity.

58 Art on the Beach was a series of performances and installations initiated in 1978 by the nonprofit arts organization Creative Time on the derelict area of landfill on which Battery Park City was constructed in the 1980s. See Anne Pasternak, *Creative Time: The Book; Thirty-Three Years of Public Art in New York* (New York: Princeton Architectural Press, 2007).

59 For more on Daley's impact on the built environment, see Carl Condit, *Chicago, 1930–70: Building, Planning, and Urban Technology* (Chicago: University of Chicago Press, 1974), and essays in John Zukowsky, ed., *Chicago Architecture and Design, 1923–1993: Reconfiguration of an American Metropolis* (Munich: Prestel; Chicago: Art Institute of Chicago, 1993).

60 Condit, *Chicago 1930–70*, 274. See also D. Bradford Hunt and John B. DeVries, *Planning Chicago* (Chicago: American Planning Association, 2013).

61 The consultants for the 1966 plan included, among others, the prominent planners Frederick T. Aschman and George Barton; the geographer Harold M. Mayer; and Art Sinsabaugh. For more on the use of photography in this plan and its predecessor, *Basic Policies for the Comprehensive Plan of Chicago* (1964), see Greg Foster-Rice's essay in this volume, pages 18–47.

62 The community's valiant battle to save this historic neighborhood was another low moment for the Daley administration's public relations and an especially sore spot considering the large quantity of vacant land located just southeast of the campus, discussed below. See Sharon Haar, *The City as Campus: Urbanism and Higher Education in Chicago* (Minneapolis: University of Minnesota Press, 2011).

63 *Chicago 21: A Plan for the Central Area Communities* (Chicago: Chicago Plan Commission, 1973).

64 Precise identification of the design team is difficult. Associate partner Roger Seitz—at the time the lead planner of the firm—headed the project, as reported in *Architectural Forum* in 1974, while partner William E. Hartmann was its public face. Partner Bruce Graham seems to have taken a more hands-on role in the later 1970s as the project shifted to become Dearborn Park. Interestingly, Chicago is identified in the same issue of the journal as a hub for vertical "cities within a city," a genre of multiuse buildings that include Bertrand Goldberg's Marina City, the SOM John Hancock Center,

and Water Tower Place by Loebl, Schlossman, Bennett and Dart. See Paul Gapp, "Chicago 21," *Architectural Forum* 140 (January–February 1974): 32–43.

65 *Chicago 21*, 30–31. See "100,000 Residents in Futuristic Superblocks," *Chicago Sun-Times*, May 15, 1973, and Paul Gapp, "Chicago Future on View," *Chicago Tribune*, November 4, 1973.

66 Skidmore, Owings & Merrill, "A Research and Development Study Proposal for the South Central Opportunity Area," October 9, 1964, 2, Skidmore, Owings & Merrill Archives, Chicago, job number 5754. It is not known whether this project ever moved beyond the proposal phase.

67 See digitized slides in the Skidmore, Owings & Merrill Archives, Chicago, Project: Chicago 21 (Chicago Central Area Plan 1973), IdAM#: 21695408-09.

68 State Street was also ground zero for the "revitalization" of the Loop as a prestigious shopping street that had transitioned to serve a lower-income, largely African American clientele, after the South Side lost nearly all its local businesses to urban renewal during the postwar period.

69 Nory Miller, "South Loop New Town: Can It Make It?" *Inland Architect* 18 (October 1974): 8.

70 Quoted in Gapp, "Chicago 21," 33.

71 *Chicago 21*, 41–45. The 1970s were a bleak time for violence and crime in Cabrini-Green, and in this context, the idea of further investment in new construction and increased density seems particularly bold.

72 Pierre de Vise, quoted in Miller, "South Loop New Town," 10.

73 Bertrand Goldberg, "Oral History of Bertrand Goldberg," interview by Betty J. Blum, Chicago Architects Oral History Project, Art Institute of Chicago, 1992 (rev. 2001), 258. In fact, River City developed out of an early survey of 350 acres of the South Loop rail properties undertaken by Goldberg and the former CEO of Commonwealth Edison, J. Harris Ward, which was taken over by Thomas Ayers around 1970 to become the basis for Chicago 21. See Goldberg, "Oral History," 251–64.

74 Bertrand Goldberg, "The Critical Mass of Urbanism," January 1984, Bertrand Goldberg Papers, Chicago. See also the essays by Elizabeth Smith and Sarah Whiting in *Bertrand Goldberg: Architecture of Invention*, ed. Zoë Ryan (Chicago: Art Institute of Chicago, 2011).

75 Goldberg, "Oral History," 260–61.

76 See Mark Wigley, "Network Fever," *Grey Room* 4 (Summer 2001): 82–122, and Sarah Jinyong Deyong, "The Creative Simulacrum in Architecture: Megastructure, 1953–1972" (Ph.D. diss., Princeton University, 2008).

77 Alvin Boyarsky, "Chicago à la Carte: The City as an Energy System," *Architectural Design* 40 (December 1970), 595–622. For more on Boyarsky, see Igor

Marjanovic, "Alvin Boyarsky's Chicago: An Architectural Critic in the City of Strangers," *AA Files*, no. 60 (Spring 2010): 45–52.

78 Boyarsky, "Chicago à la Carte," 602.

79 Wille, *At Home in the Loop*, 65–67.

80 This conservative ethos was not, unfortunately, limited to architecture. Ferd Kramer, one of the project leads, advocated strongly for racial quotas and preferential treatment of white applicants for rental units in Dearborn Park, and the new residents battled to exclude children living in nearby public housing from the new school constructed for the development. See ibid., 69, and the chapter "Our Neighborhood Lost Its School," 141–56.

81 Banham, *Megastructures*, 18, 36.

82 *Concept Los Angeles: The Concept for the Los Angeles General Plan* (Los Angeles: Department of City Planning, 1970), 1.

83 Ibid., 7.

84 City Planning Department, "A Preliminary Concept in Planning for the Central City," working paper, October 28, 1969, Los Angeles City Archives, box C-1201. See also *Centropolis: The Plan for Central City Los Angeles* (Los Angeles: Los Angeles Central City Committee, 1964). Greg Hise has argued that the rush to view the city an archetype, for better or worse, is unique to Los Angeles. See "Situating Stories: What Has Been Said about Landscape and the Built Environment," in *A Companion to Los Angeles*, ed. William Deverell and Greg Hise (Malden, MA: Wiley-Blackwell, 2010), 393–420.

85 Vinit Mukhija, "The 1970 Centers Concept Plan for Los Angeles," in *Planning Los Angeles*, ed. David Sloane (Chicago: American Planning Association, 2012), 39, 296n2.

86 See Todd Gish, "Challenging the Myth of an Unplanned Los Angeles," in Sloane, *Planning Los Angeles*, 19–34, as well as Michael Dear, H. Eric Schockman, and Greg Hise, eds., *Rethinking Los Angeles* (Thousand Oaks, CA: Sage, 1996), and Wim de Wit and Christopher James Alexander, eds., *Overdrive: L.A. Constructs the Future, 1940–1990* (Los Angeles: Getty Research Institute, 2013), among many others.

87 For more on housing and urban renewal in Los Angeles, see Dana Cuff, *The Provisional City: Los Angeles Stories of Architecture and Urbanism* (Cambridge, MA: MIT Press, 2000), as well as her essay in this volume, pages 250–53.

88 George Damon, a member of the Regional Planning Commission, quoted in Michael Dear, H. Eric Schockman, and Greg Hise, "Rethinking Los Angeles," in *Rethinking Los Angeles*, 7.

89 *Concept Los Angeles*, 11.

90 These examples are taken from Wigley, "Network Fever," 82–122.

91 See, among others, Scott, *Architecture or Techno-Utopia*.

92 Kevin Lynch, *The Image of the City* (Cambridge, MA: MIT Press, 1960), 109.

93 *Concept Los Angeles*, 15.

94 These include *Concepts for Los Angeles: Summary* (Los Angeles: Department of City Planning, 1967) and *Goals: Planning Goals for the Los Angeles Metropolis* (Los Angeles: Department of City Planning, 1967). For more on these early plans, see Greg Foster-Rice's essay in this volume, pages 18–47.

95 Eric Avila, "All Freeways Lead to East Los Angeles," in de Wit and Alexander, *Overdrive*, 37.

96 For more on the mat building, a subset of mega-structure, see Eric Mumford, "The Emergence of Mat or Field Buildings," in *Case: Le Corbusier's Venice Hospital and the Mat Building Revival*, ed. Hashim Sarkis (Munich: Prestel, 2001), 48–65.

97 *Concept Los Angeles*, 15.

98 Peter Zellner, "Downtown . . . Again," in "A Note on Downtown," eds. Vinayak Bharne and Alan A. Loomis, special issue, *Los Angeles Forum for Architecture and Urban Design Annual* 6 (Summer 2004), http://laforum .org/content/articles/downtown-again-by-peter-zellner. The City of Los Angeles Community Redevelopment Agency produced reports and new plans for the redevelopment of Bunker Hill in 1951, 1958, 1970, 1977, and 1982.

99 William H. Whyte's charming film *The Social Life of Small Urban Spaces* (1979) describes the Bonaventure as "dramatically scaled to the freeway" and as belonging to a category of buildings that take you away from the street.

100 Reyner Banham, *Los Angeles: The Architecture of Four Ecologies* (1971; Berkeley: University of California Press, 2001), 183.

101 Ray Hebert, "Five Groups Seek to Develop Huge Complex on Bunker Hill," *Los Angeles Times*, March 6, 1980.

102 Material on the CRA and the competition can be found in the Bunker Hill Redevelopment Project Records, Collection 0226, Special Collections, University of Southern California Libraries, Los Angeles.

103 John Pastier, "Grand Avenue," *Architecture and Urbanism* 81 (August 1981): 20. See also John Dreyfuss, "Commentary: Bunker Hill Project Massive, Uninspiring," *Los Angeles Times*, August 11, 1980.

104 Victor Gruen was famous for his designs for shopping malls and the first pedestrian-only downtown for Forth Worth, Texas, in 1955. Although unrealized, this project and his writing on cities were very influential for the field of urban design. See Victor Gruen, *The Heart of Our Cities: The Urban Crisis; Diagnosis and Cure* (New York: Simon & Schuster, 1964).

105 Pastier, "Grand Avenue," 20.

106 Ibid.

107 Barton Myers, "A Grand Avenue: Design Process," *Architecture and Urbanism* 81 (August 1981): 26. For more on the role of Rockefeller Center in the history of American urban development, see Manfredo Tafuri, "The Disenchanted Mountain: The Skyscraper and the City," in *The American City: From the Civil War to the New Deal*, ed. Giorgio Ciucci (Cambridge, MA: MIT Press, 1979), 389–528.

108 Rem Koolhaas, "Arthur Erickson vs. the 'All-Stars'" (1981), in *Everything Loose Will Land: 1970s Art and Architecture in Los Angeles*, ed. Sylvia Lavin (West Hollywood, CA: MAK Center for Art and Architecture, 2013), 253.

109 Ibid., 255.

110 New Urbanism describes a form of largely private development that emerged in the late 1970s and early 1980s. Like the Maguire plan, these developments borrow symbols and forms from historical urbanism to make cities more welcoming and to introduce pedestrian space and "place making" to suburbs and large housing complexes. They are often character-ized by highly centralized, and often invisible, forms of control over access and behavior. For more, see the postscript in this volume.

111 Mike Davis notes that while the new downtown has become more pedestrian-friendly, this is true only for those *inside* the acropolis; it is distinctly hostile to pedestrians attempting to enter the area from the lower-income commercial district of Broadway, which, ironically, has always been a vibrant and diverse histor-ical urban fabric. Mike Davis, *City of Quartz: Excavating the Future in Los Angeles* (New York: Vintage, 1992), 230–31.

112 Banham, *Megastructures*, 10.

Los Angeles

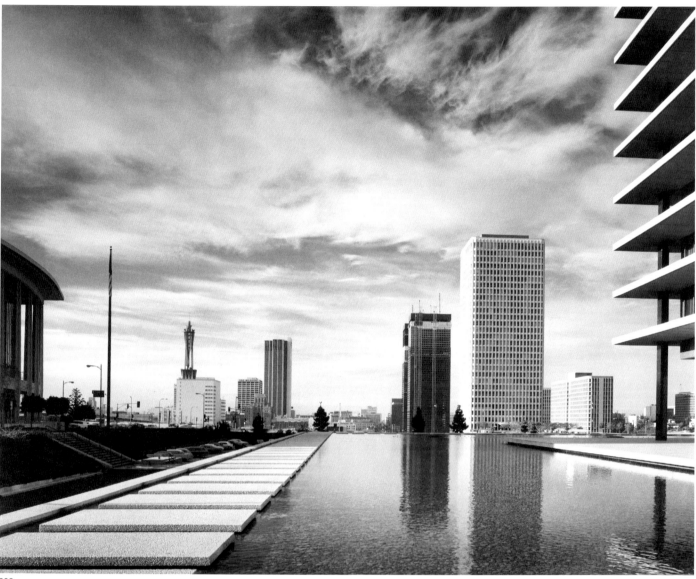

203

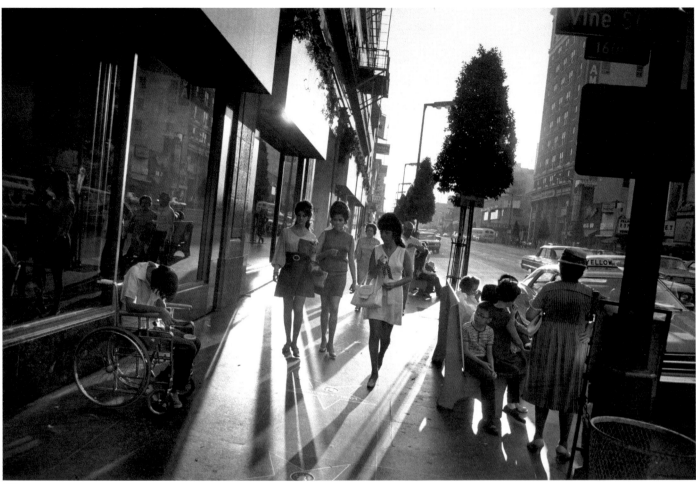

204

203 Julius Shulman, *View of Bunker Hill to the South from Department of Water and Power Building (Los Angeles, California)*, 1971. Gelatin silver print. Julius Shulman Photography Archive, Getty Research Institute, Los Angeles

204 Garry Winogrand, *Los Angeles, California*, 1969. Gelatin silver print. Princeton University Art Museum, Gift of Mr. and Mrs. Gerald Levine

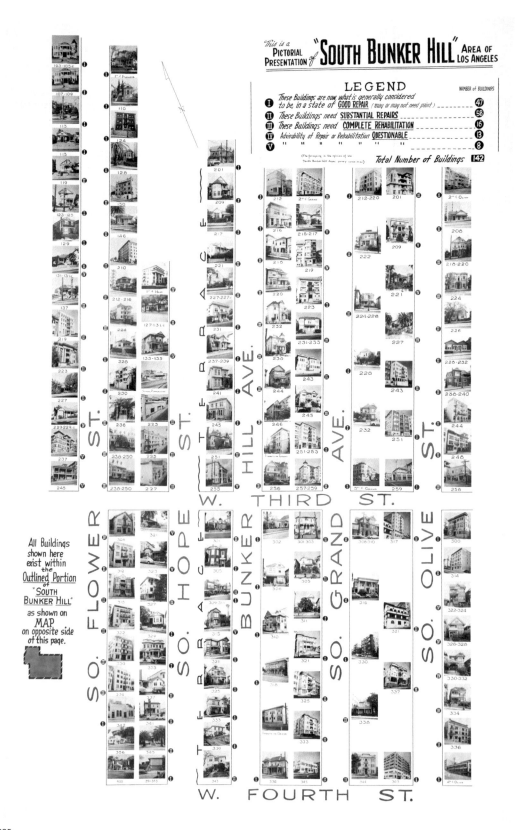

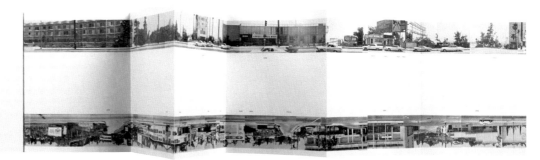

206

205 *South Bunker Hill Association, Survey Map of South Bunker Hill Area of Los Angeles*, ca. 1956. Poster. The Huntington Library, San Marino, California

206 Edward Ruscha, *Every Building on the Sunset Strip*, 1966. Paperback book in offset lithography; printed by Dick de Ruscha. Princeton University Art Museum, Museum purchase, Gift of Alexander D. Stuart, Class of 1972

207 Julius Shulman, *The Castle (Los Angeles, California) 325 S. Bunker Hill Avenue, Demolished 1969*, [1966 or 1968]. Gelatin silver print. Julius Shulman Photography Archive, Getty Research Institute, Los Angeles

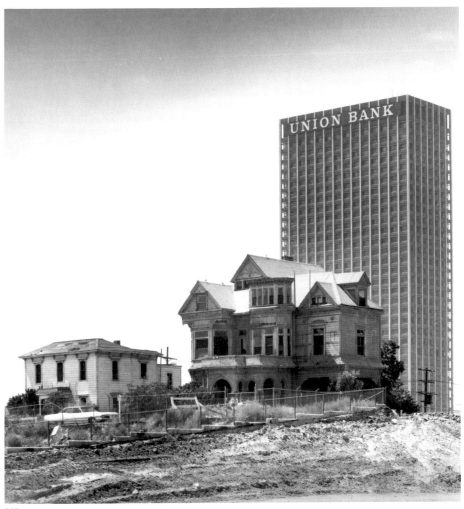

207

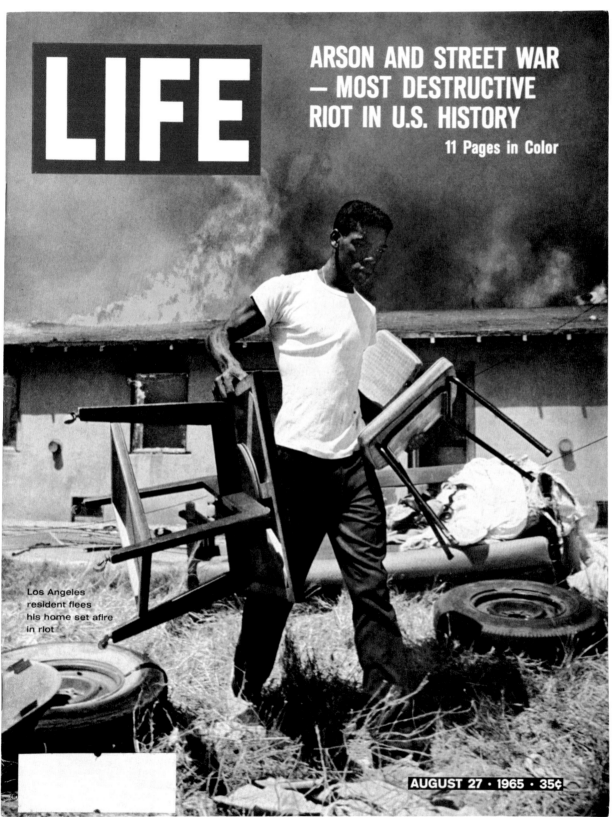

LIFE

ARSON AND STREET WAR – MOST DESTRUCTIVE RIOT IN U.S. HISTORY

11 Pages in Color

Los Angeles
resident flees
his home set afire
in riot

AUGUST 27 · 1965 · 35¢

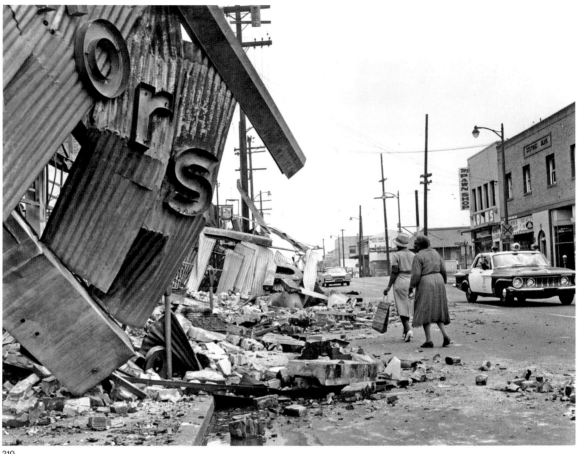

210

209

208 Cover of *Life*, August 27, 1965. Photograph by Co Rentmeester

209 Page from *Anarchy: Los Angeles*, a 64-page magazine insert in *McCone Commission Report! Complete and Unabridged Report by the Governor's Commission on the Los Angeles Riot; Plus One Hundred Four Shocking Photos of the Most Terrifying Riot in History*. Published by the Kimtex Corporation, Los Angeles, 1965

210 R. L. Oliver, photograph published in "Brown Declares: Riot Is Over," *Los Angeles Times*, August 17, 1965

MARCH 1967

MARCH 1967

211

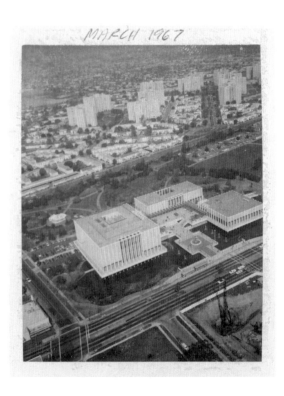

MARCH 1967

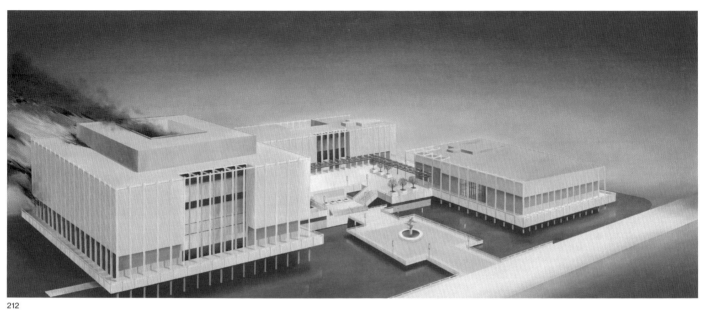

212

211 Edward Ruscha,
untitled studies for *The
Los Angeles County Museum
on Fire*, 1964-65 (dated
1967). Monochrome Polaroid
transfer prints. The J. Paul
Getty Museum, Los Angeles

212 Edward Ruscha, *The
Los Angeles County Museum
on Fire*, 1965-68. Oil on
canvas. Hirshhorn Museum
and Sculpture Garden,
Smithsonian Institution,
Washington, DC, Gift of
Joseph H. Hirshhorn, 1972

213 Grant Mudford, *Frank Gehry House #9*, 1980. Gelatin silver print. Courtesy of Rosamund Felsen Gallery, Santa Monica

214 Carlos Diniz for Maguire Partners with Harvey Perloff, Barton Myers, Edgardo Contini, Charles Moore, Lawrence Halprin, Cesar Pelli, Hardy Holzman Pfeiffer, Ricardo Legorreta, Frank Gehry, Sussman/Prejza, and Robert Kennard. Rendering for *A Grand Avenue: The Maguire Partners Proposal, Bunker Hill, Los Angeles*, 1980. Ink on paper. Archive of Carlos Diniz / Family of Carlos Diniz

214

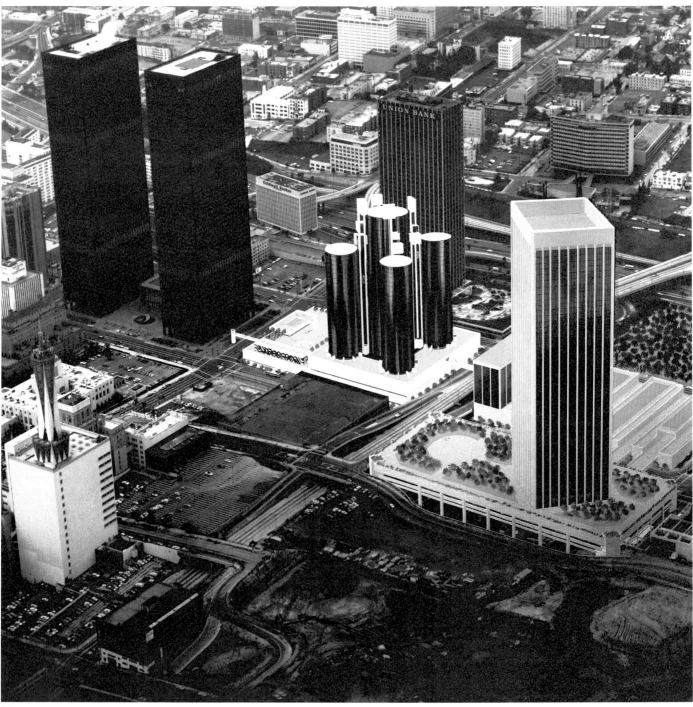

215

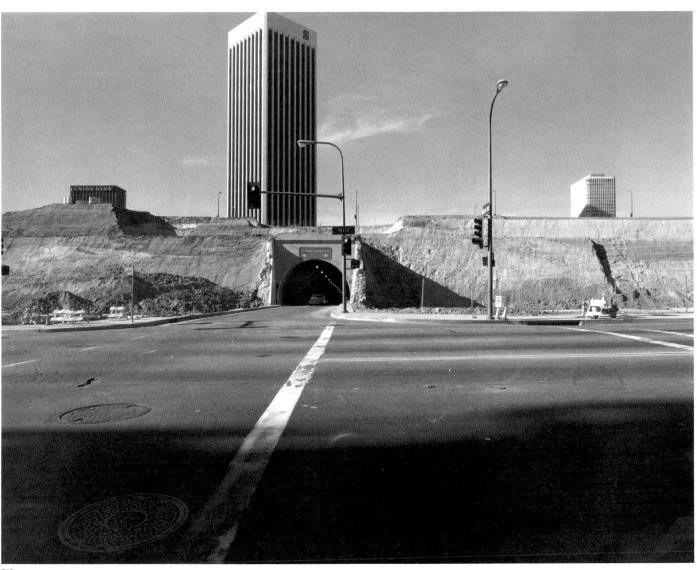

216

217

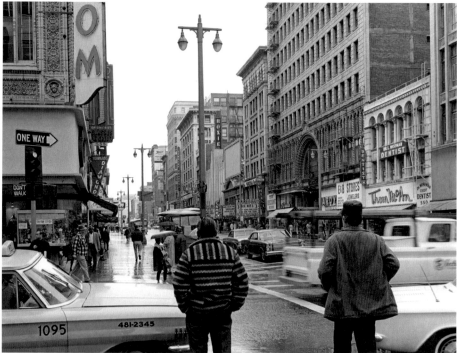

218

217 William Reagh, *Banning Street*, 1980 (printed later). Inkjet print. Los Angeles Public Library

218 William Reagh, *Pedestrian's View of Broadway*, 1966 (printed later). Inkjet print. Los Angeles Public Library

219 John Humble, *300 Block of Broadway, Los Angeles, October 3, 1980*, 1980. Chromogenic print. Courtesy of Craig Krull Gallery, Santa Monica

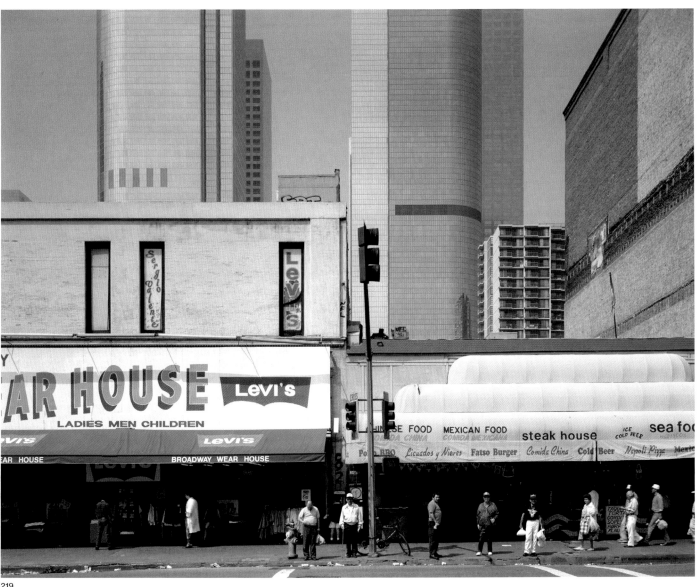

220

220 Stills from *Bunker
Hill-1956*, directed by Kent
Mackenzie (1956)

221 Map from *Concept
Los Angeles: The Concept
for the Los Angeles
General Plan*, published
by the Department of City
Planning, Los Angeles, 1970

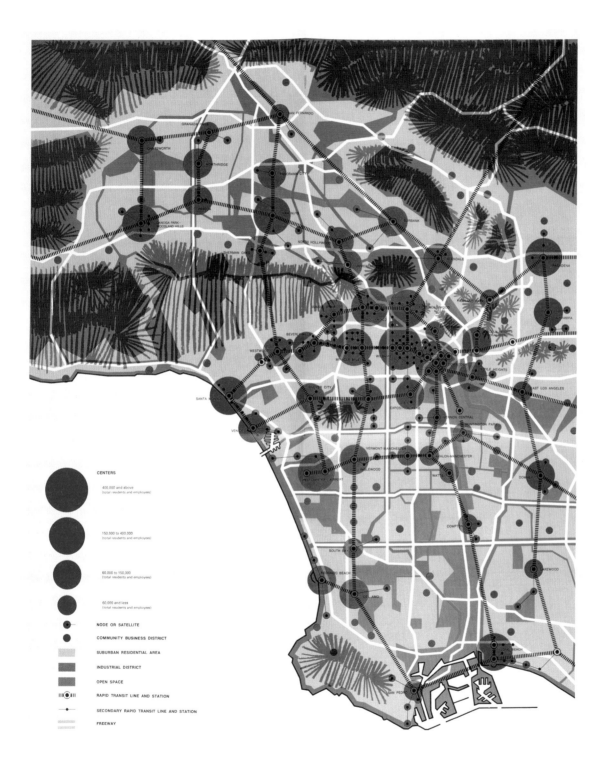

The Concept for the Los Angeles General Plan consists of this map and accompanying text

Staff Recommendation · March 1970

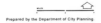

Prepared by the Department of City Planning

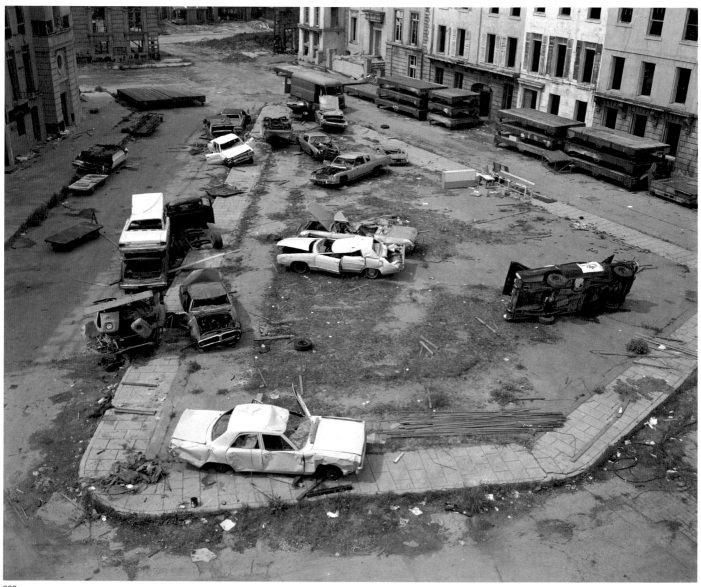

222

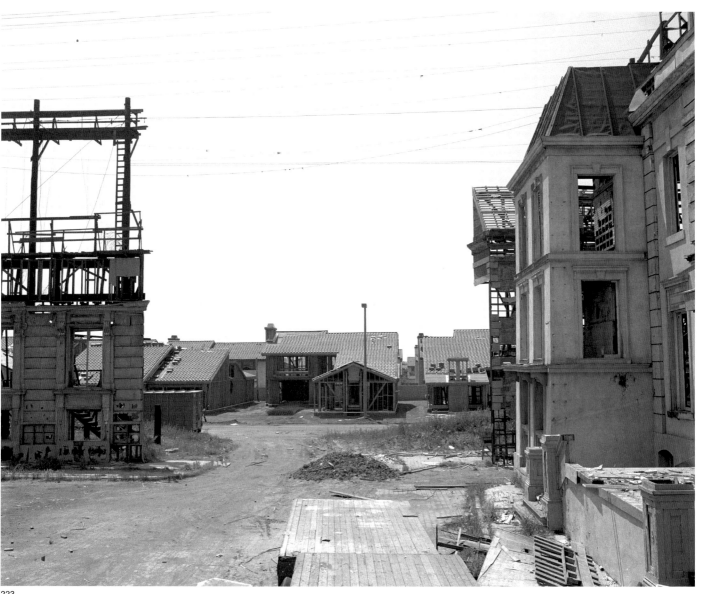

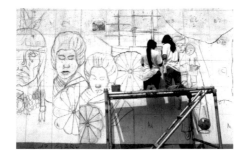

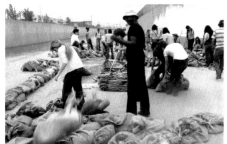

224

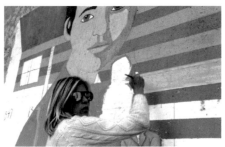

224 Stills from *The Great Wall of Los Angeles*, directed by Donna Deitch (SPARC, 1978). Photographs used for the film by Linda Eber. Judith F. Baca's *Great Wall of Los Angeles* was begun in 1976. The world's longest mural, at 13 by 2,400 feet, depicts a multicultural history of California from prehistory through the 1950s. The mural is still growing. The *Great Wall* is located in California's San Fernando Valley Tujunga Wash, a flood-control channel built in the 1930s. Courtesy of SPARC (sparcinla.org)

225 Asco, *Black and White Mural / Muralists*, 1979. Photograph by Harry Gamboa Jr. Courtesy of Harry Gamboa Jr.

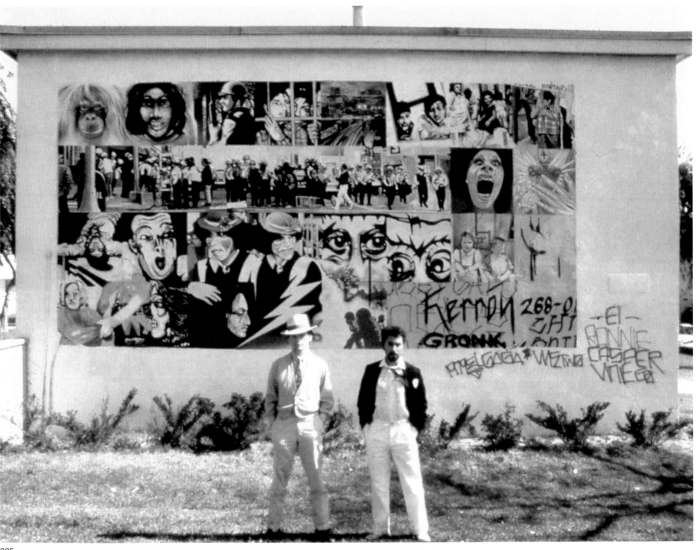

"This Spangled Pot-Hole"

Image and Materiality in Los Angeles Art of the City, 1960–80

Ken D. Allan

226

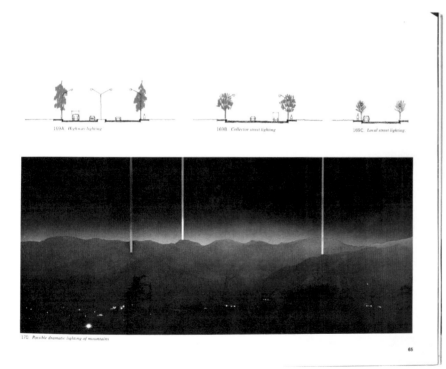

227

In 1971 the Los Angeles Department of City Planning produced a booklet titled *The Visual Environment of Los Angeles* (fig. **226**), which documented the way that the city's "rapid population growth and burgeoning economy" had "drastically altered its appearance and image."[1] One of the department's major concerns was the way that better planning might promote the legibility of the large and complex urban landscape that Los Angeles had become as a result of the postwar boom. In a spread of images and explanatory text under the heading "Changing City Image," the authors suggest ways to control urban development and highlight historic districts, but they also focus on the changes that occur in the inhabitant's perception of the city as day turns into night. A panoramic photograph of the L.A. basin illustrates the disappearance of the familiar landmark of the Santa Monica Mountains and the emergence of the vast, glowing matrix of streetlights and traffic stretching to the horizon.

This nighttime view is familiar from countless noir films, of course, in which the shimmering beauty of lights blanketing the landscape is accompanied by the knowledge that, as the sun goes down, the corruption and subversive desires that have always defined Los Angeles are truly revealed. Almost as if to combat these associations by simply providing better nighttime orientation, the Department of City Planning fancifully proposed to place "dramatic" lighting atop the hillsides and mountaintops that frame the city, as depicted in the mock-up on the facing page of its report (fig. **227**). Our experience of the urban is always informed by representations previously absorbed from popular culture, literature, and visual art.[2] The fact that Southern California became the capital of the motion picture and entertainment industries may explain why Los Angeles seems so available to our imaginations, but visual artists also powerfully shaped

the image of the city, particularly after 1960, when the new local art scene gained national attention.

During the early twentieth century the question of what single view, scene, or site could represent the diverse landscape of the region and the rapidly growing city was hard to answer. Was it the lush orange groves, the spectacle of leisure and recreation on Venice Beach, or the Olvera Street market, with its Spanish Colonial architecture that romanticized the city's Mexican origins? Or was it the tallest building—the ziggurat-topped City Hall? By the postwar period, however, a photograph such as Dennis Hopper's *Double Standard* (1961; fig. **228**) epitomized the public's idea of what made the experience of Los Angeles so different from that of other cities: its persistent horizontality and endless distances best traversed by automobile. So this image becomes a way to understand Los Angeles: to see it from the car, on the street, more specifically, at a large, multilane intersection that emphasizes the open spaces of this western city. Our view through the windshield is unencumbered by the skyscrapers and

226 Cover of *The Visual Environment of Los Angeles*, published by the Department of City Planning, Los Angeles, 1971

227 Page from *The Visual Environment of Los Angeles*, published by the Department of City Planning, Los Angeles, 1971

228 Dennis Hopper, *Double Standard*, 1961. Gelatin silver print. The Hopper Art Trust

229 Edward Ruscha, page from *Some Los Angeles Apartments*, 1965. Artist's book. Printed by Anderson, Ritchie & Simon, Los Angeles, 1970. Ryerson and Burnham Libraries, The Art Institute of Chicago

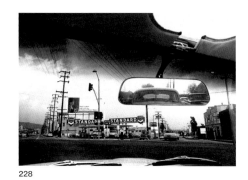

228

1555 ARTESIA BLVD.

229

canyon-like streetscapes of New York or Chicago. But Hopper's composition also presents us with a dilemma about where to focus our attention—down which street, at which sign, on the reflection in the rearview mirror, or even at the sky out the sunroof at the top? The "double standard" of the title evokes sexual and racial tension, and the gas station signs and the billboard cluttering the horizon offer ambiguous allusions to the social politics of the era. These elements, along with the multiple viewpoints, hint at the anxiety and fear wrapped up in the term *sprawl* during the postwar period.[3]

A precocious young actor in 1961, Hopper was also a budding artist and collector who was in the perfect position to witness the rise of a crucial group of Los Angeles artists that included Larry Bell, Billy Al Bengston, Wallace Berman, Robert Irwin, Craig Kauffman, Edward Kienholz, Ken Price, and Ed Ruscha. In fact, his striking portraits of many of these artists would help fix the image of Los Angeles as the "second city" of art in the 1960s.[4] Because of their use of new materials like plastic, glass, spray paints, and lacquer, these artists were seen as responding to the cars, surfboards, and light-filled atmosphere of Los Angeles even if much of their work did not directly depict urban form.

One of the most important figures of this group, Ed Ruscha, does seem to be simply documenting the city in his well-known books of photographs with titles

such as *Some Los Angeles Apartments* (1965) and *Every Building on the Sunset Strip* (1966; fig. **206**). Ruscha's photo books are in fact carefully constructed to emphasize what interested him most about the built environment. In *Some Los Angeles Apartments*, for instance, he focuses on the diluted modernism of the so-called dingbat apartments with fanciful names like "Lee Tiki" boldly hung on the facade (fig. **229**).[5] When these books are held in the hand and flipped through (or unfolded, in the case of the accordion-folded *Every Building on the Sunset Strip*), they often reveal subtle juxtapositions that suggest imaginative reconfigurations of the Los Angeles landscape.[6] Ruscha calls attention to the medium and format of the photograph's reproduction in his book projects, which is one of the many reasons why they became so influential for the following generation of Conceptual artists. Ruscha's books, with their humorously literal titles, may parody the city's history of self-promotion, but they, like Hopper's photograph, are often easily placed into preexisting narratives about the meaning of place (or the lack thereof) in 1960s Los Angeles.

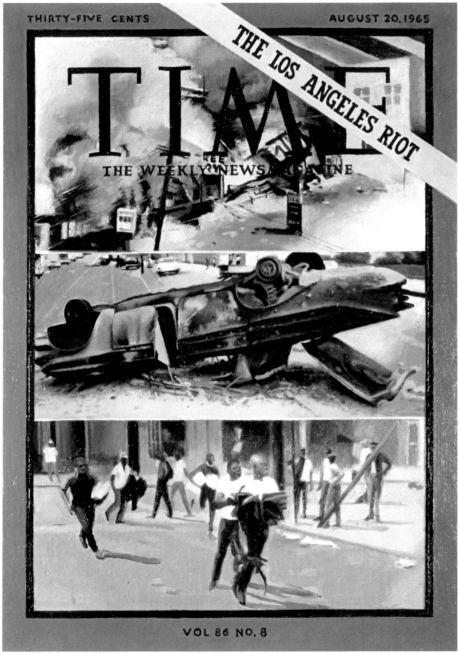

THIRTY-FIVE CENTS

AUGUST 20, 1965

THE LOS ANGELES RIOT

TIME

THE WEEKLY NEWSMAGAZINE

VOL 86 NO. 8

230

Vija Celmins's *Time Magazine Cover*, from 1965 (fig. **230**), is a stark reminder of how accepted narratives of place often serve the interests of the powerful. The painting addresses the way the national media coverage of the violence and social unrest in the long-neglected community of Watts punctured the myth that economic and racial inequality was the problem of other American cities. A Latvian-born painter who had come to L.A. from Indiana to attend graduate school, Celmins also created deadpan paintings of photographs of bomber planes and burning buildings, done primarily in muted grays, which are related to *Time Magazine Cover*. The painting's physicality and Celmins's careful execution of the magazine images are a striking contrast to the speed and mass circulation of photographic and television imagery in the postwar media landscape. Looking at these photographs as a painting, we are asked to consider the way dramatic images can quickly fix the public perception of events and even obscure the complicated historical reality in which they are embedded.

While Celmins's response to Watts gains power through displacement—a painting of a magazine page of photographic reproductions—Noah Purifoy and other assemblage artists utilized pieces of the neighborhood itself to forge a direct link between the art object and the forces of violent social change. Celmins's painting and a sculpture such as Purifoy's *Watts Uprising Remains* (ca. 1965–66; fig. **231**) demonstrate the different vantage points from which these artists experienced the event. Celmins has discussed being shocked by the images of Watts as she sat in her studio in Venice Beach during the rebellion, while Purifoy witnessed the violence firsthand from the door of his classroom at the Watts Towers Arts Center.[7] The arts center building stood in the shadow of Simon Rodia's internationally known folk art monument,

located near the epicenter of the violence on 103rd Street, or "Charcoal Alley," as it was called due to the number of stores that were set alight. In the aftermath, Purifoy and his colleague Judson Powell began to collect the fire-damaged detritus they found in

230 Vija Celmins, *Time Magazine Cover*, 1965. Oil on canvas. Courtesy of the artist and McKee Gallery, New York

231 Noah Purifoy, *Watts Uprising Remains*, ca. 1965-66. Found-object assemblage. Estate of Charles Brittin / Courtesy of Kohn Gallery, Los Angeles

232 Harry Drinkwater, *Noah Purifoy in Front of a Photographic Installation of the Watts Rebellion at the 66 Signs of Neon Exhibition at the University of Southern California, Los Angeles, 1966.* Courtesy of Harry Drinkwater

the streets with a vague intention of using it at the arts center. In a vivid description from 1966, Purifoy explains the quiet power this stuff had over them: "Often the smell of the debris, as our work brought us into the vicinity of the storage area, turned our thoughts to what were and were not tragic times in Watts and to what to do with the junk we had collected, which had begun to haunt our dreams."[8]

The resulting assemblage sculptures made from this material by a number of local artists were collected in a traveling exhibition organized by Purifoy and Powell called *66 Signs of Neon*. Named for the oddly shaped lead drippings from the armature of neon signs that Purifoy collected and used in his work, *66 Signs of Neon* was a powerful response to the violence of Watts. The exhibition ultimately demonstrated how abstraction, assemblage, and the legacies of Surrealism and Dada could speak to a traumatic event in which 34 people died, 1,032 were injured, and 977 buildings burned. Given Purifoy's remark about the smell of the debris,

one can imagine the added dimension this may have given to the viewer's experience of the show, especially while looking at the installation of Harry Drinkwater's photographs of the streets of Watts during the turmoil (fig. **232**), which included some of the very same images published on the cover of *Time* and painted by Celmins. An assemblage such as *Watts Uprising Remains*, a hunk of blackened cardboard in which Purifoy embedded an open Bible, could have originally been encountered, then, as part of a dialogue between images and things in the exhibition, between Drinkwater's powerful documentary photographs and charred pieces of the city transformed into art objects.[9]

The media imagery of the Watts rebellion has a further resonance with one of the central works of the 1960s, Ruscha's *Los Angeles County Museum on Fire* (1965–68; fig. **212**). The painting is monumental, but Ruscha also made small drawings based on photographs taken from a helicopter of the museum building (fig. **211**), which opened in 1965, the year of the

233

234

235

"L.A. Look" or the "Cool School"—could sustain themselves. The sense of crisis evoked by Ruscha's painting is in line with work from the 1970s that rejected the shiny surfaces and celebratory mood of the most successful Los Angeles art of the 1960s and embraced new strategies of art making. The black smoke and lurid yellow-green surrounding the museum in Ruscha's canvas suggest the toxic atmosphere that Bruce Nauman would explore in his book *L A Air* (1970; fig. **235**). Itself a parody of Ruscha's book projects, *L A Air* appears to be a photographic study of the city's notoriously smog-filled skies, but the gray and brown pages are in fact just ink, the result of Nauman's experimentation with offset printing.[11]

The pages of Nauman's book and Julius Shulman's photograph of the stalled redevelopment of Bunker Hill and the downtown core (fig. **256**) could nicely illustrate Peter Plagens's 1972 essay "The Ecology of Evil," a scathing review of *Los Angeles: The Architecture of Four Ecologies* by the British architectural historian Reyner Banham. Plagens calls Banham "an outside architectural geewhizzer" and condemns the book as a superficial reading of the city's built environment that does not register the problems of everyday life in the overcrowded, polluted "spangled pot-hole" of Los Angeles.[12] The attitude on display in Plagens's screed about his city is perhaps what the Los Angeles Department of City Planning had in mind when it stated in the first line of its 1971 report: "People are angry about their environment."[13]

violence in Watts. He used pencil and gunpowder wash for the drawings, a provocative choice given the content and historical moment, but this was a common medium for the artist at the time for a variety of subject matter (figs. **233**, **234**). While Ruscha has often disavowed any direct connection between the painting and Watts, the view of the art museum from above in the drawings does bear a resemblance to the aerial photography and the groundbreaking live TV footage, captured by KTLA's "telecopter," of Charcoal Alley in flames, with black smoke billowing

from rooftops.[10] The helicopter TV camera was pioneered in Los Angeles in the early 1960s, and it has become the standard viewpoint from which we receive "breaking" news coverage, only increasing the irony of Ruscha's nod to large-scale nineteenth-century history painting in his vision of the city's newly acquired cultural sophistication going up in smoke.

The Los Angeles County Museum on Fire was first exhibited in 1968, at a time when many were questioning how the decade's dominant styles of painting and sculpture—dubbed the

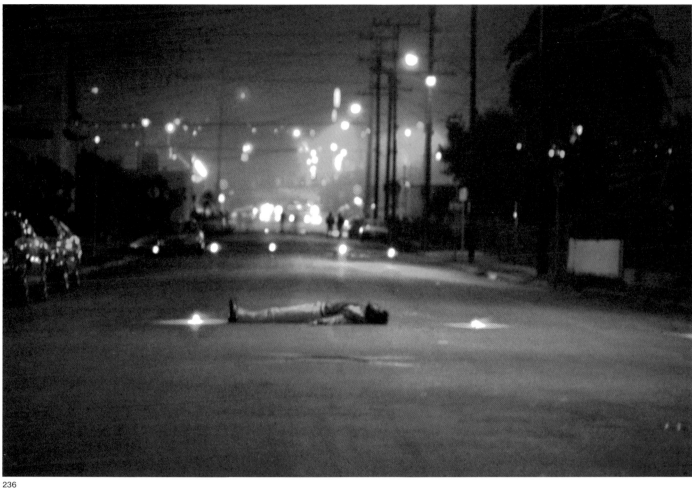

236

But Plagens's pessimism must be set against the dynamic work of the 1970s by artists who used the city's streets as a stage on which to address pressing social issues and to explore the role of art in the public sphere. Asco—Harry Gamboa Jr., Gronk, Willie Herrón, and Patssi Valdez—cannily manipulated the stereotypes of Chicano identity in works such as *Decoy Gang War Victim* (1974; fig. **236**), in which they photographed a street in East L.A. as if it were a crime scene, specifically the site of a gang killing, with safety flares surrounding a prone body. The image was then sent to local TV stations as potential fodder for the media's ongoing perpetuation of racial stereotypes. Suzanne Lacy and Leslie Labowitz also interrogated images of violence by focusing on the sensationalism of the local media coverage of the Hillside Strangler serial killer case in 1977. *In Mourning and In Rage* (1977), a performance that took the form of a press conference, was staged on the grounds of City Hall and featured a row of black-veiled women representing the invisibility of the female victims of violence, their ominous shrouds giving them a towering presence. In a photomontage documenting this and other protests organized by Lacy and Labowitz, *A Woman's Image of Mass Media* (1978; fig. **237**), Labowitz arranged images of the shrouded women among pictures of newspapers, TV sets, journalists, and cameramen, all framed by identifiable locations,

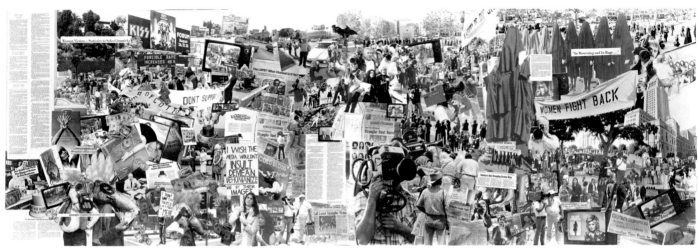

237

237 Leslie Labowitz-
Starus, *A Woman's Image
of Mass Media*, 1978.
Photomural documenting
two performances: *Record
Companies Drag Their Feet*,
1977, by Leslie Labowitz-
Starus and WAVAW (Women
Against Violence Against
Women); and *In Mourning and
In Rage*, 1977, by Suzanne
Lacy and Leslie Labowitz-
Starus. Collection of
Leslie Labowitz-Starus

238, 239 Senga Nengudi,
Ceremony for Freeway Fets,
1978. Chromogenic prints,
edition of 5 (+1 AP) from
a series of 11 prints,
documentation of performance
and installation piece.
Courtesy of Thomas Erben
Gallery, New York

including City Hall, Sunset Boulevard, and the Hollywood Hills. With this eight-by-twenty-four-foot photomural, Labowitz combined the form of the painted wall mural with Dadaist collage to suggest that the communication network through which media imagery circulates had become a kind of secondary visual environment that women may both occupy and be subjected to within the city—perhaps especially true in a place as central to the film and television industry as Los Angeles.

The gritty reality of some of the urban spaces in which artists such as Asco, Lacy, and Labowitz intervened as part of the vibrant performance art scene of the 1970s provided new opportunities for artistic exploration but also symbolized the challenges facing the city after the boom years of the 1960s. Senga Nengudi's *Ceremony for Freeway Fets* (figs. **238**, **239**), a ritualistic performance of music and dance staged under a freeway overpass in 1978, can serve as a closing example of the various forms the city takes in work produced by Los Angeles artists during these two decades. The piece was performed by Studio Z, a loose collective of African American artists that included Nengudi, Houston Conwill, David Hammons, Maren Hassinger, Ulysses Jenkins, Franklin Parker, and RoHo—all artists with their own practices who also came together in Hammons's large Slauson Avenue studio to work collaboratively. Nengudi studied dance as an undergraduate at California State University, Los Angeles, but received an MFA in sculpture from the same institution in 1971 before moving to East Harlem and splitting her time between New York and Los Angeles. She developed a Postminimal sculptural practice in this period that featured installations of stretched

and sand-filled pantyhose attached to gallery floors and walls. *Ceremony for Freeway Fets* was named for the fetish-like forms of twisted pantyhose that she tied to the cement pillars and which were incorporated into the masks and headdresses worn by the performers. Nengudi has discussed why the space under a downtown overpass near the Convention Center appealed to her: "there were little palm trees and a lot of dirt . . . even at that time there were a lot of transients who slept there; so there were little campfires . . . For me, it had the feel of what I imagined an African village to be. Because it was under the freeway it was kind of cloistered in a sense."[14] An icon of the city's self-promotion in the immediate postwar period, the freeway had become an inefficient transportation system by the late 1970s that served to shelter the homeless and hide them from public view. With her project, partly sponsored by the municipal transportation agency, Nengudi transformed this space into a fragile site in which contemporary urban problems and radical creative practice could fleetingly coexist.

If the horizontality of Hopper's photograph *Double Standard* conveys a sense of Los Angeles in 1961 as a space offering new urban experiences open to exploration via the freedom of

238

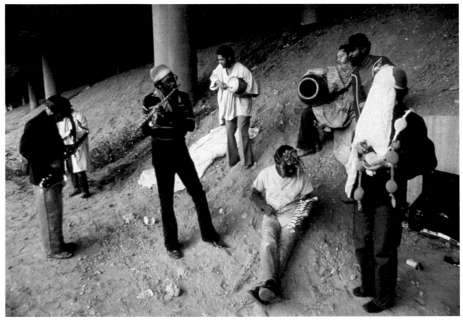

239

the car, the photographs of *Ceremony for Freeway Fets* picture the infrastructure responsible for holding up that dream (fig. **239**). The verticality of the concrete pillars, adorned with Nengudi's fetishes, suggests the weight and pressure this burden had exerted by 1978 on those excluded from the postwar image of the city. Yet Nengudi's project also demonstrates the opportunities available to those willing to look beneath the surface of Hopper's image of Los Angeles. She and Maren Hassinger had created ephemeral, undocumented performances in sites around the city, once dancing in the hole in the ground that lingered for years after the demolition of a department store on Wilshire Boulevard's Miracle Mile.[15] By appropriating a construction site on the street that epitomized the city's booming economy in the earlier twentieth century, Nengudi and Hassinger drew attention to the "spangled pot-hole" of Plagens's Los Angeles, but they also moved beyond its pessimism to briefly transform the stalled process of the city's redevelopment in the 1970s into a scene of artistic renewal.

1 Los Angeles Department of City Planning, *The Visual Environment of Los Angeles* (Los Angeles: Department of City Planning, April 1971), 64.

2 See Ben Highmore, *Cityscapes: Cultural Readings in the Material and Symbolic City* (New York: Palgrave Macmillan, 2005), for an analysis of urban space employing this model.

3 For a seminal set of essays from the late 1950s on the discourse and hysteria surrounding suburban sprawl, see William Whyte Jr., ed., *The Exploding Metropolis* (Garden City, NY: Doubleday, 1958).

4 Barbara Rose, "Los Angeles: The Second City," *Art in America* 54 (January–February 1966): 110–15.

5 The term is used to describe the boxy multistory apartment buildings featuring street-level carports that are a ubiquitous form of vernacular architecture in Southern California. See Richard Marshall, *Edward Ruscha: Los Angeles Apartments, 1965* (New York: Whitney Museum of American Art, 1990), 11.

6 See Ken D. Allan, "Ed Ruscha, Pop Art, and Spectatorship in 1960s Los Angeles," *Art Bulletin* 92 (September 2010): 231–48, for an elaboration of this argument about Ruscha's books and how it relates to his painting strategies.

7 Phong Bui, "Vija Celmins with Phong Bui," *Brooklyn Rail*, June 3, 2010, http://www.brooklynrail.org/2010/06/art/vija-celmins-with-phong-bui.

8 Noah Purifoy (as told to Ted Michel), *Junk Art: 66 Signs of Neon* (Los Angeles: 66 Signs of Neon, [ca. 1966]), unpaged, quoted in Yael Lipschutz, "66 Signs of Neon and the Transformative Art of Noah Purifoy,"

in *L.A. Object and David Hammons Body Prints*, ed. Connie Rogers Tilton and Lindsay Charlwood (New York: Tilton Gallery, 2011), 217.

9 I thank Yael Lipschutz, archivist of the Noah Purifoy Foundation, for information on this piece.

10 Paul Vitello, "John Silva, Father of Helicopter Journalism, Dies at 92," *New York Times*, December 9, 2012.

11 For a great discussion of art and smog in Los Angeles, see Donna Conwell, "L.A. Air," in *Pacific Standard Time: Los Angeles Art, 1945–1980*, ed. Rebecca Peabody (Los Angeles: Getty Publications, 2011), 231.

12 Peter Plagens, "Los Angeles: The Ecology of Evil," *Artforum* 11 (December 1972): 67–76. For more on Banham, see also Beatriz Colomina's essay in this volume, pages 236–37.

13 Department of City Planning, *Visual Environment of Los Angeles*, 2.

14 Senga Nengudi, telephone interview with Kellie Jones, June 3, 1996, quoted in Kellie Jones, "Black Arts West: Thoughts on Art in Los Angeles," in Tilton and Charlwood, *L.A. Object*, 53.

15 Hassinger recalls this performance in an oral history interview with Kellie Jones included in "Modern Art in Los Angeles: African American Avant-gardes, 1965–1990, 2008 January 15–16," Special Collections, Getty Research Institute.

Riding with the Pop Historian
Reyner Banham Loves Los Angeles (1972)

Beatriz Colomina

From the bubble letters on a billboard that proclaim the title of the film to the fascination with American cars, food, girls, freeways, gas stations, and drive-ins, the 1972 film *Reyner Banham Loves Los Angeles* is a pop statement about a pop city by a pop historian immersed in pop culture.[1] Banham, the noted historian of modern architecture, is the star, present in every scene, talking continuously to us. He presents himself not as an expert but as a fan with knowledge of the city, an unofficial guide. The documentary film was made for the BBC as part of the series *One Pair of Eyes*, produced by Malcolm Brown and dedicated to "contrarian ideas" presented by "the eccentric, unusually open minded, intelligent and uninhibited."[2] We see L.A. through Banham's eyes, but the view is medi-ated through multiple technologies: cameras, telescopes, helicopter views, silent films, audiotape recorder, and above all the car windshield.

The film starts at Los Angeles International Airport, where Banham quickly strides over the zebra crossing, as if in an echo of the cover of the Beatles album *Abbey Road* (1969), and enters a rental car equipped with a tape-recorder guide named Baede-Kar, a pun on the red-covered German Baedeker guides popular at the turn of the twentieth century with English intellectuals who took them on their travels through Italy. Since the tourist is now driving, the guide has to be audio. From the beginning we have two guides, Banham and the sooth-ing woman's voice of the Baede-Kar cassette. We are in the passenger seat, and Banham is driving.

"Like earlier generations of English intellectuals who taught themselves Italian in order to read Dante in the original, I learned to drive in order to read Los Angeles in the original," Banham wrote in the first chapter of his book *Los Angeles: The Architecture of Four Ecologies*, published a year before

the film was released and the basis for the script.[3] The language of L.A., according to Banham, is the language of mobility, of car driving, of freeways. But he does not simply drive through Los Angeles. Rather he presents driving itself as the real Los Angeles: "The destination is not so important as the journey." In fact, the journey is the destination. Freeway driving is a space, an architecture to be analyzed by pay-ing attention to seemingly innocuous details, patterns of everyday life:

> The first time I saw it happen nothing registered on my conscious mind, because it all seemed so natural—as the car in front turned down the off-ramp of the San Diego freeway, the girl beside the driver pulled down the sun-visor and used the mirror on the back of it to tidy her hair. Only when I had seen a couple more incidents of the kind did I catch their import: that coming off the freeway is coming in from outdoors. A domestic or sociable journey in Los Angeles does not end so much at the door of one's destination as at the off-ramp of the freeway, the mile or two of ground-level streets counts as no more than the front drive of the house.[4]

The city is to be found not in the streets or the public monuments—which, according to the film, are "not worth visiting"—but in the freeways and the homes. But what is really home in L.A.? "The girl" tidies her hair, according to Banham, as if she had been outside. But isn't it to go out that you tidy your hair rather than the other way around? The freeway is not the outdoors but the indoors, an extension of the house that is even more private. As Banham himself puts it: "The freeway is where the Angelenos live a large part of their lives." It is "the place where they spend the two calmest and most rewarding hours of their daily lives."[5] The seem-ingly most public infrastructure acts as the setting for the most private rituals.

The freeway system is a comforting interior. Domesticity itself occurs at high speed.

This becomes the logic of the whole film. We are in the car with Banham. He takes us to his favorite places. We meet his friends the artist Ed Ruscha and the writer Mike Salisbury at a drive-in restaurant. We even visit his class at the university, but in a sense we never get out of the car. There is something domestic about it. It is always the experience of the private moving in the public. Again and again, Banham shows us people "doing their own thing," acting out private fantasies in public: from the DIY monument of the Watts Towers, to the man living with a piano in his van (and claiming to have more privacy on the road than he had when he was living in a house), to the bodybuilders on Venice Beach, to the surfers carving patterns on the waves. "Angelenos are . . . the privileged class of pop culture today" because they relentlessly blur public and private, mass culture and individual expres-sion. Banham himself twists the mass medium of television to make a per-sonal statement, a declaration of love that changes the perception of the city but also of the role of the historian.

The love affair began in the mid-1950s, when Banham was doing his Ph.D. on modern architecture at the Courtauld and hanging out with his Independent Group friends. But even before he set foot in L.A., he had been "transported to L.A.," as he says in the film, or rather L.A. was transported to him, through the silent films of Buster Keaton and, later, the Perry Mason movies, which he saw in the movie theater of his childhood hometown, Norwich. In 1959 the art critic Lawrence

240 Stills from *Reyner Banham Loves Los Angeles*, directed by Julian Cooper (BBC Films, 1972)

Alloway, who was also part of the Independent Group, wrote about the "spatial experience" of the windscreen of the American car as a "communication device itself and the analogue of another communication device," the movies, in offering the panoramic view of the CinemaScope screen.[6] In reverse, Banham argues that Los Angeles travels through the movies.

In his own film, Banham is both actor and historian, or historian as actor, even simulating a Hitchcock suspense film when showing us a private house. But his main role is to expand the domestic interior of the car to absorb the whole of Los Angeles. Sitting on the front seat beside him, we finally inhabit the "pop architecture" that he and Alloway had been theorizing for more than a decade. The Good Life of America is L.A. not New York: dream houses, swimming pools, cars, sun, beaches, DIY culture. Except even Banham knows that not everything is so cool. The film shows footage of the Watts riots of 1965 and of gated communities, "private cities you can't get in," like Rolling Hills, where a guard stops him at the entrance and denies him access. And he criticizes Marina del Rey as "an executive ghetto, full of plastic boats and plastic people," just when we thought that everything plastic was good.

The journey lasts the whole day, from the moment Banham picks up the car in the morning to the last scenes on the highway at sunset, "that great moment of plastic fluorescent spectacle of the sun going down in man-made splendor" of fumes and pollution. The woman's voice from the Baede-Kar wishes us a good night, and Banham, in true British form, replies: "Thank you, love. I couldn't have put it better myself."

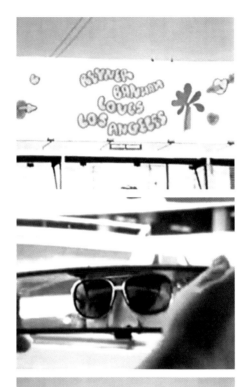

240

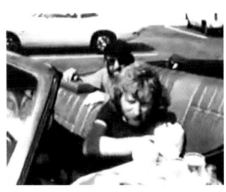

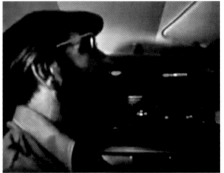

1 *Reyner Banham Loves Los Angeles*, directed by Julian Cooper for the series *One Pair of Eyes*, produced by Malcolm Brown (BBC, 1972).

2 Interview with Malcolm Brown by Edward Dimendberg, quoted in Dimendberg, "The Kinetic Icon: Reyner Banham on Los Angeles as Mobile Metropolis," *Urban History* 33 (May 2006): 111.

3 Reyner Banham, *Los Angeles: The Architecture of Four Ecologies* (Harmondsworth, UK: Penguin, 1971), 23.

4 Ibid., 213.

5 Ibid., 214, 222.

6 Lawrence Alloway, "City Notes," *Architectural Design* 29 (January 1959): 34–35.

Wattstax (1973)

Josh Glick

A year after the Watts uprising of 1965, local civic leaders, activists, and cultural organizations started the Watts Summer Festival to commemorate the event, to promote local businesses, and to celebrate black vernacular expression.[1] The 1972 festival was anticipated as the most elaborate and well-funded one yet, with a concluding concert at the Los Angeles Memorial Coliseum planned by Stax, the black–co-owned Memphis-based R&B record label. Interested in filming the spectacular musical show-case, Stax executives worked with the Hollywood documentary studio Wolper Productions and expanded the film into a portrait of South Central Los Angeles. The resulting documentary, *Wattstax* (1973), was motivated in part by Stax's transformation into a multimedia enterprise and Wolper Productions' desire to delve into new content fields and engage crossover audiences. But the project was also informed by its creators' strong social conscience. The documentary was made possible by the innovative collaboration between Stax executives Al Bell, Larry Shaw, and Forest Hamilton, who supplied the talent for the concert and retained editorial control over all race-related issues; David Wolper and Mel Stuart of Wolper Productions, who coordinated the filmmaking operations; and local citizens, who appeared in front of the camera and, in some cases, helped shoot the film.[2] Deftly shifting between the stadium and the surrounding area, *Wattstax* challenged dominant perceptions of a place so often hidden from view or distorted within popular media.

The film's opening montage roots the spectator within the neighborhood's social geography. The Dramatics' pulsating song "Whatcha See Is Whatcha Get" plays on the sound track against views of the Watts Towers, of people interacting on the streets and walking to school and work, and of the uprising of 1965 (fig. **241**). Three kinds of performances provide different perspectives on black identity and show how art and everyday life are mutually constitutive. First, the Stax stars are seen performing on a bandstand before an audience of more than one hundred thousand. Kim Weston's call to "lift every voice and sing," the Staple Singers' imperative to "respect yourself," and Albert King's empathetic offer to "play the blues for you" form a soundscape that empowers listeners and provides them with an aesthetic means to cope with personal and collective struggles. Second, individual and group interviews and observational sequences were filmed in the neighborhood's churches, diners, and barbershops and along its sidewalks and streets. And third, the monologues of the comic Richard Pryor foreground the force of comedy as both a shield and a sword: a way to deflect the painful sting of racial and socioeconomic oppression as well as a verbal weapon to critique abusive forces such as police prejudice and brutality.[3]

Wattstax's presentation of the different shades of black cultural identity generated tremendous pride for citizens both within and beyond South Central. However, the film avoided directly engaging questions concerning the deindustrialization in the area; the implications of the then-prospective electoral victory of the city's first black mayor, Tom Bradley; or the diminishing energy of the Black Power movement. Still, the documentary's framing of black subjects talking openly about themselves was a rarity on commercial screens. The film served as a contrast to television news coverage of the 1965 uprising that showed Watts as a war zone, the more recent on-location human interest stories profiling liberal reform initiatives, and Hollywood's push into sensational blaxploitation films. Seen by audiences as diverse as college students at UCLA, working-class mothers in Chicago, and cinephiles at the Cannes Film Festival in France, *Wattstax* was praised by the minority and mainstream press for its eclectic style, bold honesty, wide reach, and "palpable sense of place."[4]

More broadly, as *Wattstax* was conceived at a time of both tremendous hope and great anxiety for the city's working-class populace, one of the film's most valuable and resonant features was its assertion that social change requires a sensitivity to the ways in which cultural expressions create and reflect on a community.

1 On the history of the festival, see Bruce M. Tyler, "The Rise and Decline of the Watts Summer Festival, 1965 to 1986," *American Studies* 31 (Fall 1990): 61–81.

2 See Rob Bowman, *Soulsville, U.S.A.: The Story of Stax Records* (New York: Schirmer, 1997), 292.

3 For more on Richard Pryor's role in the film, see Scott Saul's unpublished essay "'What You See Is What You Get': *Wattstax*, Richard Pryor, and the Secret History of the Black Aesthetic" (sent to the author on January 25, 2014). For an analysis of *Wattstax* in relation to the activist film *Repression* (1969), produced by Los Angeles Newsreel, see Daniel Widener, "Setting the Seen: Hollywood, South Los Angeles, and the Politics of Film," in *Post-Ghetto: Reimagining South Los Angeles*, ed. Josh Sides (Berkeley: University of California Press, 2012), 173–90.

4 Arthur Cooper, "Watts Happening," *Newsweek*, February 26, 1973, 88. Audience information compiled from advertisement for *Wattstax* screening in Westwood, Los Angeles, *UCLA Daily Bruin*, February 28, 1973, box 131, folder 009, Wattstax [Feature Films] Press Clippings, David L. Wolper Collection, Warner Bros. Archive, University of Southern California; "Mothers Praise 'Wattstax,'" *Chicago Defender*, January 27, 1973, 19; "Wattstax Cannes Hopeful," *Los Angeles Sentinel*, May 17, 1973, C12.

241 Stills from *Wattstax*, directed by Mel Stuart (Stax Films and Wolper Productions, 1973)

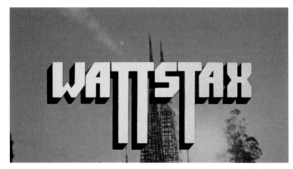

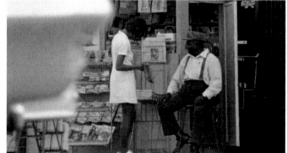

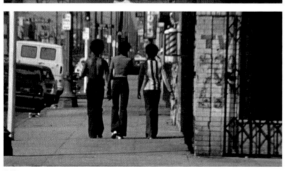

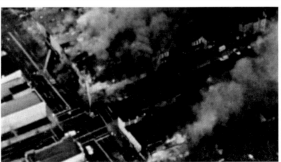

Grant Mudford, *Los Angeles (US 257/10a)* (1976)

Craig Lee

The Australian-born photographer Grant Mudford moved to California in 1977 and was immediately drawn to the industrial spaces and commercial vernacular unique to the urban sprawl of Los Angeles. This landscape offered a bounty of banality that resonated with his admiration for photographers like Walker Evans and shaped his attitude toward the medium: "One of the beautiful things about photography is that it can turn really dumb stuff that absolutely nobody takes notice of into icons."[1] The nondescript structures and less celebrated buildings that captured his visual imagination simultaneously informed a successful commercial architectural photography practice.[2]

An admitted formalist, Mudford has demonstrated a strong interest in an abstract and minimalist language of photography that highlights the textural play of material presence. This is evident in images such as *Los Angeles (US 257/10a)*, a cropped view of a gritty, unpopulated streetscape shot head-on. The abstracted image of building facades balances the vertical channels of corrugated metal siding with horizontal brick coursing and a square louvered air vent on a stucco wall. In the foreground, contraction joints in the concrete sidewalk provide just a slight sense of depth in an otherwise rigorously flat image—even the shadows seem more like tonal blocks than studies in light or space.

Mudford's practice was a natural fit with the experimental work of a group of architects emerging in Los Angeles at the end of the 1970s—chief among them Frank Gehry—engaged in a similar examination of nontraditional architectural forms and industrial materials.[3] In early residential projects like the Danziger studio and residence in Hollywood (1964–65) and the iconic renovation of his own house, a pink 1920s bungalow in Santa Monica (1977–79), Gehry channeled the raucous spirit in the air and on the streets in the Los Angeles basin. With a strategy of creating fortified compounds shielded from the surrounding environment, he argued for a wry form of "defensible" architecture that employed expansive screening walls in rough materials like stucco, exposed plywood, and corrugated sheet metal. Such ideas later developed in public projects like the Frances Howard Goldwyn Hollywood Regional Library (1982–86), featuring a steel entrance gate, high security walls, and graffiti-resistant tile that responded to the surrounding urban conditions.[4] In contrast to his cool play with the found grid in *Los Angeles (US 257/10a)*, Mudford's photograph of Gehry's house from 1978 captures the jangle of the architect's intervention: the harsh light, forced perspective, and intersecting planes. Here Mudford exposed the clash between old and new, utopian and dystopian, the place where the idyll of traditional domestic architecture meets a diagonal rupture of chain-link fencing (fig. **213**).

Although Mudford pursued two areas of practice, they are united by his dedication to a type of photographic intervention that emerged alongside the L.A. school of architecture and shared its engagement at the boundaries and on the fringe to transform the banal and dumb into the original and iconic.

1 Susan Freudenheim, "Letting Walls Talk; Top Architectural Photographer Grant Mudford Explores Disney Hall," *Los Angeles Times*, December 3, 2002.

2 Grant Mudford, in Kathleen Chapman, "Interview with Grant Mudford," in *Transfictions: Jack Butler, Eileen Cowin, and Grant Mudford* (Los Angeles: Fisher Gallery, University of Southern California, 2004), 60.

3 See Stephen Phillips, "Architecture Industry: The L.A. Ten," in *Overdrive: L.A. Constructs the Future, 1940–1990*, ed. Wim de Wit and Christopher James Alexander (Los Angeles: Getty Research Institute, 2013), 184–99, and Todd Gannon, Ewan Branda, and Andrew Zago, *A Confederacy of Heretics: The Architecture Gallery, Venice, 1979* (Los Angeles: SCI-Arc Press in association with Getty Publications, 2013).

4 For more on this quality, see Mike Davis, "Fortress L.A.," in *City of Quartz: Excavating the Future in Los Angeles* (New York: Vintage, 1990), 220–63.

242 Grant Mudford, *Los Angeles (US 257/10a)*, 1976 (printed 1980). Gelatin silver print. The J. Paul Getty Museum, Los Angeles

Anthony Hernandez, *Public Transit Areas* (1979–80)

Greg Foster-Rice

In subtle and underexamined ways, the history of urban planning underlies much of the life and work of the celebrated Los Angeles photographer Anthony Hernandez. Even his birthplace, the East Los Angeles housing project Aliso Village, is a touchstone in the history of the city's planning and development. Built in 1942 on the site of the city's worst slums, it was intended as a model of the garden city championed by Lewis Mumford and other planners but quickly sank into neglect through poor planning of the surrounding transit corridors, which effectively landlocked Aliso Village between the river basin, a massive rail yard, and freeway interchanges.[1]

Hernandez would return to photograph Aliso Village in 1999 as it was being demolished, like so many other midcentury public housing projects, but just as importantly, the project's segregation from the rest of the city seems to inform his early body of work *Public Transit Areas* (1979–80; figs. **244**, **245**).[2] For this project, Hernandez deployed a five-by-seven-inch view camera to render precise, richly detailed portraits of the bus stops that were used predominantly by the city's low-income, minority, and elderly residents. The gum-stained sidewalks and small clusters of transit riders belie the stereotype of Los Angeles as a city defined by the spaces of the private car and provide visual evidence of the need for these public spaces, supporting the statistic that transit riders made approximately 396 million unlinked bus trips in 1980.[3] Yet Hernandez's camera isolates the transit riders in the frame, pinning them against the relentless single-point perspective of the receding roadway, thereby implying their isolation within the city. Further, the public transit areas in his photographs seem haphazardly located in relation to the streetscape, and even when found in small groups, the human subjects seem

distant and removed, their gazes never acknowledging one another's presence.

If Hernandez's photographs document the existence and need for public transit in Los Angeles, the isolated, sunbaked, and seemingly unmaintained stops also implicitly point out the city's historic neglect of public transportation and the needs of much of its population. The context for *Public Transit Areas* therefore includes the widely publicized 1974 U.S. Senate hearings against General Motors for colluding to purchase and shut down the electric streetcar companies throughout America's cities—including the Pacific Electric Railway, which formerly served Aliso Village and much of Los Angeles—and replacing them with less efficient, poorly designed bus systems to free up the roadways for automobile traffic and to encourage car ownership.[4] *Public Transit Areas* thus takes on a different tone, as evidence of the city's denial of adequate services to its least enfranchised residents and the general rejection of rail transit in favor of the motorization of America's cities.

Similarly, Hernandez's subsequent *Public Use Areas* (1980) demonstrates the poor planning of the city's downtown public spaces, which effectively isolated pedestrians from the potential vitality of the street, as in the elevated pedestrian walkways (fig. **243**) that were one of the few concrete infrastructural elements to be built out of the *Concept Los Angeles* plan of 1970. In these photographs urban inhabitants appear as lonely as the figures in *Public Transit Areas*, this time against backdrops of fortress-like hedges and inhumanly scaled developments like the Bonaventure Hotel (1974–76; fig. **215**), which the urbanologist William H. Whyte criticized for seeming like it was designed to protect visitors from the city they were visiting.[5]

243

1 For a detailed history of Aliso Village, see Dana Cuff, "Provisional Places with Fugitive Plans: Aliso Village," in *The Provisional City: Los Angeles Stories of Architecture and Urbanism* (Cambridge, MA: MIT Press, 2000), 120–70.

2 On Anthony Hernandez's photographs of Aliso Village, see Susan Briante, "Utopia's Ruins: Seeing Domesticity and Decay in the Aliso Village Housing Project," *CR: The New Centennial Review* 19, no. 1 (2010): 127–40.

3 See the graph titled "Los Angeles County Metropolitan Transit Authority, All-Mode Unlinked Passenger Trips, 1980–2013," http://marininfo.org /SMART/LA_Rail_vs_Bus.htm. Also available at http:// www.mtc.ca.gov/planning/plan_bay_area/comments /Invididuals/Rubin_Thomas_5-3-13.pdf, p. 8.

4 Bradford Snell, "American Ground Transport," Subcommittee on Antitrust and Monopoly, Committee on the Judiciary, U.S. Senate, February 26, 1974.

5 Rick Hampson, "Main Street Is Coming Up Blank," *Free-Lance Star*, March 25, 1983.

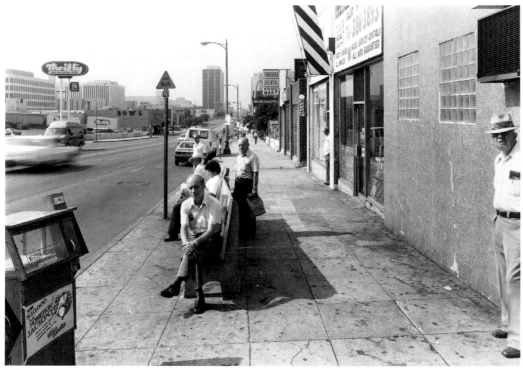

244

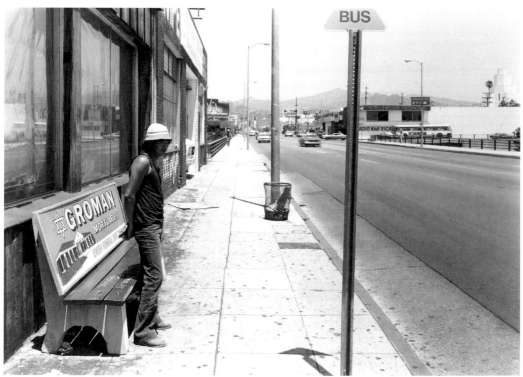

245

243 Anthony Hernandez,
Public Use Areas #22, 1980.
Gelatin silver print.
Courtesy of the artist

244 Anthony Hernandez,
*Public Transit Areas #12:
Los Angeles*, 1980. Gelatin
silver print. The J. Paul
Getty Museum, Los Angeles,
Purchased in part with
funds provided by the
Photographs Council

245 Anthony Hernandez,
*Public Transit Areas #16:
Los Angeles*, 1980. Gelatin
silver print. The J. Paul
Getty Museum, Los Angeles,
Purchased in part with
funds provided by the
Photographs Council

Fighting Freeways in the L.A. Barrio

Eric Avila

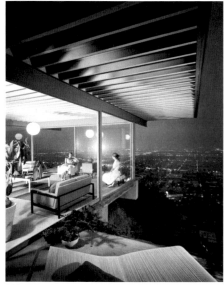

246

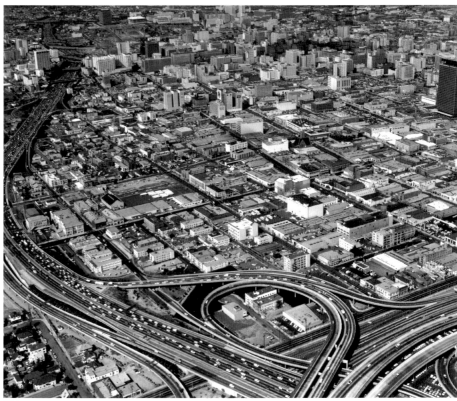

247

Los Angeles never looked so good as it does in the photographs of Julius Shulman (fig. **246**). The visual poet of midcentury modernism captured the city at the height of its postwar exuberance, an empire of concrete, steel, and glass, set against local endowments of water, sky, and palm trees. At the very height of the city's wealth and power, L.A.'s bourgeoisie actualized itself through Shulman's extensive body of work.

Curiously, the image of the freeway rarely figured into his oeuvre. Even as its massive forms debuted on the urban scene and even as a new generation of urban scholars—embracing the ordinary, everyday, and vernacular elements of the urban built environment—expressed its admiration for the freeway's accessibility, convenience, and iconic stature (fig. **247**),[1] Shulman roved the city's canyons to portray the cutting edge of hillside living in Southern California. He was mostly a commercial photographer, a for-hire stylist who created a lasting image of Los Angeles in its postwar glory. But given that he also applied his skills and talents to photographing less glamorous aspects of L.A.'s built environment—gas stations, office parks, and restaurants—it seems fair to ask why Shulman turned his back on the new freeways. With no apparent reason for this oversight, it is tempting to consider the photographer's own exodus from Boyle Heights, a community just east of downtown Los Angeles transitioning from a Jewish immigrant neighborhood to a Mexican American barrio during the mid-twentieth century. As the son of Russian Jewish immigrants who settled in Boyle Heights in the 1920s, Shulman left that neighborhood in the mid-1950s, just as the 1956 Highway Act unleashed a flurry of construction in the area. Between 1952 and 1967 six freeways converged on Boyle Heights, fueling white flight among Eastside Jews, who left for greener suburban pastures on the city's Westside.[2] Ultimately Shulman resettled in the Hollywood Hills neighborhood of Laurel Canyon, a secluded landscape free of the nuisance of freeways and freeway traffic.

It was left to a subsequent generation of East L.A. artists to grapple with the freeway and its aesthetic challenges. In the cultural work of many Chicana/o artists and writers from the Eastside—the paintings of Carlos Almaraz (fig. **248**), David Botello, and Frank Romero; the murals of Judith Baca; and the literature of Helena María Viramontes—the freeway looms large, casting deep shadows over the experience and memory of what became the nation's largest Spanish-speaking barrio by the mid-1960s. In their youth, these artists and writers confronted what Shulman left behind.

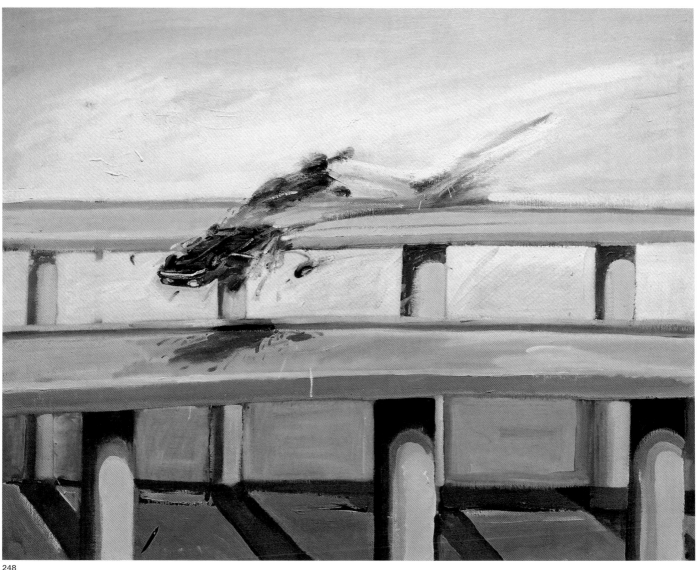

248

246 Julius Shulman, *Case Study House No. 22, Los Angeles, California*, 1960. Gelatin silver print. Julius Shulman Photography Archive, Getty Research Institute, Los Angeles

247 East L.A. Interchange, June 1965. Courtesy of the California Department of Transportation

248 Carlos Almaraz, *Solo Crash*, 1981. Oil on canvas. Courtesy of Craig Krull Gallery, Santa Monica

They witnessed a literal invasion of bulldozers, earthmovers, and armies of construction workers, who gutted the local landscape to impose massive concrete channels that fortified a new set of racial boundaries between white and Chicano Los Angeles.[3] During the late 1960s and early 1970s, at the height of the Chicano movement, these artists and writers committed themselves to the search for a Chicano aesthetic, drawing inspiration from the cultural ferment of the barrio. In a deracinated landscape ravaged by

white flight and highway construction, they found a strange beauty in the freeways that towered in their midst, soaring above or sunken below the landscape of everyday life.

Grounded in East Los Angeles, these artists and writers gave expressive form to the political imperatives of the Chicano movement. Through their unique talents and subjectivities, they rendered a Chicano critique of the freeway to call attention to the predicament of the barrio and its people. Viramontes, for example, in her novel

Their Dogs Came with Them (2007),
describes in vivid detail how highway
construction effectively quarantined
the East Los Angeles barrio from the
rest of the city. This literary portrait of a
community's constriction finds its visual
counterpart in Judith Baca's *Great
Wall of Los Angeles* (1976–; fig. **249**), a
half-mile-long mural narrating the city's
history from alternative social per-
spectives. The mural includes a scene
of post–World War II Los Angeles that
depicts the freeway's destruction
of Boyle Heights (fig. **250**). A Chicano
family is divided by the serpentine coils
of a freeway, which separates family
members and scars the neighborhood
landscape. As feminists, moreover, both
Baca and Viramontes stress a uniquely
Chicana perspective on the freeway
and its construction, emphasizing
its destabilizing influence on family
and community.

The paintings of Almaraz, Botello,
and Romero deliver a subtler critique
of highway construction in the barrio.
Like Baca and Viramontes, each of
these artists embraced the politics
of the Chicano movement in the
1970s, establishing art collectives and
community-based mural programs
to provide new possibilities for the
communal creation and appreciation
of art. With formal training in canvas
painting, they rendered their impression
of the urban scene in East Los Angeles,
self-consciously adapting Mexican
aesthetic traditions to portray the
barrio's paradox of beauty and injustice.
Unlike Shulman, whose camera
recorded the black-and-white facts
of modernist design in Southern
California, East L.A. painters of the
Chicano generation inserted wit,
color, and critical analysis into their
depictions of the urban scene. They
deliberately render a Chicano rela-
tionship to the freeway, delivering an
up-close-and-personal portrait of its
architecture and the shadows it casts
over the barrio landscape. Of the

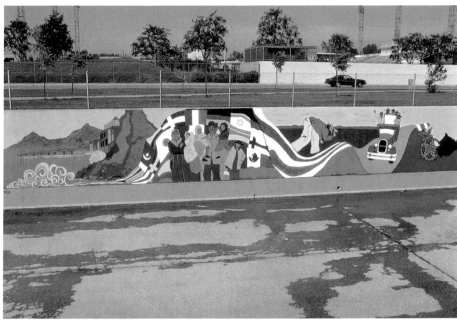

249

three, Romero presents what appears
to be the most benign view of the
freeway, applying hot pink, neon blue,
and phthalo green to its contorted yet
monumental architecture. Almaraz, in
contrast, conveyed his ambivalence
toward the freeway by creating a series
of car-crash paintings, explosive riots of
color bursting at the apex of a soaring
highway interchange. Born and raised
in East Los Angeles, Botello took a less
morbid stance, but his paintings also
reveal a critical edge. Some of them
dramatize the contrast between sunlight
and freeway shadow, while others depict
the freeway's uneasy fit into the barrio.
In their vast corpus of work, these art-
ists present a Chicano perspective on
the freeways that bullied their way into
the barrio, illuminating a form of spatial
injustice that continues to afflict poor,
urban communities of color.[4]

The portrait of the L.A. freeway—
in art, in literature, even in scholar-
ship—implicates a rich diversity of
perspectives. The British architec-
tural historian Reyner Banham wrote
a paean to the freeway, praising the
system as the city's fourth ecology,

a "state of mind" and "way of life."[5]
Another Englishman and L.A. outsider,
David Hockney, pronounced himself
a latter-day Piranesi in Los Angeles,
expressing his eagerness to discover
the freeway's aesthetic possibilities.[6]

249 Judith F. Baca, *Great
Wall of Los Angeles*,
begun 1976. Mural detail
from the first 1,000-foot
section, titled "Migrant
California." The world's
longest mural, at 13 by
2,400 feet, depicts a
multicultural history of
California from prehistory
through the 1950s. The
mural is still growing. The
Great Wall is located in
California's San Fernando
Valley Tujunga Wash, a
flood-control channel built
in the 1930s. Acrylic on
cast concrete. Courtesy of
SPARC (sparcinla.org)

250 Judith F. Baca, *Great
Wall of Los Angeles*, begun
1976. Mural detail from
the 1950s section titled
"Division of the Barrios
and Chavez Ravine." Acrylic
on cast concrete. Courtesy
of SPARC (sparcinla.org)

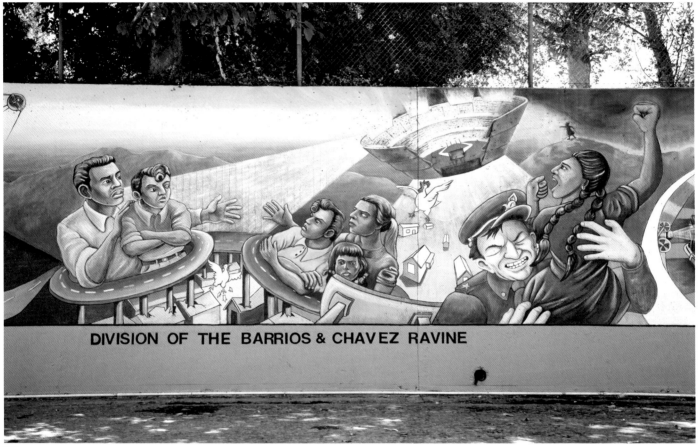

DIVISION OF THE BARRIOS & CHAVEZ RAVINE

250

In East Los Angeles, however, local Chicano artists and writers did not discover the freeway. Rather the freeway discovered them. The emerging barrio of East Los Angeles bore the brunt of interstate highway construction in the Los Angeles region. While other communities, like Beverly Hills, successfully mustered the political clout necessary to block freeway construction, East Los Angeles witnessed the incursion of six freeways in the span of some seventeen years.[7] With their community powerless to win even the slightest modification of the master plan, a subsequent generation of Chicano artists, writers, and intellectuals summoned artistic talent and cultural traditions to assert a barrio critique of the freeway, even as they rendered its strange but compelling beauty.

1 See, for example, Reyner Banham, *Los Angeles: The Architecture of Four Ecologies* (Harmondsworth, UK: Penguin, 1971), especially chap. 11, "Ecology IV: Autopia." See also David Brodsly, *L.A. Freeway: An Appreciative Essay* (Berkeley: University of California Press, 1980).

2 See George Sanchez, "'What's Good for Boyle Heights Is Good for the Jews': Creating Multiracialism on the Eastside during the 1950s," *American Quarterly* 56 (September 2004): 633–61.

3 For one of the few scholarly references to this subject, see Rodolfo Acuña, *Occupied America: The Chicano's Struggle toward Liberation* (San Francisco: Canfield, 1972).

4 A younger generation of Latino artists in Southern California continues to explore the freeway's domination of the local landscape and its bifurcation of neighborhoods. The work of Ruben Ochoa, for example, forces viewers to confront the massive concrete bulk of the freeway monolith or imagines the possibility of making the freeway disappear altogether. See Michelle Urton, "Ruben Ochoa," in *Phantom Sightings: Art after the Chicano Movement*, by Rita González, Howard N. Fox, and Chon A. Noriega (Los Angeles: Los Angeles County Museum of Art; Berkeley: University of California Press, 2008), 180–83.

5 Banham wrote, "The freeway system in its totality is now a single comprehensible place, a coherent state of mind, a complete way of life, the fourth ecology of the Angeleno." Banham, *Los Angeles*, 213.

6 In a 1975 interview Hockney described his first visit to the city, in 1964: "There were no paintings of Los Angeles.... People then didn't even know what it looked like. And when I was there they were still finishing some of the big freeways. I remember seeing, within the first week, a ramp of a freeway going into the air, and at first it looked like a ruin and I suddenly thought, 'My God, this place needs its Piranesi. Los Angeles could have a Piranesi, so here I am!'" Quoted in Christopher Simon Sykes, *David Hockney: The Biography, 1937–1975; A Rake's Progress* (New York: Doubleday, 2011), 145.

7 See Eric Avila, *Popular Culture in the Age of White Flight: Fear and Fantasy in Suburban Los Angeles* (Berkeley: University of California Press, 2004), 206–15.

Robert Adams, *Los Angeles Spring* (1978–83)

Leslie Wilson

If you climb firebreaks up through the chaparral above the Los Angeles basin . . . you are still likely to hear, eventually, the scream of a hawk, surely among the great primal sounds of nature; if, however, the air is polluted, and the cry is superimposed over the noise of dirt bikes and gunfire and the metronomic backup signal from some far-off landfill machine, then the cry will seem, in its acidity, only human.
—Robert Adams

Reflecting on the sights and sounds of the Los Angeles basin, Robert Adams offered two possibilities: to bear witness to the region's most resilient and majestic animal life or to find that human excess drowns out any evidence of its existence.[1] The tension between the natural environment of the West and the impact of land development has long been at the heart of his work, with his photographs revealing places where human encroachment threatens to silence nature. Adams worked in the basin for more than six years, from the late 1970s to the early 1980s, making the images that appeared in the series *Los Angeles Spring*.[2] These photographs represented a Southern California landscape bleached and softened by smog that threatened both to reveal and to obscure an environment giving way to development.

We see evidence of the region's cityscapes in the form of motels, wide roads, and skinny trees on small patches of grass in the hazy distance of Adams's *On Signal Hill, Overlooking Long Beach, California* (1983), a photograph in which compositional balance lives in opposition to a landscape thrown increasingly off-kilter by urbanization. In the foreground are two bedraggled trees cast in shadow, one tall and anemic, the other short and squat. Leaning to the left with their long, nerve-like branches dotted with leaves, they appear to stand somewhere between life and death. Their branches slightly intermingle, and it remains ambiguous whether these are new plantings attempting to thrive or seasoned trees being done in by urban encroachment.

After decades of growth and environmental strain driven by the discovery of oil at the turn of the twentieth century in a region home to one of the busiest ports in North America, the Los Angeles Basin of the 1960s and 1970s was contending with blight and pollution in its urban centers and initiating new plans for development (fig. **251**). Trying to overcome its reputation as a "lusty boomtown"[3] of bars, billiards, and ubiquitous oil derricks, Signal Hill attracted a new rush of interest as the population surged in greater Los Angeles. But the oil boom took its toll on the region's landscape. Describing Signal Hill in 1978, the journalist Mary Barber observed: "By almost any standards and from any angle, the hill is ugly. Except when you're on it, looking out, and then its beauty is breathtaking."[4]

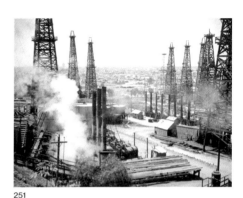

251

Epigraph: Robert Adams, "In the Twentieth-Century West," in *Why People Photograph: Selected Essays and Reviews by Robert Adams* (New York: Aperture, 1994), 160.

1 On the history of land development in Los Angeles, see Mike Davis, "How Eden Lost Its Garden: A Political History of the Los Angeles Landscape," in *The City: Los Angeles and Urban Theory at the End of the Twentieth Century*, ed. Allen J. Scott and Edward W. Soja (Berkeley: University of California Press, 1998), 160–85.

2 For more images, see Robert Hass, "Beauty and Silence," in *California: Views by Robert Adams of the Los Angeles Basin, 1978–1983* (San Francisco: Fraenkel Gallery, 2000), unpaged.

3 Ray Hebert, "Signal Hill Trades Oil for Respect: Production Falls, So Residential Development Set," *Los Angeles Times*, November 5, 1962.

4 Mary Barber, "Signal Hill Warily Awaits New Boom," *Los Angeles Times*, June 18, 1978.

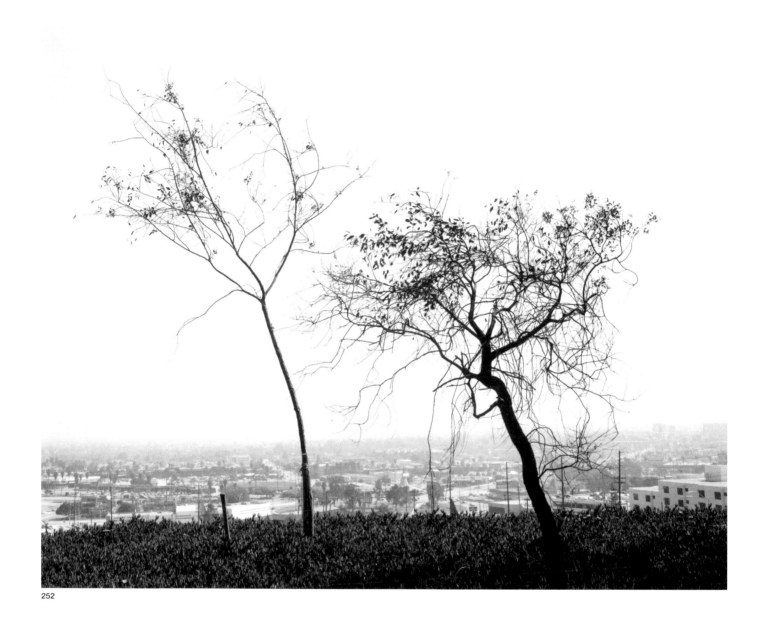

252

A Survivor's Guide to Los Angeles

Dana Cuff

Sitting at the edge of the nation, along fault lines topped by four-level freeway interchanges; portrayed as a promised land yet riven by tense racial bifurcations; imagined as sprawling without interruption but punctuated by violent urban upheavals; depicted as an Arcadian landscape yet dying of thirst, Los Angeles has a checkered history, swinging from self-aggrandizement to jaw-dropping disaster. In his literary history of the city, David M. Fine contends: "As Los Angeles emerged as America's most conspicuous city—film, media, and pop music capital; nerve center of its war and space industries; and troublesome zone of so many unassimilated, ghettoized immigrants (legal and illegal) who constitute cities within the city—it became the most conspicuous national site for disaster scenarios on screen and in print."[1] Violent endings and survivor tales are written to balance the hyperbolic dream machine that drew so many domestic and foreign immigrants west. But fiction is not the exclusive province of apocalyptic scenarios involving the city. The geographer James K. Mitchell empirically grounds fears of catastrophe: "Greater Los Angeles experiences a range of severe physical risks that is scarcely equaled by any other mega-city."[2]

It is not only in the arts that Los Angeles figures as a site of destruction, though we can certainly find jarringly beautiful imagery there (see fig. **212**). Disaster is built directly into the landscape. The physical form of the city makes legible a material record of its violent past. Consider the Los Angeles River, a never navigable but essential year-round source of water that justified settlement along its course in centuries past. Because low rainfall prevented the river from establishing a well-defined bed, it meandered and shifted dramatically. After catastrophic flooding around the turn of the nineteenth century, piecemeal

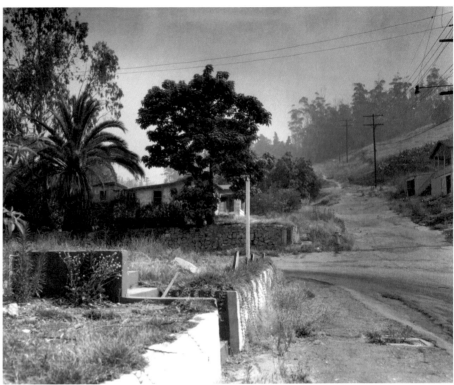

253

attempts at flood control were ineffective against the deadly New Year's Day flood of 1934, and subsequent concrete channelization just north of downtown couldn't prevent the unprecedented damage wrought by the flood of 1938. Eventually an enlarged, deepened, straightened reinforced-concrete channel would run from the Chatsworth hills to the San Pedro Bay to create a fifty-one-mile-long "water freeway."[3] The river channel is a piece of infrastructure, but unlike freeways, railways, and power lines, it is a visual testament to powerful catastrophes both past and potential. Designed to accommodate floodwaters as much as twenty thousand times the average summertime flow, the concrete channel guards a trickle of water at its bottom, a reminder of the scarcity of that precious, dangerous resource. The city's precarious relation to nature is a source of ambivalence: almost since its channelization, there has been a movement

under way to remove the concrete and restore the river.

Not only is Los Angeles subject to natural disasters, but like most U.S. cities, it breeds its own urban violence. The churning spatial politics of urban development can be difficult to read in built form, and some of that illegibility is intentional. When the emblematic freeway system unrolled across the existing city center, it was specifically tasked to demolish "slum" housing in a program called "equivalent elimination."[4] Freeway

253 Julius Shulman,
*Chavez Ravine, Los Angeles,
California,* 1953. Gelatin
silver print. Julius
Shulman Photography
Archive, Getty Research
Institute, Los Angeles

254 Dodger Stadium
construction, 1960.
Los Angeles Examiner
Collection, USC Libraries

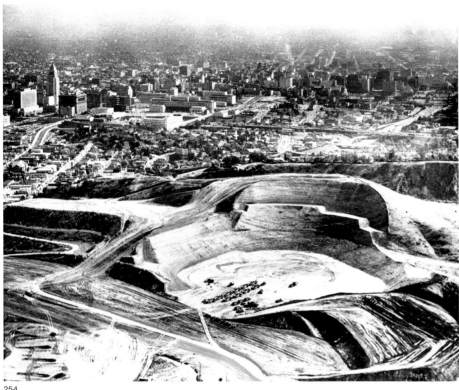

254

construction worked hand in hand with federally subsidized public housing in the mid-twentieth century, and neighborhoods occupied largely by poor people of color were destroyed to make way for the modern city. Freeways were mapped specifically to raze those areas that city leadership sought to redevelop, since every unit of public housing constructed had to be matched one-to-one by an equivalent number of demolished existing housing units. The program was backed by the home-building industry, which sought to limit competition with government-subsidized construction and rental rates. In L.A.'s final tally, more housing was demolished than built, and few of the displaced residents were rehoused in the subsidized units that they were promised. As such, public housing is better described as a program for urban modernization than a program to increase affordable housing.

Political opposition finally brought an end to public housing at Elysian

Park Heights, just north of downtown Los Angeles, where more than three thousand apartments in the architect Richard Neutra's affordable utopia might have been built in the 1950s. The city, pressured by the home-building industry and red-baiting conservatives, deployed eminent domain, evicted the last residents kicking and screaming, and tore down the homes of thousands of Mexican Americans who had been living in Chavez Ravine (fig. **253**). New leadership in the mayor's office abandoned Neutra's grand social agenda to build a major league baseball stadium on the site, importing the Dodger franchise from New York (fig. **254**). Housing activists like Frank Wilkinson argued that the Watts riots could be directly traced to the failure to build promised public housing.[5] Even where affordable housing was constructed, residents faced continual upheavals. For example, in East Los Angeles, Nueva Maravilla Public Housing was

built in 1938 and then demolished and rebuilt in 1972 because, like other public housing in Los Angeles, it was rife with gangs, drugs, and crime. Oscar Castillo's photograph captures this violent and simultaneously melancholy neighborhood destruction, repeated across the city (fig. **255**).

This city of movement, entertainment, and money in search of a modern identity had no use for its deteriorating historic core but instead wanted to fashion for itself a downtown, attempting to leave its adobe origins behind in a move to the west, onto Bunker Hill. There a kind of serial urban murder was planned over and over again, from the 1920s until it was finally accomplished in the 1970s. For the city's agents of change (politicians, builders, businesses, investors), architects and planners visualized new imaginaries, created totalizing housing schemes, then office schemes, and then corporate environments that could colonize the hill. Every plan rested on the destruction of all the buildings that were on Bunker Hill, but a clean slate was not enough. The hill itself would also be removed to smooth the way for the modern project. This spatial erasure hides the violence that lies in the development mantra of "highest and best use," the view that land can and will inevitably be capitalized, in spite of inhabitation. An array of classically inhospitable office complexes (see, for example, Arthur Erickson's 1985 California Plaza) materialized that view.

This portrayal parallels the story Mike Davis painted more forcefully in *City of Quartz: Excavating the Future in Los Angeles* (1990). But Davis felt no obligation to the future of L.A., except to admonish its agents to heed the past as a cautionary tale. Can the machine that is Los Angeles retool itself to take the violence out of city making? Davis had little use for the *vision* in *visionary*, nor for the potential of the arts in the urban. If capital is the fuel of urban

255

churning, the arts and their publics retain some authority in the system. Not only do the arts record for memory the violence that the city might otherwise erase, but they can also project postapocalyptic futures that resist totalizing utopian paths. The tabula rasa is ground zero of violent destruction and its utopian aftermath (fig. **256**). Instead, incremental cultural interventions stake a claim in the city for the arts. Piecemeal speculation about our collective metropolitan lives is exactly what has emerged along Grand Avenue in Bunker Hill, which is lined by an exquisite collection of cultural institutions: Arata Isozaki's Museum of Contemporary Art, Frank Gehry's Walt Disney Concert Hall, Rafael Moneo's Cathedral of Our Lady of the Angels. Yet topographic discontinuities remain, and fragmented publics, now joined by a new park for City Hall, coexist on Bunker Hill. There are moments—when bikes or festivals reclaim the streets or when the cathedral's congregation migrates out into the city—when a human infrastructure appears to string together the civic fragments. This is not a picturesque urbanity. It is neither the teeming crowd nor the romantic Parisian park. But to deploy these visions is to create a redemptive postapocalyptic cousin of the tabula rasa. Unlike the river's concrete channel, the city is not a safeguard against catastrophe. Instead it can be a site where our collective uncertainty and anxiety are temporarily assuaged by the material recognition of our shared condition. In Los Angeles the city is at its best in places where those experiences are linked together and where, for that moment, we recognize our shared fate.

1 David M. Fine, *Imagining Los Angeles: A City in Fiction* (Reno: University of Nevada Press, 2004), 234–35.

2 James K. Mitchell, editor's note, in *Crucibles of Hazard: Mega-Cities and Disasters in Transition*, ed. James K. Mitchell (Tokyo: United Nations University Press, 1999), 375.

3 Blake Gumprecht, *The Los Angeles River: Its Life, Death, and Possible Rebirth* (Baltimore: Johns Hopkins University Press, 2001), 224 (quoting a U.S. Army Corps of Engineers official in 1959).

4 See Donald Craig Parson, *Making a Better World: Public Housing, the Red Scare, and the Direction of Modern Los Angeles* (Minneapolis: University of Minnesota Press, 2005), 137.

5 For a thorough account of Los Angeles public housing and the life of Frank Wilkinson, see ibid.

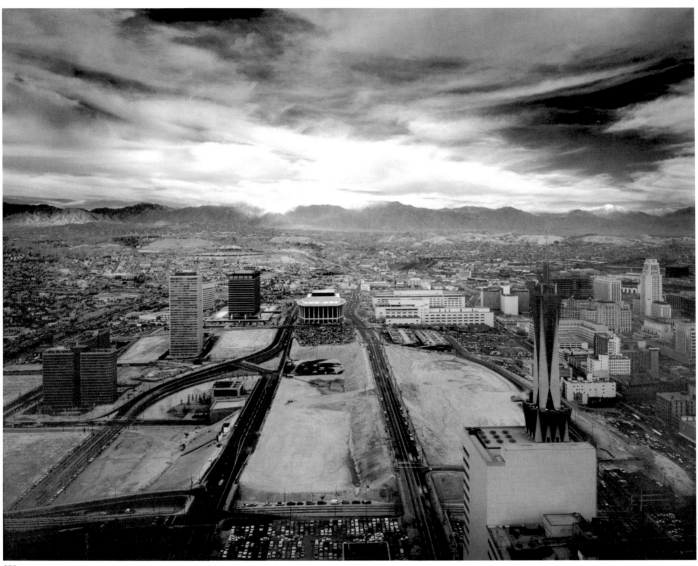

256

255 Oscar Castillo,
*Shrine to the Virgin of
Guadalupe at Maravilla
Housing Projects, Mednik
Avenue and Brooklyn
Avenue, East Los Angeles*,
ca. 1975 (printed 2014).
Inkjet print. Courtesy
of the artist

256 Julius Shulman,
Bunker Hill Development,
1969. Gelatin silver print.
Julius Shulman Photography
Archive, Getty Research
Institute, Los Angeles

Postscript

Katherine A. Bussard, Alison Fisher, and Greg Foster-Rice

With the election of Ronald Reagan to the presidency in 1980, the United States experienced a series of dramatic shifts in urban policy that had their origins in the previous decade. This conservative political realignment led to the reduction or elimination of decades-long social and environmental programs and organizations that traditionally had their greatest impact in America's largest cities.[1] One of the most telling examples of this effective dismantling of President Johnson's Great Society was the 1973 moratorium on federal funding for low-income urban housing, followed by legislation in 1983 that halted all new construction by the U.S. Department of Housing and Urban Development.[2] This political shift laid the groundwork for the eventual demolition of nearly all high-rise public housing in Chicago, for example, beginning in 1998 with the Lakefront Homes and continuing up to the present with the demolition of the last tower of Cabrini-Green in 2011.

The financial market crash of 1987 and its lingering effects into the early 1990s combined with policy changes to put new but not unfamiliar pressures on America's urban communities. Arguably the most visible reaction to these circumstances was the Los Angeles riots of 1992. In addition to the immediate trigger of the acquittal of the police officers who were caught on videotape beating Rodney King, other factors that explain the intensity, duration, and violence of these riots include high rates of recession-related poverty and unemployment among the residents of South Central Los Angeles (the center of the riots) as well as growing economic disparity and competition among urban minority populations as a result of government deregulation.[3] The writer, theorist, and historian Mike Davis has argued that these conditions engendered even more widespread frustration and resentment among city residents and therefore posits that the 1992 riots—not unlike those in Watts in 1965—served as an expression of collective public protest.[4]

In contrast to the situation in the 1960s and 1970s, however, many of these new (or simply intensified) problems in the social and physical fabric of American cities were the result of economic expansion rather than collapse. Although the 1970s were plagued by deep financial crises, they also witnessed the foundations of new, highly successful models of urban redevelopment. Instead of relying on federal funding to realize new building projects, private developers in the mid-1970s took advantage of tax breaks, market deregulation, and labor-law reform to amass property and wealth, effectively completing a long transition in American cities in which real estate, finance, and service industries took the former place of industry and infrastructure as the predominant economic drivers.[5]

The effects of this shift were felt in immediate and vivid, albeit uneven, ways during the late 1970s and early 1980s, especially in New York, where the real estate market dramatically transformed the social and economic landscape of huge swaths of the city, most notably in Lower Manhattan. In her groundbreaking 1982 book *Loft Living: Culture and Capital in Urban Change*, the sociologist Sharon Zukin was driven to explore the issue of gentrification in formerly industrial neighborhoods after she witnessed the rapid disappearance of the "urban ballet" of artists, shop owners, and small manufacturers surrounding her loft

building in New York in the late 1970s.[6] Importantly, in her study Zukin found that the cultural shifts of the previous decades—which led to a new appreciation for the distinctive qualities of historical urban neighborhoods, as promoted by Jane Jacobs and others—also gave legitimacy and prestige to a new urban culture of private capital extending from the art world to real estate developers.

In hindsight, this new wave of investment, which focused on preservation and the adaptive reuse of older structures in previously underserved neighborhoods, ended up pushing out long-term residents, not only failing to match Jacobs's intentions but also turning cities into citadels for the wealthy.[7] Cities also considered privatization an important key to the transformation of downtown commercial areas, importing concepts developed in suburban malls to bring retail and tourism to rundown areas such as Chicago's State Street and New York's South Street Seaport.[8] In the 1980s and 1990s Jacobs became the inadvertent hero of advocates of New Urbanism, a movement uniting architects, designers, and municipal governments in the promotion of a faux urbanism predicated on manufactured visual cues (i.e., vintage-style street furniture) rather than the organic development of neighborhoods.[9]

In the 1980s artists responded to these changes in the city with an even greater and more politicized emphasis on the artistic occupation of urban space. For example, on New Year's Eve of 1979, a group of thirty-five New York artists took over an abandoned building to mount a highly polemical exhibition of photographs, graffiti art, assemblage art, paintings, and installations titled *The Real Estate Show*.[10] The exhibition foregrounded issues of housing and homelessness in the city and was sharply critical of "the way money controls where and how people live in New York City in general, and the Lower East Side in particular."[11] This exhibition led to the establishment of the alternative art space ABC No Rio, which became part of a strong group of arts organizations arguing for the rights of citizens to city spaces during the 1980s.[12]

Public art gained new prominence in the 1980s, encompassing two disparate veins of practice that had developed in the 1960s and 1970s, one dominated by "public" sculptures in the corporate plazas of modernist office buildings and the other focused on local, community-based, and sometimes ephemeral projects such as the *Wall of Respect* (1967–71; figs. **10, 144**) in Chicago and *Ceremony for Freeway Fets* (1978; figs. **238, 239**), created by Senga Nengudi and Studio Z in Los Angeles.[13] These trajectories came together through new organizations such as the Public Art Fund in New York and important legislation like that city's 1982 "Percent for Art" law mandating that 1 percent of the budget for city-funded construction projects be spent on public art.[14] While such efforts increased the quantity of public art in cities, in many instances this success was accompanied by a real shift in the forms, audiences, and critical potential of art practices.

Critics have pointed to the Battery Park City development in New York as a striking example of the commodification of public art and urban communities during this period.[15] For many years the project site had been a vacant area of landfill and part of an urban fringe of piers, parking lots, and abandoned buildings in Lower Manhattan that had supported all manner of artists' practices in the 1960s and 1970s.[16] Beginning in 1980, this land was developed as an upper-income community complete with new apartment buildings, schools, lush gardens, and one of the country's most ambitious programs for public art. Featuring work by

famous sculptors as well as artists specializing in land art and site-specific installations—including Louise Bourgeois, Scott Burton, and Mary Miss—this public art program ultimately served to support and justify the high prices and exclusivity of the new community.[17] Public art and public space therefore became increasingly at odds in the city.[18]

Within this new context of the privatization of cities, the photographic and cinematic image of the city expanded beyond the specificity and direct engagement that characterized so much of the 1960s and 1970s in New York, Chicago, and Los Angeles. Certainly one could still find artworks chronicling gritty downtown urbanism, such as Nan Goldin's *Ballad of Sexual Dependency* (1979–86).[19] But the growth of edge cities, which lacked differentiation precisely because of their rapid development in the waning decades of the twentieth century, prompted photographers such as Bob Thall to turn their lenses toward the growing tide of anonymous residential developments and homogeneous corporate office buildings outside the central city.[20] At the same time, responding to the growth of international finance and the further integration of the global economy in the 1980s and 1990s, photographers like Thomas Struth began documenting the transformation of cities such as Las Vegas, Seoul, and Shanghai under late capitalism, often at the expense of local history and human-scale habitation.[21] In film, these trends resulted in creations like the Los Angeles of Ridley Scott's prescient *Blade Runner* (1982), which was rooted in elements of L.A. noir but even more broadly based on the fantasy of globalization run amok—a conglomeration of urban vistas from across the globe and history, citing contemporary Tokyo in its neon streetscape as well as ancient Tenochtitlan in its signature corporate ziggurats.

In short, after 1980 images of the city entered a phase distinct from that considered by *The City Lost and Found*. This new imagery of the global city was governed by shifts in thinking about cities as decentralized, transnational, and distinctly corporatized—more like networks of economic exchange than the frequently contested, always dynamic social spaces depicted in the visual culture of the 1960s and 1970s. At the time of this publication, there are signs that the discourse is shifting once again toward the analysis of the specific social circumstances of central cities.[22] What remains certain is that images of the city—in the popular media and the arts—continue to play a central role in defining the significance of the city in public discourse.

1 Reagan was well known for his negative attitude toward large cities and urban problems, and he dramatically cut budgets for the Department of Housing and Urban Development (HUD) and welfare programs in the United States. For more on Regan's presidency and relationship to the urban question, see Robert M. Collins, *Transforming America: Politics and Culture in the Reagan Years* (New York: Columbia University Press, 2007), as well as Steven Conn, *Americans against the City: Anti-urbanism in the Twentieth Century* (New York: Oxford University Press, 2014).

2 Despite taking an active role in creating solutions to urban issues early in his administration, in January 1973 President Nixon froze funding for all active HUD projects, largely stemming from negative reactions in the press and public to HUD's new fair housing programs—including building low-income housing in the suburbs—created after the Civil Rights Act of 1968. After this point housing policies shifted back to urban-only aid, increasingly in the form of housing vouchers. See Christopher Bonastia, *Knocking on the Door: The Federal Government's Attempt to Desegregate the Suburbs* (Princeton, NJ: Princeton University Press, 2006).

3 At least fifty-two people died and more than two thousand were injured during the six days of rioting, and physical damage to the affected neighborhoods was estimated up to $1 billion. See, for example, Janet L. Abu-Lughod, "Riot Redux," in *Race, Space, and Riots in Chicago, New York, and Los Angeles* (New York: Oxford University Press, 2007), 227–68.

4 See Mike Davis, "In L.A., Burning All Illusions," *Nation*, June 1, 1992, 743–46, and Davis, "The L.A. Inferno," *Socialist Review*, January–March 1992, 57–80.

5 David Harvey and other scholars have identified these developments with the rise of neoliberalism in the United States. See Harvey's now classic book *A Brief History of Neoliberalism* (New York: Oxford University Press, 2005), as well as more site-specific studies, such as Kim Moody, *From Welfare State to Real Estate: Regime Change in New York City, 1974 to the Present* (New York: New Press, 2007).

6 Sharon Zukin, *Loft Living: Culture and Capital in Urban Change* (Baltimore: Johns Hopkins University Press, 1982). "Urban ballet" was of course one of the phrases used by Jane Jacobs to describe the activity on the sidewalks of her street in Greenwich Village in *The Death and Life of Great American Cities* (New York: Random House, 1961).

7 This genre of latter-day urban renewal and gentrification took place (and continues to do so) in each of these three cities. Chicago's formerly industrial Printer's Row was rehabbed into smart yuppie lofts in the 1980s, and interestingly, the late nineteenth and early twentieth-century fabric of Los Angeles's downtown began to experience this transition within the past decade.

8 See the essays in Michael Sorkin, ed., *Variations on a Theme Park: The New American City and the End of Public Space* (New York: Hill & Wang, 1992).

9 See Michael Sorkin, "Acting Urban: Can New Urbanism Learn from Modernism's Mistakes?," *Metropolis* 18 (August–September 1998): 37, 39.

10 The show took place at 123 Delancey Street, a building that, ironically, had last been used as a Model Cities neighborhood office before lying vacant for more than a year. The artists had attempted to rent the space from the Department of Housing Preservation and Development, which turned a deaf ear to their requests, thus prompting the site's occupation on December 31, 1979.

11 Lehmann Weichselbaum, "The Real Estate Show" (originally published in the *East Village Eye*, 1980), http://www.abcnorio.org/about/history/res_press.html. See also Julie Ault, ed., *Alternative Art, New York, 1965–1985* (Minneapolis: University of Minnesota Press, 2003).

12 On the history of ABC No Rio, see Alan Moore and Marc Miller, eds., *ABC No Rio Dinero: The Story of a Lower East Side Art Gallery* (New York: ABC No Rio with Collaborative Projects, 1985). On the history of art and urbanism in the 1980s, see Martha Rosler and Brian Wallis, eds., *If You Lived Here: The City in Art, Theory, and Social Activism* (Seattle: Bay Press, 1991). Other organizations emerged during the 1980s and 1990s to recognize, document, and advocate for the important and often informal places in urban neighborhoods. An important example is the New York Place Matters project, an offshoot of City Lore, both of which focus on grassroots cultures and sites like the casitas built by Puerto Rican communities in abandoned lots in New York. Many of the artists in ABC No Rio were also affiliated with Collaborative Projects, Inc., or Colab, a loosely organized artists group that functioned as a social network and helped with grant opportunities. See http://98bowery.com/return-to-the-bowery/abcnorio-colab.php.

13 In addition, the general art market experienced a pronounced boom in the 1980s, which fueled the careers of celebrity artists with strong associations to street art, such as Jean-Michel Basquiat and Keith Haring as well as media-driven Pop artists like Jeff Koons, and led to the proliferation of international art fairs. For two perspectives on this era, see Jack Bankowsky, Alison Gingeras, and Catherine Wood, eds., *Pop Life: Art in a Material World* (London: Tate Publishing, 2010), and Helen Molesworth, ed., *This Will Have Been: Art, Love & Politics in the 1980s* (Chicago: Museum of Contemporary Art Chicago, 2012).

14 See Suzanne Lacy, *Mapping the Terrain: New Genre Public Art* (Seattle: Bay Press, 1995).

15 Rosalyn Deutsche, "Uneven Development: Public Art in New York City," *October* 47 (Winter 1988): 3–52.

16 Tom Finkelpearl writes poignantly about this transition, recalling the excitement of the experience of the temporary art installations and performances that took place on the desolate area of fill that would become Battery Park City, organized annually as Art on the Beach by the public art group Creative Time. See his introduction "The City as Site," in *Dialogues in Public Art* (Cambridge, MA: MIT Press, 2000), 3–51. For more on this history of Lower Manhattan, see Lynne Cooke, Douglas Crimp, and Kristin Poor, *Mixed Use, Manhattan: Photography and Related Practices, 1970s to the Present* (Cambridge: MIT Press, 2010).

17 The reactions to this corporate and in some ways un-site-specific art led to a whole new genre of critical practice, including urban projects such as *Places with a Past*, the 1991 exhibition that was part of the Spoleto Festival in Charleston, South Carolina, curated by Mary Jane Jacob. See Mary Jane Jacob and Christian Boltanski, *Places with a Past: New Site-Specific Art at Charleston's Spoleto Festival* (New York: Rizzoli, 1991).

18 For a detailed analysis of these questions, see Rosalyn Deutsche, *Evictions: Art and Spatial Politics* (Cambridge, MA: MIT Press, 1996).

19 Nan Goldin, *The Ballad of Sexual Dependency* (New York: Aperture Foundation, 1986).

20 See Joel Garneau, *Edge City: Life on the New Frontier* (New York: Anchor, 1992); Bob Thall, *The New American Village* (Baltimore: Johns Hopkins University Press, 1999); and *New Topographics: Photographs of a Man-Altered Landscape* (Rochester, NY: International Museum of Photography at George Eastman House, 1975).

21 On this phenomenon in general, see Saskia Sassen, *The Global City: New York, London, Tokyo* (Princeton, NJ: Princeton University Press, 1991), and for more on photographers' work on this topic, including that of Struth and Andreas Gursky, see the catalogue for the 2006 Venice Biennale of Architecture, Sarah Ichioka, ed., *Cities: Architecture and Society*, 2 vols. (Venice: Biennale di Venezia; New York: Rizzoli, 2006), and Pamela M. Lee, *Forgetting the Art World* (Cambridge, MA: MIT Press, 2012).

22 Some recent examples include Alan Ehrenhalt, *The Great Inversion and the Future of the American City* (New York: Knopf, 2012); Edward Glaeser, *Triumph of the City: How Our Greatest Invention Makes Us Richer, Smarter, Greener, Healthier, and Happier* (New York: Penguin, 2011); and Don Mitchell, *The Right to the City: Social Justice and the Fight for Public Space* (New York: Guilford, 2003).

Acknowledgments

This project began in 2009 with a series of lively conversations between colleagues discovering a shared interest in their areas of research. Many discussions, research trips, and collaborations later, this originating spark became *The City Lost and Found: Capturing New York, Chicago, and Los Angeles, 1960–1980*. As with any undertaking years in the making, this project would not have been possible without the support of other colleagues, sister institutions, dedicated collectors, and generous donors. We express our sincere thanks to all those who contributed to the realization of this exhibition and book.

For making the very first commitment to this project, we thank the Richard H. Driehaus Foundation. Early support for Greg Foster-Rice's research was provided by The Terra Foundation for American Art / Lloyd Lewis Fellowship for American Art at the Newberry Library, as well as a Faculty Development Grant from Columbia College Chicago. We are grateful for the continued support of Foster-Rice's contributions to this project demonstrated by Peter Fitzpatrick and the staff of the Department of Photography at Columbia College Chicago. We also join Douglas Druick and James Steward, directors of the Art Institute of Chicago and the Princeton University Art Museum, respectively, in expressing our gratitude to the Barr Ferree Foundation Fund for Publications in the Department of Art and Archaeology at Princeton University; the Graham Foundation for Advanced Studies in the Fine Arts; Susan and John Diekman, Princeton Class of 1965; Christopher E. Olofson, Princeton Class of 1992; M. Robin Krasny, Princeton Class of 1973; David H. McAlpin Jr., Princeton Class of 1950; James E. and Valerie A. McKinney; Elchin Safarov and Dilyara Allakhverdova; and the Allen R. Adler, Class of 1967, Exhibitions Fund of the Princeton University Art Museum.

Crucial to the success of this exhibition and catalogue are the many wonderful objects that we researched, considered, and were able to include thanks to the generosity of lending institutions and private collectors. We gratefully acknowledge Janet Parks, Avery Architectural & Fine Arts Library, Columbia University; Nancy Watrous, Chicago Film Archives; Todd Gaydowski, City Archives and Records Center, Los Angeles; Stuart Cohen; Edward Cella, Edward Cella Gallery; Dr. Walter O. Evans and Linda J. Evans; Greg Foster-Rice; Theresa Luisotti, Gallery Luisotti; Wim de Wit and Christopher James Alexander, Getty Research Institute; Kerry Brougher, formerly of the Hirshhorn Museum and Sculpture Garden; Jennifer A. Watts and Erin Chase, Huntington Library; Nanette Esseck Brewer, Indiana University Art Museum; Judith Keller, Virginia Heckert, Arpad Kovacs, and Miriam Katz, J. Paul Getty Museum; Anne-Dorothee Boehme, Joan Flasch Artists' Book Collection, School of the Art Institute of Chicago; Marvin Hoshino, Estate of Helen Levitt; Sofia LeWitt and Janet Passehl, LeWitt Collection; Andrew Richards and Katharine Abrams, Marian Goodman Gallery; Sheena Wagstaff and Nicholas Cullinan, Metropolitan Museum of Art; Josie Nash, Mitchell-Innes & Nash; Barbara Moore, Estate of Peter Moore; Madeleine Grynsztejn, Lynne Warren, Katie Levi, and Leah Singsank, Museum of Contemporary Art Chicago; Rhona Hoffman, Rhona Hoffman Gallery; Marco Nocella, Ronald Feldman Fine Arts; and Rebecca Zorach.

This exhibition and catalogue benefited enormously from the ongoing research support provided by the helpful staffs of the Chicago History Museum; the Chicago Public Library; the Columbia University Libraries; the Getty Research Institute; the Huntington Library; the Los Angeles City Archives and Records Center; the New York Public Library, the library and archive of the Museum of Contemporary Art, Chicago; the New York University Libraries; UCLA Library Special Collections; the University of California, Santa Barbara, Architecture & Design Collections; and the USC Libraries, Special Collections Department.

We remain deeply grateful to the Art Institute of Chicago for championing this project from the start. The support of Douglas Druick, president and Eloise W. Martin Director; former director James Cuno; and Matthew Witkovsky, Richard and Ellen Sandor Chair and Curator of Photography, has been invaluable to us. In addition, this project was immeasurably aided by the encouragement of Dorothy Schroeder, vice president for exhibitions; Martha Tedeschi, deputy director for art and research; and most of all, Zoë Ryan, chair and John H. Bryan Curator of Architecture and Design. Once the project became a collaboration with the Princeton University Art Museum, we were sustained by the enthusiasm offered by the museum's director, James Steward, and by Bart Thurber, associate director for collections and exhibitions.

Since every project like *The City Lost and Found* is necessarily a team effort, we have many individuals to thank at both institutions. This volume was produced by the Princeton University Art Museum, and we gratefully acknowledge the indefatigable, skillful, and generous Anna Brouwer, who ensured its rigor and quality, and Curtis Scott, who worked with us to shape the publication that we had always imagined. Colleagues Caroline Harris, Janet Strohl-Morgan, Johanna Seasonwein, Juliana Ochs-Dweck, Cathryn Goodwin, and Erin Firestone eagerly engaged in conversations that profoundly shaped the interpretation of this exhibition. Alexia Hughes, Liz Aldred, and James Kopp supervised the exhibition loans for the Princeton

venue, and their astuteness and patience were much appreciated. Nancy Stout, Kelly Freidenfelds, and Christine Thiel ably led the fund-raising efforts. The beautiful installation at Princeton was the work of Mike Jacobs, whose exhibition design enhanced our curatorial vision, and of a team of talented preparators headed by Mark Harris. In addition, we thank Michael Brew, Salvatore Caputo, Tracy Craig, Jeff Evans, Lehze Flax, Lisa Gratkowski, Christine Hacker, Laura Hahn, Craig Hoppock, Marin Lewis, Karen Ohland, Kyle Palmer, and Jessica Popkin for lending their talents to this project.

At the Art Institute of Chicago, we gratefully acknowledge Alison Fisher's most generous and encouraging colleagues in the Architecture and Design Department, including Lori Boyer, Jennifer Breckner, Daniel Dorough, Karen Kice, Gibran Villalobos, and Alicja Zelazko. The project also benefited from the invaluable assistance of Photography Department colleagues James Iska, Sylvie Penichon, and Michal Raz-Russo. The museum's resourceful registrars Jennifer Draffen and Allison Revello managed the many details of the loans. Members of the development staff—including Eve Coffee Jeffers and Jennifer Oatess—were instrumental in garnering support for the project. The staff of the Ryerson and Burnham Libraries—including Jack Brown, Mary Woolever, Nathaniel Parks, and Christine Fabian—proved endlessly resourceful for a project relying greatly on publications and ephemera. Colleagues in the Imaging Department, including P. D. Young and Robert Lifson, greatly assisted with photography for the catalogue. We also thank media production staff Bill Foster and Tom Riley; the imaginative designers Yau-mu Huang and Cassie Tompkins; William Caddick and members of Physical Plant. Last but certainly not least, we are grateful for the extraordinary efforts of the Education Department, including

Judith Russi Kirshner, deputy director, and Allison Muscolino.

This book's designer, Adam Michaels of Project Projects, demonstrated his deep engagement with the topics of this project time and again. This stunning publication that you hold in your hands is ample evidence of his talents. We are grateful for the insights offered by editor Karen Jacobson, especially her tireless work on our essays, which made all the difference. In creating this book, we have become convinced there is no image that Lauren Makholm cannot secure. We acknowledge Michelle Woo, Sue Medlicott, and Nerissa Dominguez Vales for managing the production of the catalogue. Color separations were expertly made by Robert J. Hennessey, and the book was printed under the supervision of Klaus Prokop. We also thank Sam Frank for proofreading and Kathleen Friello for compiling the index.

Our colleagues across many disciplines provided inspiration, provocation, and support throughout the development of this project. We thank Janet Abu-Lughod, Lila Abu-Lughod, Donald Albrecht, Christopher James Alexander, Scott Allard, Hilary Ballon, Barry Bergdoll, Jennifer Blessing, Robert Bruegmann, Peter C. Bunnell, Matti Bunzl, Tony Chen, Huey Copeland, Esther da Costa Meyer, Paul D'Amato, Doug Eklund, Philip Enquist, Hal Foster, M. Paul Friedberg, Jocelyn Gibbs, Geoffrey Goldberg, Peter Bacon Hales, Hendrik Hartog, Virginia Heckert, Sarah M. Henry, Sarah Herda, Thomas Hines, Brooke Hodge, Nathan Holmes, D. Bradford Hunt, Christine Mehring, Allison Moore, Rebecca Morse, Barton Myers, Gabriella Nouzeilles, Andrew Perchuk, Susan Piedmont-Palladino, Dan Quiles, Michal Raz-Russo, Marci Reaven, Mark Robbins, Britt Salvesen, Vanessa Schwartz, Liz Siegel, David Travis, Nat Trotman, David Van Zanten, Jan Werner-Muller, Sarah Whiting, Carol Willis, Wim de Wit, and John Zukowsky. Stan Allen, Alison Isenberg,

and Rebecca Zorach deserve special mention for their desire and willingness to engage other members of the intellectual communities of Princeton and Chicago in this project.

For their sustained intellectual engagement with this project from a variety of backgrounds and outlooks, we offer our heartfelt thanks to the contributors to this publication: Janet Abu-Lughod, Lila Abu-Lughod, Ken D. Allan, Eric Avila, Beatriz Colomina, Dana Cuff, Josh Glick, Brynn Hatton, Craig Lee, Paula J. Massood, Timothy Mennel, Mariana Mogilevich, Max Page, Erin Reitz, David Sadighian, Joshua Shannon, Jacqueline Stewart, Lawrence J. Vale, Leslie Wilson, and Rebecca Zorach. Our research assistants and interns—Ofra Amihay, Arièle Dionne-Krosnick, Brynn Hatton, Craig Lee, Erin Reitz, Marin Sullivan, Scott Tavitian, and Leslie Wilson—offered brilliant assistance with many details.

On a personal note, we would like to express our heartfelt thanks to our families, especially David and Ellen Bussard; the late Lucille Davis; Adam and Juniper Ekberg; David and Sandy Ekberg; the Fisher family and the late George Harrison Fisher III; the Foster Family; Angela, Sylvia, and Vera Foster-Rice; the Foster-Weinberg family; Krysia Kaminska-Szych; Elaine and Greg Lucas; Joseph Mulvey and the Mulvey family; Alice and Chris Rice; and Jim and Susan Rice. We are also incredibly grateful to our friends, colleagues, and students and for the rich and varied experiences of neighborhood life that influenced our thinking about the significance of cities.

Finally we acknowledge the artists whose work inspired this project—especially those who generously lent work to the exhibition—and the cities of New York, Chicago, and Los Angeles for providing insights around every corner and in every human interaction.

KB, AF, GFR

Contributors

Katherine A. Bussard is the Peter C. Bunnell Curator of Photography at the Princeton University Art Museum. Bussard is the author of *Unfamiliar Streets: The Photographs of Richard Avedon, Charles Moore, Martha Rosler, and Philip-Lorca diCorcia* (2014). Other publications include *Color Rush: American Color Photography from Stieglitz to Sherman* (2013); *Street Art, Street Life: From the 1950s to Now* (2008); and *So the Story Goes: Photographs by Tina Barney, Philip-Lorca diCorcia, Nan Goldin, Sally Mann, and Larry Sultan* (2006). Prior to her appointment at Princeton in 2013, Bussard was associate curator of photography at the Art Institute of Chicago.

Alison Fisher is Harold and Margot Schiff Assistant Curator of Architecture and Design at the Art Institute of Chicago. Since joining the museum in 2009, she has curated numerous exhibitions, including the retrospective *Bertrand Goldberg: Architecture of Invention* (2011–12), which was accompanied by a scholarly catalogue. Fisher teaches courses in art and architectural history at area universities, and her publications and research focus on issues of politics, technology, housing, and, of course, cities. Her projects have been recognized with awards and grants from the Graham Foundation, the Society of Architectural Historians, and the Bourse Chateaubriand program of the Embassy of France.

Greg Foster-Rice is an associate professor at Columbia College Chicago, where he teaches the history, theory, and criticism of photography. He is the recipient of numerous grants, including the Terra Foundation for American Art / Lloyd Lewis Fellowship in American Art History at the Newberry Library, Chicago, which funded important early archival research for *The City Lost and Found*. Recent publications include an essay for the catalogue *Black Is,*

Black Ain't (2013) and the anthology *Reframing the New Topographics* (2011), which he coedited and coauthored. He loves and admires cities across the globe.

Ken D. Allan is associate professor of art history at Seattle University. His recent work on art in 1960s Los Angeles has been published in the catalogues *Pacific Standard Time: Los Angeles Art, 1945–1980* (2011) and *Pop Departures* (2014) and in the journals *Art Bulletin*, *Art Journal*, and *X-Tra*.

Eric Avila is professor of history, Chicano studies, and urban planning at the University of California, Los Angeles. He is author of *Popular Culture in the Age of White Flight: Fear and Fantasy in Suburban Los Angeles* (2004) and *The Folklore of the Freeway: Race and Revolt in the Modernist City* (2014).

Beatriz Colomina is professor of architecture and founding director of the Program in Media and Modernity at Princeton University. Her books include *Manifesto Architecture: The Ghost of Mies* (2014); *Domesticity at War* (2007); *Privacy and Publicity: Modern Architecture as Mass Media* (1994); and *Sexuality and Space* (1992). She is curator of the exhibitions *Clip, Stamp, Fold: The Radical Architecture of Little Magazines 196X–197X* (2006–13); *Playboy Architecture, 1953–79* (2012); and *Radical Pedagogies* (2013).

Dana Cuff is professor of architecture and urban design at the University of California, Los Angeles. She founded and directs UCLA's cityLAB, a research and design center investigating experimental forms of the contemporary city. Cuff also leads the Urban Humanities Initiative, a multiyear project to bring together humanists, architects, and urbanists to imagine future possibilities of Pacific Rim megacities.

Josh Glick is assistant professor of English and film studies at Hendrix College. He is currently a Mellon Postdoctoral Fellow in the integrated humanities at Yale University. His articles have appeared in *The Moving Image*, *Film History*, and the *Historical Journal of Film, Radio, and Television*. He is completing a book on Los Angeles and documentary media, 1958–77.

Brynn Hatton is a Ph.D. candidate in the Department of Art History at Northwestern University and a Social Science Research Council Mellon International Dissertation Research Fellow for the year 2014–15. She studies art, war, and resistance in the twentieth and twenty-first centuries.

Craig Lee, a Ph.D. candidate in the Department of Art History at the University of Delaware, focuses on the history of modern architecture and design. For the 2013–14 academic year, he held a McCrindle Internship at the Princeton University Art Museum.

Paula J. Massood is professor of film studies at Brooklyn College, City University of New York (CUNY), and serves on the doctoral faculty in the Program in Theatre at the Graduate Center, CUNY. She is the author of *Black City Cinema: African American Urban Experiences in Film* (2003) and *Making a Promised Land: Harlem in 20th-Century Photography and Film* (2013). She is also the editor of *The Spike Lee Reader* (2007).

Timothy Mennel is senior editor at the University of Chicago Press. He coedited *Reconsidering Jane Jacobs* (2011) and *Block by Block: Jane Jacobs and the Future of New York* (2007) and has written extensively on Robert Moses. He was a curatorial adviser for *13 Most Wanted Men: Andy Warhol and the 1964 World's Fair* at the Queens Museum (2014).

Mariana Mogilevich is a Princeton-Mellon Fellow in Architecture, Urbanism, and the Humanities at Princeton University. A historian of architecture and urbanism whose research focuses on the design and politics of the built environment, she has written extensively on the design of the public realm in postwar New York City.

Max Page is professor of architecture and history at the University of Massachusetts Amherst and the author of *The Creative Destruction of Manhattan, 1900–1940* (1999) and *The City's End: Two Centuries of Fantasies, Fears, and Premonitions of New York's Destruction* (2008) and is the coeditor of *Reconsidering Jane Jacobs* (2011). He is a Guggenheim Fellow and Rome Prize recipient.

Erin Reitz is a Ph.D. candidate in the Department of Art History at Northwestern University. She expects to complete her dissertation on the visuals and films of the Black Panther Party and the shifting geographies of the Panthers' political ambitions by the spring of 2016.

David Sadighian is a Ph.D. student in Harvard University's Department of History of Art and Architecture. Prior to his doctoral studies, David was a curatorial assistant at the Yale School of Architecture Gallery, and he later worked as a collection research specialist in the Museum of Modern Art's Department of Painting and Sculpture.

Joshua Shannon is associate professor in the Department of Art History and Archaeology at the University of Maryland and the author of *The Disappearance of Objects: New York Art and the Rise of the Postmodern City* (2009). He is founder and director of the Potomac Center for the Study of Modernity.

Jacqueline Stewart is professor of cinema and media studies and the college at the University of Chicago. Her research and teaching explore African American film cultures from the origins of the medium to the present. She is the author of *Migrating to the Movies: Cinema and Black Urban Modernity* (2005).

Lawrence J. Vale is Ford Professor of Urban Design and Planning at the Massachusetts Institute of Technology, where he is director of the Resilient Cities Housing Initiative (RCHI). He is the author of many books examining urban design and housing, including *Purging the Poorest: Public Housing and the Design Politics of Twice-Cleared Communities* (2013).

Leslie Wilson is a Ph.D. candidate in the Department of Art History at the University of Chicago studying the history of photography and modern and contemporary art of the United States and Africa. Her dissertation examines the rise of color photography in the context of the shifting terrain of photojournalism, documentary practices, and art for photographers in postapartheid South Africa.

Rebecca Zorach is professor of art history and the college at the University of Chicago. She teaches and writes on European Renaissance art, contemporary art, and art of the 1960s and 1970s. Recent articles have addressed AfriCOBRA's gender and family politics; Claes Oldenburg's lawsuit challenging the copyright of the Chicago Picasso; and the experimental art center Art & Soul, founded on the West Side of Chicago in 1968.

Selected Bibliography

General

Abu-Lughod, Janet L. *New York, Chicago, Los Angeles: America's Global Cities*. Minneapolis: University of Minnesota Press, 1999.

——. *Race, Space, and Riots in Chicago, New York, and Los Angeles*. Oxford: Oxford University Press, 2007.

Avila, Eric. *The Folklore of the Freeway: Race and Revolt in the Modernist City*. Minneapolis: University of Minnesota Press, 2014.

Banfield, Edward C. *The Unheavenly City: The Nature and Future of Our Urban Crisis*. Boston: Little, Brown, 1970.

Banham, Reyner. *Megastructures: Urban Futures of the Recent Past*. New York: Harper & Row, 1976.

Berger, Dan, ed. *The Hidden 1970s: Histories of Radicalism*. New Brunswick, NJ: Rutgers University Press, 2010.

Bingaman, Amy, Lise Sanders, and Rebecca Zorach, eds. *Embodied Utopias: Gender, Social Change, and the Modern Metropolis*. New York: Routledge, 2002.

Boyer, M. Christine. *Dreaming the Rational City: The Myth of American City Planning*. Cambridge, MA: MIT Press, 1986.

Brougher, Kerry, and Russell Ferguson. *Open City: Street Photographs since 1950*. Oxford, UK: Museum of Modern Art Oxford; Ostfildern-Ruit, Germany: Hatje Cantz, 2001.

Bruegmann, Robert. *Sprawl: A Compact History*. Chicago: University of Chicago Press, 2005.

Bussard, Katherine A. *Unfamiliar Streets: The Photographs of Richard Avedon, Charles Moore, Martha Rosler, and Philip-Lorca DiCorcia*. New Haven, CT: Yale University Press, 2014.

Campbell, Mary Schmidt, ed. *Tradition and Conflict: Images of a Turbulent Decade, 1963–1973*. New York: Studio Museum in Harlem, 1985.

Certeau, Michel de. *The Practice of Everyday Life*. Berkeley: University of California Press, 1984.

Cohen, Lizabeth. *A Consumer's Republic: The Politics of Mass Consumption in Postwar America*. New York: Knopf, 2003.

Colomina, Beatriz, and Craig Buckley, eds. *Clip, Stamp, Fold: The Radical Architecture of Little Magazines, 196X to 197X*. Barcelona: ACTAR, 2010.

Cooper, Martha, and Henry Chalfant. *Subway Art*. New York: Holt, Rinehart & Winston, 1984.

Deutsche, Rosalyn. *Evictions: Art and Spatial Politics*. Chicago: Graham Foundation for Advanced Studies in the Fine Arts, 1996.

Doss, Erika, ed. *Looking at "Life" Magazine*. Washington, DC: Smithsonian Institution Press, 2001.

Easterling, Keller. *Organization Space: Landscapes, Highways, and Houses in America*. Cambridge, MA: MIT Press, 1999.

Fisher, Robert. *Let the People Decide: Neighborhood Organizing in America*. Boston: Twayne, 1984.

Foster-Rice, Greg, and John Rohrbach, eds. *Reframing the New Topographics*. Chicago: Center for American Places at Columbia College Chicago, 2010.

Friedberg, M. Paul, and Ellen Perry Berkeley. *Play and Interplay: A Manifesto for New Design in Urban Recreational Environment*. New York: Macmillan, 1970.

Gans, Herbert J. *The Urban Villagers: Group and Class in the Life of Italian-Americans*. New York: Free Press of Glencoe, 1962.

Geddes, Patrick. *Cities in Evolution*. New York: Fertig, 1968.

Haar, Charles Monroe. *Land-Use Planning: A Casebook on the Use, Misuse, and Reuse of Urban Land*. Boston: Little, Brown, 1959.

Hales, Peter B. *Silver Cities: Photographing American Urbanization, 1839–1939*. Albuquerque: University of New Mexico Press, 2005.

Harvey, David. *The Condition of Postmodernity: An Enquiry into the Origins of Cultural Change*. Oxford: Blackwell, 1990.

——. *Social Justice and the City*. Baltimore: Johns Hopkins University Press, 1973.

Hollevoet, Cristel, Karen Jones, and Timothy Nye. *The Power of the City: The City of Power*. New York: Whitney Museum of American Art, 1992.

Jacobs, Jane. *The Death and Life of Great American Cities*. New York: Random House, 1961.

Judd, Dennis R., and Dick Simpson, eds. *The City, Revisited: Urban Theory from Chicago, Los Angeles, and New York*. Minneapolis: University of Minnesota Press, 2011.

Kaplan, Marshall. *Urban Planning in the 1960s: A Design for Irrelevancy*. Cambridge, MA: MIT Press, 1974.

Kelsey, Robin Earle, and Blake Stimson, eds. *The Meaning of Photography*. Williamstown, MA: Sterling and Francine Clark Art Institute, 2008.

Lefebvre, Henri, and Donald Smith. *The Production of Space*. Oxford: Blackwell, 2007.

Loukaitou-Sideris, Anastasia, and Renia Ehrenfeucht. *Sidewalks: Conflict and Negotiation over Public Space*. Cambridge, MA: MIT Press, 2009.

Lynch, Kevin. *The Image of the City*. Cambridge, MA: MIT Press, 1960.

Marcus, Alan R., and Dietrich Neumann, eds. *Visualizing the City*. London: Routledge, 2007.

McMillian, John Campbell. *Smoking Typewriters: The Sixties Underground Press and the Rise of Alternative Media in America*. New York: Oxford University Press, 2011.

Miles, Malcolm. *Art, Space, and the City: Public Art and Urban Futures*. New York: Routledge, 1997.

Mumford, Lewis. *The Culture of Cities*. New York: Harcourt, Brace, 1938.

North, Whitney Seymour Jr., ed. *Small Urban Spaces: The Philosophy, Design, Sociology, and Politics of Vest-Pocket Parks and Other Small Urban Open Spaces*. New York: New York University Press, 1969.

Page, Max, and Randall Mason, eds. *Giving Preservation a History: Histories of Historic Preservation in the United States*. New York: Routledge, 2003.

Page, Max, and Timothy Mennell, eds. *Reconsidering Jane Jacobs*. Chicago: American Planning Association, 2011.

Patterson, James T. *The Eve of Destruction: How 1965 Transformed America*. New York: Basic Books, 2012.

Peck, Abe. *Uncovering the Sixties: The Life and Times of the Underground Press*. New York: Pantheon, 1985.

Rice, Mark. *Through the Lens of the City: NEA Photography Surveys of the 1970s*. Jackson: University Press of Mississippi, 2005.

Saunders, Dave. *Direct Cinema: Observational Documentary and the Politics of the Sixties*. New York: Wallflower, 2007.

Shiel, Mark, and Tony Fitzmaurice, eds. *Screening the City*. London: Verso, 2003.

Smith, Joel. *The Life and Death of Buildings: On Photography and Time*. Princeton, NJ: Princeton University Art Museum, 2011.

Soja, Edward W. *Postmodern Geographies: The Reassertion of Space in Critical Social Theory*. London: Verso, 1989.

Sorkin, Michael, ed. *Variations on a Theme Park: The New American City and the End of Public Space*. New York: Hill & Wang, 1992.

Vale, Lawrence J. *Purging the Poorest: Public Housing and the Design Politics of Twice-Cleared Communities*. Chicago: University of Chicago Press, 2013.

Vidler, Anthony. *Warped Space: Architecture and Anxiety in Modern Culture*. Cambridge, MA: MIT Press, 2000.

Wainwright, Loudon. *The Great American Magazine: An Inside History of "Life."* New York: Knopf, 1986.

Whyte, William H. *The Social Life of Small Urban Spaces*. Washington, DC: Conservation Foundation, 1980.

Wilkerson, Isabel. *The Warmth of Other Suns: The Epic Story of America's Great Migration*. New York: Random House, 2010.

Woods, Shadrach. *The Man in the Street: A Polemic on Urbanism*. Harmondsworth, UK: Penguin, 1975.

Yee, Lydia, and Whitney Rugg, eds. *Street Art, Street Life: From the 1950s to Now*. New York: Aperture Foundation, 2008.

New York

Ault, Julie, ed. *Alternative Art, New York, 1965–1985*. Minneapolis: University of Minnesota Press, 2003.

Ballon, Hilary, and Kenneth T. Jackson, eds. *Robert Moses and the Modern City: The Transformation of New York*. New York: Norton, 2007.

Biondi, Martha. *To Stand and Fight: The Struggle for Civil Rights in Postwar New York City*. Cambridge, MA: Harvard University Press, 2003.

Blair, Sara. *Harlem Crossroads: Black Writers and the Photograph in the Twentieth Century*. Princeton, NJ: Princeton University Press, 2007.

Bloom, Nicholas Dagen. *Public Housing That Worked: New York in the Twentieth Century*. Philadelphia: University of Pennsylvania Press, 2009.

Caro, Robert A. *The Power Broker: Robert Moses and the Fall of New York*. New York: Knopf, 1974.

Cooke, Lynne, Douglas Crimp, and Kristin Poor, eds. *Mixed Use, Manhattan: Photography and Related Practices, 1970s to the Present*. Madrid: Museo Nacional Centro de Arte Reina Sofía; Cambridge, MA: MIT Press, 2010.

Finkelpearl, Tom. *Dialogues in Public Art*. Cambridge, MA: MIT Press, 2000.

Flint, Anthony. *Wrestling with Moses: How Jane Jacobs Took on New York's Master Builder and Transformed the American City*. New York: Random House, 2009.

Franzen, Ulrich, and Paul Rudolph. *The Evolving City: Urban Design Proposals*. New York: Whitney Library of Design for American Federation of Arts, 1974.

Freeman, Joshua B. *Working-Class New York: Life and Labor since World War II*. New York: New Press, 2000.

Greenberg, Miriam. *Branding New York: How a City in Crisis Was Sold to the World*. New York: Routledge, 2008.

James, David E. *To Free the Cinema: Jonas Mekas and the New York Underground*. Princeton, NJ: Princeton University Press, 1992.

Lee, Pamela M. *Object to Be Destroyed: The Work of Gordon Matta-Clark*. Cambridge, MA: MIT Press, 2000.

Livingston, Jane. *The New York School: Photographs, 1936–1963*. New York: Stewart, Tabori & Chang, 1992.

Mason, Randall. *The Once and Future New York: Historic Preservation and the Modern City*. Minneapolis: University of Minnesota Press, 2009.

Massood, Paula J. *Making a Promised Land: Harlem in Twentieth-Century Photography and Film*. New Brunswick, NJ: Rutgers University Press, 2013.

Mayor's Task Force on Urban Design. *The Threatened City: A Report on the Design of the City of New York*. New York, 1967.

Moore, Alan, and Marc Miller, eds. *ABC No Rio Dinero: The Story of a Lower East Side Art Gallery*. New York: ABC No Rio and Collaborative Projects, 1985.

Mumford, Lewis, and Robert Wojtowicz, eds. *Sidewalk Critic: Lewis Mumford's Writings on New York*. New York: Princeton Architectural Press, 1998.

Page, Max. *The City's End: Two Centuries of Fantasies, Fears, and Premonitions of New York's Destruction*. New Haven, CT: Yale University Press, 2008.

———. *The Creative Destruction of Manhattan, 1900–1940*. Chicago: University of Chicago Press, 1999.

Pasternak, Anne. *Creative Time, the Book: Thirty-Three Years of Public Art in New York City*. New York: Princeton Architectural Press, 2008.

Plan for New York City, 1969: A Proposal. Cambridge, MA: MIT Press, 1969.

Plunz, Richard. *A History of Housing in New York City*. New York: Columbia University Press, 1990.

Roberts, Sam, ed. *America's Mayor: John V. Lindsay and the Reinvention of New York*. New York: Museum of the City of New York and Columbia University Press, 2010.

Shannon, Joshua. *The Disappearance of Objects: New York Art and the Rise of the Postmodern City*. New Haven, CT: Yale University Press, 2009.

Vergara, Camilo José. *Harlem: The Unmaking of a Ghetto*. Chicago: University of Chicago Press, 2013.

Viteritti, Joseph P., ed. *Summer in the City: John Lindsay, New York, and the American Dream*. Baltimore: John Hopkins University Press, 2014.

Willis, Carol, Ann L. Buttenwieser, Paul Willen, and James S. Rossant. *The Lower Manhattan Plan: The 1966 Visions for Downtown New York*. New York: Princeton Architectural Press, 2002.

Zipp, Samuel. *Manhattan Projects: The Rise and Fall of Urban Renewal in Cold War New York*. Oxford: Oxford University Press, 2010.

Zukin, Sharon. *Loft Living: Culture and Capital in Urban Change*. Baltimore: Johns Hopkins University Press, 1982.

Chicago

Basic Policies for the Comprehensive Plan of Chicago. Chicago: Department of City Planning, 1964.

Bennett, Larry. *The Third City: Chicago and American Urbanism*. Chicago: University of Chicago Press, 2010.

Bowly, Devereux, Jr. *The Poorhouse: Subsidized Housing in Chicago, 1895–1976*. Carbondale: Southern Illinois University Press, 1978.

Bruegmann, Robert. *A Guide to 150 Years of Chicago Architecture*. Chicago: Chicago Review Press, 1985.

Buckland, Gail. *The Photographer and the City*. Chicago: Museum of Contemporary Art, 1977.

Cahan, Richard. *They All Fall Down: Richard Nickel's Struggle to Save America's Architecture*. Washington, DC: Preservation Press, National Trust for Historic Preservation, 1994.

Chicago: The City and Its Artists, 1945–1978. Ann Arbor: University of Michigan Museum of Art, 1978.

Chicago 21: A Plan for the Central Area Communities; A Summary. Chicago: Chicago Plan Commission, 1973.

Cohen, Adam, and Elizabeth Taylor. *American Pharaoh: Mayor Richard J. Daley; His Battle for Chicago and the Nation*. Boston: Little, Brown, 2000.

Farber, David. *Chicago '68*. Chicago: University of Chicago Press, 1988.

Haar, Sharon. *The City as Campus: Urbanism and Higher Education in Chicago*. Minneapolis: University of Minnesota Press, 2011.

Hirsch, Arnold R. *Making the Second Ghetto: Race and Housing in Chicago, 1940–1960*. Chicago: University of Chicago Press, 1998.

Hunt, D. Bradford. *Blueprint for Disaster: The Unraveling of Chicago Public Housing*. Chicago: University of Chicago Press, 2009.

Hunt, D. Bradford, and John B. Devries. *Planning Chicago*. Chicago: American Planning Association, 2013.

Kelly, Patricia. *1968: Art and Politics in Chicago*. Chicago: DePaul University Art Museum, 2008.

Kusch, Frank. *Battleground Chicago*. Westport, CT: Praeger, 2004.

Meyerson, Martin, and Edward C. Banfield. *Politics, Planning, and the Public Interest: The Case of Public Housing in Chicago*. Glencoe, IL: Free Press, 1955.

1968: Art and Politics in Chicago. Chicago: DePaul University Art Museum, 2008.

Pacyga, Dominic A. *Chicago: A Biography*. Chicago: University of Chicago Press, 2009.

Ryan, Zoë, ed. *Bertrand Goldberg: Architecture of Invention*. Chicago: Art Institute of Chicago, 2011.

Waldheim, Charles, and Katerina Rüedi Ray, eds. *Chicago Architecture: Histories, Revisions, Alternatives*. Chicago: University of Chicago Press, 2005.

Warren, Lynne. *Art in Chicago, 1945–1995*. Chicago: Museum of Contemporary Art Chicago, 1996.

Wetmore, Louis B. *The Comprehensive Plan of Chicago*. Chicago: Department of Development and Planning, 1966.

Los Angeles

Allan, Ken. "Ed Ruscha, Pop Art, and Spectatorship in 1960s Los Angeles." *Art Bulletin* 92 (September 2010): 231–49.

Arteaga-Johnson, Giselle. *L.A. Obscura: The Architecture Photography of Julius Shulman*. Los Angeles: Fisher Gallery, University of Southern California, 1998.

Avila, Eric. *Popular Culture in the Age of White Flight: Fear and Fantasy in Suburban Los Angeles*. Berkeley: University of California Press, 2004.

Banham, Reyner. *Los Angeles: The Architecture of Four Ecologies*. New York: Harper & Row, 1971.

Central City Los Angeles 1972/1990: Preliminary General Development Plan. Los Angeles: Committee for Central City Planning, 1972.

Chavoya, C. Ondine, and Rita González, eds. *Asco: Elite of the Obscure: A Retrospective, 1972–1987.* Williamstown, MA: Williams College Museum of Art; Los Angeles: Los Angeles County Museum of Art; Ostfildern, Germany: Hatje Cantz, 2011.

Concept Los Angeles: The Concept for the Los Angeles General Plan. Los Angeles: Department of City Planning, 1970.

Concepts for Los Angeles. Los Angeles: Department of City Planning, 1967.

Cuff, Dana. *The Provisional City: Los Angeles Stories of Architecture and Urbanism.* Cambridge, MA: MIT Press, 2001.

Davis, Mike. *City of Quartz: Excavating the Future in Los Angeles.* London: Verso, 1990.

Drohojowoska-Philp, Hunter. *Rebels in Paradise: The Los Angeles Art Scene and the 1960s.* New York: Henry Holt, 2011.

Emerging Los Angeles Photographers. Carmel, CA: Friends of Photography, 1977.

Grenier, Catherine, Howard N. Fox, and David E. James. *Los Angeles, 1955–1985: Birth of an Art Capital.* Paris: Centre Pompidou, 2006.

Hines, Thomas. *Architecture of the Sun: Los Angeles Modernism, 1900–1970.* New York: Rizzoli, 2010.

Horne, Gerald. *Fire This Time: The Watts Uprising and the 1960s.* Charlottesville: University Press of Virginia, 1995.

Hylen, Arnold. *Bunker Hill, a Los Angeles Landmark.* Los Angeles: Dawson's Book Shop, 1976.

Jones, Kellie. *Now Dig This! Art and Black Los Angeles, 1960–1980.* Los Angeles: Hammer Museum, University of California; Munich: DelMonico Books / Prestel, 2011.

Kaplan, Sam Hall, and Julius Shulman. *L.A. Lost and Found: An Architectural History of Los Angeles.* Santa Monica, CA: Hennessey & Ingalls, 2000.

Lavin, Sylvia, ed., with Kimberli Meyer. *Everything Loose Will Land: 1970s Art and Architecture in Los Angeles.* West Hollywood, CA: MAK Center for Art and Architecture; Nuremberg, Germany: Verlag für moderne Kunst Nürnberg, 2013.

McCone, John A. *Transcripts, Depositions, Consultants Reports, and Selected Documents of the Governor's Commission on the Los Angeles Riots.* Los Angeles: Governor's Commission on the Los Angeles Riots, 1965.

Moore, Charles Willard. *The City Observed, Los Angeles: A Guide to Its Architecture and Landscapes.* New York: Random House, 1984.

Noriega, Chon A., Terezita Romo, and Pilar Tomplins Rivas, eds. *L.A. Xicano.* Los Angeles: UCLA Chicago Studies Research Center Press, 2011.

Parson, Don. *Making a Better World: Public Housing, the Red Scare, and the Direction of Modern Los Angeles.* Minneapolis: University of Minnesota Press, 2005.

Peabody, Rebecca, ed. *Pacific Standard Time: Los Angeles Art, 1945–1980.* Los Angeles: Getty Research Institute and J. Paul Getty Museum, 2011.

Schrank, Sarah. *Art and the City: Civic Imagination and Cultural Authority in Los Angeles.* Philadelphia: University of Pennsylvania Press, 2009.

Sides, Josh. *L.A. City Limits: African American Los Angeles from the Great Depression to the Present.* Berkeley: University of California Press, 2003.

Sloane, David Charles, ed. *Planning Los Angeles.* Chicago: American Planning Association, 2012.

Villa, Raúl. *Barrio-Logos: Space and Place in Urban Chicano Literature and Culture.* Austin: University of Texas Press, 2000.

Whiting, Cécile. *Pop L.A.: Art and the City in the 1960s.* Berkeley: University of California Press, 2006.

Widener, Daniel. *Black Arts West: Culture and Struggle in Postwar Los Angeles.* Durham, NC: Duke University Press, 2010.

Wilkman, Jon, and Nancy Wilkman. *Picturing Los Angeles.* Salt Lake City: Gibbs Smith, 2006.

Wit, Wim de, and Christopher James Alexander, eds. *Overdrive: L.A. Constructs the Future, 1940–1990.* Los Angeles: Getty Research Institute, 2013.

Index

Note: Pages with illustrations are indicated by *italics*.

Photography Credits

© 2014 Vito Acconci / Artists Rights Society (ARS), New York; photo by Jeffrey Evans: fig. 68

© Robert Adams, courtesy Fraenkel Gallery, San Francisco: fig. 252

© 2014 Victor Aleman / 2mun-dos.com: fig. 38

Courtesy of The Alvin Baltrop Trust and Third Streaming, New York: fig. 66

Courtesy of the Estate of Ralph Arnold and Corbett vs. Dempsey, Chicago: fig. 139

Photography by the Art Institute of Chicago, Department of Imaging: figs. 52, 53, 124, 125, 134, 135, 141, 142, 147, 148, 173, 195; courtesy of Ryerson and Burnham Libraries: fig. 1 / p. 18, left; figs. 3, 18, 19, 20, 26, 27, 59, 60, 118, 194, 197–99, 221, 226, 227

The Associated Press: fig. 69

© 1976 Judith F. Baca; image courtesy of SPARC (sparcinla.org): figs. 224, 249, 250

© 2014 The Barnett Newman Foundation, New York / Artists Rights Society (ARS), New York: fig. 164

© BBC Broadcast Archive / Getty Images: fig. 240

© Jeffrey Blankfort; image courtesy of the Charles Deering McCormick Library of Special Collections, Northwestern University: p. 98, center / fig. 138

© Hedrich Blessing / The Chicago History Museum, HB36092-A; photography courtesy the Ryerson and Burnham Libraries, The Art Institute of Chicago: fig. 194

© 1965 California Department of Transportation: fig. 247

© The Carlos Almaraz Estate Collection: fig. 248

© Vija Celmins: fig. 230

© 1968 Chicago Tribune. All rights reserved. Used by permission and protected by the Copyright Laws of the United States. The printing, copying, redistribution, or retransmission of this Content without express written permission is prohibited: fig. 136

© CNAC / MNAM / Dist. RMN-Grand Palais / Art Resource, NY: fig. 183

© Bruce Davidson / Magnum Photos: figs. 30, 50, 51, 86

© John Divola: figs. 222, 223

© Harry Drinkwater: fig. 232

© Robbert Flick, Courtesy Robert Mann Gallery, New York, and ROSEGALLERY, Santa Monica: fig. 32

© 1968 Free Black Press; images © Roy Lewis: fig. 36

© Leonard Freed / Magnum Photos: figs. 2, 62

Courtesy of The Estate of R. Buckminster Fuller: fig. 179

© Getty Images: figs. 10, 63, 137, 155, 156

© Hans Haacke / Artists Rights Society (ARS), New York / VG Bild-Kunst, Bonn: figs. 93–95

Art © Richard Haas / Licensed by VAGA, New York, NY; photography by The Art Institute of Chicago: figs. 96–98

Photo by Robert J. Hennessey: cover, left / fig. 14 / pp. 48–49

© Anthony Hernandez: figs. 243–45

© Dennis Hopper, Courtesy of The Hopper Art Trust: fig. 228

© John Humble: fig. 219

© 1962 Jonathan Cape Ltd.: fig. 75

© Barbara Jones-Hogu: fig. 160

© Kenneth Josephson: fig. 151; photography by the Art Institute of Chicago: figs. 131, 132

© J. Paul Getty Trust, used with permission: figs. 12, 175, 203, 207, 246, 253, 256

Courtesy Allan Kaprow Estate and Hauser & Wirth; photo by Nathan Keay, © The Museum of Contemporary Art Chicago: fig. 145

© Kartemquin Films: fig. 127

Photo by Nathan Keay, © The Museum of Contemporary Art Chicago: figs. 143, 159

© Kochi Prefecture, Ishimoto Yasuhiro Photo Center; photography by the Art Institute of Chicago: figs. 128–30

Courtesy of Kohn Gallery, Los Angeles; photo by Karl Puchlik: fig. 231

© Estate of Helen Levitt: figs. 55–58

Los Angeles Public Library Photo Collection: figs. 200, 216–18, 251

© Los Angeles Times. Reprinted with permission: fig. 109 (© 1965); p. 98, right / fig. 210 (© 1965); fig. 113 (© 1968)

© Danny Lyon / Magnum Photos; photo by Jeffrey Evans: figs. 40–42; photography by the Art Institute of Chicago: fig. 43 / p. 174, left; courtesy Rare Books and Special Collections, Princeton University Library: fig. 44

© 1966 Marzani & Munsell: fig. 53

© 1964 Massachusetts Institute of Technology, photographs by Hall Winslow: fig. 28

© Massachusetts Institute of Technology, photographs by Nishan Bichajian: fig. 13

© 2014 Estate of Gordon Matta-Clark / Artists Rights Society (ARS), New York: figs. 34, 71, 72; photo by Robert Chase Heishman: fig. 150

Photos by Susan Mogul, Suzanne Lacy, Leslie Labowitz, and Michelle Conway: fig. 237

Larry Morris / The New York Times / Redux: figs. 112, 119

© Grant Mudford: figs. 213, 242

Museum of the City of New York / Art Resource, NY: fig. 65

Courtesy of the National Archives; for further details on the images illustrated, search http://research.archives.gov/search using the following National Archives Identifiers: fig. 4: 548255; fig. 5: 553018; fig. 6: 556214; fig. 7: 557552; fig. 8: 555950; fig. 9: 549914; fig. 171: 556162; fig. 172: 553824

© 2014 Bruce Nauman / Artists Rights Society (ARS), New York: fig. 235

© Photo by NBC NewsWire / NBC / NBCU Photo Bank via Getty Images: figs. 115, 116

© 1965 Newsweek LLC. Used under License: fig. 110

New York State Archives: fig. 174

© The New York Times. All rights reserved. Used by permission and protected by the Copyright Laws of the United States. The printing, copying, redistribution, or retransmission of this Content without express written permission is prohibited: fig. 107 (© 1965); fig. 111 (©1968)

© 1975 Penguin Books: fig. 60

Photo by Quaku / Roderick Young, courtesy the artist and Thomas Erben Gallery, New York: figs. 238, 239

© 1969 Random House: fig. 52

© 2014 Cervin Robinson, cerv_rob@yahoo.com: fig. 76

Art © Romare Bearden Foundation / Licensed by VAGA, New York, NY: fig. 45; image copyright © The Metropolitan Museum of Art. Image source: Art Resource, NY: fig. 31

© Edward Ruscha; courtesy of the artist and Gagosian Gallery: figs. 211, 212, 229, 233, 234; photo by Jeffrey Evans: fig. 206

Courtesy of the Estate of Alfons Schilling, Vienna, Austria: fig. 33

Barton Silverman / The New York Times / Redux: cover, center / fig. 114 / pp. 122–23; figs. 154, 157

© 2004 Katherine Anne Sinsabaugh and Elisabeth Sinsabaugh de la Cova; photography by the Art Institute of Chicago: fig. 23; fig. 122 / p. 18, center; photography by the Art Institute of Chicago, courtesy of the Ryerson and Burnham Libraries: figs. 21, 24, 188; photo by Michael Cavanagh and Kevin Montague: figs. 123, 169, 170

© SOM: figs. 192, 193

SOM | © Hedrich Blessing: fig. 191

SOM | © Orlando Cabanban: fig. 189

© Thomas Struth: figs. 47–49, 186, 187

Courtesy of Sun-Times Media: figs. 22, 133, 161, 162

Courtesy of Sun-Times Media and the Chicago History Museum, ICHi-19630: fig. 163

© T3Media: fig. 117

© Bob Thall: fig. 173

1964 Text © Time Inc., image © Frank Dandridge: fig. 104; p. 98, left / fig. 105, left; image © Don Charles: fig. 105, right

1965 Text © Time Inc.; image © J. R. Eyerman / Life Images Collection / Getty Images: fig. 106, center; image © Joe Flowers: fig. 106, bottom left; images © Co Rentmeester: fig. 106, top left and bottom right

1968 Text © Time Inc.; images © The Gordon Parks Foundation: fig. 54

1970 Text © Time Inc.; image © John G. Zimmerman Archive: fig. 120

1970 Text © Time Inc.; image © John Olson / Life Picture Collection / Getty Images: fig. 121

LIFE logo and cover design © Time Inc.; image © Co Rentmeester: fig. 208

From TIME magazine, August 20, 1965 © 1965 Time Inc. Used under license. TIME magazine and Time Inc. are not affiliated with, and do not endorse products or services of, Licensee: fig. 108

From TIME magazine, November 1, 1968 © 1968 Time Inc. Used under license. TIME magazine and Time Inc. are not affiliated with, and do not endorse products or services of, Licensee; Art © Romare Bearden Foundation / Licensed by VAGA, New York, NY: fig. 46

Images © Arthur Tress: fig. 92

Image courtesy of Camilo José Vergara and ROSEGALLERY, Santa Monica: fig. 74

© The Estate of Garry Winogrand, courtesy of Fraenkel Gallery, San Francisco; photography by the Art Institute of Chicago: figs. 61, 204

© 1968 Ann Zelle: fig. 35

This book is published on the occasion of the exhibition *The City Lost and Found: Capturing New York, Chicago, and Los Angeles, 1960–1980*

The Art Institute of Chicago
Chicago, Illinois
October 26, 2014–January 11, 2015

Princeton University Art Museum
Princeton, New Jersey
February 21–June 7, 2015

The City Lost and Found: Capturing New York, Chicago, and Los Angeles, 1960–1980 has been organized by the Art Institute of Chicago and the Princeton University Art Museum. The exhibition at Princeton has been made possible by generous support from the Bagley Wright, Class of 1946, Contemporary Art Fund; Susan and John Diekman, Class of 1965; an anonymous fund; the Virginia and Bagley Wright, Class of 1946, Program Fund for Modern and Contemporary Art; M. Robin Krasny, Class of 1973; David H. McAlpin Jr., Class of 1950; James E. and Valerie A. McKinney; the Allen R. Adler, Class of 1967, Exhibitions Fund; and Elchin Safarov and Dilyara Allakhverdova. Further support has been made possible by the New Jersey State Council on the Arts / Department of State, a Partner Agency of the National Endowment for the Arts, and by the Partners and Friends of the Princeton University Art Museum. The publication has been made possible by the Andrew W. Mellon Foundation; the Barr Ferree Foundation Fund for Publications, Department of Art and Archaeology, Princeton University; and Christopher E. Olofson, Class of 1992.

Produced by the Princeton University Art Museum
Princeton, NJ 08544-1018
artmuseum.princeton.edu

Curtis R. Scott, Associate Director for Publishing and Communications
Anna Brouwer, Associate Editor

Edited by Karen Jacobson
Designed by Project Projects
Index by Kathleen Friello
Proofread by Sam Frank
Production by The Production Department, Whately, Massachusetts
Color separations by Robert J. Hennessey, Middletown, Connecticut
Printed by F&W Druck- und Mediencenter GmbH, Kienberg, Germany

The book was typeset in Neue Haas Grotesk, Mercury, and Pitch, and printed on 150 gsm GardaMatt Ultra

Distributed by Yale University Press
302 Temple Street
P.O. Box 209040
New Haven, CT 06520-9040
yalebooks.com/art

Library of Congress Control Number: 2014941267

ISBN 978-0-943012-52-0 (Princeton University Art Museum)
ISBN 978-0-300-20785-9 (Yale University Press)

Printed and bound in Germany

Front cover, left / pages 48–49: Pull-out map from *Plan for New York City*, 1969 (detail, fig. 14). Front cover, center / pages 122–23: Barton Silverman, photograph published in "Outlook after Chicago Violence," *New York Times*, August 31, 1968 (detail, fig. 114). Front cover, right / pages 206–7: Asco, *Decoy Gang War Victim*, 1974 (detail, fig. 236)

Page 18, left: *Plan for New York City*, 1969 (detail, fig. 1). Page 18, center: Art Sinsabaugh, *Chicago*, 1966 (detail, fig. 122). Page 18, right: Asco, *Instant Mural*, 1974 (detail, fig. 37)

Page 98, left: Page from "Harlem's 'Long Hot Summer' Begins," *Life*, July 31, 1964, photograph by Frank Dandridge (detail, fig. 105). Page 98, center: Page from "The 1968 Democratic National Convention [A Portfolio]," *Ramparts*, September 28, 1968, photograph by Jeffrey Blankfort (detail, fig. 138). Page 98, right: R. L. Oliver, photograph published in "Brown Declares: Riot Is Over," *Los Angeles Times*, August 17, 1965 (detail, fig. 210)

Page 174, left: Danny Lyon, *Facade of 82 Beekman*, from *The Destruction of Lower Manhattan*, ca. 1967 (detail, fig. 43). Page 174, center: Alvin Boyarsky, *Chicago à la Carte: The City as an Energy System*, 1970 (detail, fig. 196). Page 174, right: Carlos Diniz, Rendering for *A Grand Avenue: The Maguire Partners Proposal, Bunker Hill, Los Angeles*, 1980 (detail, fig. 214)